THOMAS EAKINS

Lloyd Goodrich

PUBLISHED FOR THE
NATIONAL GALLERY OF ART, WASHINGTON · 1982
HARVARD UNIVERSITY PRESS
CAMBRIDGE, MASSACHUSETTS, AND LONDON, ENGLAND

Library of Congress Cataloging in Publication Data

Goodrich, Lloyd.
Thomas Eakins.

(The Ailsa Mellon Bruce studies in American art; v. 2)
Bibliography: p.
Includes index.
1. Eakins, Thomas, 1844–1916. 2. Artists—
United States—Biography. I. Eakins, Thomas, 1844–1916.
II. National Gallery of Art (U.S.) III. Title. IV. Series.
N6537.E3G6 1982 709′.2′4 [B] 82-12170
ISBN 0-674-88490-6 (set)

Contents

THOMAS EAKINS

VOLUME II

11. Middle Age

AFTER TWO AND A HALF YEARS at 1330 Chestnut Street, in July 1886 Thomas Eakins returned with his wife, Susan Macdowell Eakins, to his father's house at 1729 Mount Vernon Street. His finances must have been in bad shape; the loss of his $1,200 Pennsylvania Academy salary could scarcely have been compensated for by his lecture fees from the Art Students' League of New York—$300 for the first season, $150 thereafter—or by a few small amounts from sales of his works. In 1885 his youngest sister, Caroline, had married and left their home. Benjamin Eakins is said to have persuaded Tom to come home; he did not like the way people were talking about his son (perhaps the aftermath of the Academy affair or perhaps living in the studio was considered bohemian). Thenceforth 1729 Mount Vernon Street was to be the Thomas Eakinses' home, and Benjamin's, for the rest of their lives. Thomas resumed payments to his father for "board and lodging," but doubled the amount to $40 a month. For July 1886, however, he deducted $10 for two weeks' board, "while absent on pleasure trip to Lake Champlain," evidently alone.

The household also included Aunt Eliza Cowperthwait, who became increasingly non compos mentis, to such an extent that her nephew had to rig up an electric alarm bell to warn the family when she left her room. There was an Irish woman-of-all-work, Mary Tracy.

The Chestnut Street place remained Eakins' studio for thirteen more years, until his father's death in 1899. In the late 1880s Samuel Murray began to work with him, first as his assistant, then, with the younger man's growing reputation, as sharer of the studio.

Benjamin's income from stocks, bonds, mortgages, and real estate, as well as from his teaching and penmanship, totaled about $4,800 a year—the equivalent of several times that amount today. His son never had to worry about poverty. But failure to make a living from his profession must have been a constant frustration.

In March 1887 Thomas consulted the lawyer and art collector John G. Johnson about his and his father's finances. Afterward he gave Johnson his

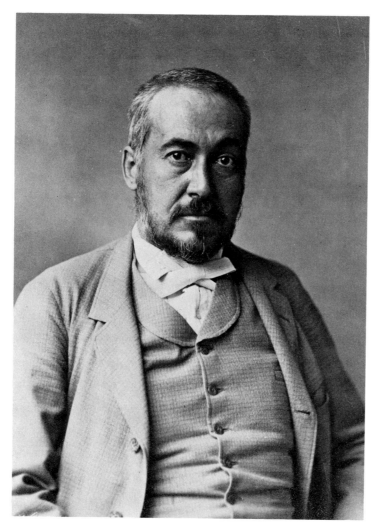

148. Thomas Eakins. Photograph by Frederick Gutekunst
July 23, 1893. Philadelphia Museum of Art; Bequest of Mark Lutz

1882 watercolor *Drawing the Seine* (ill. 124). Johnson wrote: "I am very much your debtor for your delightful little watercolor, though I have had much hesitation in bringing myself to retain it. . . . My hesitation in retaining it has arisen from the fact that it was possible for me to be of so little service in the sad situation of your affairs. It will give me much pleasure in going over your father's will. If you can stop at my house, as above, on Tuesday evening (29th inst.) at 8 I will do so."

In every aspect of his personal and professional life Eakins had the constant understanding and loyalty of his wife. In the 1930s, when I saw much of her, she was completely devoted to his memory, and to preserving everything

that had to do with him and his work. Seymour Adelman, who knew her well in her later years, wrote in 1973: "She shielded him from household chores, extended constant hospitality to his students and a large circle of friends, answered his correspondence, supervised the shipping of his pictures to exhibitions. . . . And, because she believed so intensely in the importance of her husband's work, for years she surreptitiously gathered up (and hid away in closets) his sketches, studies and perspective drawings that are, today, museum treasures, and which Eakins himself had tossed into the trash bin." She also kept a record of his works, begun by him and continued by her—an invaluable source of information for the future.

"What was there about Mrs. Eakins that friends might recall vividly?" Adelman wrote. "Perhaps it would be her perennial youthfulness—it made chronological age, whether she was in her seventies or eighties, utterly irrelevant. One remembers her quick intelligence, the amazing memory, that inexhaustible plum pudding of fact and anecdote about the people and events of her time, the eager curiosity that embraced everything under the sun, the kindness of heart. But most of all I would remember her buoyancy of spirit. As every friend of Mrs. Eakins will affirm, she possessed a positively rollicking sense of fun. Beneath the basic seriousness of her temperament, there was an irrepressibly humorous outlook on life. Now, in retrospect, one can understand why 1729 Mt. Vernon Street, even in the most troubled years, was never a dour household. There was always the saving grace of laughter, however wry or rueful it might be."

Thomas and Susan Eakins had no children, but they had ten nieces and nephews, Frances and William Crowell's progeny in Avondale. (Caroline and Frank Stephens with their three young children were permanently estranged.) Eakins' pupils and ex-pupils were always welcome in the Mount Vernon Street house. And there were many friends. With all this, and a household to manage, Susan Eakins found little time for painting. It has been said that she gave up painting altogether, feeling that there was not room for two artists in a family; even Charles Bregler, who was very close to her after Eakins' death, said that as an artist, "she was kinda killed when she married." She did not exhibit again at the Pennsylvania Academy until 1905. But recent reassembling of her pictures reveals that she continued to paint, intermittently. And after her husband's death, when she was in her middle sixties, she was to resume active work, which became an essential part of her life.

The Eakinses lived simply and frugally; they seldom left Philadelphia, even in summer, except for short excursions into the nearby country. The city was still not so large that it was necessary to go far for country life. Mrs. Eakins in 1930 told me that she hardly ever got away for long, there was so much to do at home. Their most frequent excursions were to the Crowell farm in Avondale. Eakins visited the farm often; kept his horses there, did some painting

and modeling; took full part in the activities of his nephews and nieces, and became strongly attached to them, as they did to him.

His lecturing career, while it lasted, took him regularly to New York and Brooklyn, and to Washington during a year or so; and he occasionally painted portraits in places other than Philadelphia. When the bicycle was introduced, about 1890, he became an active cyclist; he and Samuel Murray would sometimes go off on trips of several days. Aside from these excursions, he did little traveling. William Sartain, a cosmopolitan and a bachelor, wrote frequently from Europe, urging him to come over again, but Eakins was not interested; he used to say that his favorite places were Philadelphia and Spain. Except for

149. Eakins in his Chestnut Street studio. Probably 1892
Photographer unknown

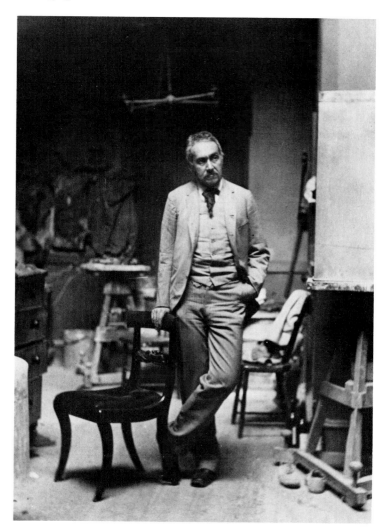

Thomas Eakins

his student years, practically his whole life was spent in the same city, and most of it in the same house.

After the Pennsylvania Academy affair, the respectable Philadelphia art world looked upon him as an outlaw. But he still had many artist friends, mostly old colleagues, or pupils and former pupils who remained loyal to him. And his circle of friends was by no means confined to fellow artists: it included men and women of varied occupations. Many were professionals outside the art field: scientists, physicians, teachers, musicians. He belonged to no clubs, but he was one of a small group of men, mostly professors of the University of Pennsylvania, who met on Sunday evenings in one another's houses: among them, William D. Marks, engineer; Harrison Allen, physiologist; and Hugh A. Clarke, musicologist and composer.

There was nothing of the hermit in Eakins, as in his contemporaries Homer and Ryder; he enjoyed social gatherings. Visitors to his studio were frequent: pupils, friends, sitters. His powers of concentration enabled him to work with people around him talking and making comments; he seems to have liked it.

"Mr. Eakins was not a talker," his wife said to me. Like many artists who express themselves well in their own medium, he was inclined to be silent. But he was a good listener; intelligent conversation interested him. Harrison Morris, managing director of the Pennsylvania Academy in the 1890s, wrote: "Eakins used to come in and sit down for a little visit. I had to do the talking, for he was very silent. He could lecture well, . . . but his talk was slender— yet illuminating when it came. I would ask many questions and have yea or nay for an answer."

When he did speak, he spoke tersely, clearly, and to the point. His choice of words had a bare simplicity: he preferred "naked" to "nude"; "painter" to "artist"; "picture" to "painting." Although he knew French, Italian, and Spanish, he avoided foreign terms, saying that it was an affectation when there were good English words for the same things. Always frank, he could be devastatingly so when the occasion called for it. His language was sometimes so free as to shock proper people. A woman friend told me that he did not use euphemisms for bodily functions: "he would always use the word." He enjoyed improper stories and had a good memory for them.

Publicity was distasteful to him; an artist's personal life, he said, was of no concern to the public. In answer to a request in 1893 for biographical information (probably from *The National Cyclopedia of American Biography*, the first important American publication of its kind), he wrote: "I was born July 25, 1844. My father's father was from the north of Ireland of the Scotch Irish. On my mother's side, my blood is English and Hollandish. I was a pupil of Gérôme (also of Bonnat and of Dumont, sculptor). I have taught in life classes, and lectured on anatomy continuously since 1873. I have painted many pic-

tures and done a little sculpture. For the public I believe my life is all in my work. Yours truly, Thomas Eakins."

A Mrs. Benson, who asked him to give a talk before a workingman's club, about the Pennsylvania Academy exhibition of 1897, received this reply: "With regard to the matter of your letter of the 2d., I do not see my way very clear to comply.

"The artist's appeal is a most direct one to the public through his art, and there is probably too much talk already.

"The working people from their close contact with physical things are apt to be more acute critics of the structural qualities of pictures than the dilettanti themselves and might justly resent patronage.

"In my own case, I have not yet found time to examine the Academy exhibit, and would be puzzled indeed to tell anybody why most of the pictures were painted.

"I have however the greatest sympathy with the kindly and generous spirit which prompts the action of your Club."

"When he made up his mind to a thing, it was done," Samuel Murray said. "Nothing could swerve him once he got started." Though never sharp or bitter, he was "just absolutely determined," the Nicholas Doutys said. Many of his friends described him as "gentle"—at the same time stressing his determination. With anyone who did him an injury he would not quarrel, but he would not forgive them, simply have no more to do with them. "To abuse and insult he turned a deaf ear," Mrs. Eakins said. "He was quiet under abuse, he believed in writing rather than talk." When angry the only sign he gave was to whistle softly to himself. His friend Mrs. Stanley Addicks, née Weda Cook, recalled only two incidents of his being ungentle: one involved Francis Ziegler, of which more later; the other when the critic Sadakichi Hartmann, who had been a friend, appeared at the studio; Eakins, without a word, took him by the shoulders, opened the door, and almost threw him down the stairs; then came back and said only: "I can't stand that man." What the offense was is not known, but it must have been forgiven, for Hartmann was later one of the first critics to praise him. The late Franklin Watkins once had a model who had posed for Eakins. Asked what he was like, she seemed at a loss for words, but finally said, "He was rough but right."

"An incident that will show his lack of fear and also his spirit toward his fellowman happened soon after his return from the West, where he had been living among the cow-boys," Gilbert S. Parker wrote. "He had occasion to cross Walnut Street bridge, which was infested with thugs in those days, late one night, and therefore took his large revolver along. Two toughs were waiting for a possible victim, and, as Eakins walked across the bridge, he cocked his revolver in his pocket. The thugs evidently heard it, for one said to the other, 'Let him go by, we'll get the next.' After Eakins had passed the men, he

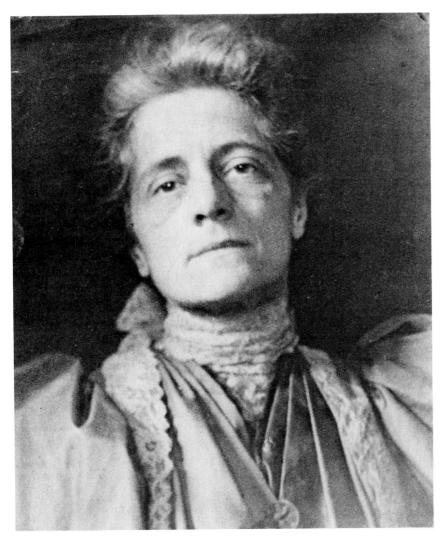

150. Susan Macdowell Eakins. Photograph by Elizabeth Macdowell Kenton
Mrs. Peggy Macdowell Thomas

waited for the man following and escorted him the rest of the distance over the bridge."

Physically, in his forties he had put on weight but was still a powerful figure. His outdoor activities continued: riding, bicycling, swimming, and skating. He particularly enjoyed swimming, naked, regardless of an audience. William Glackens, also a Philadelphian, remembered seeing him in the 1890s skating, wearing a little tight skating-cap, shooting around with his hands behind his back, or skating backward.

Mrs. Eakins and Murray, who were hardly impartial witnesses, described

pupils. "A half an hour of work that you thoroughly feel will do more good than a whole day spent in copying."

"He was a great one for going to bed early," Mrs. Eakins said. Usually he went to bed at nine, and got up early—four or five in the summer. His pictures of Franklin Schenck were painted at the League in the morning before classes began. At evening parties, if the talk or music did not interest him, he would doze off.

He drank no coffee or tea, and little spirituous liquor, but he liked a good bottle of wine. A nonsmoker, he disliked the smell of tobacco that clung to his clothes after an evening with cigar-smoking friends, and next morning he would change all his clothes. His appetite was hearty and he enjoyed good cooking; sometimes he cooked lunch for sitters in his Chestnut Street studio. His diet included an enormous quantity of milk—too much, as it turned out, for his health in later life.

The Eakinses had a number of French and Italian friends in Philadelphia, with whom he talked in their own languages. His French, which he used also in speaking with occasional European visitors, remained excellent; a French-woman said that one would take him for a Frenchman, though not a Parisian. The Italian section of Philadelphia attracted him. Particular friends were Enrico Gomez d'Arza and his wife, actors on the Italian stage in Philadelphia. Signor d'Arza, who described himself as an "artista drammatico," also conducted an Italian marionette show. Mrs. Eakins later wrote that in the early 1900s "a party of us went often to the Italian quarter (Little Italy of Phila.) to see the marionettes perform in Classic Plays, and hear the beautiful Italian spoken by the Master, Impresario I think they called him, also interesting performances at the Italian Theatre. There we saw Signor & Signora Gomez act and through this association Mr. Eakins painted [her] portrait. They were very poor, depending on their acting and Signora's teaching young actors, for a living. They could not speak English, Mr. Eakins spoke Italian and learned from her that she had had tragic experiences in her early life. She was about thirty years old when the portrait was painted.

"During the period of the posings for the portrait, Miss Williams [who lived with the Eakinses] and I cooked and served a noon dinner for them and their two children, a boy 'Mario', and a baby 'Immaculata' marvel of happiness and comfort, always smiling. The baby was swathed in white wrappings, we were curious, so different from the American way. Signora unwrapped the cloths to show us the custom, and we also noted the exquisite care and cleanliness, altho so poor.

"Signora showed us how to cook spaghetti & kidney the finest way, she said 'I know how, but cannot afford it myself.' The dish became famous in our house. Soon after the portrait was finished they left Philadelphia. We heard only once from them."

The portrait, now in the Metropolitan Museum (ills. 246, 247), is one of Eakins' most penetrating portrayals of women. The Signora's fine gaunt face bears the signs of the tragic experiences she told the painter about; her slender sensitive hand is as expressive of her character. The portrait is another manifestation of Eakins' affinity with Latin people.

Alice Kurtz, who as a young woman posed for her portrait in 1903, wrote me: "I greatly enjoyed knowing Mr. Eakins. . . . He was most entertaining and let me try to translate an Italian newspaper between the sittings. I guessed the words from my knowledge of Latin and French and he helped me, even inspiring me to get a dictionary and simple grammar. . . . Mr. Eakins and Mr. Murray the sculptor took us (my father and mother and me) one evening down to the Italian quarter of Phila.—to a delightful marionette show. How we enjoyed it—except the smells. The air was thick with smoke, garlic, and other rich Italian smells—which clung to our clothes for days afterwards. To me, it was a *most* Bohemian experience—perfectly delightful and how Mr. Eakins laughed and enjoyed it all."

Eakins was fond of animals, as was his wife, and the Mount Vernon Street house and its backyard contained a small menagerie. Their favorite was the red setter Harry, who had originally belonged to Margaret. "My husband and I had the entire care of Harry after his mistress, my husband's sister, died," Mrs. Eakins wrote in 1923. "He was a magnificent dog, & lived to be 16 years old." Harry was intelligent and well-behaved. He and Eakins were inseparable; as a student said, "Whenever you saw Harry you'd know Eakins was coming." Harry always accompanied his master to school, and would lie in a corner until criticism was over. He was trained not to hurt the other animals; when a tame bird pecked at his nose or the tame mice played around him, he would look wild-eyed but would restrain himself. It has been said that he was also trained so that when biscuits were laid in front of him he would not touch them until they were arranged to spell "Harry." When Eakins was painting the portrait of Professor Fetter, principal of the Girls' Normal School, the young ladies were much intrigued by this accomplishment and tempted Harry with fresh biscuits from a fine caterer, not arranged in order; but Harry was resolute. (One might dismiss this story as apocryphal except that the program of the school's exercises for presentation of the portrait includes a drawing by Eakins of Harry with his name spelt in biscuits.) Harry appears in four of his master's paintings, notably in *The Swimming Hole* and *The Artist's Wife and His Setter Dog.*

Other animals at 1729 Mount Vernon Street included cats, a rabbit, birds, tame rats and mice, and a turtle. (The last had been found by Eakins in Fairmount Park, and in 1930 could still be seen wandering around the yard.) When Susan Eakins returned from one of the few occasions that she was away from Philadelphia, she found that her husband had bought a monkey, Bobby. At

first he was kept in the Chestnut Street studio, much to the annoyance of sitters and visitors; then he was brought to the house, where he was permitted to run around until he became such a nuisance that he was chained to a stand or confined in a cage. Eakins was indulgent with him; he would hand the creature two silver dollars and allow him to climb on his shoulder and pound his head with the coins. Bobby had the best of food; once when his cage was in the kitchen the cook was heard saying: "But Bobby, I can't carve the roast before it goes into the dining room." Eakins' friends disliked Bobby heartily; E. Taylor Snow, when he came to sit for his portrait, would call on his way upstairs: "Here I come, Eakins; lock up that damned monkey."

"Bobby is quite unfriendly with the cats," Eakins wrote the ethnologist Frank Hamilton Cushing. "If one comes within his reach, he runs & pinches it or bites it & quickly retreats. He entices the cats by holding back of the full length of his chain ready to dart forward.

"If the cat is just beyond his reach, he gets one of his numerous war clubs, & then whacks her with that. In case the cat is too far even for that, he then hurls his war club at her and shows a fiendish delight if it hits. The first time we saw this done we felt there might be chance; but now we have seen it so frequently as to eliminate all the factors but those of pure intention."

Eakins was perhaps more attached to the animals than his wife was; she was not so fond of Bobby, who once bit her. Their friends tried to persuade Eakins to get rid of him, without success. It was only after Eakins' death, and after Bobby attacked her viciously, that on Murray's insistence she gave the creature to the Philadelphia zoo.

Eakins was gentle and patient with their animals; he often said that there was no good in being impatient with animals or inanimate things. Mrs. Eakins told me that the only time she ever saw him angry with any of them was when the rabbit, who fraternized with Harry, stuck his nose in the dog's face, and Harry snapped at him, breaking a blood vessel in his head; the rabbit went in to Eakins and climbed on his lap and died. Eakins ran out with tears streaming, and gave Harry a whipping. But when any of the animals had to be put away, he did it himself.

One wonders whether this engaging but excessive concern with animal pets might have been a partial compensation for not having children.

"He really seemed to prefer things that are outside the range of what are usually reckoned as constituting not only the charms but even the amenities of existence," Leslie Miller wrote. "He declared, for example, that he preferred to ride a horse bareback rather than on a comfortable saddle with stirrups, and if you could have seen how he kept his studio and even his house, and on what terms he lived with his monkey and other pets, you would know what I mean."

Though seldom going to the regular theater, Eakins enjoyed the circus and

taking his young nephews and nieces to it. Music was one of his greatest pleasures. Susan Eakins was an excellent amateur pianist, and they had many musician friends. Eakins read little: seldom novels, which he scorned; mostly scientific works. While in middle years not as active in scientific research as earlier, his chief mental avocation still remained the physical sciences. "To relax his mind after painting," Mrs. Eakins said, he would work out problems in calculus. The pianist Mary Hallock Greenewalt, who was also scientifically inclined, but on a more mystical level, said that often when she arrived to pose for him she found him reading a mathematical book, for enjoyment, as others would read a novel. She tried to interest him in the fourth dimension, but he refused to take stock in any such "poetical mathematics," saying, "You can't tie a knot in the fourth dimension." His pupil Thomas Eagan recalled his teacher walking along the street and doing mathematical problems in his head, to keep himself from "silliness." In the dining room hung a blackboard on which any point that came up in conversation could be illustrated. He liked to work with his hands and was a good craftsman; the top floor of the house contained a workroom with carpentry tools and Benjamin's lathe that Tom had drawn as a high-school student.

In politics he was a Democrat; he voted, but was not prone to political arguments. His letters to his father from Paris had shown a keen interest in French politics, and presumably he was later interested in American politics, but of that we have no evidence. But when an organization called the National Art Association was formed in 1892 to lobby for repeal of the 15 percent customs duty on imported foreign art (a reform supported by a large proportion of American artists, to their credit), Eakins was a member of the Association's three-man Philadelphia committee, went to Washington as a delegate to the Association's National Art Congress in May 1892, and appeared with a number of his colleagues at a hearing before the House Ways and Means Committee in support of the bill to repeal the tax. To publicize the cause the Association held a big exhibition in Washington of works by living American artists, to which he lent a picture. The House took no action, and ten years later the artists submitted another protest; Eakins was one of the signers. But it was not until some years later that the tax was finally repealed.

II

The artistic viewpoint and opinions expressed in Eakins' letters and notes written in France and Spain, and in what he said to his students, remained essentially the same throughout his life, though somewhat broadened. His basic naturalistic philosophy never changed; his preferences in other art (except Greek sculpture) were for naturalistic art, past and present.

Until the middle 1890s Philadelphia offered only limited opportunities to see the art of other countries and periods. The city had no public collections of

any importance except the Pennsylvania Academy, whose holdings, aside from antique casts, were chiefly American. In 1876 the Pennsylvania Museum and School of Industrial Art had been founded, but its collections, housed in Memorial Hall in Fairmount Park (the former art gallery of the Centennial), consisted of the decorative and applied arts, with only a few paintings of inferior quality. It was not until the middle 1890s, with the receipt of the Wilstach bequest, that the museum began to assemble the collection that today is part of the Philadelphia Museum of Art.

As to the Academy, its collection was strongest in works by American artists of the past. There were Benjamin West's huge religious and romantic canvases such as *Death on a Pale Horse* and *Christ Rejected*, Washington Allston's *Dead Man Restored to Life*, and John Vanderlyn's *Ariadne*. None of these could have had much appeal for Eakins. The Academy's greatest strength was in its historic portraits by Philadelphians or painters who had worked in the city: Charles Willson Peale and Rembrandt Peale; many works by Gilbert Stuart (including his Lansdowne *Washington*), Thomas Sully, and John Neagle with his *Pat Lyon at the Forge*. In other fields there were Thomas Birch's view of the *Fairmount Water Works* and Krimmel's *Fourth of July in Centre Square*. Eakins may well have admired some of these native painters, as he did the sculptor William Rush, but there is no record of his opinions about them.

In the old-master field, the Academy collection was a miscellany of the second-rate and the dubious, with nothing to compare with the Louvre or the Prado or the growing collection of the Metropolitan Museum in New York. Contemporary and recent European art was as poorly represented, until the bequest of the Gibson collection with its concentration on nineteenth-century French painting, academic and nonacademic, ranging from Cabanel, Gérôme, and Bonnat to the Barbizon school and Courbet's magnificent *The Great Oak*. But the Gibson bequest was not to be received until 1892. So in his formative years, from his return from Europe until the 1890s, Eakins could have had only a restricted opportunity to see great art in his native city.

In his personal preferences, his admiration for the Greek sculptors, particularly Phidias, remained constant. On his visits to the Metropolitan Museum he always went to see the collection of Greek casts. Among the old masters "the great Velázquez," as he called him, was his chief admiration, then Ribera and Rembrandt. Spanish and Dutch painting meant more to him than Italian or Flemish. In contemporary European painting he retained his preference for the more solid academicians: Bonnat, Regnault, Jean Paul Laurens, Fortuny, and above all, Gérôme, whom he continued to call "the greatest painter of the nineteenth century." (But he told his pupil George A. Reid that he did not think that Gérôme would approve of his work.) Among French nonacademi-

cians, past and contemporary, he esteemed Corot, Millet, Barye, and Courbet; and as time passed, Manet, Degas, and Forain. Of American contemporaries he ranked Winslow Homer highest; and he admired Sargent and, to a lesser degree, Chase, and in later years, Bellows. In the 1890s he owned a plaster cast of William R. O'Donovan's bust of Homer; he lent it to the National Art Association exhibition in Washington, and in 1911 he allowed it to be cast in bronze for the Pennsylvania Academy collection.

The literary, poetic, and decorative aspects of art did not interest him. He was not given to aesthetic discussion, and he seldom used the word "beauty." When Violet Oakley, the Philadelphia illustrator and painter of idealistic murals, showed him one of her pictures, he commented, "That's *beautiful*," and she gathered from his tone that it was not meant as a compliment. In a loan exhibition at the Pennsylvania Academy in the early 1900s, the Academy's secretary saw him intently studying a painting by Whistler and inquired what he thought of it. "I think it is a very cowardly way to paint," he said. Asked whether he did not think that the picture had charm and beauty, he looked at it again and said that he had never thought of that. Later, in 1914, he said in an interview, "Whistler was unquestionably a great painter, but there are many of his works for which I do not care." (Yet in his *Music* Whistler's *Sarasate* is represented as hanging on the wall.) "He was wont to term 'cowardly' those paintings that left much to the imagination," Gilbert S. Parker wrote. Another phrase of disapprobation was "no guts"; for him Italian painting had no guts, Weda Cook Addicks recalled.

Eakins had a powerful and penetrating intellect, but not of the kind that could be called cultured. Scores of his American colleagues—Inness, La Farge, Martin, Vedder, Shirlaw, Duveneck, Chase, Blashfield, Cox, and many less well-known—spent more years abroad, had more knowledge of historic and international art, and were more indebted to it. By comparison, Eakins' cultural horizons were limited, and the artistic world he inhabited was narrow and relatively provincial. It was not from knowledge of other art that his own drew its strength.

In many ways he can be considered overserious: working hard, teaching, going to bed and getting up early, traveling little, reading little, seldom going to the theater, drinking no spirits, coffee, or tea, not smoking, and condemning "idleness" and "silliness." On the other hand, he enjoyed active outdoor life: swimming, sailing, hunting, skating, riding, bicycling. He liked to watch prizefights, marionette shows, and the circus. He liked food and good wine; Philadelphia's Little Italy; the Art Students' League parties; broad jokes; and his menagerie of pets. His pleasures and recreations were far from sophisticated: simple, largely physical, and even boyish. With all his intellectual powers, in certain respects Eakins remained naive throughout his life.

In the summer of 1887 Eakins spent two and a half months out West in what was then Dakota Territory, now North Dakota. His good friend Dr. Horatio C. Wood, physician and naturalist, had a financial interest in the B-T Ranch near Dickinson, which he and his sons James and George used to visit; James had been a pupil of Eakins at the League. In June, Dr. Wood wrote the ranch manager, Tripp: "Mr. Eakins is an especial friend of mine who proposes to spend some time with you studying cowboy life in order to paint pictures of it." But there were undoubtedly other reasons, particularly the trauma of the Pennsylvania Academy affair; he had finished no paintings so far in 1887, and had exhibited only once. Walt Whitman, who was to know Eakins well, said later that he had been "sick, run down, out of sorts: he went right among the cowboys: herded: built up miraculously. . . . He needed the converting, confirming, uncompromising touch of the plains."

The B-T Ranch was in western Dakota's Bad Lands, a desertlike region of bare hills and steep ravines, eroded by millennia of wind and rain into fantastic forms, many-colored: yellows, salmon pinks, pale grays, reds, the only green in the valleys. The Bad Lands were well named; they were inhospitable and dangerous to men and animals.

Eakins arrived by train at Dickinson on July 26 and was met by Tripp and young George Wood. He bought a white bronco, then or later called Billy, and they were to start for the ranch, about forty-five miles north, early next morning. "I don't know what Tripp calls early," he wrote Susan that morning. "I got up at daylight 4 o'clock and have been walking about the town till now 5 o'clock and only 2 people in the town awoke." After several days' wait for his trunk, on the ride to the ranch they sighted antelope, and "I got a shot at one 400 yards off. . . . The ball must have struck very close by the dust it threw, Tripp said within six inches at the furthest. . . . Tripp was much pleased both with the little gun and the way I shot, and he will take me out hunting."

Next week he rode with the cowboys to Medora for a roundup of cattle for shipment East. "The horses are unshod and I never saw anything more sure footed. . . . We had come through a rattle snake country at one place, and heard them rattle a good many times. . . . The snakes cannot strike through our leather chaps, so we only fear for the horses. . . . I shot a jack-rabbit for our supper. He would make more than four of little bunny. . . .

"I did not catch any cold sleeping in my wet clothes and wet bed. I had so many blankets that I kept warm and not uncomfortable. . . . The country here is exceedingly beautiful."

A few days later: "I am in the best of health: although I have not slept in a bed I have no cold. The living on a round up is better in quality than in the palace Pullman dining cars. A fine beef is killed as fast as needed, we eat beef three times every day, and beans and bacon, and canned corn, canned toma-

toes, rice and raisins, and everything of the very best. I think you would laugh to see me devour a big hunk of meat lifted out of the big fat pot it was fried in.

"I have not been bilious yet for all that. My horse has carried me through all right, although I was offered as many gentle horses as I would want to ride. As I became well acquainted with all the fellows, I would have trusted any of them without the least fear, but if I had put on any airs I think I would have been hoisted."

Since one horse per man was not enough on the ranch, he bought a brown Indian pony, Bally or Baldy, from George Wood. "I do not get stiff or tired riding," he wrote in late August. "I can ride all day and not feel it, but I get sleepy as soon as night comes and sleep right through till daylight. . . . I have no good shot gun so I don't go after [prairie chickens], but if we are out of deer meat I often shoot their heads off with my rifle. . . .

"I killed a big rattlesnake the other day and will bring home the rattle for Ella. My horse is the fastest of all those on the ranch, and the Indian pony is next to one the fastest with light weight George Wood on him, but he carries a heavy man very well. Two winters ago he carried George Tripp who is as heavy as I am 60 miles from sunrise to dark night part of the time through snow drifts. It would not hurt him to carry me a hundred miles in a day if he rested the next. . . . The time is more than half gone. How happy I shall be to see you again."

On September 7: "I rode my little pony all day with rifle and cartridges and he came in on the full run, in spite of my weight. The pony has a very easy movement something like a rocking chair and will suit your style of riding. I think you can soon learn to ride easy on him. . . .

"The new round-up started yesterday and I guess I can join it day after to-morrow. I will go through country now near home, country that I am getting acquainted with. At first it looked as if I could never learn it. Dr. Wood told me never to go out of sight of the ranch alone but I have passed that stage long ago. . . .

"I wished to make some arrangement for paying board to Mr. Tripp but he won't hear of my paying him. He says that I am earning a great deal more than my board for the company and as to personal obligations he is obliged to me for coming to see him. I want to send him a good spyglass when I get home. I have no news of kitty or bunny or brother turtle. . . . Harry will soon see me again. Don't tell him about me till I am almost home. . . . We are going to sleep out on the ground tonight. We prefer it to hotel."

On Monday morning, September 26: "I have washed up all my dishes and pans and swept the house and watered and fed the work horses and fed the chickens and cleaned the stables and now I sit down to write you a long letter for it lacks yet 10 minutes of 8 and I am all alone at the ranch. I don't know for how long and must not leave it and this is how it came about." He then launched into a long detailed story. On Friday night a stranger, Mont, had rid-

den up to the ranch, been fed and stayed the night, and spent the next morning with Eakins, who was photographing the view from a butte three miles away. When they returned, "we got up a big dinner. I am a big eater myself but I was surprised at the amount that man put away." That night "he was very merry and gave us a lot of comic songs and tunes on the mouth organ. He had a pretty good voice."

Mont had six horses with him, and it turned out that he was a horse thief, who had ridden over five hundred miles from Wyoming. He was being trailed by two men, who caught up with him the third day; but he escaped from them. "He had driven very fast and had no idea that the horses had been missed so soon and that he was followed so quickly. I wish you could see trailing. There was a lame horse in his bunch who pressed more on one side of his foot than the other and sunk down there and made an unequal step and their hoofs were all worn so by travel that no other bunch of round up horses or others would be the same; so they could leave the trail if there was doubling or uncertainty and strike for a high divide and then find it again with certainty. If a horse treads where there is dampness they see which side of the mark the sun has dried off and they know if the horse passed morning or afternoon and they see if the wind has blown steady how much sand has blown into the sharpness of the hoof print and they do these and a hundred other things as quickly as you would read a newspaper."

The pursuers and the B-T ranchmen set out after the thief, alerting each ranch they came to, which lent fresh horses and more men. All the B-T men joined in the chase, and Eakins was left to watch the ranch. "I am very sorry there is no one here that I might see the pursuit; I would have walked twenty miles to get a horse, but they tell me my own part is a most useful one. I am to hold down the camp for there's a lot of food here and he cannot live in the bad lands. . . . They told me to keep my Winchester constantly at hand, not to leave the place and mind the dog. If he should appear I am to hold him up, cover him with my Winchester make him dismount and then watch him till some one comes. If he makes the slightest attempt at resistance or disobedience I am not to hesitate to shoot him as he is known to be a cool and desperate villain. He nearly killed a man on the trail last year."

Monday afternoon: "I have fed the stock and watered the horses and eaten a bread and milk dinner and am soon going to paint around the shack. . . . If the thief offers no resistance to capture they will lariat him and bring him to the nearest ranch probably ours, and Dakota will enjoy the novelty of a trial for horse stealing, a legal trial. A very short time ago horse thieves were hung as soon as caught. If he makes the least resistance or show of it they will not bother with him at all. Horse stealing is the most serious crime against property where horses wander in herds over great stretches of country."

The thief was caught that afternoon by men of a neighboring ranch, Arnott's, and brought back there. "So every one was happy and Mont who used

to work for Arnott picked the banjo and blew the mouth organ and sung his comic songs and was thankful enough they treated him kindly."

"While I was holding down the ranch," he wrote on Friday, "I had all the chores to do milking the cows cleaning stables watering and feeding stock, etc.

"On the second day the twin calves broke out of the stable. I tried to show them in but they wouldn't go. Then I ran into the stable and picked up the first rope I saw and made a loop and tried to catch one. The rope was too short and mean and I couldn't get them so then I went and got my good lariat. By that time the calves were wild hardly letting me within 40 feet of them. I chased them up and down throwing at them for about an hour till I was so hot and mad I should have enjoyed branding those same calves. An animal as obstinate as a calf has no business to look as innocent as it does. Maybe if one of my horses had been home I could have roped them. The boys had a good laugh when they heard how I had tried to rope the calves afoot. They got on their horses and caught them right away."

In the same letter, on September 26: "Jeffries [a neighboring rancher] having promised me to see my horses to Chicago, I think the children might know now that I am going to bring them an Indian pony. The contemplation will give them perhaps almost as much happiness as the pony itself. I know how happy it makes me to think of giving it to them. I will come riding down Mount Vernon St. and you will be looking out for me and then I will bring the two horses into the yard and show them to Aunt Eliza, and Harry will smell at them as soon as he finds time to get away from me and on Saturday you will go down in the morning train to the farm and I shall ride down stopping at Concord for dinner and getting to the farm in the afternoon. Maybe Poppy would like to ride with me as far as Media or Markham or Concord or some of those places and come back in the train if the riding makes him stiff. Next day the children will have lots of fun and you will too, riding the little rocking chair pony. I have two saddles and two bridles with me."

About to start East, he wrote John Wallace in Chicago: "I have been out here living, sleeping and working with the cowboys since July to learn their ways that I might paint some. A nicer set of fellows I never met with. Sleeping on the bare ground often in blankets that have been through the river I have not caught a cold nor had a single bilious spell since I have been out here. So I am in perfect health and so feel moderately happy. I came out here in a palace car but shall go back in a caboose helping take care of some cattle for Jeffries' ranch from here to Chicago because he is going to let me ship my horses with his cattle. I am taking home my broncho and little Indian pony."

On October 8 he arrived in Dickinson just in time to see Jeffries' train pull out, but caught another cattle train two days later. "So I shall soon be home now in a week or ten days if I have any kind of luck in Chicago," he wrote Sue. "Let the children know their Indian pony is coming and I shall write to you as

I come along. We come very fast but stop to feed and let the cattle stretch themselves outside the cars." By the 14th he was at the Transit House in the Chicago stockyards, from which he wrote Wallace to come see him. "I cannot very well leave as I am watching a chance to ship my horses east with some one else's."

About October 20 he arrived in Philadelphia with his horses. He had been in Dakota from July 26 to October 10, two and a half months; and away from Philadelphia three months—his longest absence from home except for his student years abroad.

Several weeks later he told Wallace about his homecoming: "I had a splendid time coming on meeting with no accidents and no unpleasantness except a little delay around Baltimore. I was entirely comfortable, more so than in a sleeper. I could lie down or go back into the caboose or climb up on the top of my car to enjoy the scenery. I came through as pretty a country as ever I saw especially around Harper's Ferry, that I passed soon after sunrise. The delay around Baltimore was probably fortunate for I arrived home in the middle of the night. If I had got in when school was out, I fear I would have been as bad as a circus coming down Mt. Vernon St. on my broncho, leading the mustang packed with my blankets and traps.

"My trunk had arrived long before with my clothes, so I stabled the horses and then went into the bath tub and to bed and next day rigged out in a biled shirt etc.

"On Saturday I got my father to ride down in the cars to Media and wait there for me to pass through on my way to the farm 40 miles down the road, W.S.W. from Phila. where my sister's husband's farm is. I started down on the broncho leading the pony. At Media where the prettiest country begins my father got on Baldy and we had a delightful ride down to the farm. At Kennett Square six miles this side of the farm we met Susie on horseback and all the little children and their father in the wagon coming out to meet us. Then my father got in the wagon and little Ben got on the pony, and little Ella on Susie's horse and we scampered home like cowboys.

"Little Baldy is ridden everyday to school by one of the children at least an hour before school and then the school children are allowed to ride him by turns until Mr. Crowell returns with the milk wagon. Then he leads Baldy home unless another child coming on the milk wagon rides him home and in the village he is met by another crowd of children who would like to ride him as far as the farm. So I have been a public benefactor with the little beast besides giving the children the greatest happiness they have ever had. Nor is the pleasure confined to the children only. My sister is very fond of the little beast and often rides him in the afternoon when she has finished her work and Susie rides him whenever we go down to the farm.

"The other horse, the broncho, had a bad cold the first week he was here

but got over it all right. He has the sweetest disposition that a horse ever had. He follows my sister around and the greatest trouble is to keep him from coming into the house after her. When the door is shut he puts his nose against the panes in the kitchen window. They wheel the baby coach under his nose for the baby to play with him.

"Although so rough gaited the children ride him too, but not so much as little Baldy the mustang."

<div align="center">IV</div>

After his return from Dakota, Eakins' ties to the Crowells and Avondale must have been closer than ever. On his visits he rode the Dakota horses with a Western saddle, or bareback, dressed in his cowboy clothes. Children for miles around rode them, and the whole neighborhood began to call him "Uncle Tom." He explained that the reason the horses would not cross a stream without stopping for a long drink of water was that they were used to the Bad Lands. With the help of Benjamin Eakins he constructed a rotary horsepower machine for shelling corn: a six-foot wheel with Baldy hitched to it; it took six months to build.

"With the cowboy horses," Will Crowell, Jr., wrote in the 1940s, "Uncle Tom brought to the Farm firearms that he had had in the West, a 44 calibre Winchester rifle, a double barrelled shot-gun and a 22 calibre squirrel rifle. He may have given the 22 calibre rifle to Ben as it was Ben who mostly had it and who cared most about shooting. Also it was chiefly Ben or Uncle Tom who used the shot-gun. A few times, probably in the autumn of 1887, there was target practise with the Winchester at 100 yards by Uncle Tom, Papa and Mamma and, I think, also Ella and Ben."

Harrison Morris, managing director of the Pennsylvania Academy, told of a visit to the farm in the 1890s: "One sunshiny day—perhaps it was August or September—I went down there by train to be met by Eakins on my arrival at the station. My attire was of the usual style for a visit. I had a stiff hat, and good clothes, with no idea of any rough travel. When I got off, there was Eakins on the back of a lean Western pony, leading a white one by the bridle. Before I knew it, I was mounted on this led broncho, and Eakins started off on the other. I protested that I knew little about riding—tried to stop him; but he took for granted that anybody ought to stick on a horse, and he looked back without a flicker of sympathy at my plight. He was dressed as a robust cowboy, . . . and he looked to me in his fringed leggings and sombrero hat like the attendant of a circus. All he told me, when mounting, was to steer the beast by throwing the bridle to the left and right on his neck. Then he galloped off under the trees, and I, like John Gilpin, galloped after. I soon saw that my broncho was trained to do whatever his did, and he wickedly led me a mad race—always just behind him, with no control of the rudder, no knowledge of

the road, no security in my seat, trying to hold on by what I might call mane-force.

"We must have galloped miles on those primitive Delaware [sic] roads, Eakins entirely satisfied that I could take care of myself—which was far more than I was—hardly ever looking back, enjoying the break-neck pace; while I was shouting to him to stop for Heaven's sake—and every minute expecting to be hurled to the road.

"Somehow, I held on; and we reached the farm of his brother-in-law, . . . at a gallop so wild that I nearly ran into the rail fence of the barn-yard—my good stiff hat, I believe, did pitch over it.

"As a guest, I had to be pleased with the experience; but I thought it a miracle I had come through it alive. Eakins was a serious person, but he enjoyed a sly inward chuckle at me, and his sister was very sympathetic. . . .

"He ate eagerly, in shirt-sleeves, with little attention to the children at the table, talking hardly at all. Not long after lunch I had to go. He said he would take me to the station, which meant, I found, that I was again to mount. Sportsmanship demanded no show of retreat; I got on the back of my broncho, but with a sinking heart, and we were off down the farm lane to the road. . . . We took a steadier pace; but going downhill under the edge of a wood, my horse fell down. I had judgment or luck enough to spring from the stirrups on the far side, and thus escaped injury. Eakins paused and looked back with a rather listless attention, and I again mounted when the nag came top uppermost. I was not sorry to be safely on the train."

When Weda Cook and her cousin Maud Cook visited the farm Eakins insisted that they go riding with him. They protested that they didn't know how to ride, but he said that the way to learn was to do it; and he had his way.

In Avondale, Eakins made the preliminary studies for his one Dakota painting, *Cowboys in the Bad Lands*, featuring Billy and Baldy with two cowboys; his pupil Edward W. Boulton posed for one of the men. In the early 1890s two of his most important sculptures, the horses for the Brooklyn Memorial Arch, were executed at Avondale, the model for one of them being Billy.

For Eakins, Avondale and the Crowell family continued to be a second home. Its beneficent influence may have helped to heal, at least partly, the wounds of the Pennsylvania Academy affair. As James W. Crowell recalled: "Here he forgot his quarrels with the outside world, while painting and photographing his nieces and nephews and the farm animals. Here he could wear sloppy clothes without criticism, come to lunch in his long-sleeved underwear and bring his artist friends. Everyone was welcome in our informal and loving family." Of his three sisters, Margaret had died; Caroline with her three children was estranged from him, and she herself died in 1889; so that only Fanny and her family remained. His Crowell nephews and nieces must have gone far to make up for not having children of his own.

In Dakota, Eakins had taken photographs, including views of the Bad Lands, but the only surviving ones are three or four of cowboys and a mounted cowgirl. He had painted sketches of the desert country, little more than summary color notes, and of cowboys riding, but he had done no finished paintings.

A year after his return he wrote Wallace, in October 1888: "I have nearly completed a little cowboy picture, and hope to make more. The cow boy subject is a very picturesque one, and it rests only with the public to want pictures." The only Western painting dated 1888, *Cowboys in the Bad Lands*, is not "little"—45½ inches wide—except by comparison with his full-length portraits, but he had a habit of applying "little" to anything that was not big.

In *Cowboys in the Bad Lands* two men with horses stand on a high bluff, gazing out over miles of bare, eroded hills and valleys. (The models for the horses were the brown Indian pony Baldy and the white bronco Billy, evidently posed at Avondale.) In the strong sunlight and clear Western air, under a light blue sky with a few thin clouds, the desert landscape appears in its fantastic forms and colors: pale grayed pinks of the hill crowns, pale grays of the lower slopes. The landscape is the highest-keyed in any of Eakins' outdoor scenes. By comparison, the men and horses are much darker, in a full range of values, standing out in startling contrast to the blanched, dreamlike landscape; at first they seem not to exist in the same light and atmosphere. Perhaps the cause was that the landscape was painted from sketches and memory, the men and horses from life. But the contrast is not disturbing; since the figures are in the foreground and most of the landscape in the distance, the difference is not untrue, and it gives substance and weight to the figures, as in some of Eakins' earlier open-air pictures such as the little *Shad Fishing at Gloucester* of 1881.

The tonality is closer to impressionism than in any previous work, but there is no envelopment in luminous atmosphere, no softening of edges; everything is precise and substantial. The technique is far from that of the impressionists. Instead of division of tones and heavily loaded opaque pigment, the picture is underpainted in a thin stain of pinkish brown, and traces of black outlines can be seen around the figures, which were evidently drawn on the canvas before being painted. There is a good deal of glazing, especially in the landscape; the figures are more heavily painted.

This was Eakins' last outdoor subject. It is tantalizing to speculate about what he might have accomplished in landscape painting if he had pursued this direction of higher key and luminosity.

Four years later, in 1892, he returned to the cowboy theme in four smaller indoor pictures, three oils and a watercolor, for which Franklin Schenck posed in Eakins' cowboy clothes. Poetic, bohemian Schenck had never been near the West as far as we know, but his full undisciplined hair and beard made him

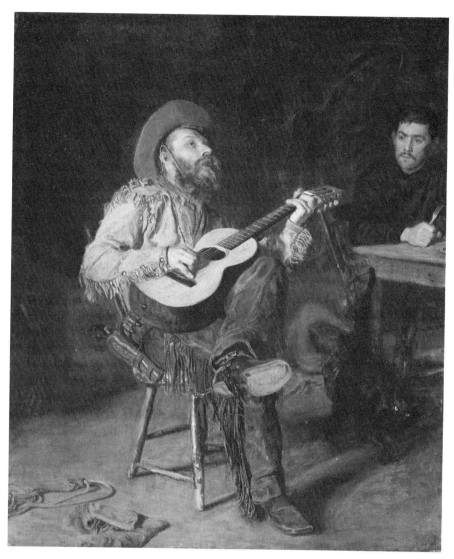

154. HOME RANCH
1892. Oil. 24 × 20. G 248
Philadelphia Museum of Art; Gift of Mrs. Thomas Eakins
and Miss Mary Adeline Williams

superior in characterization to most illustration of the time. But with all their
excellent qualities, they are not among his most moving works. They have an
air of masquerade; Eakins was painting what he saw, which was Schenck
dressed up as a cowboy. They lack the warmth and intimacy of the earlier sim-
ilar pictures of students and friends making music, *The Zither Player* and *Pro-
fessionals at Rehearsal.* Much as Eakins had enjoyed and participated in ranch
life, the cowboy theme was not as central to his interests as the rowing, sailing,

and hunting subjects or domestic scenes. Nor did these posed cowboy pictures have the spectacular visionary quality of *Cowboys in the Bad Lands.*

In spite of Eakins' belief that "the cow boy subject is a very picturesque one," none of these works found buyers. In the early 1890s he gave *Cowboys in the Bad Lands* to John Hemenway Duncan, architect of the two monumental sculpture projects on which he and William R. O'Donovan were engaged. The smaller pictures remained in his possession until his death.

These Western subjects were his last genre pictures until his prizefight and wrestling scenes of 1898–99.

12. Walt Whitman

WALT WHITMAN HAD BEEN LIVING for some years in Camden, New Jersey, just across the Delaware River from Philadelphia, after having suffered a paralytic stroke from which he never fully recovered. In *Specimen Days* he told how he partly regained health by returning to nature: sunbathing naked in a secluded dell, bathing in a stream of clear water, wrestling with saplings. "Every day, seclusion—every day at least two or three hours of freedom, bathing, no talk, no bonds, no dress, no books, no *manners*. . . . It is to my life here that I, perhaps, owe partial recovery (a sort of second wind, a semirenewal of the lease of life). . . . (I call myself a half-paralytic these days.)"

There were fundamental affinities between Whitman and Eakins. The art of both was based on the realities of contemporary America, its men and women, their daily lives, occupations, and pleasures; on democracy, belief in the individual, regardless of rank, privilege, or social distinctions; on the human body; on a deep sense of sex; and on outdoor life. Both were basically realists, creating their art out of actualities. Whitman expressed Eakins' philosophy when he said to his biographer Horace Traubel: "Be sure to write about me honest; whatever you do, do not prettify me; include all the hells and damns." Both were deeply at home in their native environment, but in rebellion against its puritanism; and both had suffered from their revolt.

Throughout *Leaves of Grass* there are words and images that parallel Eakins' mind and work:

I sing the Body electric.

If any thing is sacred, the human body is sacred.

The love of the Body of man or woman balks account—the body itself balks account;
That of the male is perfect, and that of the female is perfect.

The expression of the face balks account;

But the expression of a well-made man appears not only in his face;
It is in his limbs and joints also, it is curiously in the joints of his hips and wrists.

This is the female form;
A divine nimbus exhales from it from head to foot.

Twenty-eight young men bathe by the shore.

I think I could turn and live with animals, they are so placid and self-contain'd.

A gigantic beauty of a stallion.

This is the carol of occupations.

The pure contralto sings in the organ loft.

The regatta is spread on the bay—the race is begun—how the white sails sparkle!

The bending forward and backward of rowers.

Will you seek afar off? You surely come back at last,
In things best known to you, finding the best.

Come, Muse, migrate from Greece and Ionia;
Cross out, please, those immensely overpaid accounts.

But with these affinities went wide differences. In Eakins there was none of Whitman's mystical and prophetic expansiveness, just as in Whitman there was little of Eakins' science, his intense concentration on specific realities, his exactness of representation, and his feeling for subtleties of individual character. Whitman was a prophet-poet, Eakins a scientist-artist. They took off from similar grounds, but went in different directions.

Whitman believed not only in the individual human being but in all of humanity: "One's-Self I sing—a simple, separate Person; Yet utter the word Democratic, the word *En-masse.*" Eakins did not share this all-inclusive religion of democracy; he was concerned primarily with specific men and women, particularly those close to him or the exceptionally intelligent and able. While drawing his content from the American scene, he did not attempt the immense panorama that Whitman covered: the wide geographical range, the innumerable persons, the many occupations. He was never a cataloguer, as Whitman too frequently was.

The art of both men was centered on the life of the body, and both were shameless about sex. But Whitman's sexuality was all-embracing, and completely open in its expression, more so than any poet of his time; while Eakins'

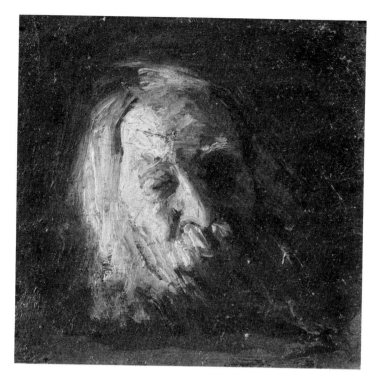

155. WALT WHITMAN
Probably 1887. Oil. 5¹/₄ × 5¹/₄. G 221
Museum of Fine Arts, Boston; Helen and Alice Colburn Fund

sexuality, though fundamental, was limited in overt expression by his realism and the prudery of his environment; there was no parallel in his art to "Who goes there? hankering, gross, mystical, nude." Though Eakins loved outdoor life, his art expressed no such emotional relation to the world of nature and to the visible universe as Whitman's delight in the sea, skies, night, the stars, "the splendid silent sun."

Both men's language was original, based on personal experience and observation, free from derivative style. But Whitman, rejecting traditional diction, meter, and rhyme, had invented radically new poetic forms, and effected a revolution that was to profoundly influence the poetry of the future. Eakins made no such innovations; his art was traditional, in the deepest sense. There is no question that it was a more limited art than Whitman's, confined to the actualities of his immediate time and place, reserved in its response to nature, repressed in its sexuality, traditional in artistic forms and style. But its narrower content was realized with maximum completeness, depth, and power.

Weda Cook Addicks, born and raised in Camden, told me that she had met Whitman when she was fifteen or sixteen, he in his sixties. She had been brought up on the Bible, and when she first saw him, "all I could think was:

'It's Moses.'" The young girl and the old poet became friends; she used to sing for him, and she composed music for "O Captain! My Captain!" and other poems. She told me that when she was posing for Eakins' *The Concert Singer* in the early 1890s, the painter often spoke of Whitman with admiration and quoted his verses, particularly those about the body. She cited phrases he had repeated about the hand of the mechanic, of the sculptor, of the surgeon, commenting that there was as much character in hands as in faces; he said that the thumb was the brain of the sculptor. It was the realistic side of the poet that appealed most to the painter: the observation, the truth, the quality of coming directly out of life. "Whitman never makes a mistake," he said. But she recalled that he did not share Whitman's belief in the average man: "The average man is a nincompoop"; he himself admired the exceptional individual of real strength and sincerity, "the true aristocrat."

By the late 1880s Whitman was an object of pilgrimage by the intelligentsia of Philadelphia, and was surrounded by a group of young disciples, including his future Boswell, Horace Traubel, who wrote down every word he spoke. Though an invalid, Whitman was far from senile: still clear-headed, shrewd, and with a sense of humor. He enjoyed his friends and visitors, and liked to talk about every kind of subject. While basking in the admiration of his young intimates, he remained more sensible than they; and as late as 1888, at sixty-nine, he composed his major mature statement, "A Backward Glance O'er Travel'd Roads," the preface to *November Boughs*.

It was probably in the spring of 1887 that Talcott Williams, associate editor of the Philadelphia *Press* and friend of both Whitman and Eakins, took the painter over to Camden to meet the poet. Later, Whitman expressed his opinion of Eakins, recorded by Traubel: "I asked: 'Does Eakins wear well? Is he a good comrade?' W.: 'He does: he is: he has seen a great deal: is not too ready to tell it: but is full, rich, when he is drawn upon: has a dry, quiet manner that is very impressive to me, knowing, as I do, its background.' I asked: 'Did you find him to lack the social gifts? he is accused of being uncouth, unchary, boorish.' 'Perhaps: I could hardly say: "lacking social gifts" is vague: what are social gifts?' Then after further cogitation: 'The parlor puts quite its own measure upon social gifts: I should say, Tom Eakins lacks them as, for instance, it would be said I lack them: not that they are forgotten, despised, but that they enter secondarily upon the affairs of my life. Eakins might put it this way: first there is this thing to do, then this other thing, maybe this third thing, or this fourth: these done, got out of the way, *now* the social graces. You see, he does not dismiss them; he only gives them their place.' He 'remembered well' his first meeting with Eakins. 'He came over with Talcott Williams: seemed careless, negligent, indifferent, quiet: you would not say retiring, but amounting to that.' They left. Nothing was heard from them for two or three weeks. 'Then Eakins turned up again—came alone: carried a black [obviously blank] canvas

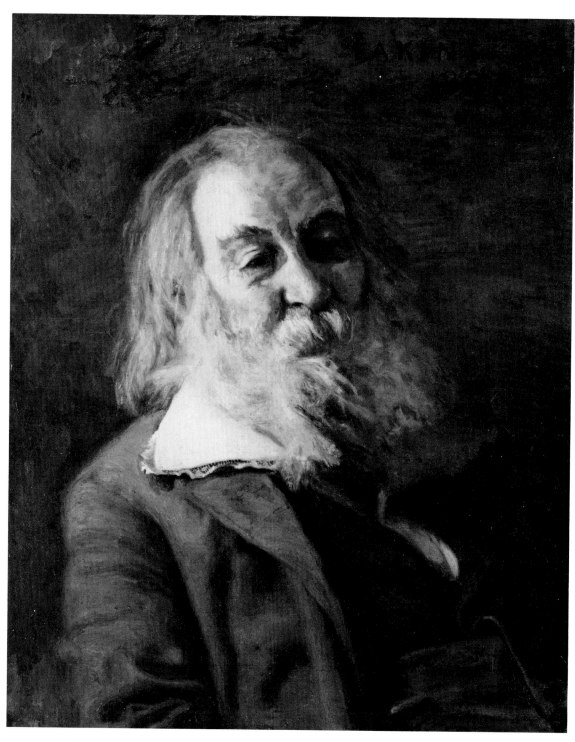

156. WALT WHITMAN
1887–1888. Oil. 30 × 24. G 220
Pennsylvania Academy of the Fine Arts

under his arm: said he had understood I was willing he should paint me: he had come to start the job. I laughed: told him I was content to have him go ahead: so he set to: painted like a fury. After that he came often—at intervals, for short stretches.' I interrupted: 'And that is the result'—motioning down-stairs. W. at once: 'Yes: and that is the result.' Eakins was 'no usual man,' but he did 'not lack the graces of friendship.' He had 'no parlor gallantries' but 'something vastly better.' At first sight 'he might be taken to be negative in quality, manner, intuition' but that surface impression 'wears off after a few meetings.'"

The portrait was painted in Whitman's second-story bedroom, with the poet sitting beside a window. Eakins did a small oil study for it, unusual in that it shows just the head, not the whole composition. The position of the head and the lights and shadows on it are the same as in the final painting; but Whitman's eyes are closed; he was asleep. Posing can be tiring, and he was old. Though a sketch only five inches square, this is one of Eakins' most moving works.

The full-scale portrait shows a different Whitman. With his ruddy face, flowing white hair and beard, wide collar with lace edging, and his jovial look, he is a veteran who has lived much of his life in the open, has seen and experienced much and is full of memories, but is far from superannuated or sad. He is gazing in front of him, not at us; his eyes are inward-looking, remembering; he is half-smiling. His face is more alive than in contemporary photographs; his eyes, though not the extraordinary leonine eyes of his younger photographs, are more visible than in Eakins' own photographs of him, and more expressive. Altogether, this is one of Eakins' strongest portrayals of old age. There is no trace of idealization, as in John White Alexander's vaporous image of "The Good Gray Poet." Yet, to me personally, it does not embody the full spirit of Walt Whitman. Eakins, as always, painted what he saw: a venerable man, human and humorous, rich in experience and memories, still vigorous in mind if not in body. The portrait reveals one true and elemental aspect of that complex genius; other aspects—the mystic, the prophet, the rhapsodist— seem to have eluded his brush. Could any portrait, whether painted or photographed, capture so large a spirit?

Whitman had often been portrayed by photographers, painters, and sculptors. He himself preferred the photographs to the artists' portraits, and preferred the bust by Sidney H. Morse to any of the paintings; but of all the latter he liked Eakins' best. Most of his circle, however, disliked it. Traubel wrote: "Even Eakins seems to me to have caught Whitman rather as he said, 'I have said that the soul is not more than the body,' than as he said, 'I have said that the body is not more than the soul.'" Traubel's four-volume *With Walt Whitman in Camden,* covering March 28, 1888, to September 14, 1889, records many discussions between the poet and his young friends about the relative

merits of the various portraits, particularly those by Eakins and the British painter Herbert Gilchrist, a bland conventional image.

On February 28, 1888, Whitman wrote Morse: "Eakins' 'pict.' is ab't finished—It is a portrait of power and realism ('a poor, old, blind, despised and dying king.').'" But the painter was still working on it in April, according to Traubel's record for April 15: "Eakins' portrait of W. being mentioned, W. said: 'It is about finished. . . . The portrait is very strong—it contrasts in every way with Herbert Gilchrist's, which is the parlor Whitman. Eakins' picture grows on you. It is not all seen at once—it only dawns on you gradually. It was not at first a pleasant version to me, but the more I get to realize it the profounder seems its insight. I do not say it is the best portrait yet—I say it is among the best; I can safely say that. I know you boys object to its fleshiness; something is to be said on that score; if it is weak anywhere perhaps it is weak there—too much Rabelais instead of just enough. Still, give it a place; it deserves a big place.'"

From Traubel's record, April 16, 1888: "'I never knew of but one artist, and that's Tom Eakins, who could resist the temptation to see what they think ought to be rather than what is.'"

The same day: "W. has hung the Eakins portrait in a better light. 'Does it look glum?' he inquired: 'that is its one doubtful feature: if I thought it would finally look glum I would hate it. There was a woman from the South here the other day: she called it the picture of a jolly joker. There was a good deal of comfort to me in having her say that—just as there was when you said at Tom's [Harned] the other day that it made you think of a rubicund sailor with his hands folded across his belly about to tell a story.'"

May 10: "W. talked of portraits. He affects 'the unceremonious—the unflattered. Of all portraits of me made by artists I like Eakins' best: it is not perfect but it comes nearest being me. I find I often like the photographs better than the oils—they are perhaps mechanical, but they are honest. The artists add and deduct: the artists fool with nature—reform it, revise it, to make it fit their preconceived notion of what it should be. We need a Millet [Whitman's favorite painter] in portraiture—a man who sees the spirit but does not make too much of it—one who sees the flesh but does not make a man all flesh—all of him body. Eakins almost achieves this balance—almost—not quite: Eakins errs just a little—a little—in the direction of the flesh.'"

May 14: "'The Eakins portrait gets there—fulfills its purpose: sets me down in correct style, without feathers—without any fuss of any sort. I like the picture always—it never fades—never weakens.'"

May 15: "W., speaking of the Gilchrist-Eakins portraits, said they excited in him some remembrance of two Napoleonic pictures. . . . '[One] crossing the Alps on a noble charger, uniformed, decorated. . . . Delaroche, not satisfied with such a conception, took the trouble to investigate the case—to get at

the bottom facts. What did he find? Why, first this: that Napoleon rode on a mule—that the mule was led by an old peasant—that the journey was hard, the manner humble—that the formal-picturesque nowhere got into it. . . . Well, Herbert painted me—you saw how: was it a success? Don't make me say what I think about that. I love Herbert too much. Then Tom Eakins came along and found Walt Whitman riding a mule led by a peasant.'"

June 5: "'Look at Eakins' picture. How few like it. It is likely to be only the unusual person who can enjoy such a picture—only here and there one who can weigh and measure it according to its own philosophy. Eakins would not be appreciated by the artists, so-called—the professional elects: the people who like Eakins best are the people who have no art prejudices to interpose.'"

June 8: [About Alexander's portrait.] "'Alexander came, saw—but did he conquer? I hardly think so. He was here several times, struggled with me— but since he left Camden I have heard neither of him nor of his picture. The Century purpose using the Alexander picture, which, indeed, I never liked. I am not sorry the picture was painted but I would be sorry to have it accepted as final or even as fairly representing my showdown. I am a bit surprised too— I thought Alexander would do better, considering his reputation. Tom Eakins could give Alexander a lot of extra room and yet beat him at the game. Eakins is not a painter, he is a force. Alexander is a painter.'"

June 22: "Eakins was over today. W. could not see him. 'I told Mary to tell him my head was too sore. You can imagine how I must have felt at the time to refuse to see Eakins. He is always welcome—always except. Today it was except."

July 8: "'Eakins, I am told, is quite a Rabelaisian. When I get better or well enough—on my feet again—I shall have him come over and talk while I listen.'"

January 13, 1889: "W's friends in the main resent E's picture. But he is obdurate. 'For my part I consider that a masterpiece of work: strong, rugged, even daring': and as to the criticisms: 'We don't care: we'll go on holding our own view: I stick to it. . . . I have told you before, I think, of a speech I heard from Webster: it was years and years ago. He started off with saying: "I come, not to tell you pleasant things but true things." . . . It always hits me that way with this portrait: not what he wanted to but what he did see.'"

February 7: "As to Eakins' work in general: 'I should suppose it to be high-tide product: his best canvas, his crowning canvas, so far seems to have been the Gross picture in Jefferson College.' Had he seen the original? He has a reproduction of it downstairs given him by Eakins. 'No: I have not seen it— have never been there: but I realize its manifold adequacies—its severe face: the counterfeit, much as it necessarily must have lost, is convincing.'"

February 26: "Bucke asked: 'You still stick to the Eakins picture, Walt?' 'Yes: closer than ever—like the molasses holds on to the jug.'"

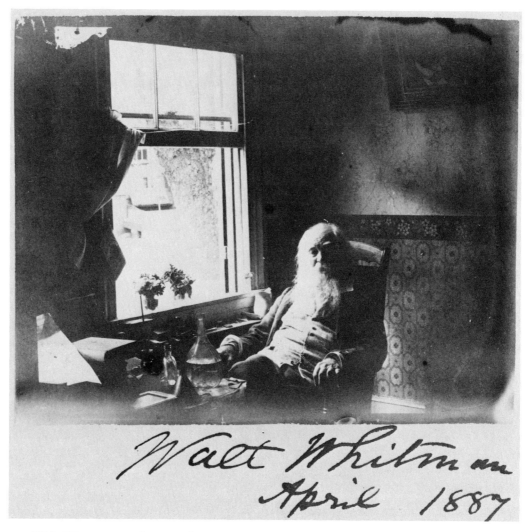

157. Walt Whitman. April 1887. Photograph by Eakins
Collection of American Literature, Beinecke Rare Book and
Manuscript Library, Yale University

September 10: "I told him [Whitman] a story I had heard of Eakins—of a girl model who had appeared before the class, nude, with a bracelet on—Eakins, thereupon, in anger, seizing the bracelet and throwing it on the floor. W. enjoying it: 'It was just like Eakins—and oh! a great point is in it, too!'"

In the late 1880s and early 1890s Eakins (and perhaps Murray) took at least ten photographs of Whitman, seated in his bedroom. In seven of them he is beside a window, with strong daylight from the left falling on his face: the same lighting as in Eakins' portrait. Only the earliest one, which Whitman himself dated April 1887, seems to have been taken before the painting. But

Eakins did not use it for the painting; the pose is different. The others were probably taken in the 1890s, only a year or two before Whitman's death; with his patriarchal white hair and beard and his rather lackluster eyes he looks very old indeed.

On Whitman's seventy-second birthday, May 31, 1891, Eakins was one of thirty-two friends, including Talcott Williams, Harrison Morris, and William R. O'Donovan, who attended a dinner in his honor at the house in Camden. Whitman had to be almost carried down from his bedroom, but after being plied with champagne, "was at once built up" and took over the proceedings

158. Walt Whitman. Probably early 1890s. Photograph by Eakins
Philadelphia Museum of Art; Bequest of Mark Lutz

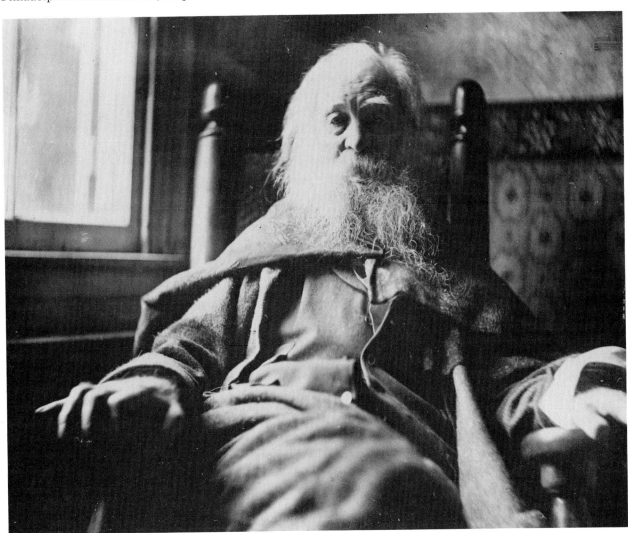

from the official toastmaster. Admirers from this country and Europe had written or telegraphed greetings, and these were interspersed with speeches by the guests. Traubel reports this dialogue: "*Whitman.*—'And Eakins—what of Tom Eakins? He is here. Haven't you something to say to us, Eakins?' *Eakins.*—'I am not a speaker—' *Whitman.*—'So much the better—you are more likely to say something.' *Eakins.*—'Well, as some of you know, I some years ago—a few—painted a picture of Mr. Whitman. I began in the usual way, but soon found that the ordinary methods wouldn't do—that technique, rules, and traditions would have to be thrown aside; that, before all else, he was to be treated as a *man,* whatever became of what are commonly called the principles of art.'" (I doubt that he really thought so.)

When the portrait was "about finished," in April 1888, Whitman had reported to his friends: "Eakins asked me the other day: 'Well, Mr. Whitman, what will you do with your half of it?' I asked him: 'Which half is mine?' Eakins answered my question in this way: 'Either half,' and said again regarding that: 'Somehow I feel as if the picture was half yours, so I'm going to let it be regarded in that light.' Neither of us at present has anything to suggest as to its final disposition."

The painting remained in Whitman's house, though Eakins borrowed it for the Pennsylvania Academy annual exhibition in January 1891, listing it as "Portrait of a poet. Property of Walt Whitman." Years later, in 1908, the critic Annie Nathan Meyer, who had just talked to Eakins about it, wrote that it had been sold to Whitman's friend Dr. Richard Maurice Bucke, and that the money had been divided between artist and sitter. In 1893 Eakins tried to borrow it from Dr. Bucke in Canada, for the World's Fair in Chicago, but it became entangled in the red tape of customs and had to be returned. In 1908 the Bucke estate, probably at Eakins' request, lent it to the Pennsylvania Academy and Corcoran Gallery annuals. Finally, in 1917, after Eakins' death, the Pennsylvania Academy bought it from the Bucke family for $600.

When Whitman died, March 26, 1892, on the next day Murray and Eakins made casts of his face, shoulders, and right hand. At the funeral, attended by several thousands, with many notables, Eakins was one of the honorary pallbearers. There were speeches, the most eloquent by Robert G. Ingersoll, "the great agnostic" and orator. Weda Cook Addicks told me that she was present when, after the funeral, many of Whitman's friends, including Ingersoll, came to Eakins' studio; the painter picked her up, stood her on a table, and told her to sing "O Captain! My Captain!"

13. *The Agnew Clinic*

THE MAJOR PAINTING of Eakins' middle years, and the most important commission he ever received, was *The Agnew Clinic*. In 1889 Dr. D. Hayes Agnew, eminent surgeon and anatomist, was about to retire at seventy from the faculty of the University of Pennsylvania's School of Medicine, where he had been professor of surgery for twenty-six years. A great teacher, noted for his clear, simple exposition, author of a three-volume *Treatise on the Principles and Practice of Surgery*, as a surgeon he was sure, rapid, and calm. During the Civil War he had become an expert in gunshot wounds; after President Garfield was shot by an assassin in 1881, he had acted as the chief operating surgeon. Physically strong, six feet tall, he said in later life that he had never known what it was to be tired. His hundreds of students and former students adored him.

It was an established custom for a portrait of a distinguished retiring professor to be presented to the University. In the spring of 1889 the three undergraduate classes of the School of Medicine commissioned Eakins to paint Agnew's portrait, for $750, to be raised by subscription among the students. It was assumed that the portrait would be a single figure of the usual kind, but Eakins was led by his admiration for Agnew, and by the opportunity for an ambitious composition, to embark on his largest painting, showing the surgeon during an operation before his students, like Dr. Gross. But he told the students that the price would be the same; all he asked was that they come to his studio and pose.

The conception is the same as that of *The Gross Clinic*, but this time the patient is a woman and the operation is for cancer of the breast. Agnew, performing the operation, stands aside to talk to his students, scalpel in his left hand (he was ambidextrous), gesturing with his right. His face (photographs show that the portrait was an excellent likeness) reveals in his frown, his concentration, and the firm lines around his mouth, the marks of a life lived at high pressure, with an iron control different from the Olympian imperturbability of Dr. Gross. His assistants are busy with the patient: Dr. J. William

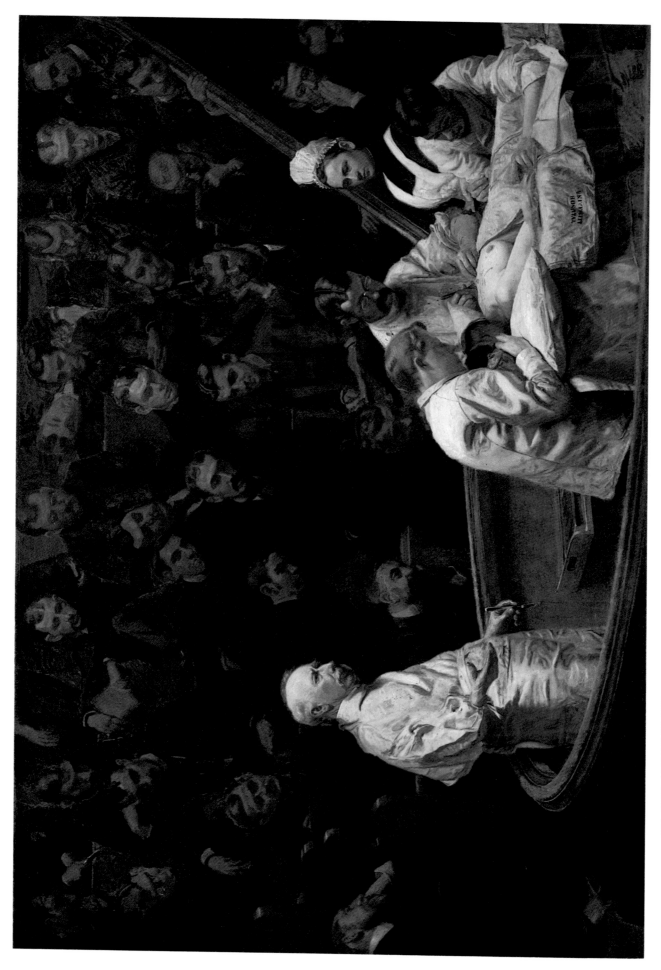

159. THE AGNEW CLINIC
1889. Oil. 74½ × 130½. G 235
University of Pennsylvania School of Medicine

White is applying a dressing; Dr. Joseph Leidy II is wiping the blood; and Dr. Ellwood R. Kirby is administering anesthesia; all were to become well-known surgeons. In the entrance Dr. Fred H. Milliken is whispering to Eakins (whose portrait was painted by Mrs. Eakins). Beyond and above rise four rows of seated students. All twenty-five were members of the three classes that had commissioned the painting; all have been identified.

In many ways *The Agnew Clinic* represents a different medical age from that of *The Gross Clinic*. In the fourteen years since Gross and his assistants operated in their dark, everyday clothes, surgery has changed: now all the doctors wear antiseptic white, there is a woman nurse, and the anesthetist is holding an ether cone instead of a cloth. (But the doctors are not yet wearing surgical masks or gloves.)

The composition is entirely different from *The Gross Clinic*'s. The canvas is horizontal, not vertical, and instead of the centered, pyramidal composition of the earlier work, the design is asymmetric, and in the form of a frieze: Agnew by himself at the left, separate from the group around the patient. But though not in the center like Gross, his figure dominates the composition, by his very isolation, and by his upright stance contrasted with the stooping postures of the others. These two elements, bound together by the curving line of the rail, achieve a fine balance. Agnew's white-clad figure stands out in strong relief against the dark background of the audience; his head, with its intensely realized character—one of Eakins' most powerful plastic creations—commands the space around it and becomes the focal point of the whole design.

The tonality is considerably lighter than that of *The Gross Clinic*. This is partly because of certain actualities: the doctors' white garments, the fact that more of the patient's bare body is visible, and probably stronger lighting in the operating theater. Contrasting with the older painting's Rembrandt-like light and deep shadows, the illumination is clear and pervasive. The color in general is warmer: instead of Gross's marmoreal hue, Agnew's complexion is florid; Kirby is blond; even White's and Leidy's shadowed faces are ruddy; and the terra-cotta of the operating pit and the benches creates a warm unifying tone. Although the color is far from high-keyed, it is definitely more luminous than in *The Gross Clinic*. (Francis Ziegler told me that Eakins, recalling the complaints about the earlier picture's alleged lack of color, said, "I'll give them color.")

The students, seated nearer the pit than in *The Gross Clinic*, are larger in scale and more individually characterized. An evenly lighted and similarly modeled crowd of faces, they are unlike the earlier audience, with its sense of remote, ghostly presences; and they form a less mysterious, dramatic feature of the composition. The later painting does not present the elements of enigma that the earlier one did: the puzzle of the patient's body, the half-hidden figure behind the surgeon, the horror-stricken woman, the obscured

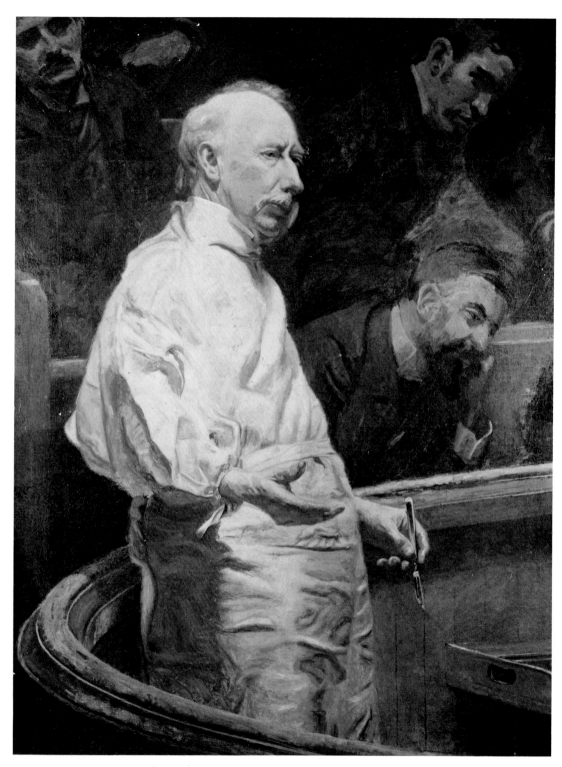

160. THE AGNEW CLINIC: DETAIL

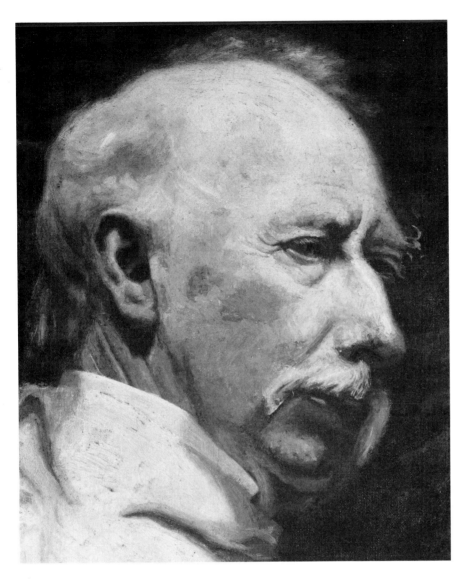

161. THE AGNEW CLINIC: DETAIL

watchers; here everything is open and clear. In these respects *The Agnew Clinic* does not possess the full measure of mystery and depth of *The Gross Clinic*. But this is a comparison of works on a very high level; like its predecessor, it is one of the great paintings of the nineteenth century.

In preparation for the painting Eakins visited the University clinic many times to watch Agnew in action, as he had Gross. The big canvas, about six by eleven feet, had to be finished in three months, by commencement day, May 1, 1889. Too large to go on an easel, it was placed on wood strips on the floor of the Chestnut Street studio, and supported by strips nailed to the stretcher.

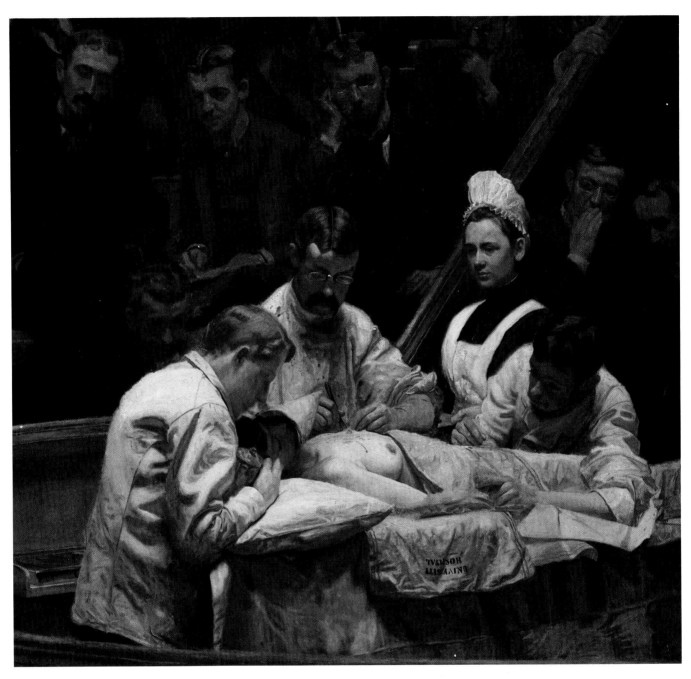

162. THE AGNEW CLINIC: DETAIL

The most important figures being in the lower half, Eakins had to sit on the floor to paint them. Working on the picture from early morning into the evening, he was ill with grippe part of the time, but kept on painting. When he became tired he would sleep on the floor for a couple of hours, then go on. Charles Bregler remembered visiting the studio one night and finding him stretched out asleep in front of the canvas.

Agnew came to the studio to pose, and Eakins first painted a full-scale study of him, much more complete than his usual sketches. Slight but definite differences from the final work make it probable that the surgeon continued to pose for the latter. On arriving, Agnew would say, "I can give you just one hour," but he gave as many poses as were needed. His students, on the other hand, would come rushing in late and say that they could stay only a little while. Eakins had put up tiers of benches for them to sit on.

Agnew's biographer wrote: "While engaged in painting this picture, the artist discovered forcibly one of Dr. Agnew's peculiarities. Dr. Agnew had been represented with blood attached here and there to his hands; noticing this point, at once he objected most strenuously, and, despite the artist's protests for fidelity to nature, he ordered all the blood to be removed. The criticism is made that surgeons grow brutal, but here was a surgeon, who had been accustomed to working in blood for fifty years, who had not had his sense of propriety blunted in the least." However, Eakins did not obey these orders completely, for there is some blood on the surgeon's hands and gown, although it is not as prominent as in *The Gross Clinic*.

The plain wooden frame, designed by Eakins, has an inscription carved by him: D. HAYES AGNEW M · D · CHIRURGUS PERITISSIMUS · SCRIPTOR ET DOCTOR CLARISSIMUS · VIR VENERATUS ET CARISSIMUS · MDCCCLXXXIX (The most experienced surgeon, the clearest writer and teacher, the most venerated and beloved man).

The presentation to the University was made at the commencement on May 1. "This is our Agnew day," said the spokesman for the graduating class. A veil covering the painting was lifted off, and the portrait was received on behalf of the trustees by Dr. S. Weir Mitchell. When he sat down there were loud cries of "Agnew" from the students, and in response their teacher spoke briefly, saying that after he retired, "I shall still retain the consolation of going across the river occasionally to hear the boys yell." At this, there was such yelling that he could not continue for several minutes.

When Agnew died three years later, on March 23, 1892, Eakins and Murray took plaster casts of his head, face, and hands.

The public reaction to *The Agnew Clinic* was much like that to *The Gross Clinic*. Exhibited at Eakins' dealers, the Haseltine Galleries in Philadelphia, soon after it was finished, but not shown in any other art exhibition until four

years later, it therefore aroused no such extensive written criticism as its predecessor had, but in established Philadelphia art circles it created a scandal. That the patient was a woman and the operation was on her breast must have added to the condemnation. The saying that went around was, "Eakins is a butcher." Weda Cook Addicks told me that he repeated this to her, with tears in his eyes, saying: "They call me a butcher, and all I was trying to do was to picture the soul of a great surgeon."

163. Samuel Murray: THOMAS EAKINS
(Painting "The Agnew Clinic.") 1907. Bronze. 9 in. high
The Metropolitan Museum of Art; Rogers Fund, 1923

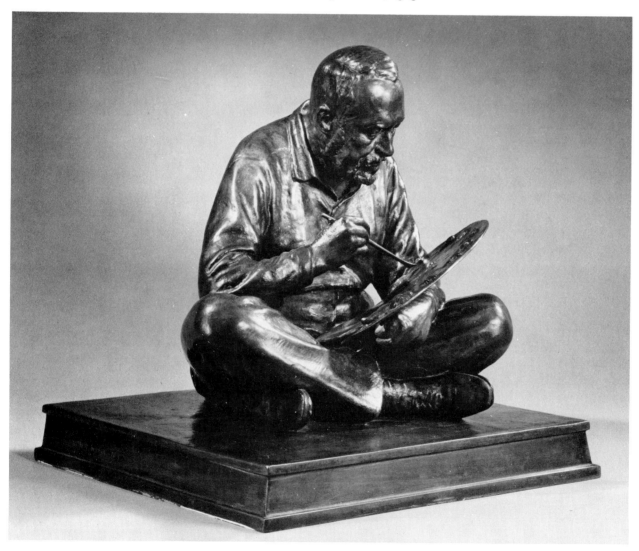

Thomas Eakins

For five years after his resignation from the Pennsylvania Academy, Eakins had exhibited little: twice in New York and once each in Chicago and Louisville, Kentucky, and in the Paris Exposition Universelle of 1889. In Philadelphia his only recorded showing, except at Haseltine's, was at the new Art Club in 1889. He had not exhibited at all in the Pennsylvania Academy.

In 1890, with the election of Edward Hornor Coates as its president, the Academy acted to establish better relations with the artists of Philadelphia. The selection and hanging of the annual exhibitions were placed in the hands of an artists' jury instead of the former Committee on Exhibitions, which had been made up half of directors and half of artists. (However, there was still a Committee on Exhibitions, now composed entirely of directors.) The circular for the 61st annual exhibition, to open on January 29, 1891, stated that "the selection and arrangement of the Exhibits, and the award of medals, are absolutely in charge of the Jury and Hanging Committee of Artists." The jury— Clifford P. Grayson, chairman, Charles Linford, Frederick J. Waugh, Colin Campbell Cooper, Jr., and Benjamin F. Gilman—asked Eakins to contribute works, including *The Agnew Clinic*, and he sent it and five portraits. The Academy circular limited exhibits to works which "have not been before publicly exhibited in Philadelphia," but this rule was not strictly enforced.

On January 20 the chairman of the directors' Committee on Exhibitions, Charles Henry Hart (who had been a member of the Committee on Instruction which forced Eakins' resignation in 1886), wrote Grayson: "The Committee on Exhibitions request you not to hang the large picture known as portrait of Dr. Agnew by Thomas Eakins the Committee being of the opinion that its exhibition at the Hazeltine Gallery in this city was such a public exhibition as to make it ineligible for exhibition here in an Annual Exhibition. Your attention to this will oblige the Committee and, Yours very truly, Chas. Henry Hart."

Grayson replied: "In reply to your favor of this day, I beg to state that the jury of selection and Hanging Committee regret that they cannot agree with you in your opinion that the exhibition of Mr. Eakins' picture of Dr. Agnew at the Haseltine Gallery was such a public exhibition as to render it ineligible for the coming exhibition at the Academy of Fine Arts. Nevertheless, in deference to your wishes and to your supreme authority in such matters, they are willing to withdraw the picture."

On January 31 Grayson wrote Eakins: "Every member of the Artist's Committee of Selection for this year's exhibition regrets that your portrait of Dr. Agnew was not hung, particularly as we had decided before soliciting the picture that its having been seen in the Haseltine Gallery was not to render it ineligible for our exhibition." He enclosed Hart's letter and his own reply.

Four days later Eakins went to see Coates, who then wrote him: "Referring

to my conversation with you this morning, as to your picture of Dr. Agnew, I desire to repeat that you are right in stating that, under Section 14 of the Exhibition circular, 'the selection and arrangement of the Exhibits, and the award of medals, were absolutely in charge of the Jury & Hanging Committee of artists.' It was with no thought or desire of *interference,* and, in my judgment, quite properly, that the Exhibition Committee, believing one of the six pictures entered by you to have been already publicly exhibited, called the Hanging Committee's notice to this fact, and requested that section 2 of the circular, which limits exhibits to such as 'have not been before publicly exhibited in Philadelphia,' should be complied with. With this request, put in writing by their suggestion, the Hanging Committee thought proper to comply. At the same time it was clearly within their power to have declined doing so, had they thought proper.

"While, therefore, I am still of the opinion that the picture having been at different times, and for some months, hung in the Haseltine Galleries, there was such an exhibition as contemplated in section 2 of the circular, I beg leave to state distinctly that the ultimate decision as to the selection and arrangement of the exhibits for the 61st annual exhibition was, is now, and has always been, absolutely in the charge of the Jury and Hanging Committee, subject only to such general regulations as have been laid down upon the subject."

Eakins' reply was more direct: "I thank you very much for putting into writing your conversation with me.

"I still beg leave to say, that in order to call the Hanging Committee's notice to a fact already well known, it was hardly necessary to have a controversy extending over many days until wearied with the great labor of hanging pictures, the artists in a moment of weakness ceded to the importunity, and asked to be relieved of a responsibility they had no right to surrender."

His own copy of this letter (but not the original, which is still in the Academy archives) contains a long postscript: a passage from Rabelais' *Pantagruel* in which Panurge recounts to Pantagruel how a nun who had been made pregnant by a lay brother justified not having called for help or confessed her sin, by saying that she had signaled for help with her buttocks, and afterward had confessed to her partner in sin, who had bound her to silence, since to reveal the confession was such a heinous offence that it would have brought down fire from heaven upon the abbey. The quotation ended with Pantagruel's comment: "Vous ja ne m'en ferez rire. Je sçai assez que toute moinerie moins craint les commandemens de Dieu transgresser, que leur statuts provinciaulx."*

* The full text of Eakins' quotation is: "Vous scavez comment, à Brignoles, quand la nonnain soeur Fessue fut par le jeune briffault Roydimet engrossie, et la grossesse cognue, appellée par l'abbesse en chapitre et arguée de inceste, elle s'excusa, alléguant que ce n'avait esté de son consentement, ce avait esté par violence, et par la force du frère Roydimet. L'abbesse répliquant, et disant: 'Meschante, c'estoit au dortoir, pourquoi ne criois-tu à la force? Nous toutes eussions couru à ton aide.' Respondit qu'elle n'osoit crier au dortoir pource qu'au dortoir y ha silence sempiternel.—Mais, demanda l'abbesse, meschante, pourquoi ne

A week later the whole story, including the letters from Hart to Grayson, Grayson to Hart, Grayson to Eakins, and Coates to Eakins (but not Eakins to Coates), found its way (one wonders how) into a Philadelphia paper, which commented that the painting's "absence when the Academy exhibition opened, caused general remark." But the directors did not change their decision.

Years later Mrs. Eakins wrote: "It is believed by many that the technical objection to the Agnew was a pretext, possibly the best that could be found. The Marks portrait [which was accepted] staid longer at Haseltine's than the Agnew." She could have added that it had also been exhibited at the Art Club of Philadelphia in December 1889. "Other works (notably those of Mr. Stokes) were exhibited at Earles [Gallery] one at least in the window. Watercolors in the exhibition had just been exhibited in the Art Club exhibition. The directors gave privately other reasons for not wishing to hang the picture. Some thought the picture not cheerful for ladies to look at."

Thus, the history of *The Gross Clinic,* Eakins' chief work of the 1870s, was

faisois-tu signe à tes voisines de chambre?—Je, respondit la Fessue, leur faisois signes du cul tant que pouvois; mais personne ne me secourut. Mais, demanda l'abbesse, meschante, pourquoi incontinent ne me le vins-tu dire, et l'accuser régulièrement. Ainsi eussé-je faict, si le cas me fust advenu, pour démonstrer mon innocence.—Pour-ce, respondit la Fessue, que craignant demourer en péché et estat de damnation, de paour que ne fusse de mort soubdaine prévenue, je me confessai à lui, avant qu'il départist de la chambre, et il me bailla en pénitence de non le dire ne déceler à personne. Trop énorme eust esté le péché révéler la confession, et trop détestable devant Dieu, et les anges. Par adventure eust-ce esté cause que le feu du ciel eust ars toute l'abbaye, et toutes fussions tombées en abysme avec Dathan et Abiron.

"Vous, dist Pantagruel, ja ne m'en ferez rire. Je sçai assez que toute moinerie moins craint les commandements de Dieu transgresser, que leur statuts provinciaulx.

"Livre III. Chapitre XIX. Pantagruel. Francois Rabelais."

There are a few minor inaccuracies in Eakins' copy.

Sir Thomas Urquhart's translation, 1693: "You know very well how at Brignoles, when the religious nun, sister Fatbum, was made big with child by the young Stiffly-stand-to't, her pregnancy came to be known, and she, cited by the abbess, and in a full convention of the convent, accused of incest. Her excuse was,—That she did not consent thereto, but that it was done by the violence and impetuous force of the Friar Stiffly-stand-to't. Hereto the abbess very austerely replying, Thou naughty wicked girl, why didst thou not cry—A rape, a rape? then should all of us have run to thy succour. Her answer was,—that the rape was committed in the dortor, where she durst not cry, because it was a place of sempiternal silence. But, quoth the abbess, thou roguish wench, why didst not thou then make some sign to those that were in the next chamber beside thee? To this she answered, That with her buttocks she made a sign unto them as vigorously as she could, yet never one of them did so much as offer to come to her help and assistance. But, quoth the abbess, thou scurvy baggage, why didst not thou tell it me immediately after the perpetration of the fact, that so we might orderly, regularly, and canonically have accused him? I would have done so, had the case been mine, for the clearer manifestation of mine innocency. I truly, madam, would have done the like with all my heart and soul, quoth sister Fatbum; but that fearing I should remain in sin, and in the hazard of eternal damnation, if prevented by a sudden death, I did confess myself to the father friar before he went out of the room, who, for my penance, enjoined me not to tell it, or reveal the matter unto any. It were a most enormous and horrid offence, detestable before God and the angels, to reveal a confession. Such an abominable wickedness would have possibly brought down fire from heaven, wherewith to have burnt the whole nunnery, and sent us all headlong to the bottomless pit, to bear company with Corah, Dathan, and Abiram.

"You will not, quoth Pantagruel, with all your jesting, make me laugh. I know that all the monks, friars, and nuns, had rather violate and infringe the highest of the commandments of God, than break the least of their provincial statutes."

repeated for his chief work of the 1880s—and even more drastically. The early painting had been rejected by the art jury of the Centennial, but it had been hung among the medical exhibits; and later shown, reluctantly, by the Pennsylvania Academy. But *The Agnew Clinic* was rejected outright by the directors of the leading art institution of his native city, where he had studied and taught, and of whose school he had been the head.

<div align="center">III</div>

The Society of American Artists was founded in revolt against the conservative National Academy of Design. Eakins exhibited in this liberal organization's first show in 1878, and in every annual exhibition except two through 1887. In 1879 the young Society had had the courage to accept *The Gross Clinic* and to fight to have it included in its show at the Pennsylvania Academy; the next year it had elected him a member—his only national art organization until 1902.

But through the years, as the Society grew larger, it became conventional, and by the 1890s it was hardly distinguishable from its rival, the National Academy. With two other organizations it was participating in the building of an imposing new home on West 57th Street in New York. Its Committee of Selection had increased to twenty-seven, with a complex system of voting that involved "preliminary examination" by nine jurors, who rated each work numerically, and a second vote by the whole committee. The committees of the late 1880s and early 1890s included some artists who still seem outstanding, including La Farge, Saint-Gaudens, Shirlaw, Chase, Thayer, Weir, Twachtman, Hassam, and Dewing, but more who were essentially academic, such regulars as Beckwith, Coffin, Cox, Francis C. Jones, Low, Mowbray, H. O. Walker, Wiles, and many others like them—all pleasant, clubbable fellows, but not memorable. The Society was repeating the history of many artists' organizations: a decline to its lowest common denominator.

Eakins was not included in four successive exhibitions from 1888 to 1891, and in 1892 only, inexplicably, by a plaster of his small relief *Spinning*, which had been shown in bronze five years earlier.

Among the rejected works was *The Agnew Clinic*. Just when this rejection occurred is not known; it was in 1890, 1891, or 1892. On May 7, 1892, five days after the opening of the fourteenth annual exhibition, Eakins wrote the Society: "Gentlemen: I desire to sever all connection with the Society of American Artists.

"In deference to some of its older members, who perhaps from sentimental motives requested me to reconsider my resignation last year, I shall explain.

"When I was persuaded to join the Society almost at its inception, it was a general belief that without personal influence it was impossible to exhibit in New York a picture painted out of a very limited range of subject and narrow method of treatment.

"The formation of the young Society was a protest against exclusiveness and served its purpose.

"For the last three years my paintings have been rejected by you, one of them the Agnew portrait, a composition more important than any I have ever seen upon your walls.

"Rejections for three years eliminates all elements of chance; and while in my opinion there are qualities in my work which entitle it to rank with the best in your society, your society's opinion must be that it ranks below much that I consider frivolous and superficial. These opinions are irreconcilable."

A few months later, when the Society's new galleries opened with a big retrospective exhibition, he showed nine paintings of the 1870s and 1880s— doubtless for old time's sake; thereafter he exhibited with it only once in the next ten years. His resignation, at the moment of the Society's triumph, was a more radical act than it would be today: he was not yet a member of the National Academy, and the Society and the Academy included almost all the country's leading artists; in those years academicism dominated the American art world. (Six years later, in 1898, ten of the more liberal members of the Society, including Weir, Hassam, and Twachtman, believing like Eakins that it had lost its original purpose, resigned to form the "Ten American Painters," who exhibited together for the next twenty years.)

The Agnew Clinic, except for the unsuccessful submissions to the Society and the Pennsylvania Academy, remained hung in the School of Medicine at the University, where like *The Gross Clinic* at Jefferson it was seen by medical students but not by the art public. Its first appearance in an art exhibition (aside from Haseltine's) was in 1893 at the Chicago World's Fair (with a brief preliminary showing at the Pennsylvania Academy), which also included *The Gross Clinic*, unexhibited for fourteen years. The next appearance of both big paintings was in 1904 at the Louisiana Purchase Exposition in St. Louis. Then in 1912 *The Agnew Clinic* was included in an exhibition of historic portraits at Lancaster, Pennsylvania, the surgeon's birthplace. These four exhibitions were its only ones during Eakins' lifetime, except at Haseltine's.

14. The Portrait-Painter

Up to the middle 1880s Eakins had pictured a variety of subjects. His art had been that of a man who was part of his community, involved with its people and their occupations and recreations, and himself participating in them. He had painted varied aspects of the life around him in a strongly affirmative spirit. Domestic genre scenes had expressed his attachment to familiar home life. Rowing, sailing, and hunting pictures had embodied his love of outdoor activities and his admiration of the male body in action. *The Gross Clinic* had been a powerful portrayal of the drama of science's battle against disease—a vital contemporary subject seldom attempted before. In *William Rush*, recreating a legend of early American art, he had essayed the female nude. His historical genre scenes had reconstructed daily domestic life of the past. *The Crucifixion* had portrayed this traditional religious subject in naturalistic terms. His shad-fishing scenes had shown men at work outdoors, with a new awareness of nature's changing moods. He had painted many landscape sketches outdoors, and one full-scale landscape. The Arcadian oils and reliefs had revealed an unexpected strain of pagan idyllic poetry; and *The Swimming Hole*, an actual contemporary Arcadia, had incarnated the beauty of the nude human body in nature. In the early 1880s he was manifesting a growing freedom and variety in subject matter, particularly in landscape and the nude.

Then, after 1886, he abandoned these varied subjects, except occasionally, and devoted himself almost exclusively to portrait-painting. There were no more outdoor paintings after *Cowboys in the Bad Lands,* 1888; no more genre paintings except small cowboy pictures in 1892 and prizefight and wrestling scenes in 1898–99; no more historical subjects, aside from two monumental sculpture commissions in 1892–93; and, except for a few sketches, no more female nudes until he returned to the William Rush theme in the last years of his active career.

In a sense, all his works from the beginning had been portraits: every figure in his indoor and outdoor genre pictures, even his historical genre, had

been an actual person. *The Gross Clinic,* in one aspect, was a group portrait. And he had painted many straight portraits. But from the middle 1880s portraiture was to be his almost exclusive field.

This narrowing and concentration in subject matter can be attributed to a combination of facts: the coming of middle age (he turned forty in 1884), with its diminution of youthful exploration; failure to sell more than a few of his genre pictures; the indifference or antagonism of critics, the public, and the art establishment; rejection of his works for exhibitions; opposition to his emphasis on the nude in teaching; and finally, in 1886, his forced resignation as head of the Pennsylvania Academy school, resulting in the loss of his leading position in the art world of his native city and his country. I do not believe that it was merely a coincidence that the Academy affair was followed by his abandonment of the nude and seminude, of outdoor pictures, of genre, and of his other varied subjects. In the essentials of his mind and art—his realism, devotion to his community, love of the human body, and dedication to teaching—he had met with frustration and defeat.

On the other hand, he had always been interested in human beings more than nature per se, in individuals and their actions more than the broad social scene, in character more than ideal beauty. Even his genre subjects had been within a definitely limited range. Now, turning away from other themes, he was concentrating on one of his central interests: portrayal of the individual. In a way he could be considered to have attained his own kind of artistic maturity. But this mature self had been shaped to some extent by thwarting experiences, by the limitations of the society of which he was a part, and by lack of response to the freer side of his nature. In a freer and more responsive environment he might have pursued freer and broader subjects.

II

As a portrait-painter Eakins was never successful in a worldly way. Commissions were few; his sitters were mostly people he asked to pose: family, friends, pupils, and men and women who attracted him by their qualities of mind and character; and in the cases of women, particularly the younger ones, by their looks. The wealthy and the fashionable were conspicuously absent. Many of his sitters were professional people like himself: scientists, physicians, educators, musicians, writers, painters, and sculptors. They included many eminent men: surgeons such as Brinton, Gross, Agnew, and J. William White; physicians such as Horatio C. Wood, DaCosta, Holland, and Forbes; Leonard the X-ray pioneer, Thomson the ophthalmologist, Spitzka the brain specialist; the chemist Rand, the engineer Marks, physicists Barker and Rowland; ethnologists Cushing and Culin. Outside the scientific fields were Whitman; Talcott Williams, editor; Riter Fitzgerald, critic; Leslie Miller, art educator; Chase, Beckwith, and Borie, painters; O'Donovan, sculptor; Clarke,

164. RITER FITZGERALD
1895. Oil. 76 × 64. G 280
The Art Institute of Chicago; Friends of American Art Collection

musicologist; Hennig, cellist; Van den Beemt, violinist. There were Rear Admirals Melville and Sigsbee. And, in an entirely different field, Archbishops Wood and Elder, Bishops Dougherty and Prendergast, and Apostolic Delegates Martinelli and Falconio. These men were intellectual, artistic, or religious workers, distinguished by intelligence, knowledge, and achievements. Between them and Eakins existed rapports unusual in portrait-painting.

Professional women were fewer, a reflection of the limited role of women in the professions in those years. But there were musicians, the singer Weda Cook and pianists Mary Hallock Greenewalt and Edith Mahon; actresses Suzanne Santje and Signora d'Arza; educators Emily Sartain, Florence Einstein, and Lucy L. W. Wilson; collectors Mrs. Frishmuth and Mrs. Drexel; and women painters, his pupils and former pupils.

Besides these, he painted scores of men and women who were not especially distinguished but who were part of his personal life. The only types who hardly ever appeared were the millionaire and the society woman, chief support of most portraitists.

To Eakins a person's work was an essential part of his individuality. Often, instead of showing sitters merely posing, he showed them at work or in their working habitats. This had been true from the beginning: his sisters and Elizabeth Crowell were playing piano; Benjamin Eakins was engrossing a document; Professor Rand was at his desk with books and chemical apparatus; Dr. Gross and Dr. Agnew were portrayed, not like Sargent's *The Four Doctors* in the elegance of academic robes, but in the operating theater, scalpel in hand, talking to their students. Rowland is in his laboratory, holding one of his famous diffraction gratings for spectrum analysis, his assistant working in the background. On Marks's desk is the chronometer he designed for Eakins' Marey-wheel camera. Cushing stands in a Zuñi pueblo in full Indian dress. Holland is calling the roll of graduates at Jefferson Medical College, Miller is addressing an audience at his School of Industrial Art, the anatomist Forbes is lecturing to his students. Beckwith is painting his wife's portrait, O'Donovan is modeling a bust of Eakins. Mrs. Frishmuth and Mrs. Drexel are surrounded by objects from their collections. Weda Cook is on the concert stage, singing; Hennig is playing the cello, Van den Beemt the violin. Although most Catholic dignitaries are simply posing, Dr. Henry is translating the poems of Leo XIII, Monsignor Turner is officiating at a funeral, and Father Fedigan stands beside a drawing-board with a rendering of the monastery he had built at Villanova College. Even President Hayes had not been idle; he was working at his desk. All this is opposite to the conspicuous leisure favored by more fashionable portraitists. On the other hand, only a few women are pictured at work; most are shown in simple portraits, including some of his finest—again reflecting the professional difference between the sexes.

In his portraits Eakins was concerned above all with character: the basic forms of the head, the bone structure of the skull, the individuality of each fea-

165. PROFESSOR WILLIAM D. MARKS
1886. Oil. 76 × 53½. G 216
Washington University Gallery of Art, St. Louis

166. PROFESSOR WILLIAM D. MARKS: DETAIL

ture, the character of the hands, the forms of the body beneath the clothes—all the physical qualities that made the sitter unique, like no one else in the world. His grasp of character was sure and unerring, an inborn gift. In particular, he had complete mastery of the head—the seat of intelligence and will, the product of millennia of evolution—for us human beings, the most vital form in nature.

Many portraitists have the ability to capture a "likeness," to picture the sitter's visual appearance with cameralike skill. Eakins' mastery of character went much deeper; for him, character resided in the underlying structure of bones and muscles. Head, hands, and body were solid forms, possessing substance and weight and definite character; they were modeled in the round and with full realization of every subtle individual variation. It was this creation of substantial forms, exactly characterized—this sculptural sense—that distin-

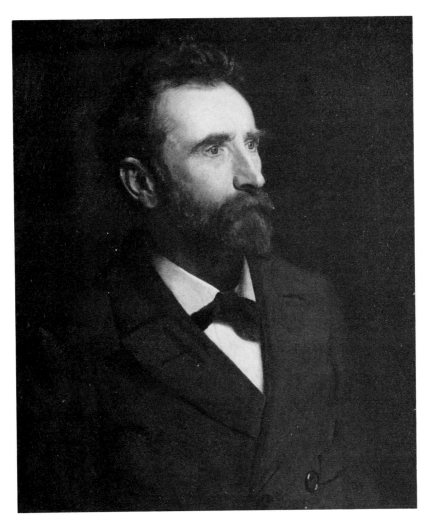

167. LOUIS HUSSON
1899. Oil. 24 × 20. G 328
National Gallery of Art; Gift of Dr. and Mrs. Simon M. Horstick

guished him from other portraitists of his time and that linked him to the great portrait tradition of the past.

To his unrelenting concentration on character Eakins subordinated less fundamental qualities: fashion, glamour, conventional ideas of beauty. He was incapable of beautification: no woman ever emerged from his brush prettier than she was, or any man handsomer. His people were seen with complete honesty, with no trace of the idealization, sometimes slight, almost imperceptible, by which most portraitists made their pictures pleasing to sitters and their families. In his portraits the features were never more regular, the face younger, the skin more glowing, the hair more colorful, than they actually were. Instead, there was an uncompromising search for the unique human

being. As he said to his students: "Get the character of things. I detest this average kind of work. . . . I'd rather see exaggeration, although it is a weakness, than not enough."

His sitters are pictured as serious persons; they are seldom smiling—even the young women. Their expressions, though not sad, are sober, thoughtful, meditative. They do not appear self-conscious, or trying to make an impression, as with many more fashionable portraitists. In fact, most of them are not looking at us, as is customary in portraiture. Not usually shown full-face, they look in front of them, absorbed in their thoughts or engaged in their occupations. (Personally, I find this a relief—all those eyes staring at one!) It has sometimes been said that his portraits are tragic, that his sitters were tragic figures, embodying the disillusionment and pessimism of post-Civil-War America. Rather than tragic, it seems to me that the predominant tone is serious, expressing the temperament of an artist who was himself an exceptionally serious man.

Like Rembrandt, Eakins loved old age, the marks of years and experience, the essential character that youth conceals but age reveals. He often asked old people, including women, to pose. "How beautiful an old woman's skin is— all those wrinkles!" he said to Mary Hallock Greenewalt. Helen Parker Evans wrote: "I remember his telling me of an old model who came to see him and he found her whole body a net work of beautiful *fine* wrinkles." Even when he painted a portrait of the deceased father of Dr. Henry Beates from a photograph, he was particular about getting a photo that showed all the wrinkles.

"Eakins never cared, or sought, for anything that made for 'effect' or charm of any kind," Leslie Miller wrote, "and one of the few times when I ever heard him speak of anything that he thought of as beautiful was when he spoke of Mrs. Miller's hair as he painted it in this picture. He did speak of that as beautiful or at least as something that he admired. It was just turning gray and he really did paint it with something of a loving touch."

He sometimes made sitters look older than they were. In at least one case this was deliberate: the portrait of Walter Copeland Bryant. "He thought Mr. B. too youthful looking," Mrs. Bryant wrote me, "and said in 50 years nobody would know only the portrait. . . . Mr. Eakins asked Mr. Bryant if he could take all the liberty he wanted to do a fine piece of work as a work of art rather than a likeness. . . . He was pleased with it and said if people criticized it one must have a photograph if a likeness was wanted. . . . Hand painted for a 70 years old man at Mr. E's request to do as he wished. Mr. Bryant was 50. . . . Day beard at Mr. Eakins' request." When painting the banker William B. Kurtz, Eakins used to ask him to go unshaved for twenty-four hours.

"A hand," he wrote in 1877, "takes as long to paint as a head nearly and a man's hand no more looks like another man's hand than his head like another's." One of his favorite occupations was taking plaster casts of hands, his sisters' and friends'. The hands in his portraits are clearly characterized: Ben-

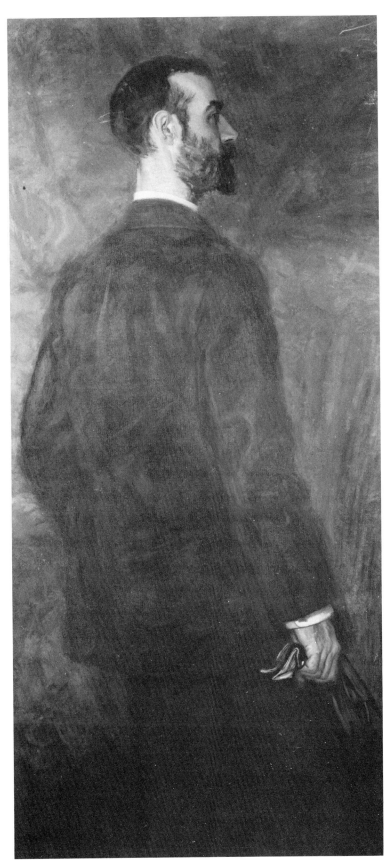

168. DAVID WILSON JORDAN
1899. Oil. 60 × 28. G 329
Anthony Mitchell. Courtesy of Kennedy Galleries

169. WILLIAM H. MACDOWELL
Probably c. 1890. Oil. 28 × 22. G 261
Randolph-Macon Woman's College Art Gallery, Lynchburg, Virginia

jamin Eakins' firm hands, used to years of fine penmanship; Susan Eakins'
thin but capable hands, the wrists strong for so slight a woman; Miss Van
Buren's tense, nervous hands; Mrs. Frishmuth's domineering forefinger press-
ing down a key of her piano; the banker John B. Gest's pair tightly clenched,
as if holding money bags. Some of Eakins' most masterly painting can be
found in his modeling of hands, with every variation in color, light, shadow,
and reflected light. This complete realization contrasts with the average por-
traitist's perfunctory treatment.

The men he painted did not have the benefit of the magnificent male attire
that Renaissance portraitists had exploited; most of them wore the stiff, color-
less clothes of the period: black or gray suits, high starched white collars,

The Portrait-Painter

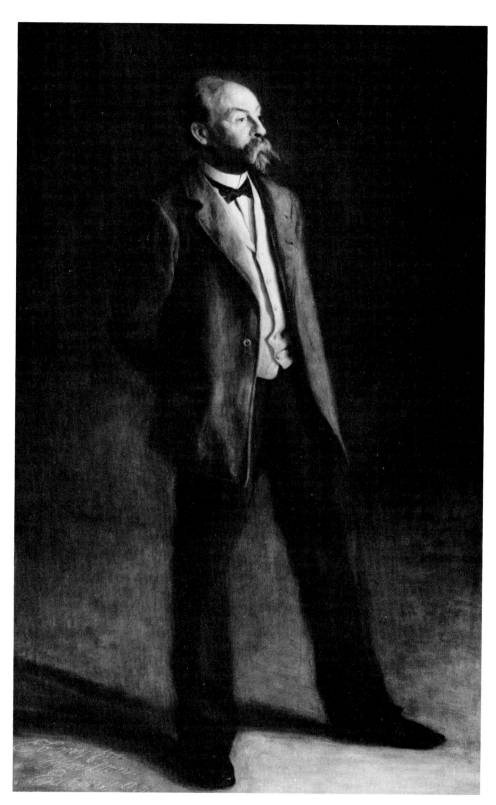

170. JOHN McLURE HAMILTON
1895. Oil. 80 × 50¼. G 284
Wadsworth Atheneum, Hartford; The Ella Gallup Sumner
and Mary Catlin Sumner Collection

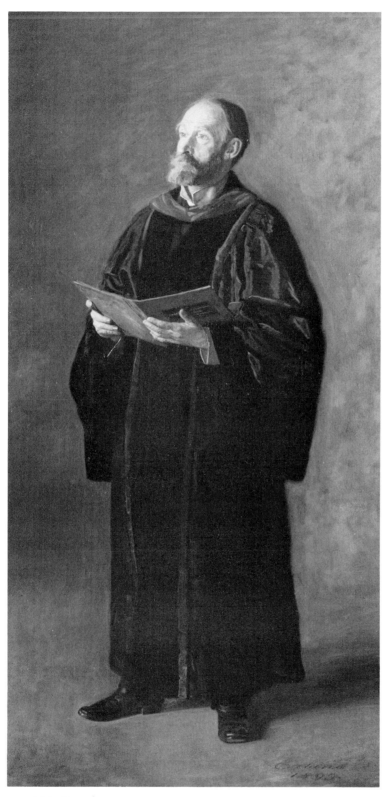

171. THE DEAN'S ROLL CALL
1899. Oil. 84 × 42. G 327
Museum of Fine Arts, Boston; Abraham Shuman Fund

shiny, high black shoes. Without any touch of satire, he did not soften their ungainliness. But occasionally he imposed on them his own preference for informal clothing. "When he painted my portrait," Leslie Miller wrote, "He not only wanted me to wear some old clothes but insisted that I go and don a little old sack coat—hardly more than a blouse—that he remembered seeing me in, in my bicycle days, and which I certainly never would have worn facing an audience which the portrait represents me as doing [ill. 233]. He did much the same thing with Dean Holland—see the picture 'The Dean's Roll-call' [ill. 171]. The Dean and I had lots of fun over his predilections in these cases. He made the poor Dean go, too, and put on a pair of old shoes that he kept to go fishing in, and painted him, as you know, shod in this way when he faced a distinguished audience on a very impressive occasion." (Compare Thoreau: "Every day our garments become more assimilated to ourselves, receiving the impress of the wearer's character. . . . Old shoes will serve a hero longer than they have served his valet. . . . If you have any enterprise before you, try it in your old clothes.")

The apparatus of the sitter's occupation often plays an essential part in the portrait: Rand's, Marks's, and Rowland's scientific equipment, Cushing's and Culin's Indian artifacts, Mrs. Frishmuth's musical instruments, Mrs. Drexel's fans. Such objects not only complete the portrayal of the person but contribute to the complexity and richness of the composition. They are pictured with the full understanding and exactness with which Eakins had always depicted such things, from the time of his boyhood drawing of Benjamin Eakins' lathe. These later renderings, however, are no longer dry mechanical drawings, but forms in shining metal and glass shown in full color and light—still-lifes in themselves, as precisely and beautifully painted as the flowers and fruit in Copley's portraits.

The mahogany and rosewood furniture of the period is portrayed with equal exactitude. Certain pieces from the Mount Vernon Street house appear again and again: one handsome, ornate Victorian mahogany armchair with red plush upholstery is shown in twelve pictures, from the early 1870s paintings of Elizabeth and Kathrin Crowell and Professor Rand, to *The Old-fashioned Dress* in 1908. The clearest representation of it is in *Miss Van Buren*, where every detail—the carving of the back, the varying colors of the worn upholstery, and the polished wood knobs of the arms—is painted with photographic truthfulness. For four of his historical works of the late 1870s and early 1880s he borrowed a fine old Chippendale side chair from his friend Dr. S. Weir Mitchell; in the 1877 *William Rush* Louisa Van Uxem's clothes are spread on it, and her chaperon sits in a duplicate of it. On the other hand, when it was appropriate to include ordinary contemporary utilitarian objects such as roll-top desks and swivel chairs, as in the portrait of Professor Fetter, he made no attempt to conceal their lack of elegance.

Eakins painted about two-thirds as many women as men: a hundred to a hundred and fifty. In established American art of the 1880s and 1890s the American Woman played a central part. Never before had our artists concentrated so much on the feminine. With the deep-seated idealism of the nineteenth-century American mind, they pictured the female as a being finer and purer than the male, more beautiful not only physically but spiritually. She was shown in varied roles: the young mother with her children; the housewife

172. CLARA
c. 1900. Oil. 24 × 20. G 341
Centre National d'Art et de Culture Georges Pompidou, Paris

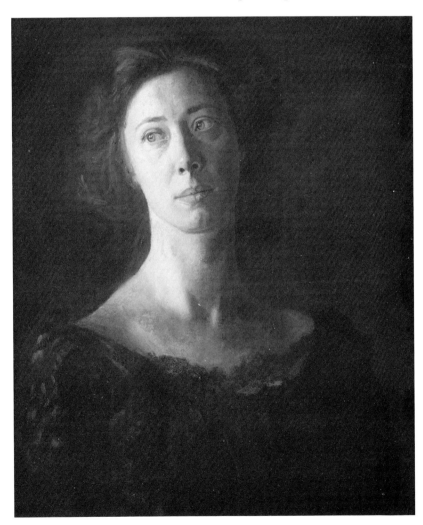

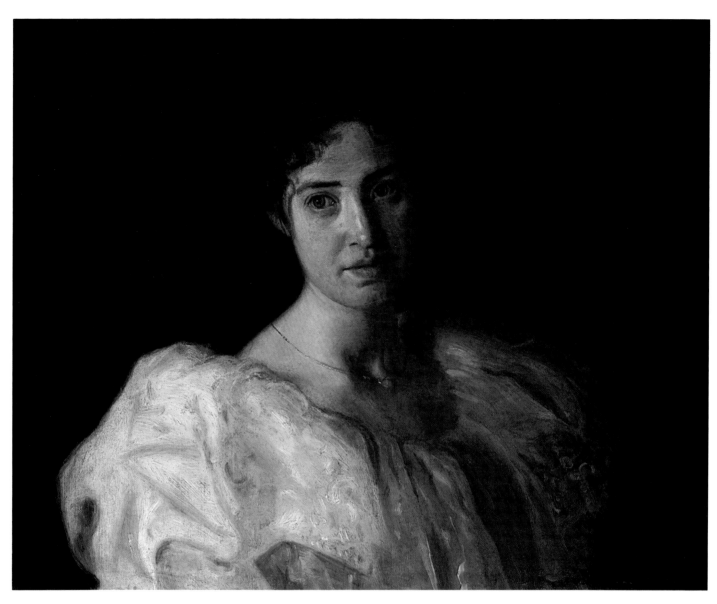

173. MISS LUCY LEWIS
c. 1896. Oil. 22 × 27⅛. G 299
Private Collection

in her sheltered home; the chaste nude; the allegorical figure symbolizing abstract virtues; the maiden still untouched by life, embodying the prevailing cult of virginity. This idealistic devotion to womanhood had its affirmative qualities, achieving worthy expression in the art of certain of the best traditional painters and sculptors of the time: Abbott Thayer's serene, candid goddesses; George de Forest Brush's Pre-Raphaelite mothers and children; Thomas W. Dewing's exquisite, rarefied sonnets to femininity; Augustus Saint-Gaudens' triumphant combination, in his words, "of the real and the ideal."

Eakins' women are different. They are not in the least ideal, but very real. They are not bodiless visions but flesh-and-blood human beings; not Greco-American types but individuals. They range from the young through the middle-aged to the old. They are pictured in essentially the same way as his men, with a dominant interest in character, and without glamour; but although never beautified, they convey an ever-present sense of their sex. Each one is portrayed with complete understanding of her uniqueness as a person. In their faces and bodies, solid substance is combined with exactness and subtlety of characterization; every form and line and curve is modeled with the utmost precision and refinement. This intense realization of individual character makes his portraits of women among his finest works. In a way quite different from Gilbert Stuart's wit and charm, Sully's romantic poetry, or Sargent's brilliance, Eakins can be called particularly an interpreter of women. Yet no portraitist of his time presented a more masculine view of the male and his world.

More than half of his portraits of women were of younger women, from their late teens to their early thirties. Contrary to the common impression of him as a cold, severe portraitist, there is no question that he admired and liked to paint young women. Practically all the portraits of them (and of older women as well) were done at his request; only three of his female portraits are known to have been commissioned. His young women included his sisters, pupils and former pupils, friends, and daughters of friends. Some were strangers he met on social occasions and asked to pose for him. At parties he had a habit of observing individual women intently. One of them, disconcerted by the directness of his gaze, asked, "Why are you looking at me like that, Mr. Eakins?" His reply was equally direct, "Because you're so beautiful."

His pupil and friend David Wilson Jordan told me that when his older sister Letitia took him to social affairs, he could always look around and see that she was the best-looking girl there. At one party, dressed in an evening gown, she passed Eakins on the stairs; he stared and kept watching her. The next day he told Jordan that he would like to paint her in the same gown. In the portrait she stands in her black evening dress, her arms bare except for long wrinkled gloves, with a red ribbon around her neck, a scarf across her arm, and an open fan—one of Eakins' most attractive young ladies, with black hair, hazel eyes, red lips (no lipstick in those days), and warm golden complexion. Her face is

The Portrait-Painter

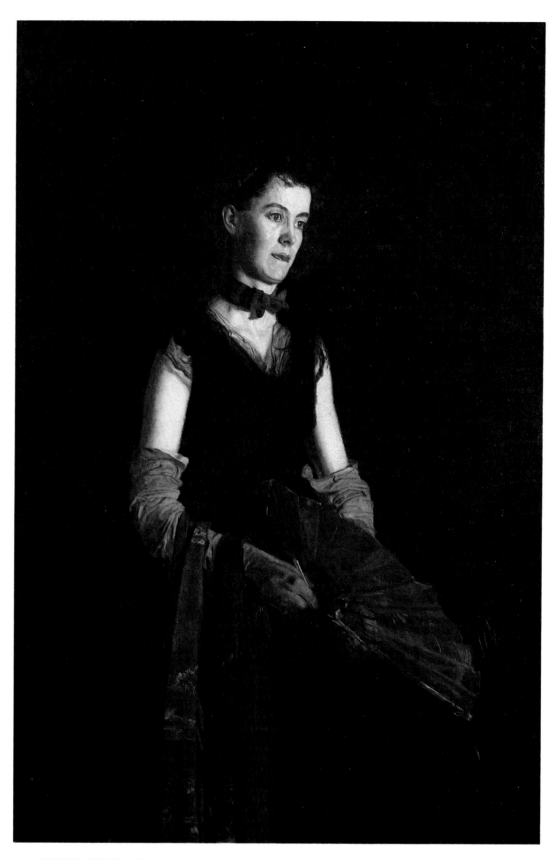

174. LETITIA WILSON JORDAN
1888. Oil. 60 × 40. G 222
The Brooklyn Museum; Dick S. Ramsay Fund

strong as well as good-looking: a firm chin, plenty of character. A little gauche in her finery, she is not looking at us and smiling, but gazing in front of her. She exists physically: there is no comparison in substance and vitality between her figure and those in fashionable portraits of the time.

Eleanor S. F. Pue was twenty when Eakins, in his sixties, met her at a party in the studio of his former pupil Frank Linton. Eakins followed her around, looking at her. Linton told her not to mind, he was "painting" her.

"I want to make a little painting of your head," he wrote her. "Could you come up tomorrow Tuesday morning about 9 o'clock?

"You might bring a dress or two or shirt waist, that we may fix a pose. I will give you the study but you must lend it to me if I want it for exhibition purposes."

Weda Cook's cousin Maud Cook was a beautiful girl, as shown by Eakins' photographs of her as well as his portrait: a fine brow, eyes wide apart, a generous mouth. "As I was just a young girl," she wrote me in 1930, "my hair is done low in the neck and tied with a ribbon. . . . Mr. Eakins never gave [the painting] a name but said to himself it was like a 'big rose bud.'"

His former pupil Elizabeth Coffin recalled that a friend of Eakins once asked him, "Why do you paint such homely women, Tom?"; and Eakins, after looking at him for a moment, said, "I never knew that I did."

Eakins gave his young women vitality, individuality, and corporeal existence, but not the kind of beauty that Gainsborough, Romney, and Lawrence had given their female sitters: rosy complexions, smiling lips, touch-me-not beauty. His flesh tones never had their glowing, peach-bloom quality. Sometimes, as in his early portraits of women such as his sisters and Kathrin Crowell, flesh colors tended to be dark, earthy, and sallow. In later works they became more varied and colorful. He always paid close attention to light and reflected light on flesh, and to the variety of colors and tones produced by light. Yet even at their most luminous, his flesh tones never had cosmetic glow.

His occasional insistence on informality in men's clothes did not apply to women's. On the contrary, he liked feminine finery, and he often asked women sitters, especially younger ones, to wear their party or evening dresses: low-necked, sleeveless, or short-sleeved gowns that left bare the neck, shoulders, arms, and upper bosom—in other words, as much of the female body as could be publicly uncovered in those days. But his older sitters usually, though not always, wore high-necked, long-sleeved dresses.

He appreciated fully the elaborate feminine costumes of the 1870s, 1880s, and 1890s: the long skirts, ruffles, bows, lace, and ribbons, the fine solid materials, the rich colors; and he painted them with as much loving care as he gave to their wearers' faces and hands. There was nothing gauzy or flimsy in his rendering; every detail was precisely drawn; a dressmaker could reconstruct them from his paintings. They were pictured without the display and

superelegance of such portrait-painters as Sargent. Eakins seldom if ever had sitters as rich or socially prominent as Sargent's, but his women often wore handsome attire. It was not so much the clothes themselves that were different, as the way he painted them: realistically, with love of their sensuous qualities, but without panache. One always feels the body beneath the clothes, as one does not in most academic American figure-painting of the time. In view of Eakins' devotion to the nude, one might expect that his portraits would reveal resentment of the all-concealing feminine costumes of the period, some element of satire; but this is not evident. For him there were obviously two distinct qualities: the beauty of the body, and the beauty of clothes.

In *The Pathetic Song* (ills. 87, 88), 1881, the singer's dress is a main feature: a voluminous, gray-lavender taffeta creation, with a skirt down to the floor and a train, an imposing structure of elaborate forms; every pleated ruffle is detailed, with the play of light, shadows, halftones, and reflected lights. About ten years later Miss Van Buren wears a handsome dress with a high neckline and long sleeves, in salmon pink and flowered material (ill. 176). Eakins' interest in the costume is evident, his care in painting every fold and every nuance of light and color, with a sensuousness that one does not often find in his portraits of more simply dressed women. In 1903 the pianist Mary Hallock Greenewalt wears a low-necked gown that reveals her magnificent shoulders and arms and chest (ill. 248); she wrote to me of "the joy he took in representing the exquisite shade of rose-violet silk of my dress."

Eakins' portraits of women were by no means confined to the young; almost half were of middle-aged or elderly women. One of his earliest portraits had been of Mrs. James W. Crowell, mother of William, Kathrin, and Elizabeth. In 1878 he painted Mrs. John H. Brinton (ill. 23), wife of the surgeon whom he had recorded two years earlier. Probably in her middle forties, her face is unwrinkled but not young, though no traces of gray appear in her dark hair. With a pensive, meditative expression she is looking down at her left hand (a middle-aged hand, with a prominent wedding ring) which is touching her red fan: a subtle, unobvious pose, that of a person "lost in thought." It is an introspective portrait, deeply empathetic; her individuality is exactly, intensely realized. The modeling of her face and hand is masterly, both solid and delicate, and the unusual depth and richness of color add to the penetrating mood. Eakins was thirty-four in 1878; she was probably ten years older—a remarkable portrayal of an older woman by a relatively young man. This is consistent with the interest in older men and women that he had shown in his letters: his father's and mother's friends, the fathers and mothers of his friends.

Though Amelia Van Buren was a former pupil of Eakins and later a photographer, and remained his friend, little is known about her personally. A lean face, the bone structure clearly revealed; a fine aquiline nose; black hair streaked with gray; somewhat sallow skin. Her head rests on her hand in a rather weary way; she is not looking at us but away, with a brooding expres-

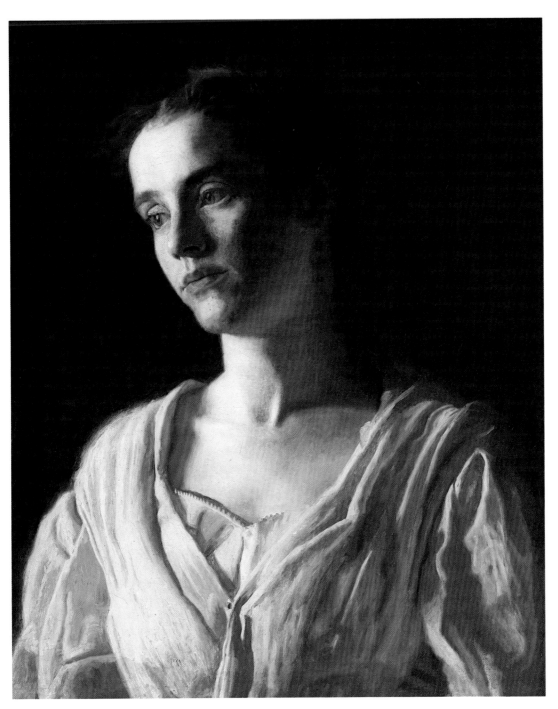

175. MAUD COOK
1895. Oil. 24 × 20. G 279
Yale University Art Gallery;
Bequest of Stephen Carlton Clark, B.A. 1903

The Portrait-Painter

sion. Her hands are thin and sensitive; among the most beautifully painted in any of his portraits. Her fine dress does not seem altogether congruous with her melancholy air, but Eakins has given it maximum attention, making it an essential element in what is obviously a complex personality. At once sympathetic and revealing, the portrait combines perfection of realistic representation, psychological penetration, and haunting mood.

A completely different sitter was Josephine Kern Dodge, wife of Eakins' good friend James Mapes Dodge, engineer, inventor, and successful businessman. Aged thirty-nine, a buxom woman of enormous vitality and joie de vivre, she had recently given birth to a daughter and had to be excused every so often to nurse the baby. Far from ethereal, she is definitely fleshy, her bosom bursting, her skin warm, healthy, radiant. (She was to live to ninety-six.) Her low-necked velvet evening dress had been made for President Cleveland's second inaugural ball three years earlier. When I saw Mrs. Dodge in 1930 she told me that the portrait was painted in the parlor of the Dodge house in Germantown, facing a window from which Eakins had removed the shade and curtains to get the most light. At one point he came over and started to dig his fingers into her chest. She said, "Tom, for heaven's sake, what are you doing?" and he replied, "Feeling for bones." (Mrs. Dodge observed that their neighbors must have thought this rather peculiar.) She did not like the portrait, said it made her look like a fishwife, and kept it in an unused third-floor room.

Elizabeth Duane Gillespie was probably about seventy-five when Eakins painted her in the 1890s. A formidable dowager, great-granddaughter of Benjamin Franklin, a founder of the Colonial Dames of America, she was a power in the Philadelphia cultural world. She had started the women's committee of the School of Industrial Art, of which Eakins' friend Leslie Miller was principal, and she was active in support of the school. A dictatorial old lady with a stern face, piercing eyes, long strong nose, firmly set mouth, and gray hair parted in the middle and smoothed down tight (no feminine nonsense), she sits with her hands clasped in front of her, as if presiding over a meeting or passing sentence. For strength of character in the face and the wonderfully painted hands, this is a powerful portrait, scarcely "sympathetic," yet a living tribute to a strong-minded woman. Except for the face and hands it is unfinished; yet everything essential is there, more compelling because not too finished.

The reason it was not completed was explained by Leslie Miller, who wrote me: "Mrs. Gillespie refused to go near him again after he received her one blistering hot day in his studio up three or four flights of stairs in the old Presbyterian Building on Chestnut Street dressed only in an old pair of trousers and an *undershirt!* He wanted her to give him one or two more sittings but she not only refused them, but wanted me to destroy the portrait after it came into my possession,—which of course I didn't do."

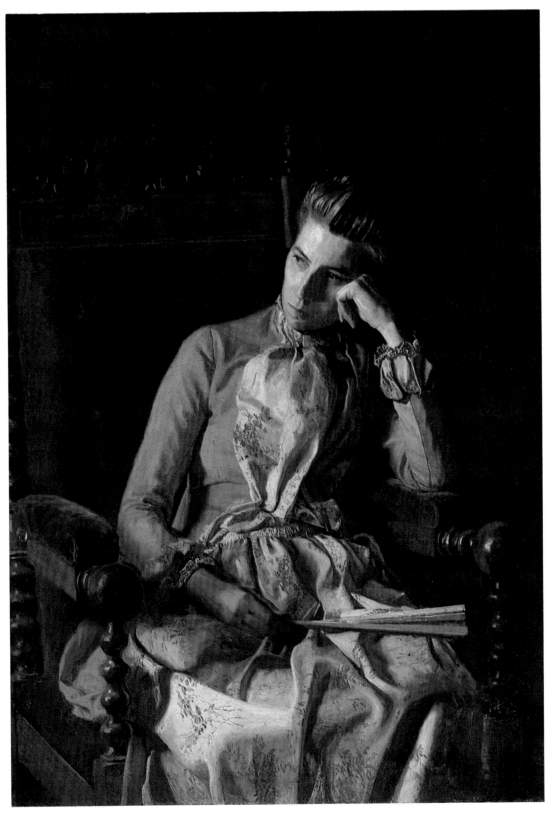

176. MISS AMELIA C. VAN BUREN
c. 1890. Oil. 45 × 32. G 263
The Phillips Collection, Washington

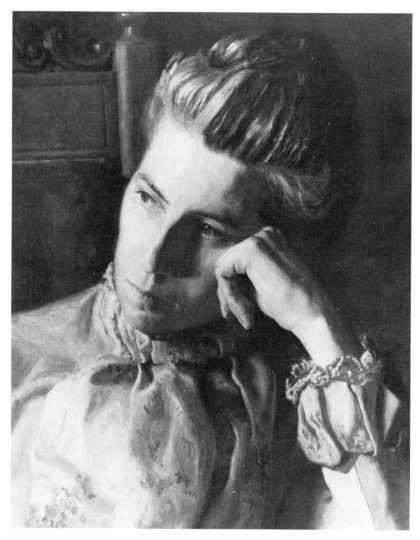

177. MISS AMELIA C. VAN BUREN: DETAIL

In 1901, about the time that he was painting a portrait of Miller, Eakins wrote him: "Some years ago I painted a portrait of Mrs. Gillespie. Although never finished, it is still I think a valuable likeness of that noble woman, and as such I would like to give it to your school, the institution which owes so much to her energy and wise benevolence." He evidently also suggested that she give him a few more sittings to finish the picture.

Sending the letter to the school's Committee on Instruction, Miller commented: "Eakins is certainly one of the strongest painters we have. I examined the work in question, and regard it as a faithful likeness." The committee accepted the gift unanimously, with a motion requesting Mrs. Gillespie to

give Eakins more sittings. Miller wrote her reporting the acceptance and passing along the request. Her answer was an emphatic "no," evidently with the story of Eakins in his undershirt and the demand that the portrait be destroyed. Miller replied placatingly: "I am sorry you feel as you do about the portrait, and of course neither the Committee nor I knew anything about its history. . . . Regretting the misunderstanding which has occurred, and the annoyance which I now see you have suffered. . . ." But he did not destroy the picture. "On the contrary," he wrote me, "I hid it away until the lady died, when I had it framed and hung in the Board Room."

178. MRS. JAMES MAPES DODGE
1896. Oil. 24⅛ × 20⅛. G 293
Philadelphia Museum of Art; Gift of Mrs. James Mapes Dodge

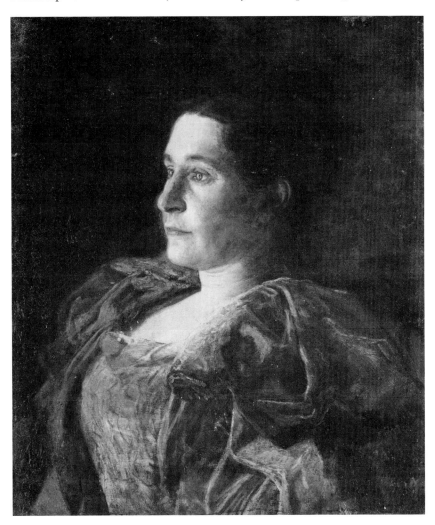

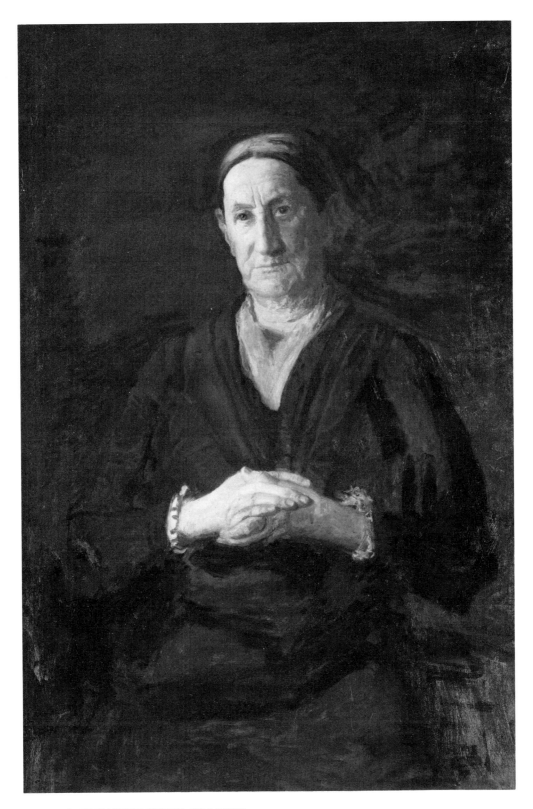

179. MRS. ELIZABETH DUANE GILLESPIE
c. 1900. Oil. 45⅛ × 30. G 351
Women's Committee of the Philadelphia Museum of Art

180. MRS. ELIZABETH DUANE GILLESPIE: DETAIL

IV

None of the qualities of Eakins' portraiture were calculated to make him a popular portrait-painter. Few of us like to see ourselves as others see us; we do not even enjoy candid photographs. A woman looking in the mirror or a man shaving may see themselves truthfully, but this is not the public image they desire. As Edwin Austin Abbey said when asked why he did not have Eakins paint his portrait: "For the reason that he would bring out all those traits of my character I have been trying to conceal from the public for years." Most sitters do not care for too much character. Sargent said that every portrait he painted made him at least one enemy; he defined a portrait as "a likeness in which there is something wrong with the mouth," and remarked, "Women don't ask you to make them beautiful, but you can feel them wanting you to do so all the time."

A certain degree of idealization is normal in most portraiture; perhaps, from a humane standpoint, even desirable. The function of the usual portrait is to please the sitter when he is alive and remind his family agreeably of him when he is gone. Eakins' portraits were not like that: they were not intended to please anybody; they were not necessarily pleasant for the family to have around. They were something more important: works of art, meant primarily to satisfy the artist, but satisfying also to those who appreciate truth, character, and superb painting.

The most frequent objection to his portraits was that they were not good "likenesses." But if one compares them with his photographs of the same sitters, one sees that almost invariably the painted portraits were true. In the large majority of cases, the photograph shows the person no more beautiful or younger than the painting. On the other hand, the comparison also proves that he definitely did not beautify his sitters. It was not a question of poor "likenesses"—his portraits were very "like," too much so for many sitters and their families—but lack of the customary beautification.

Another complaint was that he made his sitters look older than they were. With his interest in picturing old age went a tendency to disregard the bloom of youth in favor of the lasting character of mature years—even in the 1886 portrait of his own wife. In certain cases, as we have seen, this was deliberate. But generally the alleged fault was in his failure to provide juvenescence. Time usually took care of this. When I was examining the portrait of James A. Flaherty, Supreme Knight of the Knights of Columbus, the old Irish superintendent of the Knights' headquarters said that at first they all thought the portrait looked too old and severe, but "it's getting to look more and more like him every year." (Even Gertrude Stein did not at first care for Picasso's portrait of her. "But it doesn't look like me!" she objected; to which he replied, "But it will.")

A common criticism was that his sitters were made to appear too serious. There were frequent complaints about the sitter's "expression," which was felt not to be his or her usual one. Owners often explained to me that "Mother was sick when this was painted" or "Father was tired" or "having business troubles." His portraits, it was said, lacked "sympathy."

Actually Eakins was no more unsympathetic than he was sentimental. His dominating purpose was to recreate, truthfully and fully, the physical reality of the individual man or woman. But his realization went deeper than the physical externals; whether consciously or unconsciously, he captured the essential element that can only be described as life. His men and women are alive; young or old, handsome or homely, they exist. They are portrayed with a vitality, a strength, and a depth that make most portraitists of his time seem superficial. In the end one feels about them as one does about real people, that

one can never get to the bottom of even the most commonplace of them, that there remains some unfathomable element of essential humanity.

By and large, Eakins' sitters, aside from his pupils and fellow artists, were not people of artistic knowledge or judgment. They included very few art patrons or collectors, or socialites who might be presumed to know something about art. The most eminent and intelligent of them—scientists, physicians, professors, Catholic clergy—were outside the field of art, and with a few exceptions not knowledgeable artistically.

Even if more of his sitters had been cognoscenti, however, it might not have made much difference. The qualities of his portraiture, indeed, of any of his work, were not designed to be acceptable to the American art world of 1870 to 1910. After all, many of his strongest pictures were rejected for exhibitions by artist juries. On the other hand, as time passed, the art community's response to his work was to become on the whole more affirmative than that of some lay sitters and their families and friends.

One fact that had nothing to do with the nature of his portraits but that did not help his popularity as a portraitist, was the number of sittings he required. On *The Gross Clinic* he worked for at least six and possibly nine months, in the course of which, as already quoted, Dr. Gross said, "Eakins, I wish you were dead!" For *The Concert Singer* Weda Cook posed during two years, the first year three or four times a week. These were extreme cases. But Francis Ziegler told me that for the head and shoulders portrait of himself sitting reading, he sat from nine to five every day for a week; he never knew that a knee could hurt so much; at the end of the day he came home exhausted and went right to bed. For the same size picture Mrs. Dodge posed for about forty hours. Harrison Morris wrote: "I stood day after day while he patiently transcribed me—for his method stuck closely to the object. . . . I posed on my feet so many hours that I was seized of an irruption on my weary legs and had to go to a doctor." Alice Kurtz wrote me: "He worked days and days," and Mary Hallock Greenewalt: "I gave Mr. Eakins forty sittings." Eleanor Pue told me that she posed three or four mornings a week during a whole winter. Helen Parker's mother recalled: "She posed about thirty-five times; two or three hours at a time." Samuel Myers said that, although his portrait was only of head and shoulders, on the first day Eakins made him stand from nine to five; it was one of the worst days of his life; he posed eight or nine times more (seated, I hope). Such reports of his demands on sitters caused some to hesitate or refuse to pose for him.

There has been a tendency (to which I plead guilty) to exaggerate the negative response to Eakins' portraiture. The reactions were more varied than has been generalized, depending on the sitter and his family and friends; their relationship to Eakins; the circumstances of the portrait's inception (commission or request by the artist); and the portrait itself. Quite a few sitters appreciated

their portraits. They included, with a few exceptions, his pupils and fellow artists, and many of his personal friends. Nevertheless, the fact remains that a much larger proportion of his portraits were negatively received than those of the average portrait-painter; and that the negative response was often brutally discourteous and disagreeable.

Of the 246 portraits Eakins is known to have painted in his entire career, only 25 are known to have been commissioned, and 5 more that had not been commissioned were later sold during his lifetime—a total of 30. Of the uncommissioned, almost all must have been of sitters whom he asked to pose. Most of these portraits he gave to the sitters, or at least offered to them; hence the frequent inscription TO MY FRIEND on the front, or more often the back, of the canvas. Even then, many sitters did not bother to take them away, so that they accumulated year after year until the Mount Vernon Street house was full of them, hung on every wall space or stacked against the walls of his studio. Some sitters would not continue posing, hence a number of portraits remained unfinished.

Of the portraits that were accepted by the sitters, a good many were put away out of sight. When I was tracing Eakins' works in the 1930s I came to realize that many of them had just been taken out of closets or attics or unused rooms. And I discovered that through the years some had been conveniently lost, and some had been destroyed by the sitters' families.

We have seen the fate of the 1877 portrait of President Hayes. One woman sitter, a florid alcoholic type, sister of one of Eakins' friends, was pictured about 1895 in a full-length portrait, wearing evening dress and an opera cloak; her daughter informed me that she had destroyed it because "it did not do justice to my mother." Two sons of Eakins' friend Dr. Horatio C. Wood—James who had studied at the Art Students' League of Philadelphia, and George who had spent the summer of 1887 at the Dakota ranch—somehow lost their portraits. George wrote me: "He painted a portrait of me which was quite 'Eakineeze,' so much so that my family got it lost." In 1903 Eakins painted another former pupil, Frank W. Stokes, and gave the portrait to his family, who later destroyed it. In 1898 he did a portrait of the mother of the pugilist Charlie McKeever, who appears in *Taking the Count*, and gave it to her; the family destroyed it. Even John Singer Sargent (or his family) seem to have misplaced the portrait that Eakins gave him in 1906 of their mutual friend Dr. J. William White. That same year Eakins painted Edward S. Buckley, member of a prominent Philadelphia family; the portrait was a gift, not a commission; his family destroyed it. There were other such cases, of which more later. It is probable that most of the portraits still unlocated were similarly destroyed or "lost."

Among Eakins' few commissions to paint a portrait for an institution was for that of Dr. Jacob Mendez DaCosta. A Sephardic Jew of Spanish and Portuguese ancestry, trained at Jefferson Medical College and in Europe, DaCosta was a cultivated man with an exceptional literary gift. A leading diagnostician, author of the basic *Medical Diagnosis*, and an eminent teacher, he was often called "the physician's physician." As a professor at Jefferson since 1872, he had been a colleague of Gross and Pancoast; and he had married a sister of Dr. John H. Brinton. Thus, there were several links between him and Eakins. In 1892, almost sixty, he was retiring from active teaching. At a meeting of his friends in Dr. S. Weir Mitchell's home, arrangements were made for two portraits, to be presented to Jefferson and the College of Physicians of Philadelphia, of which DaCosta had twice been president; so numerous were the subscribers that money had to be returned.

Eakins was commissioned to paint one of the portraits. Exhibited in November 1892 at the Art Club of Philadelphia, it received unfavorable newspaper reviews and did not please the doctor's friends. DaCosta wrote Eakins, evidently suggesting that it be worked on more, or another portrait painted, using photographs. Eakins replied, January 9, 1893: "As your picture was not elected to go to Chicago, it will very shortly be at your disposal.

"You gave me patient sittings. I have profited by them, and the picture is done.

"It is I believe to your interest and to mine that the painting does remain in its present condition.

"Any attempt on my part to get from mean sources what I may have failed to get from the best would be disastrous, and I do not consider the picture a failure at all, or I should not have parted with it or consented to exhibit it.

"As to your friends, I have known some of them whom I esteem greatly to give most injudicious art advice and to admire what was ignorant, ill constructed, vulgar and bad; and as to the concurrent testimony of the newspapers, which I have not seen, I wonder at your mentioning them after our many conversations regarding them.

"I presume my position in art is not second to your own in medicine, and I can hardly imagine myself writing to you a letter like this; Dear Doctor, The concurrent testimony of the newspapers and of friends is that your treatment of my case has not been one of your successes. I therefore suggest that you treat me a while with Mrs. Brown's Metaphysical Discovery."

However, this time he agreed to try again, doubtless out of respect for DaCosta. He destroyed the first canvas—cut it up in pieces—and painted a second, a three-quarter-length picture of the doctor seated, including his hands. DaCosta's urbane, sensitive face, seen in pervading light against a plain terra-

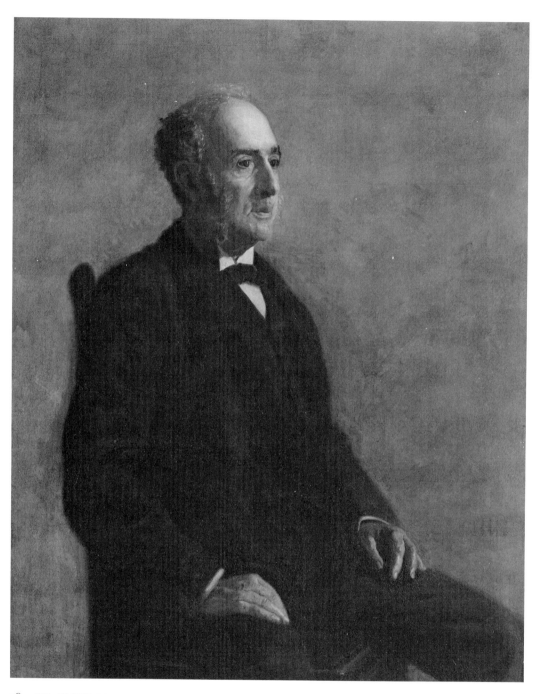

181. DR. JACOB MENDEZ DaCOSTA
1893. Oil. 42 × 34. G 270
Pennsylvania Hospital. Courtesy of the Philadelphia Museum of Art

cotta background, is one of Eakins' subtlest portrayals of a fine, distinguished man. The doctor accepted it, but instead of giving it to Jefferson or the College of Physicians, gave it to the Pennsylvania Hospital, where he had been attending physician for many years.

<center>V I</center>

Although he played no musical instrument and had been given up as hopeless by a singing teacher, Eakins loved music. His sisters Frances and Margaret had played piano, and Susan Eakins was an accomplished amateur pianist. "Of her many interests," Seymour Adelman wrote, "music was second only to painting. . . . For many years she attended concerts and the opera regularly, often accompanied by her husband." They had many musician friends, and often held musical evenings in their home. Eakins' taste, although not highly educated, was good, if confined to the classical, which was almost all that was widely performed in America in those days; as Weda Cook Addicks said, "There was no other—it was before Richard Strauss." His favorite composer was Beethoven. He especially enjoyed listening to singing; and he himself would sometimes sing snatches of French student songs.

"He was fond of music," Leslie Miller wrote, "and used to take great pleasure in coming to my house (I lived in the School Building at Broad and Pine Streets), either to enjoy our own Sunday evening musicales, or to watch and listen to the old Symphony Society,—the predecessor of the present Philadelphia Orchestra,—which used to rehearse in my lecture-room every Saturday evening. I say 'watch' as well as listen because he used to say that what he liked especially was to *see* the men play." Anyone who is visually as well as musically aware knows the added pleasure given by the performer's motions in harmony with the music.

Eakins' enjoyment of the visual aspects of music was embodied in no less than twenty-two works: paintings, watercolors, and reliefs, extending over most of his career. Among his earliest oils were those of his sisters and Elizabeth Crowell at the piano. In the 1876 watercolor *The Zither Player* Max Schmitt plays while Bill Sartain listens, and in the 1883 oil *Professionals at Rehearsal* John Wallace plays the zither and George Reid the guitar. *The Pathetic Song* of 1881 might be a recital at 1729 Mount Vernon Street, with Susan Macdowell at the piano. In the 1883 oil *Arcadia* and the Arcadian reliefs, nude youths are playing pipes. Franklin Schenck sings cowboy songs in two oils and a watercolor of the early 1890s. In the 1892 oil *The Concert Singer* Weda Cook is the performer. In 1896 Eakins persuaded the noted cellist Rudolph Hennig to pose for *The Cello Player;* in 1903 the amateur Dr. Benjamin Sharp for *The Oboe Player;* and in 1904 the violinist Hedda van den Beemt and the pianist Samuel Myers for *Music.* In addition, he painted eleven straight portraits of musicians and musicologists, as well as the great canvas of Mrs. Frishmuth, collector of musical instruments.

Of his paintings of musicians performing, the finest is *The Concert Singer.* When I talked in 1930 with Weda Cook Addicks she was in her early sixties, a charming woman, lively and frank, with a nice sense of humor, and still devoted to her friend Thomas Eakins. Born and growing up in Camden, she had often sung for her friend Walt Whitman. One of his favorite arias was "O rest in the Lord" from Mendelssohn's *Elijah,* and in her written reminiscences she recalled that he concluded their first conversation by quoting from the oratorio "and He shall give thee thy heart's desire." "In the years that followed," she wrote, "I saw him many times, and he always asked me to sing 'O rest in the Lord.'" A natural contralto (who changed to soprano in middle age), she made her debut at the Philadelphia Academy of Music when she was sixteen. She told me that she first met Eakins at a party at the Art Students' League of Philadelphia (the program for the League's "Third Annual Riot," in 1889, referred to her as "the Favorite Contralto").

She was only twenty-three in 1890 when she began to pose for *The Concert Singer.* She told me that she posed for two years, not steadily since she sometimes was away on concert trips, but three or four days a week during the first year. Every day when she started posing Eakins asked her to sing "O rest in the Lord" so that he could observe the muscles of mouth and throat. "I got to loathe it," she said. But she spoke of how accurately he had caught the singer's action in producing the utmost fullness of tone. He would look at her "as if through a microscope," she said. There was a wrinkle across her bodice, which he put in. When a visitor asked why, Eakins replied, "Why, what's the matter with that? It's there, isn't it?" The hand of the conductor in the foreground was posed for first by someone who held the baton as if it was a brush (it is like this in the preliminary sketch). Eakins got Charles M. Schmitz, conductor of the Germania Orchestra and one of Philadelphia's leading musicians, to pose for this hand, holding the baton correctly. The roses lying on the platform, Mrs. Addicks said, were given to her, fresh almost every day, by Eakins' colleague the sculptor William R. O'Donovan, "who fell in love with me, the old fool." Finally she could pose no more. Eakins had not quite finished: he had not completed the right foot projecting from under her skirt. He put her slipper on the floor and draped her dress over it; but in the painting it does not seem to have quite the right relation to her body—another example of his adherence to the facts before him. On the plain chestnut frame he carved the opening bars of "O rest in the Lord." "To musicians I think it emphasized the expression of the face and pose of the figure," he later wrote.

In *The Concert Singer* an attractive young woman with an engaging upturned nose and slightly receding chin stands on a stage with her mouth open, giving everything to her singing. Her low-necked sleeveless gown leaves bare her fine neck, chest, shoulders, and arms. Her face and hands are a delicate warm ruddy color; her arms and shoulders are paler, having been less exposed

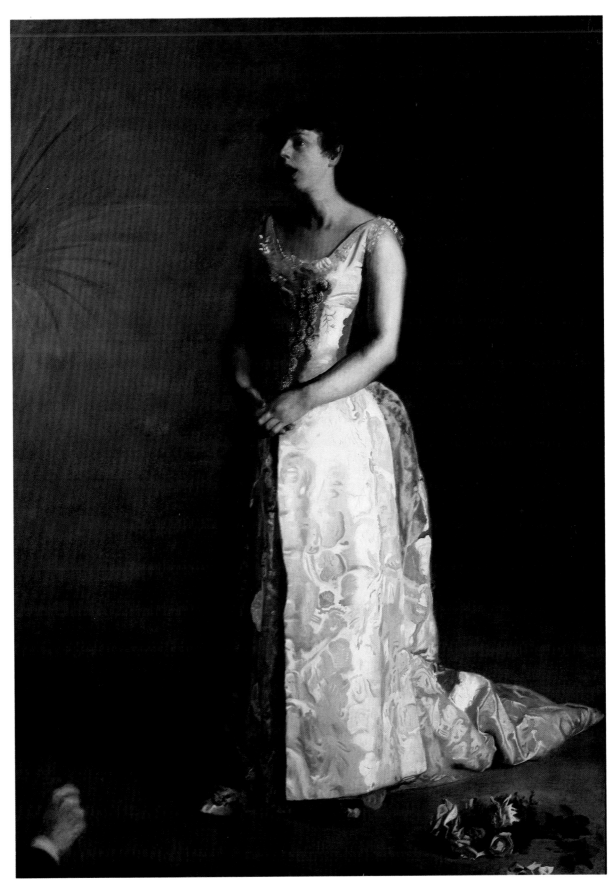

182. THE CONCERT SINGER
1890–1892. Oil. 75⅛ × 54¼. G 266
Philadelphia Museum of Art; Gift of Mrs. Thomas Eakins
and Miss Mary Adeline Williams

to light—again an example of Eakins' realism. Her gown is not the usual evening one, but a more elaborate creation appropriate for a public appearance: a light rose-pink brocade trimmed with lace and pearl beading; her sisters had made it. Its pale pink and gray and oyster white form a subtle color harmony. Eakins has given the gown its full value, but without flamboyance or allowing it to compete with the woman inside it. Her figure is solid and substantial, modeled in the complete round, and with the utmost refinement. There is a dramatic contrast between the lighted figure with its warm tones of flesh and gown, and the dark, cooler background. The light, an indoor light but not daylight, comes from the right and a little below eye level, so that it falls most strongly on her left hip and forearm, and slightly less so on her shoulder, neck, and head, which however are no less substantial. This subtle gradation of light adds to the pictorial depth, and to the painting's profoundly poetic mood. It is one of Eakins' most masterly achievements in the relations of form, light, and color. *The Concert Singer* is at once a living image of a beautiful, vital young woman, a creation in sculptural form, and a drama of light. In spite of his two years' work, it shows no sign of overlabor; on the contrary, it is one of his richest, most sensuous works—ripe, mellow, with a kind of bloom. These qualities are all the more moving because of its complete honesty, its freedom from prettification, and its powerful substance.

Four years later, in 1896, Eakins painted Rudolph Hennig, former leading cellist of the Thomas Orchestra and one of the city's outstanding musicians. The portrait was painted while Hennig practiced (not a public performance like Weda Cook's), seated in an ordinary chair, wearing an everyday suit, without a music stand, and against an empty background. His eyes cast down, he is listening intently for the correctness of the pitch and the quality of the tone. The background is brushed in so thinly that the squaring-off lines are visible; the concentration is on the face and hands. The right hand holding the bow is masterfully painted; one feels its strength and sensitivity, its control of the vibrating strings. When *The Cello Player* was purchased by the Pennsylvania Academy that same year, Eakins gave half the purchase price of $500 to Hennig for posing.

The same feeling for the hand holding the bow, as well as the hand controlling the strings, and the same intent listening to the tone appear in *Music*, but Hedda van den Beemt's hands are gentler and suaver, his face younger. Only twenty-four, he was first violinist of the Philadelphia Orchestra. Again, this is not a performance in an auditorium, but in a home. As compensation for the violinist's posing Eakins began a three-quarter-length portrait to give him, but Van den Beemt could pose only a few more times, so it was never finished.

Among Thomas and Susan Eakins' particular friends were the Nicholas Doutys. He was a tenor, noted as a Bach interpreter, a frequent soloist for the Bethlehem Bach Choir, as well as a teacher, composer, and writer on music;

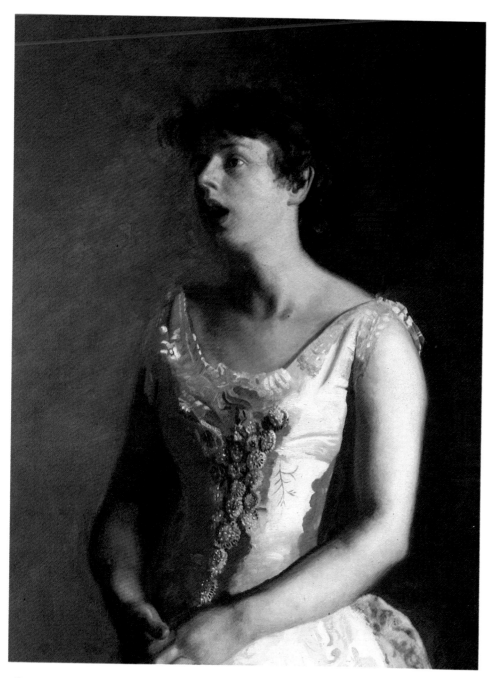

183. THE CONCERT SINGER: DETAIL

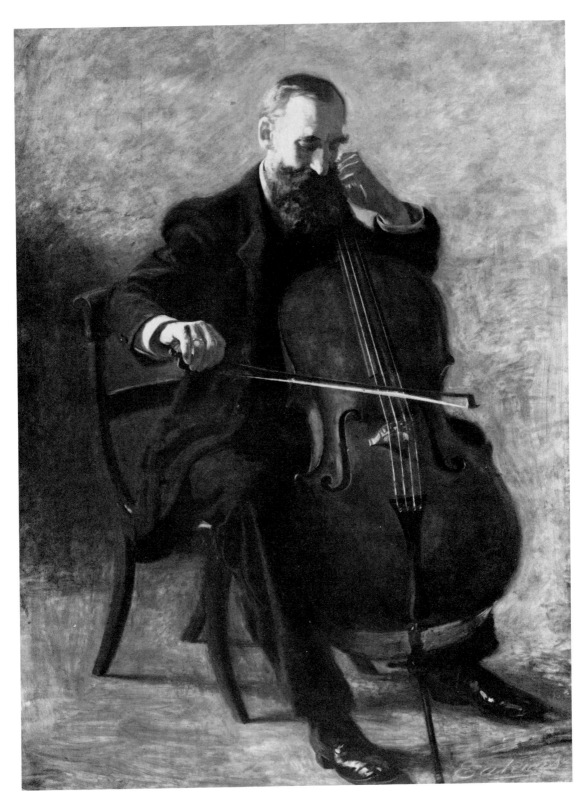

184. THE CELLO PLAYER
1896. Oil. 64½ × 48¼. G 291
Pennsylvania Academy of the Fine Arts; Temple Fund Purchase, 1897

185. THE CELLO PLAYER: DETAIL

186. MUSIC
1904. Oil. 39¾ × 49¾. G 402
Albright-Knox Art Gallery; George Cary, Edmund Hayes,
and James G. Forsyth Funds, 1955

he appeared in several recitals with Weda Cook. His wife, née Frieda Schloss, was a musicologist. They were intelligent, warmhearted people, and fond of Eakins. He used to call on them and would say, "Nick, what about singing?" Douty would ask what he wanted to hear, and Eakins would always ask first for Beethoven's love song "Adelaide"; he would sit looking perfectly happy while it was sung.

In 1906 he painted a portrait of their seven-year-old son, Alfred, and at Christmas the following year gave it to Frieda Douty. "When Nick came home the other evening with the beautiful portrait of Alfred," she wrote Eakins, "I knew my Xmas was complete and I do not know how to thank you, our good friend, for being so generous as to give us this bit of yourself. We are overjoyed to own it and so proud to be able to say our friend, Thomas Eakins, made it and gave it to us." Three years later Eakins painted her portrait as a surprise for Nicholas Douty; she had visited his studio "surreptitiously" to pose. So all of Eakins' portraits were not negatively received.

VII

In spite of Eakins' concentration on the nude in teaching and lecturing, he had pictured it only rarely, and the male somewhat more than the female nude: besides the half-naked bodies of oarsmen there had been *The Crucifixion*, the Arcadian oils and reliefs, and *The Swimming Hole*. As for the female nude, there had been *William Rush* and the studies for it; two small studies in the late 1870s; and a single figure in the oil *Arcadia*. Except for these, until his last years we know of only four paintings of female nudes: studies of single figures, not connected with any known compositions, all rather sketchy, and none signed or dated.

This is an extremely small production considering Eakins' dominating concern with the human body, his emphasis on it in teaching, and his gifts as a painter and modeler of the nude when he did picture it. This small number contrasts with the major role of the nude in nineteenth-century European art: Ingres, Delacroix, Corot, Courbet, Renoir, Rodin, as well as the Salon exploiters of female nudity. Even in the United States the nude, especially the female nude, was becoming an accepted subject, with the rise of the New Movement and the proliferation of mural painting and neoclassic sculpture. It is ironic that when the female nude was being so widely accepted, the most knowledgeable and powerful American figure painter pictured it so seldom.

Eakins was as pure a realist as could be found in American art of the period. His few imaginative subjects had had no successors. He painted what he saw in the real world, and American society of the late nineteenth century offered few opportunities to see the unclothed or even partially clothed female body. He seems to have felt a lack of reality in professional models: perhaps their very professionalism, their impersonality, the absence of the personal re-

lations and qualities that led him to ask other women to pose for portraits. Professional models were all right for the classroom, but he evidently had little interest in using them in his own paintings. In his Pennsylvania Academy years he had occasionally used women students (with their mothers' consent) as models for photography, but there were few women in the League, and the school ended in the early 1890s.

All of this helps to explain his habit of asking women who were sitting for portraits if they would also pose for him nude. In almost every case he met with refusal. In interviews and correspondence with former sitters I found several who told of the same experience. Weda Cook Addicks told me that when she was posing for *The Concert Singer* he "kept after her" to also pose nude, in spite of her constantly refusing. His eyes, she said, would become soft and appealing, and he would drop into the Quaker "thee"—"gentleness combined with the persistence of a devil," she said. He almost wore her down; she was often glad that Murray was present in the studio. But "one day the two of them got me down to my underclothes." She believed that Eakins did succeed in wearing down certain others she named, including his niece Ella Crowell. She felt that it was "an obsession" with him. He said that society was hypocritical, that he would like everybody to go nude. Mrs. Eakins told me that he thought it wrong that women with fine figures should not pose nude. When she said that he was unconventional, he replied that it was the others, those who would not act naturally, who were in the wrong. She confirmed that he did not care for professional models.

The portrait of Alice Kurtz, daughter of Eakins' friend the banker William B. Kurtz, was painted in the summer of 1903, when she was about twenty. In 1930, then Mrs. John B. Whiteman, she wrote: "One amusing incident was my losing a collar button down the inside back of my dress—I wore high starched collars over shirtwaists in those days. I sat as long as possible with the wretched button pressing into my spinal column & then during a rest I screwed up my courage to ask Mr. Eakins if he could reach down my back & get it out. After doing so, he remarked, 'You have a nice back—much like a boy. I would like to paint you nude.' His manner was so simple, so honest, I said, 'Well I will ask my Mother and see.' My Mother did not forbid it, but said perhaps it would be better not on the whole, and that Tom Eakins was somewhat hipped on nudes or words to that effect. My father had known Tom Eakins for years—of course I knew his great interest and knowledge of anatomy. My personal reaction would have been that I'd have quite liked to do it, for I felt he was quite pure-minded in the matter. I was rather a simple minded young thing of twenty or thereabouts when he painted me and the idea of being a nude model quite appealed to me."

Mary Hallock Greenewalt, a strikingly beautiful woman who at thirty-two had sat for her portrait, told me that he had wanted to paint her also in the

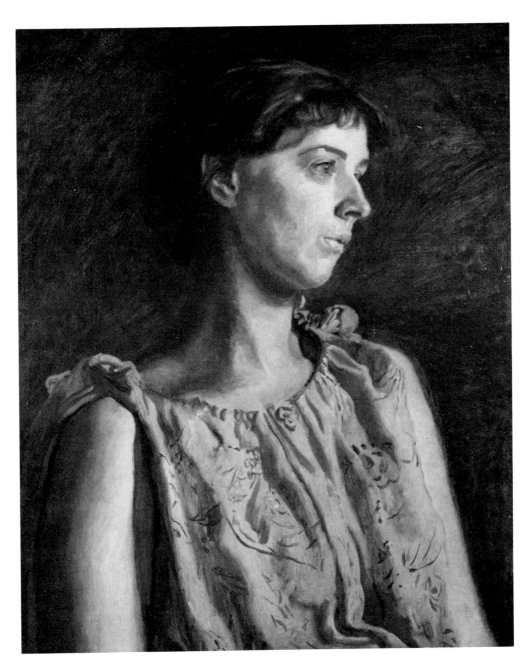

187. WEDA COOK
c. 1895. Oil. 24 × 20. G 277
Columbus Museum of Art, Columbus, Ohio;
Howald Fund Purchase

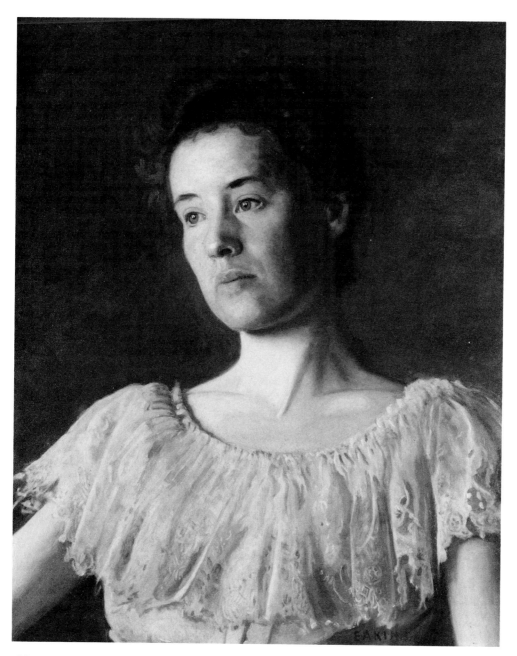

188. MISS ALICE KURTZ
1903. Oil. 23⁹/₁₆ × 19¹/₄. G 379
Fogg Art Museum; Purchase by John Coolidge
with funds contributed by his friends, 1969

nude, but she had not consented; she now wished that she had. In the portrait (ill. 248) the lines of her shoulders and arms, not concealed by her low-necked sleeveless gown, show that she would have been a superb model.

Mrs. James G. Carville, niece of Eakins' friend the photographer Louis Husson, was painted in 1904, when she was about thirty—one of his few commissions. Her daughter Elizabeth Carville wrote me in 1969: "I remember Momma telling me that Mr. Eakins asked her to pose for him in the nude,—and even though this was over thirty years later, she blushed when telling me about it, and was still indignant and outraged as she was the day she refused,—muttering to herself,—'I just let him know I wasn't that kind of a woman!' Isn't it a pity? I'm sure it would have been a beautiful portrait because my mother was a beautiful and gracious woman,—shy, quiet, completely honest."

Mrs. E. Farnum Lavell, née Eleanor S. F. Pue, a pleasant, witty, rather conventional person, told me that when Eakins in 1907 asked her, then twenty, to pose for her portrait, she hesitated; people said that he had a bad reputation and might say something "disgusting" to her. But he never did; he told a few "broad stories" of student days in Paris, but "he made no advances." She said that he had "a sensual face" and "was like a bear—big, dirty, that thick through." For the portrait (ill. 259) she wore a very low-necked dress; he admired the bones of her shoulders and chest, and would poke at them with the handle of his brush and say "beautiful bones!" He asked her to pose nude, kept on urging her, and finally went to her mother and asked her to allow her daughter to do so. "He seemed to feel that there was something disgusting in my not being willing to." But Mrs. Lavell felt that his interest was purely artistic.

Susan Eakins' niece Rebecca Macdowell (later Mrs. John Randolph Garrett, Sr.), whose portrait Eakins painted in 1908, told Gordon Hendricks that she often visited the Eakinses when she was young and that her uncle-by-marriage asked her to pose nude; "he always wanted us to pose in the nude," she recalled. Helen Parker, later Mrs. Evans, whose portrait *The Old-fashioned Dress* (ill. 260) was painted in 1908, was asked to pose in the nude also, she told Hendricks. Elizabeth Dunbar, an art reporter for the Philadelphia *Press* and for many years secretary of Talcott Williams (and later his biographer), told Margaret McHenry that she was often in the Eakins house and "was asked several times by the painter to run upstairs to the studio and pose for a life study. When she was older and Eakins had died, she very much regretted that she had always refused from a sense of modesty."

Mrs. Nicholas Douty told me that when Eakins painted her portrait (ill. 271) in 1910 he wanted her to pose nude also; she believed that he did not like professional models. She declined, saying that she wasn't proud of her figure; but he said that didn't matter, every figure was beautiful. She said: "He seemed starved for the nude."

There must have been many more such cases. Of the eight women with whom I talked or corresponded about their portraits, five (Mesdames Addicks, Whiteman, Greenewalt, Lavell, and Douty) all told the same story, and without my bringing the matter up. The other three were unlikely subjects for one reason or another. Besides those with whom I communicated, four more had had the same experience (Mesdames Carville, Garrett, and Evans, and Miss Dunbar). All these women were living in the 1930s and could tell their stories; there must have been others who had had the same experience. It seems probable that at least in the 1890s and 1900s Eakins asked most of his younger women sitters to also pose nude. This habit continued into the last years of his painting career, when he was in his middle sixties. He did not hesitate to ask married women, nor was he deterred by his relations with their husbands or families.

His continuing persistence in these importunities, in spite of rebuffs, is a curious psychological phenomenon, showing a complete disregard of his sitters' codes of behavior and the mores of his community. But rather than immorality it seems to me to reveal a strange naiveté, an obliviousness to the realities of the society in which he lived—even a kind of innocence. It was like his stubborn insistence on the entirely nude male model in certain anatomical lectures, and his ignoring of popular squeamishness in his two great clinic paintings—manifestations of uncompromising adherence to his artistic principles. In the end, this obsessive persistence may have had an element of conscious defiance of social conventions.

Yet it did become an obsession, and a self-defeating one. His fixation on painting, in the nude, women whom he knew, and the inevitable frustration of this desire, resulted in only a small number of works featuring the nude—the subject which he was uniquely qualified to paint, and which called forth his full powers. If he had been able to free himself from strict adherence to the actualities of Philadelphia, 1870 to 1910, and to essay freer, more imaginative subjects, he might have channeled his passionate concern with the human body, and his mastery in depicting it, into freer plastic creation. His close relation to the actualities of his place and time was at once a source of his strength, and a limitation.

<p style="text-align:center">VIII</p>

From the time of the Pennsylvania Academy affair in 1886 there were all kinds of rumors in Philadelphia about Eakins and his alleged immorality. They were fed by the Drexel Institute fiasco, his openly expressed attitude toward nudity, his freedom in boating and swimming nude, and his habit of asking women to pose nude. Many of the men and women I talked with in the 1930s, people who knew him well and in most cases were well-disposed toward him, brought the matter up voluntarily. Mrs. Eakins was sensitive on

the subject. When I asked her whether Nannie Williams had posed for *William Rush*, she looked taken aback and said "it wasn't generally known." She reacted in the same way when I spoke of Wallace's posing for *The Crucifixion*. Though no one agreed more completely with her husband's beliefs, she was still nervous about such incidents, clearly an echo of past scandals.

Eakins' reputation was not helped by his frankness about nudity. One of his best friends among socially solid Philadelphians was James Mapes Dodge. Mrs. Dodge (ill. 178) told me that he once invited her and her husband to come to his studio to see a red-haired female model he and Murray had. When he admitted them, there stood the model completely nude. Mrs. Dodge said that it was the first time she had ever seen either a woman or a man nude. Eakins insisted on taking them over to examine her; he ran his hands down her side and said how fine it was ("He didn't need to do that," Mrs. Dodge said), and took them around to admire her back. Mrs. Dodge also told of some "lantern slides" (perhaps photographs) that he had given them, of himself and models, one or more showing him carrying a nude female in his arms—"not the kind of thing for a respectable widow," so she gave them to her son Kern. (I would have doubted this except that I saw one or more similar photographs in Mrs. Eakins' possession.)

A few of his more conservative students disapproved of his frankness. Francis Ziegler recalled that once when he was posing nude for Murray, Eakins brought in a girl from the League. Ziegler didn't mind posing in the school, but this was different—a girl who might work alongside of him in the class. (The difference seems minimal.) He said that "the nude was rather rammed down our throats." Another conservative pupil told wilder tales, which were made unreliable by his inaccuracy in other matters.

The rumors extended into supposed immorality in sexual relations with women. I never found any basis for such allegations. Mrs. Addicks, who knew him as well as any of his friends and who was very frank, said that he was "absolutely unmoral," but that "he would never hurt a woman who did not want to be hurt," and that she knew of no woman with whom he had relations. She said that he spoke of Mrs. Eakins as "my Susie," and that when she came to the studio, which was not often, "he treated her like a queen." Mrs. Addicks herself did not consider him attractive to women; several other women friends agreed. Murray told me that "he never heard a harsh word between Eakins and Mrs. Eakins," even though he felt that she had sacrificed her career for his.

Eakins seems to have aroused widely differing reactions in different women. In Weda Cook he inspired "love and fear," but she said that she owed more to him than to anyone, and that in the end "he measured up to any man I ever knew." Other women, however, were repelled by his ideas and reputation—and in his later years, by his deteriorating physique.

Lucy Langdon W. Wilson, liberal educator, feminist, former friend of Nannie Williams, and highly critical friend of Thomas Eakins, told me that when he was painting two portraits of her in 1908 and 1909 he talked freely. At first, she said, he tried to shock her, but when he saw she didn't mind, he stopped. She believed that his sexuality was largely talk, that if a situation developed, "he would leave before the critical moment," that he had "physical inhibitions," and that "he never loved anyone." He said, "Susan is enough for me." But she considered him a very selfish man, especially toward his wife, who sacrificed herself to him. Seeing him in his middle sixties, she did not know of him as formerly an outdoor man and athlete; she described him as sedentary and bowed. Altogether, a somewhat negative picture.

On the other hand, Mrs. Wilson said that Nannie Williams had been much interested in him (but not he in her) and that "his girl students were crazy about him." It seems likely that his physical and mental vitality attracted young women students, and that some fell in love with him. In certain cases this had unfortunate results. Lillian Hammitt studied with him at the Pennsylvania Academy from the time she was eighteen, in 1883, until he left in 1886. In his portrait of her, *Girl in a Big Hat* (one of the few portraits of women students), she peers at us through steel-rimmed spectacles, a rather plain young woman with searching eyes. A clever girl, Mrs. Eakins told me, who became insane; "a poor, unhappy, demented girl," according to Murray and Mrs. Addicks. Murray said that she used to burst into the Chestnut Street studio saying that she was Mrs. Eakins and asking where Eakins was. In the mid-1890s she was picked up by the Philadelphia police wandering in the streets, wearing only a bathing suit—shocking in those days. She told them that she was married to Eakins and that he had slept with her. Francis Ziegler (ill. 147), who had abandoned art to become a newspaper reporter, was assigned the story. He got the police records, then went to the studio to see Eakins. The latter was out, and Murray told him that Eakins didn't talk for publication. Ziegler wrote his piece; he told me that he did not play up the sensational aspects nearly as much as he could have; and anyway it was all in the police records. But Eakins wrote him that he had come to the studio and got information and used it against him, and that he never wanted to see him again. Nevertheless, Ziegler went to the studio. Mrs. Addicks told me that Eakins said, "Never come here again," and shut the door in his face.

Years later, a few months after Mrs. Eakins' death, Charles Bregler wrote Murray: "In a box I found letters relative to the trouble at the Academy and also those relating to the Hammitt incident. Enclosed with these was a note in Mrs. E's handwriting that they be completely destroyed by burning them. I was surprised to find them, but glad they were discovered before they fell into the hands of strangers. Well do I recall the sorrow and trouble of those unhappy days."

Personally I find it difficult to picture Eakins as a participant in extramarital affairs, in view of his seriousness, dedication to work, scorn of "silliness," and incapacity for the customary idealization and illusion—even his abstention from spirituous liquor and his habit of going to bed early and getting up early. He had married relatively late in life, and perhaps his earlier relations with Emily Sartain and Kathrin Crowell had held more youthful ardor; but in his marriage to Susan Macdowell there was complete mutuality of interests, ideas, and beliefs, and, judging by his letters to her from Dakota, deep emotional attachment.

15. Sculpture

FROM THE LATE 1880s on, an important part in Eakins' professional and personal life was played by his favorite pupil and companion, Samuel Murray.

Samuel Aloysius Murray, eleventh of twelve children, was born in Philadelphia, June 12, 1869, to parents who had emigrated from Cork, Ireland. His father, a stonecutter, was employed by Woodland Cemetery in the city, and the son is said to have met Eakins there. Seeing an artist sketching, young Samuel asked how he could learn to paint, learned about the Art Students' League of Philadelphia, and was invited to visit it. He did, and joined the school on election night, November 1886, at the age of seventeen.

Murray was a fast learner, and within two or three years, no later than early 1889, Eakins took him on as his assistant in his studio, squaring off sketches and enlarging them on to full-size canvases, and so on. He helped with *The Agnew Clinic,* working out the perspective of the benches and laying in parts with a broad brush. He remembered that Eakins, in painting the lower half of the big canvas, would sit cross-legged on the floor. (Years later, in 1907, Murray made a statuette of him in this position, mixing paint on his palette; ill. 163.) The year of the Agnew painting, 1889, Eakins painted his portrait and gave it to him. The young man showed an aptitude for modeling, so his master encouraged him to concentrate on sculpture, and taught him the technique of the craft, helping him to cast from clay to plaster. (He was always to be a modeler, not a carver.)

So quickly did Murray learn that in 1890 Eakins obtained for him the position of instructor in modeling from life at the Philadelphia School of Design for Women, of which Emily Sartain was principal, a post Eakins had helped her to get in 1886. Murray was to retain his position for the rest of his life, fifty years. He also lectured on anatomy, using his master's anatomical casts. And in the fall of 1892 Eakins made him his assistant in teaching at the Art Students' League of Philadelphia: the Circular for the 1892–93 season read: "Instructors / Thomas Eakins / Assisted by / Samuel M. [sic] Murray."

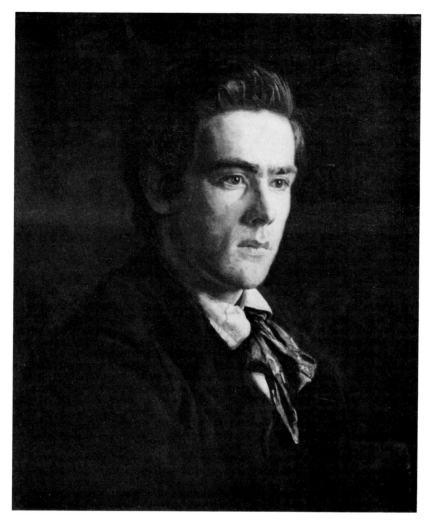

189. SAMUEL MURRAY
1889. Oil. 24 × 20. G 238
John R. and Eleanor R. Mitchell Foundation, Mount Vernon, Illinois

After Murray became a full-fledged professional sculptor the two artists shared the Chestnut Street studio. Even after Eakins gave up the place in 1900 and they took separate studios, their close professional and personal relationship remained unchanged, continuing until Eakins' death.

Murray was a good-looking young man, though not what could be called handsome; of middle height, with abundant dark brown hair (and later a moustache), and a decidedly Irish physiognomy; a strong face, not overrefined, with the determined look of one who had come up from nothing to make his way in the world. Photographs of him as a student, in the nude, show a sturdy, compact body, with good shoulders and legs. William Crowell, Jr., recalled him at

the Avondale farm: "I remember Murray as athletic, able to use his hands well and to cut straight with a saw, and that he was a fast runner; that he and Boulton ran a race in the Meadow against Ella or Ben on Baldy; that he was quickest in starting and for a short distance kept ahead of Baldy."

When I visited him several times in 1931 he was in his sixties and almost completely deaf, but he enjoyed talking about Eakins and everything that had to do with him. Frank, with a keen sense of humor, he was full of stories about the people they had known and the experiences they had shared. (Some of his stories, I came to realize, were embroidered, for he had an Irish imagination.) He always spoke of Eakins with understanding and love, as one would of a father, recognizing both his strengths and his idiosyncrasies. Of all those persons I talked with, he, next to Mrs. Eakins, was the most generous with time and information, as he was to be later with Margaret McHenry for her book.

From the time he became Eakins' assistant, he took full part in the older man's personal and social life. In the Mount Vernon Street house he was a member of the family, on affectionate terms with Susan and Benjamin. In talks with me he must have felt that I was getting from others too sad a picture of his master, for he kept emphasizing the good times they had had. Both active bicyclists, they would go on long cycling trips, sometimes putting their machines on the train to Washington, then riding south, "eating Virginia ham and waffles." They often visited the boathouse on the Cohansey and went swimming there. They enjoyed the Italian sections of Philadelphia, and sometimes of New York when Eakins went there to lecture. On one trip to New York, the hotel porter took them for a couple of hicks, so they entered into the spirit of the occasion; Eakins pointed to the folding beds and asked what those things were, and Murray played his part by trying to blow out the gas.

As a sculptor Murray was strictly a realist, and primarily a portraitist, even in his monuments, which were usually full-length portraits of the men memorialized. He did only a few allegorical figures such as most of his colleagues were turning out. His works fall into three main classes: monuments, bust portraits, and full-length statuettes. The last-named are the most original: authentic in character, and sometimes with a touch of humor. In his honest realism the strong influence of Eakins is obvious, but it is also evident that this was his natural bent. It cannot be said that his sculpture reveals the sense of form that Eakins' painting does; he was a limited artist, but genuine within his limits, and certainly one of Eakins' ablest pupils.

His professional career started early. He began to exhibit in the Pennsylvania Academy (a bust portrait of Susan Eakins' father, William G. Macdowell) when he was only twenty-two, in January 1892; and he was represented in almost every annual exhibition thereafter, usually by several works. (Eakins himself was not included in the 1892 and 1893 shows.) In the 1895–96 annual Murray was on the three-man sculpture jury with two older sculptors, John J.

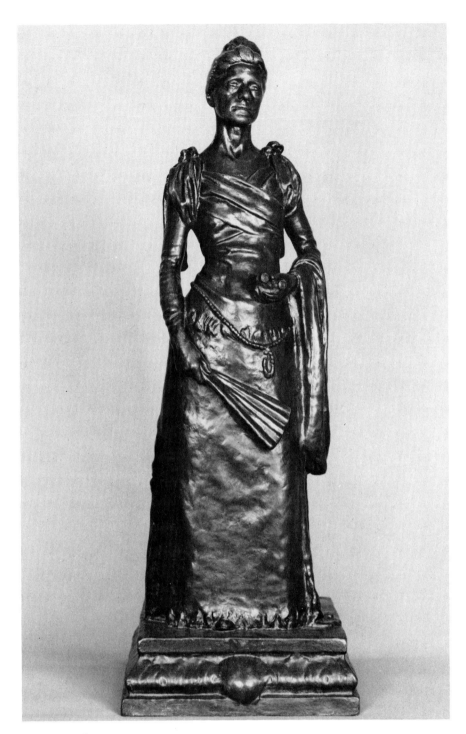

190. Samuel Murray: MRS. THOMAS EAKINS
1894. Bronze. 21¼ high
Pennsylvania Academy of the Fine Arts;
Gift of Mrs. Samuel Murray, 1942

Boyle and Herbert Adams. (Eakins did not serve on an Academy jury until 1901). In 1894 the younger man's bust of Benjamin Eakins was awarded the Gold Medal of the Philadelphia Art Club, and in 1897 the club gave him an honorable mention. (Although Eakins exhibited there frequently the club never gave him an award.) So in Philadelphia in the 1890s the pupil was ahead of the master in official acceptance. Within a few years he was more successful as a sculptor, in a modest way, than Eakins was as a painter.

In the wider art world Murray showed in the National Academy in 1892 and 1893; in the Chicago World's Fair of 1893, where he received an honorable mention; in the Paris Exposition Universelle, 1900; the Pan-American Exposition, Buffalo, 1901, with an honorable mention; the Louisiana Purchase Exposition, St. Louis, 1904, with a silver medal; and occasionally in annual shows elsewhere. But he was never to achieve the national reputation of his more brilliant eclectic fellow sculptors, nor their more grandiose commissions. His reputation, solid as it was, was confined almost entirely to his native city and state. He never went abroad.

At least forty of his portraits were of men and women whom Eakins painted. Several were statuettes, while Eakins' were generally head and bust likenesses. They were usually done about the same time, though not at the same sittings; for example, two photographs show Frank Jay St. John posing in the Chestnut Street studio, seated for the painter and standing for the sculptor; both works are dated 1900. Even after the two artists had separate studios, the parallels continued.

Murray did several portraits of the Eakins family. His bust of Benjamin in the Pennsylvania Academy is inscribed "To My Dear Friend Benjamin Eakins." The same year, 1894, he modeled an engaging full-length statuette of Susan in evening dress, setting forth for the opera or a concert, with opera glasses and a fan.

The following July, Eakins wrote the ethnologist Frank Hamilton Cushing: "I wish you were here now. Murray is just starting a statuette of me to go with that of my wife.

"He is modelling my naked figure before putting on the clothes and I wish you were modelling alongside of him." The statuette, the same size as the one of Susan, is quite different in costume: Eakins stands in his working clothes, shirt open at the neck, baggy pants, holding his palette and brush. It is inscribed "To my dear master." When Murray gave a bronze of it to the Pennsylvania Academy in 1941, shortly before his death, he explained that he had chosen it "because it showed Eakins defiant."

Eakins, for his part, painted portraits of several of the Murray family, aside from the one of young Sam: his father the stonecutter; his sister Gertrude; his fiancée, Jennie Dean Kershaw, and her mother; and Jennie's niece Ruth Harding. He gave these to the Murrays; and to Murray he gave several works,

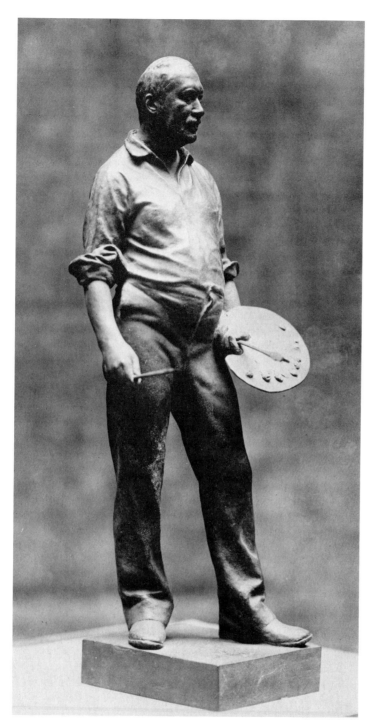

191. Samuel Murray: THOMAS EAKINS
1894. Bronze. 21¼ high
Pennsylvania Academy of the Fine Arts;
Gift of the artist, 1941

mostly studies; the fine one of *The Cello Player* is inscribed on the front: "To my dear pupil Samuel Murray, Thomas Eakins."

Eakins was as solicitous as a father in looking out for Murray's interests. It was probably about the latter's bust of Walt Whitman that Eakins wrote him in November 1892, seven months after the poet's death: "Dear Sam, I have lost Harned's letter that I rec'd to-day & intended to send to you. He says he intends to come to the studio shortly. He did not say anything about the bust. He may still have some notion about getting it cheaper. I advise you to tell him it is $200 the old price this year, but $300 next year and $400 the next. Yours, T.E."

Murray soon began to receive commissions for public monumental sculpture. His first important one, in 1896, was for ten statues on the Witherspoon Building in Philadelphia, headquarters of the Presbyterian Board of Education and Sabbath School Work. The big building, occupying the whole block on Juniper Street between Walnut and Sansom streets, was designed by the young architect Joseph Miller Huston, and was unusual in that its exterior was to display heroic-sized sculptures. For the two main portals, Huston chose Alexander Stirling Calder, who had been a pupil of Eakins briefly at the Pennsylvania Academy, to execute six nine-foot figures of the fathers of American Presbyterianism. Calder was only twenty-six, but he was a friend of Huston's, and his father, Alexander Milne Calder, another former pupil of Eakins, had produced the innumerable sculptures for Philadelphia's huge City Hall, culminating in the thirty-seven-foot statue of William Penn on top of it. (The third-generation Alexander Calder was to be one of the most inventive sculptors of our time.)

It was probably because of these personal and professional connections that Huston commissioned Murray, then only twenty-seven, to model ten ten-and-a-half-foot statues of biblical prophets, to be placed on the eighth floor, around the three public sides of the building. "I personally selected Mr. Murray as the Sculptor of this work," Huston wrote in 1921, "and the information upon which he worked was given me by the distinguished Hebrew Scholar, Prof. William Henry Green, of the Princeton Theological Seminary, who selected the prophets and gave us the most accurate description in literature of them, and you will notice that there are two women prophetesses, Hulda and Deborah, showing that the ancient Hebrews were strictly up-to-date." The prophets were Moses, Samuel, Elijah, Isaiah, Jeremiah, Ezekiel, Daniel, Deborah, Huldah, and John the Baptist. On September 9, 1896, Huston wrote Murray: "Please proceed with these figures at once and finish them as quickly as possible." The price was $300 each.

Eakins worked with Murray on the commission. They took a studio on Wissahickon Avenue, because the statues were almost twice life-size, and the Chestnut Street studio was not large enough, and up several flights of stairs.

The figures were in very high relief, nearly in the round. The material was terra-cotta, which Huston used on other buildings; it was light, for the statues were hollow. They were fired by a firm in Tioga, Pennsylvania, each being divided into horizontal sections, which were later cemented together.

Murray and Eakins were both portraitists, and for the faces and bodies of the prophets they drew on real individuals: friends, relatives, Eakins' pupils —people whom both of them had portrayed. Maria Chamberlin-Hellman, in a fascinating piece of iconographic research, has identified six of the models. The majestic figure of Moses, with the Tablets of the Law, was Walt Whitman. Jeremiah was William G. Macdowell, who they considered a modern Jeremiah preaching reform and threatening doom; his thoughtful pose, chin in hand, was borrowed from Michelangelo's fresco of the prophet in the Sistine Chapel. Isaiah was the old blind painter George W. Holmes, friend of Benjamin Eakins and one of the players in the 1876 *Chess Players*. Samuel, anointing Saul or David, was Franklin Schenck. Huldah, her arms outstretched in prayer, was Susan Eakins. Deborah was Jennie Dean Kershaw, with her slender face and hands. The other four have not yet been identified, but Mrs. Chamberlin-Hellman suspects that Daniel was Benjamin Eakins and Ezekiel was Talcott Williams.

The ten oversize sculptures involved much work: first, three-foot models in plaster, then the full-scale figures. The sculptors had to spend some time at the Tioga studio. In October 1897, more than a year after Murray received the commission, Eakins wrote Professor Henry A. Rowland, whose portrait he had been painting: "I have been very busy with the big statues for the Witherspoon Building and have not done much to the picture."

Calder's and Murray's statues were duly installed on the building, but through the years they suffered much damage from erosion and polluted atmosphere; and in 1961, in the interest of pedestrian safety the exterior of the building was renovated and all the sculptures were removed. Calder's were preserved and are now installed on the grounds of the Presbyterian Historical Society. But Murray's and Eakins' prophets met more bizarre fates. They were put up for sale, for the cost of crating and shipping, $319 each. *Moses* and *Elijah* were purchased by Arthur Garrett of Skagway, Alaska, and eventually given to a Catholic church there. The remaining eight were acquired by two cemeteries, Christian and Jewish, in Frazier, Pennsylvania, where all but Samuel fell prey to vandalism, weather, or neglect. Aside from the three survivors, all that remains of this grandiose project are some rather indistinct photographs.

Just how great was Eakins' part in the Witherspoon Building sculptures is not definitely known. From his letter to Rowland and one to Harrison Morris in February 1897, saying that he would be "very busy tomorrow at the Tioga studio," it is evident that he worked closely with Murray. The statues them-

selves show a vitality of characterization in the faces, a skill of modeling in the robes, a sense of movement in the figures of the two prophetesses, and in general a freedom and mastery greater than in Murray's relatively pedestrian work—and indeed in much of Eakins' own previous sculptures. It seems possible that the challenge of the commission, and partnership between the two sculptors was a stimulus to both of them. However, Eakins never claimed publicly to be co-author of the statues; and *Jeremiah*, the only one known to have been exhibited, at the Pennsylvania Academy in January 1898, was shown as Murray's.

As he grew older Murray was to prove effective in getting more public commissions, some important, such as the statue of Rear-Admiral George W. Melville for the League Island Navy Yard, Philadelphia, in 1905 (Eakins had painted Melville's portrait the preceding year); the figure of Commodore John Barry for Independence Square, Philadelphia, in 1907; and the Pennsylvania State Memorial on the Gettysburg battlefield in 1909. Murray was a Catholic, and he became friendly with many of the clergy, including some of high rank, especially the faculty of St. Charles Seminary at Overbrook outside Philadelphia. He executed several monuments to prominent prelates, and many less formal portraits of them. He became a member of the Friendly Sons of St. Patrick, which did not harm his professional career.

Eakins had an extravagantly high opinion of his protégé's work. In 1899 he wrote John W. Beatty of the Carnegie Institute: "Mr. Samuel Murray would like to send to your exhibition two portrait busts in bronze. Will you send him a blank to my address which is also his.

"No better work in my judgment has ever been done in America."

Writing Mrs. Alexander Johnston in 1907, he said: "Murray's nine foot statue of Commodore Barry the father of the American navy was unveiled on St. Patrick's day the 17th of March with great ceremonies followed by a banquet.

"The statue is planted in the very centre of Independence Square, where the old commodore walked many a time smoking his pipe at the close of the revolutionary war. The statue is a gift to the city by the Friendly Sons of St. Patrick a very rich society dating away back to the revolution.

"George Washington was one of its members. As nobody can belong except he has Irish blood in his veins the members were hard put to it to find an expedient. Finally George Washington was legally adopted by a very Irish member as his son and then all trouble ended.

"Artistically the statue is I believe the best in the country and I am proud to have assisted Murray in its execution.

"As soon as I can get hold of a good photograph of the statue I shall send it to you."

This letter raises the question of how much Eakins helped Murray with his

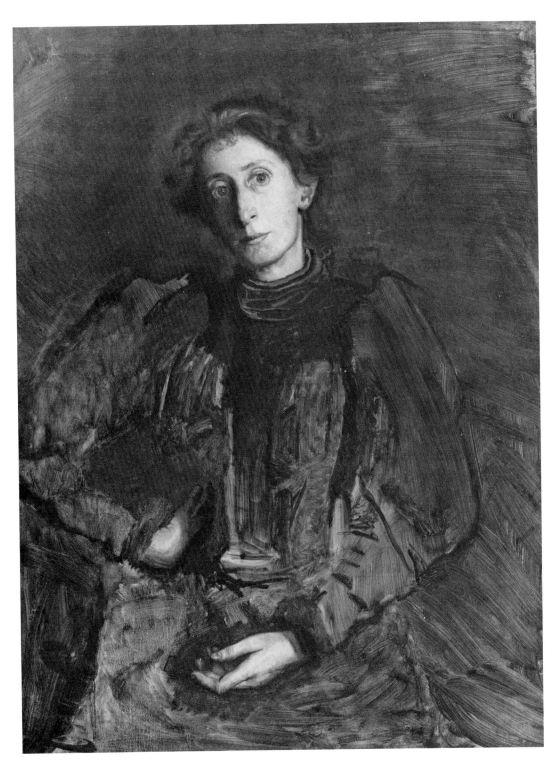

192. JENNIE DEAN KERSHAW
About 1897. Oil. 40 × 30. G 297
F. M. Hall Collection, University of Nebraska Art Galleries, Lincoln

sculpture. Margaret McHenry, who got much of the information for her book from Murray, wrote: "Murray remembered Eakins had helped him with nothing but the prophets." This is in direct contradiction to Eakins' letter. Between Eakins' contemporary statement and Murray's memory of events fifty to thirty years earlier, perhaps colored by self-interest, the former is more dependable. If Eakins was assisting Murray as late as 1907, he probably had done so on earlier works. But on which ones, and to what extent, will never be known.

Not that the relation between the two artists was a one-way street. Murray helped Eakins with two sculpture commissions in the early 1890s. He played a part in the older man's new interest in the world of prizefighting and wrestling in the late 1890s. Through Murray came Eakins' involvement with the Catholic clergy in the early 1900s, which resulted in some of his finest portraits. As often happens, the pupil influenced the master.

At the Philadelphia School of Design for Women, Murray met Jennie Dean Kershaw, who had taught perspective there and then had become the school's actuary. He was about three years younger. They became engaged in the 1890s, but it was to be a long engagement, twenty years or so. Yet they were very close, and both were close to Eakins. He (or Murray) took many photographs of her intelligent if homely face and thin figure, usually dressed in elaborate white gowns; and about 1897 he painted two portraits of her, neither of them entirely finished. In 1903 he painted her mother, Anna A. Kershaw, and Jennie's young niece Ruth Harding. With all this familial closeness it is hard to understand why the engagement was so prolonged; it could hardly have been a question of money. When they finally married, in March 1916, only a few months before Eakins' death, Murray was forty-six. When I met them in 1931 she was in her middle sixties. She was to survive him by eleven years: he died in 1941, she in 1952. They had no children.

The companionship of Eakins and Murray meant much to both of them. The suggestion has been made that the relation was a homosexual one. There is no need to get involved in moral issues about this; it is an interesting question that deserves consideration. There is of course no factual evidence. None of Eakins' friends, pupils, and sitters with whom I talked in the 1930s, several of whom were entirely frank about sexual matters, mentioned homosexuality; on the contrary, the more critical accused him of too much sexuality with regard to women. His intense interest in the female nude and his persistent habit of asking women to pose nude for him have been detailed. As to his art, he painted many portraits of women, almost as many as of men, and they are among his most sympathetic portraits. His genre scenes feature women and their activities as much as the male world. In his pictures of the female nude, especially the William Rush works of the 1870s and 1908, his attitude is affirmative.

Without being so rash as to try to define homosexuality in art, it does seem

to me that in modern times (not Greece or the Renaissance) the art of homosexuals tends to show certain qualities that are conspicuously absent in Eakins': sophistication, wit, elegance, fantasy, satire, decorative values. And specifically, an attraction toward the male more than the female, and a tendency to idealize the male face and figure. I do not perceive any of these characteristics in Eakins' work.

Everything that we know about Eakins and his art, I believe, shows that his relation to Murray was that of father to son. In his youth he had expressed a desire for "strong beautiful children." Now he had a son who was a talented co-worker and a companion.

<center>II</center>

Eakins himself had produced no original sculpture since the early 1880s: the ill-fated Scott reliefs and his Arcadian subjects. But in 1891 and 1892 came two commissions for monumental sculpture: for the Soldiers' and Sailors' Memorial Arch in Brooklyn, and the Trenton Battle Monument in Trenton, New Jersey.

The imposing Brooklyn arch, dedicated "To the Defenders of the Union, 1861–1865," stands in the Grand Army Plaza at the entrance to Prospect Park. Designed by John Hemenway Duncan, architect of Grant's Tomb in Manhattan, the arch, based on Roman memorial and triumphal arches, was planned to be embellished with sculpture. The top is surmounted by a bronze group of heroic size: a quadriga, or four-horse chariot, driven by the female figure of America, holding aloft her oriflamme and attended by two palm-bearing, trumpeting winged Victories; and the two piers bear crowded many-figured groups, also heroic-sized, symbolizing the Army and the Navy. All these principal sculptures, reminiscent of François Rude's on the Arc de Triomphe in Paris, were executed by Frederick MacMonnies, the most brilliant and flamboyant American exponent of the Beaux-Arts style, creator of the spectacular *Barge of State* or *Triumph of Columbus* at the World's Columbian Exposition in Chicago in 1893.

Much more modest were Eakins' contributions. Inside the arch on either side were to be life-size bronze equestrian statues of President Lincoln and General Grant. The commission for these was given in 1891 to William Rudolf O'Donovan, who in turn engaged Eakins to model the two horses. O'Donovan, born in Virginia the same year as Eakins, had enlisted in the Confederate Army at seventeen and served in the artillery until Lee's surrender. Self-taught as a sculptor, he had settled in New York and become known for his portrait busts of eminent men and of fellow artists, and for his soldiers' monuments, including several statues of Washington. He was a competent realistic sculptor, with an excellent sense of character and of historical detail. A genial, gregarious man, he had been one of the founders of the diverting Tile Club

193. Samuel Murray, Eakins, William R. O'Donovan, and Harry,
in the Chestnut Street studio. Probably 1892. Photographer unknown
Mr. and Mrs. Daniel W. Dietrich II

and had been elected to both the National Academy of Design and the Society
of American Artists in the late 1870s; and he had been one of the Society's two
representatives who came to Philadelphia in 1879 to protest the Pennsylvania
Academy's treatment of *The Gross Clinic.* He knew Walt Whitman and did a
bust of him; and like Eakins he attended Whitman's seventy-second birthday
dinner in 1891, and was one of the honorary pallbearers at his funeral. So he
and Eakins had many things in common. That they enjoyed each other's com-
pany is shown by photographs of the two (and sometimes young Murray) in
Eakins' studio sharing bottles of wine.

In O'Donovan's and Eakins' bronzes for the Brooklyn arch, Lincoln sits his
horse as if reviewing passing troops, his bared head turned toward us, his tall
hat in his right hand. His horse stands restive, champing his bit. Grant,
mounted on a powerful charger, rides along as with his army on the march,
looking neither right nor left, characteristically businesslike and unheroic.

Shortly after the statues were finished, a detailed account of their making

was written by Cleveland Moffett for *McClure's Magazine*, October 1895. "Mr. O'Donovan," he wrote, "although himself a practical horseman, being a Virginian and an old soldier, decided to associate with him some artist who possessed such expert knowledge of a horse's anatomy as would render impossible any error in the modelling. His ambition from the first was to show in these two statues real men on real horses. . . .

"Mr. O'Donovan found the very man he wanted in his old friend Thomas Eakins. . . . There is probably no man in the country, certainly no artist, who has studied the anatomy of the horse so profoundly as Eakins, or who possesses such intimate knowledge of its every joint and muscle. He was therefore called into collaboration with O'Donovan, and the statues as they stand to-day are the joint work of these two artists.

"In modelling the horses the artists agreed to depart from the method, frequently adopted, of presenting a composite horse, patched together from fragments of many horses, taking the good points of each and avoiding the defects. They decided, rather, to choose an animal which should possess a union of fine qualities. . . . Then came a search for two horses worthy of such high honor, and months were spent before the sculptors found the animals they wanted. The chief difficulty encountered was in finding a horse for Grant, since any strong mount would do for Lincoln, who never cared for a showy charger. . . . For the Lincoln statue they selected a powerful 'cowboy' horse, named 'Billy,' that Eakins had brought from the West, an animal of great strength and endurance, but not of specially fine breed. 'Billy' was felt to be in harmony with Lincoln's simple and unpretentious character. . . . But to find a horse suitable for Grant was another matter; for here was needed a charger of ideal proportions, a creature of strength and race, a splendid animal fit to carry a great commander into battle. Nor could they choose at random; for . . . the names and descriptions of Grant's horses, with careful photographs, are preserved in history. . . . But . . . all the horses ridden by the general were dead. So the best they could do was to find some horse such as Grant himself might have chosen. . . .

"They visited West Point and saw many valuable and spirited saddle-horses, but they did not find what they were seeking. They gained, however, valuable suggestions for the action of horse and rider, and spent many days observing how our soldiers ride. . . . To assist the sculptors, Captain Craig, the instructor of cavalry, . . . ordered out some of his best riders, who posed for the artists in every position a soldier would take on a horse; Mr. Eakins making dozens of instantaneous pictures. . . . Other photographs were made at another place with the rider sitting nude on the horse's bare-back. And, not content with the photographs, the sculptors went even to the length of making many small studies in wax of various actions.

"Continuing their search for a horse for General Grant, O'Donovan and

Thomas Eakins

194. GENERAL GRANT
(Grant's horse by Eakins.) 1892. Bronze. Life-size. G 509A
Soldiers' and Sailors' Memorial Arch, Prospect Park, Brooklyn

Eakins visited many places, saw prize horses at the horse show, fashionable horses at Newport and Long Branch, trick horses in circuses, and rejected them all in favor of 'Clinker,' a saddle-horse owned by A. J. Cassatt, of Philadelphia [Mary Cassatt's brother]. In 'Clinker' there is not a pound of waste matter, but everything seems to be made for speed and endurance. He is a short-coupled horse, with just room on his back for a saddle, as a charger should be, with great breadth of chest, and at once heavy and compact.

"Thus the two artists spent months of serious effort before a single stroke in the clay had been made, or the first step taken in the actual work of sculpture. And before commencing the real work on the large statues they were obliged to make quarter-size models, and submit these to the Brooklyn committee for their final acceptance. All this having been done, the two horses were taken to a farm near Avondale, Pennsylvania, where Mr. Eakins's sister lived, and where the sculptors could be sure of the desired seclusion for the important work of modelling from life.

"First a wax model was made one-sixteenth the linear size of the finished statue. Then a quarter-size model was done in clay, and afterwards in plaster; and, finally, the life-size work was begun. Hour after hour, day after day, Mr. Eakins, mounted on an Indian pony, rode about a field studying whichever of the two horses he was modelling, 'Clinker' or 'Billy,' ridden by a colored lad as the sculptor might direct. With the wax model in hand he studied every step and movement, making in the wax now and then some quick correction with a sweep of his thumb. The wax model thus perfected contained the germ of the finished statue. Next the quarter-size model in clay was finished, also in the field, and cast into permanent plaster form. This, when finished, was scratched with parallel lines running from side to side and from top to bottom, about three inches apart. These lines were for guidance in building up the frame for the life-size statue. . . .

"The frame for the full statue was not made in one piece, but in ten, each being set up and finished separately; thus there was one section for each of the legs, one for the hind quarters, one each for the head and shoulders, and three for the body. . . . These preliminaries accomplished, modelling began again from direct study of the live, moving horse. Every day Mr. Eakins would have the horse he was portraying led out beside the box on which his frames were placed, and he would copy in the clay every curve and muscle and vein of that part of the horse corresponding to the frame. As soon as each section was finished in the clay a cast of it was made in plaster, and when all the sections were done they were carefully fitted together into a whole. . . .

"To assist in the work of composing true images, the sculptors obtained from the War Department prints of all the Brady negatives stored there of both Grant and Lincoln, not less than a hundred, and many of them very large. . . . The sculptors were also fortunate in obtaining death-masks of Grant and Lincoln.

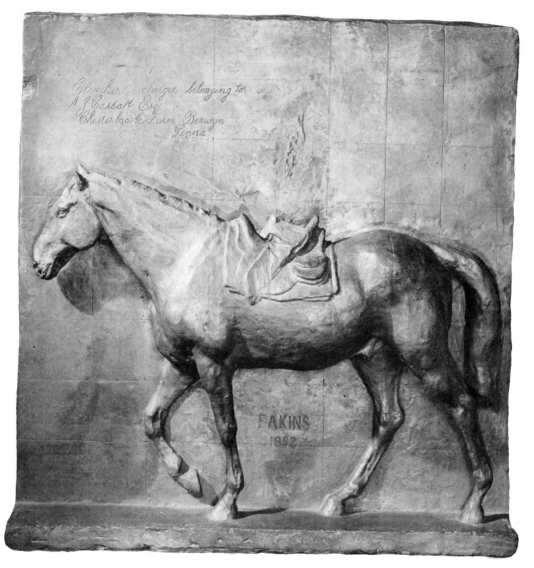

195. CLINKER
Quarter-size model. 1892. Bronze (cast 1930). 25 × 25½ × 4³/₈. G 511
Philadelphia Museum of Art; Gift of Mrs. Thomas Eakins
and Miss Mary Adeline Williams

"Thus gathering material from many sources, they began modelling in clay the face and figure of General Grant, aiming to express as faithfully as might be his likeness and character at a period somewhat prior to the ending of the war. . . .

"But they also studied a living model, sitting actually in the saddle, a man of about forty-six, of soldierly build, who, being the son of a Philadelphia painter, possessed himself some sense of art. The same man served also as a model for the Lincoln statue. Most of this study was for anatomical detail; for,

strange to say, each figure was first carefully and completely fashioned in the nude, and the dress put on afterward. For the sculptors find that it is impossible to make boots and coat and trousers appear in the finished statue as if there was a body inside them, unless the body is there first."

In April 1892 the full-size "Clinker" was finished in clay and cast in plaster, and the plaster shipped to O'Donovan's New York studio for Grant to be mounted on him. Moffett's article does not give the dates of "Billy's" being finished or the completion of the two mounted figures; but it was probably not until late 1894 that the plasters were delivered to the bronze founders, the National Fine Art Foundery in New York. Moffett wrote that the foundry was working on the bronzes in the summer of 1895, and that "for seven months the workmen were busy with [them]. The largest mould ever made in the foundry was the one for the body of General Grant's horse." The completed bronzes were installed on the Memorial Arch in December 1895.

Moffett's article and its photographic illustrations make it clear that Eakins modeled the horses, but not how much he had to do with the riders. The author continually speaks of "the sculptors" as selecting the horses, assembling information on Lincoln and Grant, and conceiving their actions and poses; at one point he even says that "they began modelling in clay the face and figure of General Grant." But Moffett was not knowledgeable about technical matters. Unquestionably the two artists worked closely together from the beginning, and Eakins, who had taught sculpture, may have advised his partner; but it is hard to believe that they both modeled the riders' figures. Although Eakins preserved his small-scale models of the horses and photographs of the plasters, he left no studies or photographs of the riders, or of riders and horses together. The bronzes on the arch are signed W. R. O'DONOVAN / & / THOMAS EAKINS / SCULPTORS / 1893–94.

The statues are generally referred to as reliefs, but actually they are in the almost complete round, with the forms furthest from the front cut through by the background plane. Doubtless the sculptors rightly felt that in the reduced light under the arch, low reliefs would be almost invisible. The two horses are the most nearly round of Eakins' sculptures, except for his small studies for paintings. They suggest that if he had done more sculpture in the round he might have produced works more powerful than his reliefs, fine as the latter are. The horses show not only his knowledge of equine anatomy and a command of the differing character of the two animals, like his command of human character, but vitality and largeness of form. Particularly in "Clinker" there is a sensation of powerful forward movement, involving all the muscles of the body, greater than in any of Eakins' paintings of horses. Although it is remarkable that two artists creating different parts of the same sculptures could have produced works so well coordinated, nevertheless Eakins' horses dominate O'Donovan's riders.

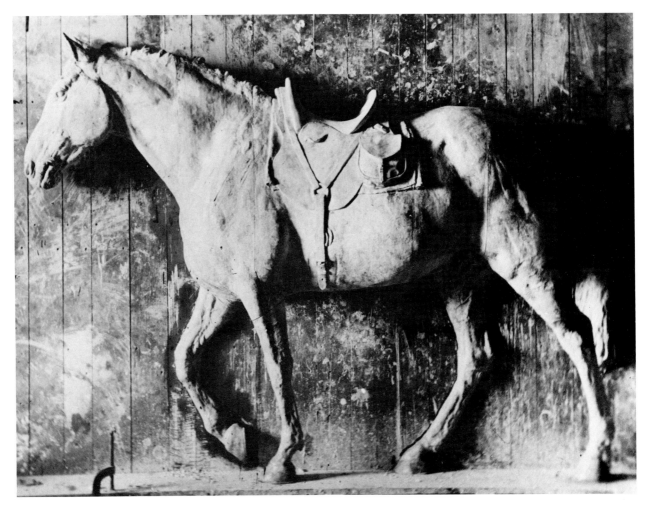

196. GENERAL GRANT'S HORSE
1892. Plaster. Life-size. Photograph by Eakins, 1892. G 509A

The unheroic realism of the O'Donovan-Eakins figures contrasted with the rhetoric and idealization of most American monumental sculpture of the 1890s. No sooner had the Lincoln and Grant been installed than they came under attacks, led by the Brooklyn *Daily Eagle*, and demands were made for their removal. *The Art Amateur* said that "the two reliefs . . . seem to have come in for a liberal share of adverse criticism. They have grave faults"; and went on to criticize the Lincoln "as offering for public inspection the interior of a shockingly bad hat. . . . If this bit of 'realism' was intended to distract attention from faults of the horse and figure, it fails of its object. The figure is poorly modelled, and the horse's legs are notably weak. The Grant figure has

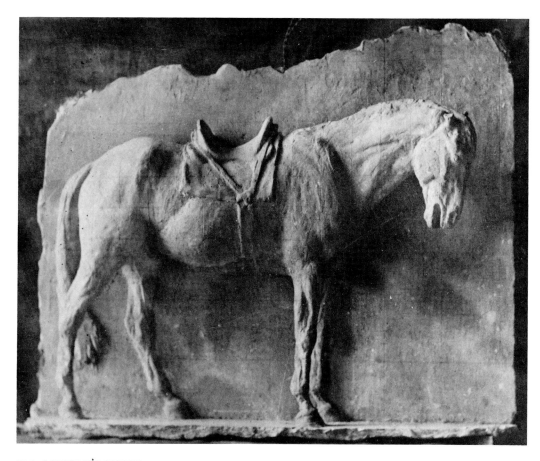

197. LINCOLN'S HORSE
Probably 1892–1893. Quarter-size model. Plaster. About 25 × 26. G 512
Photograph by Eakins, probably 1892 or 1893

one good point: it sits the horse well. But the latter is one of the ugliest beasts that we have seen in bronze, and trails his right foreleg like a tired donkey." (Even horses must be idealized.)

The Brooklyn Parks Department's annual report for 1896 noted that it had accepted the reliefs "under protest. The bill covering the last payment was not passed until the corporation Counsel decided that under the terms of the contract made with Power [owner of the National Fine Art Foundery] by the Arch Commission, there was no escape. The work has been declared unartistic by those who profess to be critics; and there has been a public demand for the removal of the bas-reliefs. . . . It has been suggested that . . . in place thereof tablets bearing the names of Brooklyn's famous soldiers and the battles in which Brooklyn regiments fought" should be placed. Nevertheless, the two figures remain on the arch.

No record has been found of how much O'Donovan and Eakins were paid for their work. The Arch Commission and the Parks Department paid a total of

$17,500 for the two bronzes, but at least $7,500 of this went to the National Fine Art Foundery—probably more, considering the long time spent in casting them. But whatever the two sculptors received was dwarfed by what Mac-Monnies was paid: $100,000 for the quadriga, and $50,000 for the Army and Navy groups. The total cost of the arch and its sculptures was $546,883.

<div align="center">III</div>

Eakins' second commission for public sculpture was for bas-reliefs on the monument commemorating the Battle of Trenton. In December 1776 the American cause was at its lowest point of the war. Washington had not won a battle in six months, and had retreated across the Delaware River into Pennsylvania opposite Trenton, which had been occupied by Hessian troops. His army had been reduced by casualties and desertions; the enlistments of half his men were to expire at the end of the year. He was in desperate need of a victory. During Christmas night, December 25–26, he had his force of 2,400 men ferried across the river, full of floating ice, in hail and snow. Early in the morning they descended on the sleeping Hessians, who were taken completely by surprise. The Americans encircled the town and set up their artillery to sweep the streets. The Hessians were trapped, their commander Colonel Rall was mortally wounded, and they surrendered; by nine in the morning the battle was over. The enemy had 22 men killed, 92 wounded, and over 900 captured. No Americans were killed in the fighting and only four were wounded. The victory at Trenton, followed by that against the British at Princeton, was a turning point in the Revolution.

Over a century later, the Trenton Battle Monument Association, with financial backing from the federal and state governments and private subscribers, purchased the land where the battle had started, known as Five Points, and in the spring of 1891 commissioned John Hemenway Duncan to design a commemorative column "along classical lines." The column, 135 feet high, was to be crowned with a 13-foot bronze statue of Washington; on its massive square base, flanking the entrance, were to stand two full-length bronze portraits of individual privates who had fought in the battle, from Pennsylvania and Massachusetts; and higher up on the base, about 25 feet above the ground, three bronze bas-reliefs depicting successive events: the Continental Army Crossing the Delaware; the Opening of the Fight; and the Surrender of the Hessians. The home states of the troops that had taken part in the battle each contributed $2,500 for a relief featuring its troops: Pennsylvania for the Crossing; New York for the Opening; and Connecticut for the Surrender.

In 1892 O'Donovan was commissioned to do the figure of Washington. The Association's minute book for December 26, 1892, recorded: "When it became time for Mr. Duncan to decide who would design these two statues at the doorway of the Monument and the three historical tablets, a large number of prominent sculptors sent in estimates for the work. Unfortunately for us, many

of these men were crowded with orders for sculpture to be exhibited at the World's Columbian Exposition, Chicago, and we feared that they would do crude and hasty work." Neither O'Donovan or Eakins were in this situation. The former was asked to produce the portraits of the two privates. For the reliefs, Duncan "brought to his aid Mr. Thomas Eakins. . . . He is now engaged in preparing some new, and if possible, some historically accurate sketches of the Crossing of the Delaware, the Opening of the Fight, and the Surrender of the Hessians." However, Eakins executed only the first two subjects, probably because of pressure of work on the Brooklyn arch. The *Surrender* was done by Charles H. Niehaus. In securing accurate historical information Eakins was undoubtedly helped by the Association's president, William S. Stryker, Adjutant General of New Jersey, who had for years been gathering data on the history of Trenton and who in 1898 was to publish his authoritative book *The Battles of Trenton and Princeton*.

The reliefs are approximately four and a half feet high by eight feet wide. In *The Continental Army Crossing the Delaware* the troops are being transported in a fleet of Durham boats, sturdy double-ended craft, thirty to forty feet long, ordinarily used to carry freight on the river. Washington had collected them on his retreat, with the double purposes of denying them to the enemy and using them to recross the river. Each boat is manned by four or five fishermen from Marblehead, Massachusetts, who in the shallow waters of the river are poling, not rowing them. Standing on the bow of the nearest boat at the left are three officers: Captain William Washington; the lieutenant of his company, James Monroe, future President of the United States (both were to be among the four men wounded while capturing a Hessian battery); and Colonel Edward Hand, whose Pennsylvania regiment of riflemen, seated in the boat, were to play an active part in the battle. Colonel Hand, alarmed by a noise on the New Jersey shore, is pointing toward it. In the middle distance (not the foreground), seated in a small boat rowed by a Jersey farmer, are General Washington and the artillerist Colonel Henry Knox, in charge of the embarkation. In the distance are many more loaded Durham boats, and rafts carrying horses.

This realistic representation contrasts in every way with Emanuel Leutze's huge canvas of *Washington Crossing the Delaware*, painted forty years earlier in Düsseldorf and now in the Metropolitan Museum. Leutze's theatrical tableau shows George Washington in an overloaded rowboat half the size of the Durham boats, standing in a noble pose, thereby risking capsizing the boat; behind him is a soldier, also standing and holding aloft the Stars and Stripes (not adopted until June 14, 1777); two soldiers with oars are frantically trying to move the boat forward through pieces of ice like small icebergs (the ice on the river that night was pan ice, flat cakes, dangerous enough); and in the distance, rearing horses are being transported in similar capsizable rowboats. If

the crossing had been undertaken according to Leutze, there would have been no Battle of Trenton.

The Opening of the Fight pictures the first shot being fired, from the spot on which the monument stands, by a battery commanded by Captain Alexander Hamilton. "This officer," the dedication program said, "was then only nineteen years of age and his company of New York Artillerists were all young men, but it was said to have been a model of discipline." The cannon, positioned to fire down King Street toward Rall's headquarters, is tended by six soldiers, one of whom is leaning over to adjust the elevating screw. In the right foreground Hamilton is mounted on a gun-shy horse recoiling from the blast. Another mounted officer rides up on the extreme right. In the distance appear a wounded Hessian beside his dead horse and three other Hessians running away. The houses then standing on the west side of King Street are precisely depicted, though some are partly obscured by cannon smoke.

Unlike the Brooklyn bronzes, these two panels are in low relief, lower than Eakins' Arcadian scenes and considerably lower than the Scott reliefs, *Spinning* and *Knitting*. The principal figures and objects in the foreground and middle distance, though low, stand out strongly against the almost flat distant forms, which are delineated like drawings. More than any other of his sculptures, these two bas-reliefs demonstrate the logic of Eakins' principles of perspective in relief sculpture, his consistency in applying the principles, and the resulting pictorial effectiveness. A problem such as the foreshortening of the cannon wheels in the *Opening* has been solved with great skill. On the other hand, the reliefs were placed high up on the base and were relatively not large, so that it was difficult to see their finer details. Hence it is well that the original bronzes have now been transferred to the New Jersey State Museum, where they can be seen properly.

Dedication ceremonies for the monument were held on October 19, 1893. Trenton was crowded with "at least 100,000 people," the *New York Times* reported; there were "half a million yards of bunting," bands, cannon salutes, speeches and speeches; "at one time the crush was so great that a dozen women fainted." The column was unveiled, and the governors of Pennsylvania, New York, and Connecticut presented their respective reliefs.

Actually, however, although O'Donovan's bronze Washington was in place on top of the column, the three reliefs had not yet been cast in bronze and were represented by bronzed casts in staff—plaster combined with straw or paper, the temporary material used in the decorative sculpture of the Chicago World's Fair. An illustration of *The Opening of the Fight* in the dedication program shows several differences from the final bronze, so evidently Eakins had not finished modeling both reliefs.

The casting in bronze, like that for the Brooklyn arch, was done by the National Fine Art Foundery. The casting of one relief, probably the *Opening,*

198. THE CONTINENTAL ARMY CROSSING THE DELAWARE
Relief for the Trenton Battle Monument. 1893–1894
Bronze. 54¹/₂ × 94 × 3⁷/₈. G 513
New Jersey State Museum, Trenton

199. THE CONTINENTAL ARMY CROSSING THE DELAWARE: DETAIL
Photograph from bronze cast in the Hirshhorn Museum and
Sculpture Garden, Smithsonian Institution

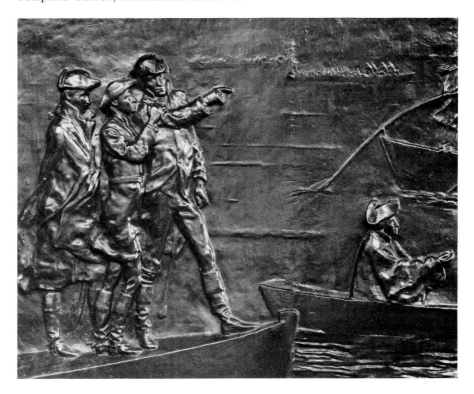

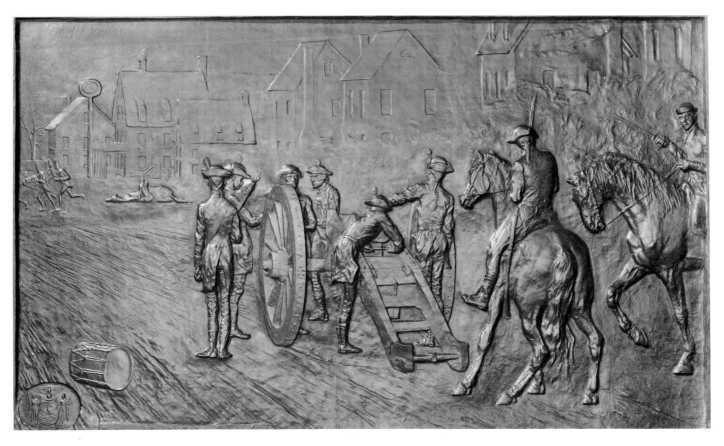

200. THE OPENING OF THE FIGHT
Relief for the Trenton Battle Monument. 1893–1894. Bronze
54¹/₂ × 93¹/₂ × 3¹/₄. G 514
New Jersey State Museum, Trenton

201. THE OPENING OF THE FIGHT: DETAIL
Photograph from bronze cast in the Hirshhorn Museum and
Sculpture Garden, Smithsonian Institution

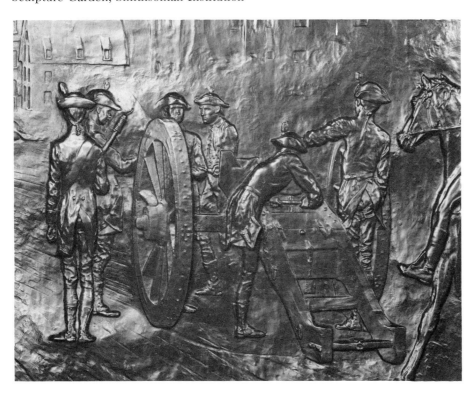

was finished by December 1894, when Eakins showed it in the Pennsylvania Academy's annual exhibition—his only exhibit in that year's show. The following March the *Opening* was exhibited at the Architectural League in New York. Both bronzes were finally installed on the monument that spring. Next December he chose to show a plaster, probably of the *Crossing*, in the Pennsylvania Academy's annual show. Evidently he was proud of these two works. The Battle Monument Association was pleased with them, and they did not come under critical attack as the Brooklyn sculpture had.

No contract between Eakins and Duncan or the Association has been found, and Eakins' fee for modeling the reliefs is not recorded in the Association's minute books. He was probably paid by Maurice Power of the National Fine Art Foundery, who received $2,528.75 for each of the reliefs, plus $1,078.75 for casting a fourth bronze tablet bearing an inscription. If the charge for casting each relief was about $1,100—it could have been more—

202. THE CONTINENTAL ARMY CROSSING THE DELAWARE
1893–1894. Plaster, full-size. Photograph by Eakins, probably 1894

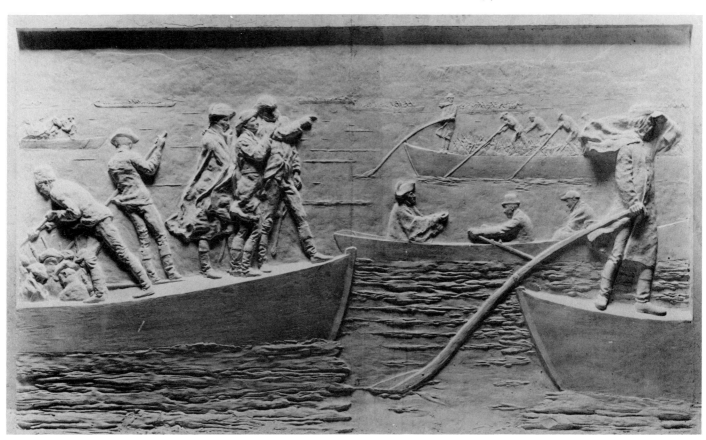

Thomas Eakins

this would leave about $1,400 each for the sculptors' shares—or about $2,800 for Eakins' two reliefs. The total cost of the monument was $91,911.81.

During the first year or so of Eakins' and O'Donovan's association, O'Donovan modeled a bust of Eakins, and Eakins painted a portrait of O'Donovan modeling the bust: half-length, in a working blouse, both hands showing. They gave each other the portraits, which were shown together in the National Academy's annual exhibition in April 1892 (the bust in bronze). Eakins' painting was among his works exhibited at the Chicago World's Fair, lent by the sculptor. Unlocated to date, it must have been one of his better portraits, for O'Donovan was a picturesque-looking character. His bust of the painter also seems to have disappeared; it was not at 1729 Mount Vernon Street in 1930. Susan Eakins had strong feelings about portraits of her husband, and she may not have liked it. Eakins gave O'Donovan one of his best early hunting paintings, which also is still unlocated. To complete the record of mutual gifts,

203. THE OPENING OF THE FIGHT
1893–1894. Plaster, full-size. Photograph by Eakins, probably 1894

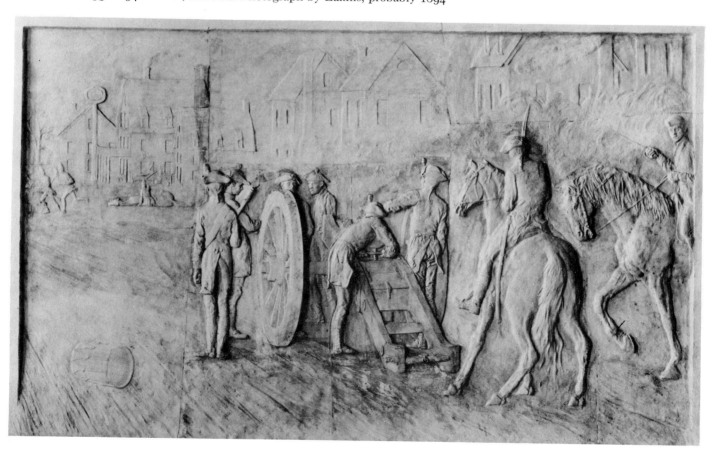

O'Donovan gave Eakins a plaster of his 1876 bust of Winslow Homer, which Eakins lent to an exhibition in 1892, and in 1911 to the Pennsylvania Academy to have a bronze cast made. To John Hemenway Duncan, Eakins gave his fine 1888 painting *Cowboys in the Bad Lands*. Fortunately, Duncan did not lose it; his widow sold it to the collector Stephen C. Clark in the 1920s.

In 1969 the Corcoran Gallery of Art in Washington held the first complete exhibition of Eakins' sculpture, organized by the gallery's assistant director, Moussa M. Domit, who arranged with the New Jersey State Department of Conservation and Economic Development to have the two reliefs removed from the Trenton monument and included in the exhibition. The bronzes were heavily encrusted with grime, and Domit proposed that they be cleaned at the Corcoran, and that bronze casts should be made and placed on the monument, the original bronzes being deposited in a New Jersey museum. The cleaning was done by the expert conservator Joseph Ternbach. At the conclusion of the show the Joseph H. Hirshhorn Foundation offered to pay for the casting if a second set was made for the Hirshhorn Collection. This was done, and now the original bronzes are in the New Jersey State Museum in Trenton, one pair of bronze casts is on the monument, and another pair is at the Hirshhorn Museum and Sculpture Garden in Washington.

IV

The Brooklyn and Trenton sculptures were the last that Eakins did, except for a small relief portrait of Mary Hallock Greenewalt in 1905 (now unlocated), and whatever work he may have done on Murray's commissions.

From the time of his brief study under Dumont in Paris, sculpture had always played some part in his study, teaching, and production, not so much for itself as for its aid to painting. For his early rowing pictures he had constructed little rag figures in a boat. He had made small wax models for some paintings: the six figures and statues in *William Rush*, the four horses in *A May Morning in the Park*, the diver in *The Swimming Hole* (not preserved), and possibly others that did not survive. While produced as models for paintings, they showed a sculptural sense consistent with the sense of form in his pictures. In particular, the horses for the coaching scene revealed a command of living, moving forms that made them in themselves fine as sculpture.

In addition, in 1878 he had modeled four anatomical reliefs of Fairman Rogers' mare "Josephine," shown in various stages of dissection. Probably in reference to these he wrote in 1911: "The anatomical studies of the horse were made in quest of knowledge only. The opportunity came to me afterwards to profit by the knowledge in modelling the horses on the Brooklyn Soldiers' & Sailors' Monument, on the Trenton Battle Monument, on the painting of the 4 in hand coach of the late Fairman Rogers."

Eakins evidently did not think of these various models and anatomical re-

liefs as works of art. His first sculptures unconnected with paintings or scientific studies were his two 1883 reliefs, *Spinning* and *Knitting*. Realistic in subject and style, with no trace of the prevalent neoclassicism, they revealed a fullness and strength of modeling and an understanding of relief that proved him to be an accomplished sculptor. The three Arcadian reliefs of the same year, a departure from his usual realism, were less strong in design, but the figure of the piper in *Arcadia* was one of his finest nudes. So far his sculpture had been modest in purpose and scale. Then came the Brooklyn and Trenton commissions, his only public and full-scale sculptures.

The 1880s and 1890s saw the greatest burgeoning of sculpture in American history—until our own time. Increasing national wealth, the increment of historical patriotic subjects, the new American imperialism, produced a proliferation of public buildings and monuments, the lifeblood of sculpture. The lavish decorations of the Chicago World's Fair ushered in the golden age of academic sculpture and mural painting. In this expansion of public art the sculptors in general produced more solid achievements than the muralists. American mural art was still in its infancy, and most of its products were enlarged easel paintings, whereas sculpture had had a long history in this country.

The ascendancy of Rome as a center for study and work had given way to that of Paris, where current creation was livelier, the range of subjects wider, the viewpoint more contemporary, and the École des Beaux-Arts provided the most thorough technical training of the day. The Paris-trained Americans, breaking away from the cold neoclassicism of the Roman school, displayed a vigorous naturalism and a greater technical skill and facility in modeling. Traditional values still predominated, ranging from Saint-Gaudens' fine balance "between the real and the ideal" to the brilliant theatrical rhetoric of Mac-Monnies. The subject matter of most monumental and architectural sculpture was allegorical and idealized, featuring Greco-American goddesses personifying civic virtues. At its most banal the new public sculpture was glorified three-dimensional illustration.

Eakins never had the opportunity to create such imposing sculpture. The Scott panels were intended as interior architectural ornaments; the Arcadian reliefs were purely personal expressions of a passing phase of his art; and both sets were small in scale. The Brooklyn statues were done in partnership with an artist of lesser powers, and they were of horses, not men and women. The Trenton reliefs were of a special nature, their subjects determined by authenticated historical information; but in them he had a freer hand, and they are his most complete public sculptures.

Except for his assistance to Murray, Eakins never produced a full-scale human figure in sculpture, or even a bust. His only nudes, aside from the lost small model of Louisa Van Uxem, were the three young men in his Arcadian scenes. There was no larger-scale female nude, the immemorial theme of

sculptors throughout the ages. All his sculptures, except the models for paintings, were in relief, not in the full round. In a sense they were the sculptures of a painter, parallel to painting in their involvement in backgrounds and perspective. All his sculptural works were modeled, not carved; his only attempt to carve stone, in the Scott panels, was thwarted.

Yet with all these limitations in number, subject, and conditions, his two public works in their different ways possessed essential plastic qualities that much of the current grandiose monumental sculpture lacked. The horses on the Brooklyn arch, especially "Clinker," have a largeness, an inner life in their forms, and a sense of movement, which indicate what he might have achieved in less restricted circumstances. In a different fashion the Trenton reliefs show his ability to create three-dimensional forms and space within the deliberately limited dimensions of low relief. They equal Saint-Gaudens' and Olin Warner's reliefs in skill, with more power, if less charm.

Because of the special character and the limitations of his sculpture Eakins cannot be numbered among the outstanding figures in the history of American sculpture. As he himself wrote in 1893: "I have painted many pictures and done a little sculpture." But in intrinsic plastic qualities if not in quantitative production, his sculpture has its own individual strength and value. And he was one of the very few American painters who also produced sculpture, by contrast with the number in France, including Daumier, Degas, Renoir, and Matisse.

V

Eakins' study of the anatomy and movement of the horse did not end with his work on the Muybridge Commission or with his teaching. In studying the muscular processes of equine locomotion he became particularly interested in the action of the so-called flexor and extensor muscles: those that bend a part of the body or extend it, which in anatomy books had been described as working and resting alternately. He became convinced that this distinction was incorrect: that actually the flexors and extensors were in action at the same time. This conviction was reinforced by his observation of horses starting a horse-car; "when he stood on the curb," wrote Leslie Miller, "and saw those poor beasts pulling the horse-car, and straining their *flexors* as hard as their *extensors*, while all the books on anatomy that any of us had ever studied had told us that those muscles ought to be passive and let the extensors do the work."

His interest in the problem dated back at least to 1884, as shown by certain of his photographs taken at the University of Pennsylvania. About 1887 he had written a draft of a paper on the subject. He constructed wooden models demonstrating the actions of the muscles in the horse's legs, with rubber bands representing the muscles. In the early 1890s, probably stimulated by his work on the two horses for the Brooklyn Memorial Arch, he wrote the paper, and

took his idea and models to the University's eminent zoologist and paleontologist Edward Drinker Cope, who at first declined to consider the findings of an artist, but then became interested.

On May 1, 1894, Eakins delivered the paper, "The Differential Action of Certain Muscles Passing More than One Joint," before a weekly meeting of the Academy of Natural Sciences, Philadelphia, illustrating it with his models, with slides of his 1884 photographs, and with drawings on a blackboard. The audience numbered thirty-eight: twenty-five members and thirteen visitors; there was discussion afterward. The paper was published in the *Proceedings* of the Academy, with notes by Eakins' former colleague in the Muybridge project, the physiologist Dr. Harrison Allen of the University. This was the only writing by Eakins published during his lifetime.

"It is not without diffidence," he began, "that I, a painter, venture to communicate with a scientific body upon a scientific subject; yet I am encouraged by thinking that Nature is so many sided that the humblest observer may, from his point of view, offer suggestions worthy of attention.

"I have long been dissatisfied with the account in standard works of the muscular action in animal locomotion. The muscles are classified principally as flexors and extensors, working and resting alternately. Wishing to apply this system during my early dissections to the leg of the living horse, I was surprised to observe in the strain of starting a horse car, that the so-called flexors and extensors were in strong action at the same time.

"The classification was still farther from satisfactory when applied to muscles passing over two or more joints, flexing perhaps one joint, while extending another. In trying to understand the significance of these last named muscles, I came to believe it to be very important to discover if the one joint was extended more rapidly than the other was flexed. This investigation demanded a consideration of the amount and kind of leverage, and was extended from the muscles to tendons which pass over the two or more joints. I next constructed a model of the entire limb with flat pieces of half-inch board, cut to the outline of the bones, the pieces pivoted together, having catgut for tendons and ligaments, and rubber bands for muscles, all attached to their places and properly restrained.

"I had then the satisfaction of seeing this mechanism imitate in many ways the action of the real leg, and was enabled to establish two important principles, thus: First, the hoof-pieces properly set upon the ground, the leg stood firm, all tendency to collapse being prevented by the leverage of tendons passing joints. Secondly, the tightening of the rubber bands representing all the principal muscles, both the so-called flexors and the so-called extensors, *at the same time,* caused the upper part of the limb to spring forward when released, and proved to me that I was not mistaken in my observation on the living horse.

"Returning to the dead horse, I denuded both a front and back leg of every shred of muscular fibre, yet they sustained weight.

"There was no tendency to collapse, and an increase in the weight only measured an increase of resistance."

At this point, Dr. Allen noted, "Mr. Eakins exhibited to the members of the Academy photographs made by him at the University of Pennsylvania in 1883 [sic], showing the front and back leg of a dissected horse, all the muscles having been removed. Nevertheless the limbs sustained weight." (In Gordon Hendricks' book on Eakins' photography, numbers 119 and 121 show a man on a stepladder leaning, at a forty-five-degree angle, with all his weight, on the dissected front and hind legs of a horse.)

Eakins proceeded into a thorough discussion of the processes involved in the horse's muscular actions, with detailed consideration of every muscle, tendon, and joint in the animal's legs, each identified by its Latin name, and with analyses of their individual functions, taking into account their trajectories, rates of motion, and so on. Only twice did Dr. Allen feel obliged to translate the artist's words into more strictly scientific terminology. "To investigate the action of a muscle," Eakins said, "I believe it necessary to consider it . . . with relation to the whole movement of the animal. Then it will be seen that many muscles rated in the books as antagonistic, are no more so than are two parts of the same muscle."

He concluded: "The least action anywhere is carried through the whole animal. The differential action of the muscles secures to the scapula from which the horse's body hangs, a much longer and swifter throw, a concurrent and auxiliary movement of great muscles, generally supposed to be antagonistic, a grace and harmony that any less perfect system of co-ordination would surely miss. This differential scheme is, perhaps, more apparent in the limbs of the horse than anywhere else, but it extends to other parts of its muscular system and to that of other animals including man.

"I think these differential muscles have been a great obstacle to study. One is never sure that he understands the least movement of an animal, unless he can connect it with the whole muscular system, making, in fact, a complete circuit of all the strains. The differential muscles once understood, it is less difficult to connect nearly all the other great muscles with the principal movement of the animal, that of progression in the horse; and to understand, roughly, the combinations necessary for other movements.

"On the lines of the mighty and simple strains dominating the movement, and felt intuitively and studied out by him, the master artist groups, with full intention, his muscular forms. No detail contradicts. His men and animals live. Such is the work of three or four modern artists. Such was the work of many an old Greek sculptor."

16. The Later 1890s

IN THE FOUR YEARS, 1891 to 1894, while he was working on the Brooklyn and Trenton sculptures, Eakins' painting production declined. He had begun the big *Concert Singer* in 1890, and he worked on it, though not continuously, until 1892. But in 1891 there was only one dated painting, a portrait of Thomas B. Harned. The portrait of O'Donovan was done probably in 1891 or early 1892. Two portraits were painted in 1892, and four indoor cowboy pictures. Only one painting was dated in 1893, and none in 1894. There are a number of undated paintings, some of which may have been painted in these years, but their probable dates are uncertain. With 1895 he resumed a more usual production: six dated paintings, and two probably of that year.

One of Eakins' most remarkable but least known works is a large portrait of the ethnologist and pioneer in the study of the American Indian, Frank Hamilton Cushing. Frail from birth, forced to live outdoors, Cushing had learned ethnology not from books but by studying Indian artifacts and discovering how to make them. In his twenties he had lived for five years in the Zuñi pueblo in New Mexico, learning their language, wearing their dress, and practicing their handicrafts. Adopted into the tribe, he had been initiated into the sacred esoteric society of "The Priesthood of the Bow." The hardships of Indian life and the terrible tests of the initiation broke down his health; but "struggling with a frail body and an over-active mind," he made a basic contribution to the firsthand knowledge of Indian customs. His writings were notable for imagination and literary quality. "He was a man of genius," more than one of his colleagues said.

When he was in Philadelphia in the 1890s under the care of Dr. William Pepper of the University of Pennsylvania, Eakins met him through their mutual friend Stuart Culin, curator of ethnology at the University Museum of Science and Art. Cushing was a man after Eakins' own heart, and he asked to paint him, writing, probably in July 1894: "I hope sincerely you may be able on coming back to Philadelphia to prolong your stay beyond a few days.

"I think I could paint the whole picture in a couple of weeks if you would help me with the background and accessories, and in so helping me, I could teach you perspective. . . .

"I have bought myself a new bicycle, the latest Columbia, and my father has besides his own bought one for my wife, so there are now four new bicycles in the house, so that when you come back you shall not want for a wheel. Could you not stay at our house while I paint you? Or whether I paint you or not."

The portrait, seven and a half feet high (Eakins' fifth largest canvas) represents the ethnologist in the Zuñi pueblo, performing an incantation. The two men turned the Chestnut Street studio into a replica of a room in the pueblo—to the extent of building an altar and a fire on bricks on the floor, to get the authentic effect of smoke. Cushing, thin, with a hard-bitten pockmarked face (scarred from smallpox), his long auburn hair hanging down to his chest, wears his costume as Priest of the Bow: black shirt, tight buckskin trousers and leggings adorned with silver buttons, moccasins, a black scarf around his head, and a large earring set with turquoises. In his left hand he holds prayer feathers, in his right a war club. From his belt hang a knife and a pouch; a bow and a quiver of arrows are slung across his back. On the wall are his feather headdress and his shield bearing the emblem of the Zuñi war god with lightning beneath its feet; his spear leans against the wall. In the background a ladder leads up to the entrance on the roof, in pueblo fashion; the light comes from the opening. Nothing is missing in this reconstruction of Cushing's habitat and regalia. Yet his lean, weathered face is the center of the composition. The prevailing tonality is a warm, light terra-cotta, the color of earth and Indian pottery. With its wealth of components, this is one of Eakins' most complex designs.

Cushing designed and constructed a frame of flat boards with carved primitive images and other aboriginal decorations, the whole fastened at each corner by wood strips bound with leather thongs. What with this frame, the unfamiliar iconography, and its large size, the painting must have bewildered the Pennsylvania Academy jury when Eakins submitted it in December 1895 for the 65th annual exhibition; they rejected it, while accepting four other works by him. One of Eakins' major paintings, it was never to be shown in a national exhibition, and only once in any art exhibition, his one-man show at the Earle Galleries in Philadelphia in 1896.

In 1900, a week after Cushing's death, Eakins wrote Professor W. J. McGee, ethnologist-in-charge of the Bureau of American Ethnology of the Smithsonian Institution: "I have in my possession a full length life size portrait of Frank Hamilton Cushing which will cause me uneasiness until it finds a resting place in some fire proof building.

"He is represented as in Zuñi land performing an incantation.

204. FRANK HAMILTON CUSHING
1894 or 1895. Oil. 90 × 60. G 273
Thomas Gilcrease Institute of American History and Art, Tulsa, Oklahoma

205. FRANK HAMILTON CUSHING: DETAIL

206. FRANK HAMILTON CUSHING: DETAIL

"An altar was built by Cushing in a corner of my studio, and all the proper details were assembled by him. Even the frame of the picture was designed by him, largely made and ornamented by him.

"Its lower piece contains his name (the picture of a plant), his office and his clan.

"I should be glad if the picture could be acquired by the Government Bureau or by the University of Pennsylvania."

Whether he intended a purchase or a gift is not clear. In any case, nothing came of the offer. He lent the portrait to Culin's ethnological section of the University of Pennsylvania Museum; and after Culin left for the Brooklyn Museum, to the latter institution, where from 1905 it was hung in the Zuñi collection. It remained on loan at Brooklyn until after Eakins' death. The museum finally bought it from Mrs. Eakins in 1928, but in 1947 sold it to the Gilcrease Institute in Tulsa, Oklahoma, which specializes in Western art; the Institute has a policy of never lending to exhibitions elsewhere. Of all Eakins' chief works, even the *Gross* and *Agnew* clinics, none has been seen so little by the national art audience.

About 1899 Eakins also painted Culin's portrait, life-size and full-length, seated at a table covered with Indian artifacts. Exhibited at the Carnegie Institute in 1899–1900 and the Pennsylvania Academy in 1901 (at the latter titled *The Archaeologist*), it was evidently one of his more ambitious works. In 1930 Mrs. Culin informed me that it had been stolen some years earlier and its whereabouts were unknown.

<div align="center">II</div>

As Eakins' Crowell nieces and nephews grew older, they were often at the Mount Vernon Street house. The oldest, Ella and Margaret, studied for a time with their uncle in the Art Students' League of Philadelphia, beginning when they were sixteen and fourteen. Samuel Murray remembered Maggie as feminine, rather delicate, and a good painter; Charles Bregler recalled that she painted quiet woodland and snow landscapes, and portraits, some of which were exhibited at the Pennsylvania Academy.

Ella, the Crowells' firstborn, had been painted by her uncle in 1876 as a two-year-old playing in the Mount Vernon Street backyard. Murray remembered her in League years as mannish and restless, more of a tomboy than Maggie. She later abandoned art to study nursing at the Presbyterian Hospital. By all accounts, she was mentally unbalanced. (Her Eakins grandmother, we recall, had died of "exhaustion from mania.") Once she gave the wrong medicine or an overdose of it to a patient, who almost died; she took the same dose herself, which almost killed her. In 1896, when she was about twenty-two, she was committed to a mental hospital. Released the following summer, she was brought back to the farm and confined in an upstairs room. On July 2, 1897, she managed to get out, found a shotgun, and killed herself.

In the agonizing aftermath of her suicide the Crowell family, especially Will Crowell, blamed Eakins: he had corrupted Ella and driven her insane. Will refused to allow his brother-in-law to come again to Avondale and forbade his children to mention their uncle's name. From then on, Eakins had no communication with his sister or her family, except for a telegram to her in late 1899: "Your father dangerous ill." (That Frances may not have agreed with her husband is suggested by the fact that she preserved her brother's long letters to her from Paris.)

The rights and wrongs of the tragedy are far from clear. Mrs. Addicks, who knew Ella and had firsthand experience of her insanity, told me that Benjamin Crowell had said to her that it was his uncle's fault, he had driven Ella out of her mind; and on the basis of this she wrote Eakins saying that she never wanted to see him again. But a year later Ben came to see her and said that he had been wrong, that his uncle was not to blame; whereupon she wrote Eakins begging his pardon and asking if they might be friends again, and received a sweet letter in reply. Yet even as late as 1931 Frances Crowell, the next-to-youngest sibling, said to me that her uncle had "contaminated her sister with his beastly ideas." Through the years some family members continued to blame Eakins, while others no longer did. But there was general agreement that in Ella's last years she was insane.

Ella had been young when she began to study at the League, and she and Maggie were among the very few females in a class of men, where the male models (often fellow students) posed completely naked (as shown in photographs). Eakins' insistence on the nude in teaching, his frankness about nudity, and his obsessive striving for women to pose nude for him (he may have persuaded Ella to do so)—all could have been disturbing for a young woman brought up in the country, especially if she was already unstable. His was a powerful personality, which evidently exercised an unintended sexual magnetism. She may have been in love with him (perhaps not consciously).

What Eakins felt about the fatal event can only be imagined. There is no mention of it in his existing letters. Mrs. Eakins never spoke of it to me; of his friends, only Mrs. Addicks did, and Murray briefly. It was only two weeks later that Eakins wrote Professor Henry A. Rowland about going to Maine to paint his portrait, and his subsequent letters to Rowland are full of the picture's progress with no hint of any tragedy. He must have been aware of Ella's mental condition and her actions, and he may have been prepared for her death.

Eakins' life had been marked by a series of personal tragedies: the mania and early death of his mother; the deaths of his fiancée Kathrin Crowell and his sister Margaret; the loss of his position in the Pennsylvania Academy; the estrangement and early death of his sister Caroline. And now the suicide of his niece, with the blame fixed on him, and banishment from his sister Frances, his nephews and nieces, and the much-loved life of Avondale.

Henry A. Rowland, professor of physics at Johns Hopkins University, Baltimore, has been called "one of the most brilliant men of science that America has produced." At Hopkins from 1876 he had carried on basic experiments in electricity, light, and heat, using methods more exact than any previous ones. He had made the most accurate calculations until that time of the value of the ohm and of the mechanical equivalent of heat. In the field of spectroscopy, to secure more accurate diffraction gratings (producing spectra by diffraction), he had constructed a dividing engine which ruled 14,000 to 20,000 lines to the inch by means of a diamond point on a surface of glass or speculum metal. With these gratings he had photographically mapped the solar spectrum for the first time. His gratings came to be used in physics laboratories the world over, and the study of spectroscopy as an exact science dated from his inventions. A basic scientist, he combined a grasp of fundamental principles, extreme accuracy, and the ability to design and construct scientific engines of great precision—all qualities that must have appealed particularly to Eakins, who said he "ought to be painted" and asked him to sit for his portrait. How Eakins came to select him we do not know; he was little known to the public. There may have been some Philadelphia connection, for Rowland had furnished the Central High School with one of his gratings.

Eakins chose to picture the scientist in his laboratory; as he wrote: "Professor Rowland is shown with a diffraction grating in his hand. His engine for ruling is beside him and in the background his assistant, Mr. Schneider, is working at his lathe." In the summer of 1897 Rowland had left Baltimore for his summer home at Seal Harbor, Maine. Eakins' painting materials were shipped there; he followed about July 20, and worked on the portrait until the middle of August. He and Rowland, who was four years younger, became good friends. After Eakins' return to Philadelphia, his letters to his sitter, which have been preserved, give a unique account of the painting of the portrait. (The first began "Dear Sir," but after the stay at Seal Harbor it was "My dear Rowland.")

On August 17 Eakins asked to have the canvas shipped to him in Philadelphia. "I shall probably go down to Baltimore tomorrow or next day to study your engine," he wrote. "It is much warmer here than at Seal Harbor. Bobby was delighted to see me again, and played all the little antics that he thought would please me. Susie has a little rabbit now too, so that our yard looks something like a zoological garden."

August 28: "My picture has not yet arrived, and I would like to be working on it, so if you have not sent it, please express it at your earliest convenience. . . . I was in Baltimore last week and made a perspective drawing of your engine, and got an understanding of it. The directness and simplicity of

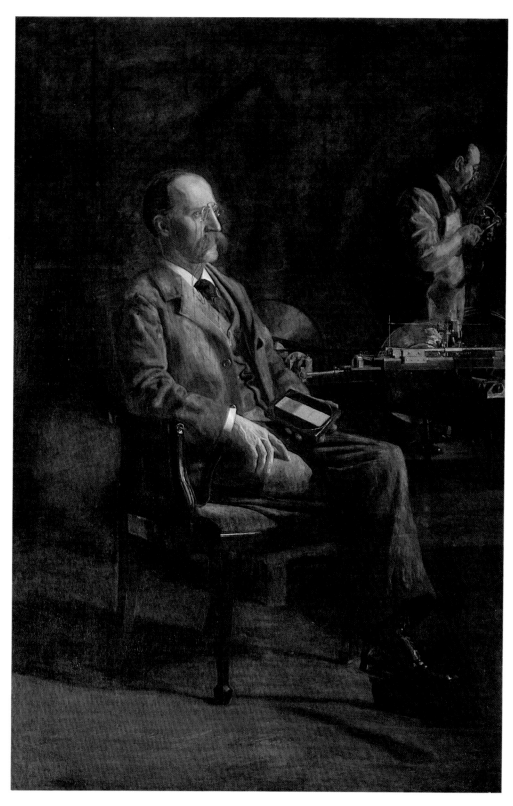

207. PROFESSOR HENRY A. ROWLAND
1897. Oil. 82½ × 53¾. G 264
Addison Gallery of American Art, Phillips Academy, Andover,
Massachusetts; Gift of Stephen C. Clark

that engine has affected me and I shall be a better mechanic and a better artist. . . .

"I have changed somewhat my idea of the composition of your picture. I am going to give the engine a little more prominence than I had at first intended. Putting it on a lower table or bench will keep it away from the head and I shall let in on it some of the direct light, instead of lighting it only by that reflected from walls. . . .

"My regards to Mrs. Rowland and the children; to you September breezes & no fogs."

September 3: "I worked all yesterday on your machine, and can now see its effect on the picture.

"I think I told you that instead of keeping the machine in shadow I was going to let light in on it. I have done so and do not regret it. It spots the picture somewhat but I shall with other details spot the picture in other places, except behind the head, which will again simplify things in this way. The most prominent thing in the picture will be the head, whereas before it was the whole figure.

"Schneider will now go particularly well in the background to continue the bright spots of the machine; and to the other side of the picture I shall put some shelves with bottles.

"So I trust the picture may gain in interest and not lose breadth.

"It will only take me a day to put in Schneider who will be out of focus entirely.

"I must ask you then to write to Schneider giving him the necessary permission to absent himself for a day next week, and I shall then write to him fixing a day and providing for his expenses."

October 4: "I have been very busy with the big statues for the Witherspoon Building and have not done much to the picture. I have Schneider in now however & he has the effect in the composition that I had intended. He carries away the important machine from the important figure.

"So far the picture has been growing better all the time.

"I sometimes think of the framing of it.

"My exhibition frames are mostly of plain chestnut gilded right upon the wood and showing the grain. Now it seems to me it would be fine to saw cut shallow some of the Fraunhofer lines which you were the first man to see, or the double scale of the Fraunhofer lines and the inch or centimetres. Would there be some simple & artistic way I wonder of suggesting the electric unit that I heard of your measuring so accurately.

"I once painted a concert singer and on the chestnut frame I carved the opening bars of Mendelsohn's 'Rest in the Lord.'

"It was ornamental unobtrusive and to musicians I think it emphasized the expression of the face and pose of the figure."

208. PROFESSOR HENRY A. ROWLAND: DETAIL

But instead of using the spectrum lines of Joseph von Fraunhofer, the early nineteenth-century Bavarian optician and physicist, Rowland himself supplied the data for the frame: as Eakins later wrote: "The frame is ornamented with lines of the spectrum and with coefficients and mathematical formulae relating to light and electricity, all original with Professor Rowland and selected by himself."

On November 17 the painting was still being worked on: "I have concluded that before taking up the background of the portrait I must see you. I shall therefore send the picture to you at the Johns Hopkins & come down some day soon. I want to look over the drawing of the engine with you." But the portrait was finished within the year 1897, when he signed and dated it in

Thomas Eakins

flowing script on the floor, in perspective, going halfway across the bottom of the canvas.

Rowland's face—high forehead, long nose, determined chin, prominent eyes behind pince-nez, walrus moustache—is that of an intellectual. The diffraction grating in his left hand reflects the colors of the solar spectrum in full range and purity. His engine for ruling gratings, a complex mechanism with two revolving wheels, is represented with the complete precision with which Eakins always rendered scientific and mechanical apparatus. Rowland is facing directly into the light, which strikes most strongly his face, upper body, and right hand, diminishing in strength as it goes down his figure, leaving his lower legs and feet in half-light—a modulation that makes his face the dominant feature of the composition, as Eakins intended. The engine is less strongly lighted, but entirely clear. Schneider is in still more subdued light, and slightly out of focus, so that his figure, while adding to the composition, does not compete with Rowland's. The background of the laboratory is dark but not empty, with dimly lit objects; not the plain blank background frequent in Eakins' portraits, but a definite pictorial space. The area behind Rowland's head, however, is without competing forms, as pointed out by Eakins. The scientist's figure, saliently modeled by the light, has maximum substance; the other elements, in more subdued light, have less weight. The handling of light to model forms, construct space, and create design—one of Eakins' great skills—was never more masterly. That it was fully conscious and planned is proved by his letters.

The color is quiet: browns, grays, gray-browns, off-white, with a pervading warm golden tone. Then the startling note of the spectrum colors, giving value to the prevailing sober hues—an original and effective pictorial device. Although the general chromatic range is limited, the black-and-white values are varied and finely handled—what Eakins called "spotting"—so that the painting is alive in every part. The technique is much more complex than the direct, *alla prima* one of most painters of the period. It is an opaque/translucent, thick-and-thin technique, with relatively heavy pigment in the lighted and solid parts, and more translucent glazing and scumbling in the shadowed and less substantial parts—a technique that produced solidity and depth. There is not a flat passage anywhere; the modeling throughout is round and deep. This is painting in a great technical tradition, harking back to Eakins' study of the old masters in the Prado.

Eakins' correspondence with Rowland had not been confined to the portrait. At Seal Harbor they had constructed a kite, according to the best scientific principles, but it failed to fly. Back in Philadelphia, Eakins wrote Rowland: "I have tried in vain so far to find a Japanese kite. They were so plentiful ten years ago." Five days later he reported: "I sent you by express yesterday two little Japanese kites and a ball of gilling twine. One might be called Henry and the other Harriet. I wish they had been bird kites with pretty red wings.

209. PROFESSOR HENRY A. ROWLAND, WITH FRAME CARVED BY EAKINS

210. PROFESSOR HENRY A. ROWLAND: DETAIL

Anyhow they are ten times prettier than the abomination we made with the misnomer scientific.

"Unscientific it should have been called.

"How should a combination of strain factors ever evolve a brick shape.

"A yacht is beautiful & shapely, and so are all good things, flowers, axe handles, the tools of workmen, but above all the living animal forms."

Rowland replied: "Let me thank you most cordially for your beautiful Japanese kites. They flit among the trees like large birds and, whenever they see a tree, they dive for it like a living being and perch in its branches until rescued by human hands." On the way back to Baltimore, he sent Eakins a present of wine from Boston.

Eakins tried to win the professor over to his favorite means of transporta-

tion, bicycling, as he had Cushing. "I hope that as soon as you find the time to count up your money," he wrote, "that you will have so much left that you can dance right off to the bicycle shop. . . .

"As soon as I hear that you have a bicycle I shall get Murray, and we will open a bottle of your wine & drink to your good success.

"I have great faith in your riding ability and would not be a bit surprised if some day I should come to Baltimore and see you riding down the cable slot like a little telegraph boy."

The portrait not having been commissioned, while working on it Eakins evidently asked his sitter about the possibility of Johns Hopkins buying it. Rowland wrote in September: "Possibly an effort may be made among my friends to purchase it, but the trustees of the J.H.U. have never done such a thing. Mr. Gilman [the president] thought that it was wonderfully good." Soon after it was finished, in January 1898 Eakins exhibited it at the Pennsylvania Academy—curiously enough, as "lent by Mrs. Henry A. Rowland." In the next few years he showed it four times, but not as owned by her. When it was on view at the National Academy in 1904, he wrote Frank W. Stokes in New York: "Have you been to the Academy? I am wondering where they have hidden my Rowland whose frame they hate but I like. The Admiral Sigsbee is probably in a better place."

Rowland had died in 1901. In 1908 Eakins' friend Dr. William P. Wilson wrote a professor at Hopkins suggesting that the University purchase the portrait. The then president, W. A. Remsen, replied: "I wish we owned it, but we have one life-size portrait of Professor Rowland, and I do not know where I could go to secure the funds to buy a second. The portrait ought to be here. How to get it here is a question that I cannot answer." So it remained at 1729 Mount Vernon Street until after Eakins' death. In the 1920s Stephen C. Clark bought it from Mrs. Eakins, and later gave it to the Addison Gallery of American Art.

<p style="text-align:center">IV</p>

In 1898 Eakins became interested in a new subject, prizefighting, which like rowing in the 1870s gave opportunities to see the partly nude male body in action. In this new world he had the help of a sportswriter friend, Clarence Cranmer. The result was three paintings of fights and one of wrestling. Murray told me that for a while Eakins and he used to go to fights several times a week; and that in the excitement of watching the bouts Eakins would go through the fighters' motions, twisting in his seat so that his neighbors protested. He always kept up his interest in the sport, Murray said; and Cranmer told me that at polite parties the artist would draw him aside and ask, "What do you think of the fight between So-and-So and So-and-So?" "Eakins saw over 300 rounds of fighting, before he started this group of paintings," Cranmer wrote in 1953.

Through Cranmer and another sportswriter, Henry Walter Schlichter, Eakins got to know some of the Philadelphia fighters and persuaded them to come to the Chestnut Street studio to pose. One of them, the featherweight Billy Smith, became the central figure in two paintings. In preparation for *Between Rounds* Eakins did a head-and-bust portrait of him in the pose of the painting—not a sketch but a finished portrait—and gave it to him. When Billy sold the canvas in 1940 he wrote the Walker Galleries, who had handled the sale: "You want to know something about Mr. Eakins, and the picture. First, as Mr. Eakins would say, when asked to speak of himself, My all is in my work. But, what I know. It was 1898, when Mr Eakins came to a Boxing Club, to get a modle for his first fight picture, titled, *Between rounds*. He choose me. I posed first for the picture you just sold.

"Then, for the Between Rounds, and next for the one titled Salutat. Mr Eakins, to me was a Gentleman and an Artist, and a Realist of Realists. In his work he would not add or subtract. I recall, while painting the portrate you just sold, I noticed a dark smear across my upper lip, I asked Mr. Eakins what it was. He said it was my mustache, I wanted it of, He said it was there, and there it stayed. You can see that he was a Realist.

"The purchaser of my painting may want to know a little about me? I boxed over 100 times made a living at it for ten years, in my time I fought two Feather weight champions Tommy Warren and Terry McGovern, and Harry Forbes of Chicago, who won the Bantam weight championship in think in 1901.

"I was known then as Turkey Point Billy Smith.

"I am now past 66 years of age."

Murray said that Billy was "a very clean little fellow," who later joined the Salvation Army and became an officer. In 1899 Murray modeled a full-length statuette of him, *The Boxer*, one of his best works. Billy was to remain a friend of Eakins' all the artist's life.

Murray had many tales about the fighters who came to the studio. Ellwood McCloskey, known as "the Old War Horse" and "the Willinun," who was often there, "thought a lot of Eakins." He used to round up fellow pugilists who had promised to pose but didn't show up; he would go to see them and say, "Hey, you son of a bitch, haven't you got a date to pose for Mr. Eakins? Come on now, or I'll punch your goddamn head off." The fighters, Murray said, made the studio a kind of workout place, demonstrating the science and tricks of their art and showing Eakins and Murray how to fight. Even old Benjamin Eakins and William Macdowell would pretend to square off at each other. Once when Billy Smith and another pugilist were squaring off, Macdowell (who knew everything, Murray said) laughed and remarked, "What a funny way you're standing, it's all wrong." One of the fighters, who were always very polite to the noncombatants, asked, "Now tell us how you'd stand, Mr. Macdowell." The latter replied that he would put his foot out and trip up

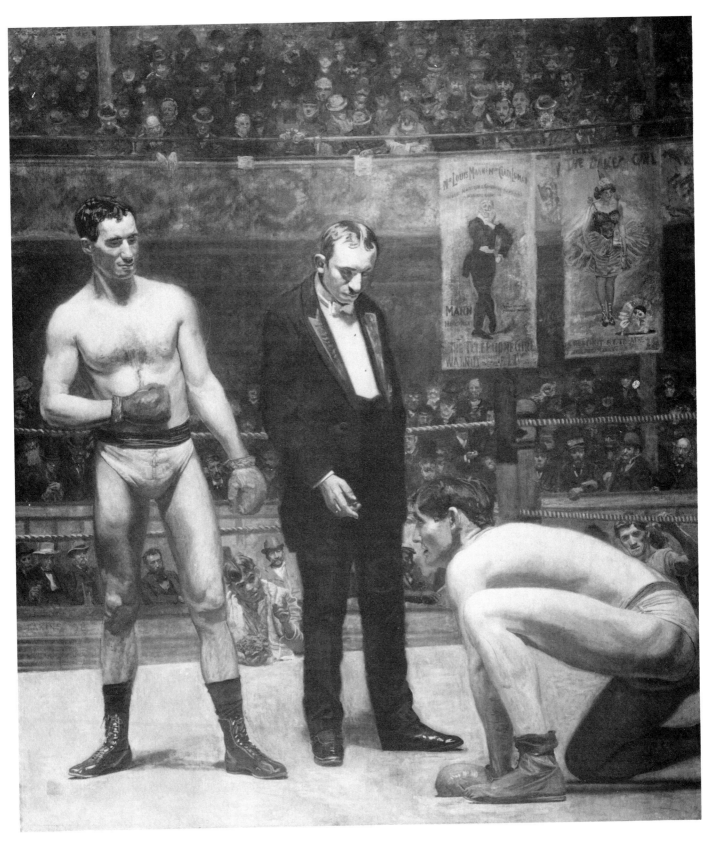

211. TAKING THE COUNT
1898. Oil. 96⁵/₁₆ × 84⁵/₁₆. G 303
Yale University Art Gallery; Whitney Collections of Sporting Art,
given in memory of Harry Payne Whitney, B.A. 1894, and
Payne Whitney, B.A. 1898, by Francis P. Garvan, B.A. 1897

the other fellow; and the pug said, "And what do you think I'd be doing, Mr. Macdowell?" Once when Eakins, Murray, and Billy, on a bicycle ride, had to ride on a sidewalk because the street was torn up, and Eakins, as the eldest, was bawled out by an officious gentleman, he said later, "I'd like to punch the fellow in the stomach." Billy became very serious and said, "Don't never punch a guy in the stomach, punch him in the jaw." Eakins paid the fighters for posing, Murray said, but they used to call and ask for loans, to get a friend out of jail or such, and "Eakins would reach into his pocket." Murray remonstrated with him, and finally made himself a watchdog.

When Eakins was painting the prizefight scenes with their big audiences, and friends would drop in to the studio, he would say, "Stay a while and I'll put you in the picture," so that the audiences are filled with small portraits.

Prizefighting was not yet a diversion for high society or for women, and Eakins was one of the first American artists to paint it, anticipating the urban realists of a decade later. However, he never pictured actual fighting, the violent physical encounter that George Bellows was to depict so vividly; his three fight scenes showed moments of pause between action or of applause after action. As in his earlier rowing pictures, he may have come to believe that the representation of movement was not his forte.

Taking the Count, dated 1898—probably his first prizefight painting—was an ambitious one: his second largest canvas, eight by seven feet, next in size to *The Agnew Clinic* and bigger than *The Gross Clinic.* The setting is the Arena at Broad and Cherry streets, demolished long ago. The standing fighter is Charlie McKeever; the one on his knee waiting out the count, is Joe Mack; the referee is Henry Walter Schlichter. David Wilson Jordan told me that all the visible spectators are portraits. The two posters of the Walnut Street Theatre advertise plays opening April 11 and 18, [1898], which indicates about when the picture was started.

The painting is impressive in its size and the scale of the two almost-nude figures (the only life-sized ones since *The Crucifixion* of 1880), and in its solidity and physical power. But it has a curiously awkward, almost primitive quality. The figures are stiff and wooden. McKeever stands posed and immobile; his body conveys little sense of capacity for movement. Mack and Schlichter seem equally posed and static. The composition is not well conceived: McKeever is too far to the left to dominate it, his figure leaning leftward out of the picture; and Mack is too far to the right and too low to be well related to the others.

It is suggestive to compare the big canvas with a small oil study owned by the Hirshhorn Museum. (In this both fighters are naked.) The figures are in the same general positions; but McKeever stands as if he had just delivered the knockdown blow, his torso bent back and his right shoulder dropped, ready to follow up the blow; Mack is kneeling but ready to spring up;

212. THE REFEREE, H. WALTER SCHLICHTER
1898. Oil. 20$^{1}/_{2}$ × 16$^{1}/_{4}$. G 306
Hirshhorn Museum and Sculpture Garden, Smithsonian Institution

Schlichter is turned more toward him, counting to him. These differences are slight, but they add up to a livelier composition: the figures are alive, and more closely related. Evidently the big composition had proved too large and ambitious for Eakins. He had not painted the nude since *The Swimming Hole* of 1884–85 (except perhaps some small studies of female models). Of his previous nudes or semi-nudes, aside from *The Crucifixion,* even the largest such as those in *Turning the Stake* had been nowhere near life-size. It is significant that we have no record of his exhibiting *Taking the Count,* and that his next two prizefight pictures were about a quarter the size.

In preparation for *Taking the Count* he had painted a study of Schlichter's

Thomas Eakins

head in the same pose. He also did a finished portrait of the referee's buxom wife, Maybelle, inscribing it "To my friend Mrs. Schlichter."

Eakins' second fight picture was probably *Between Rounds.* Again the location is the Arena. The match depicted was an actual one, on April 22, 1898: the semi-windup between Billy Smith and Tim Callahan. (Billy lost.) He is resting; one of his seconds, Billy McCarney, is fanning him with a towel, while the other, Ellwood McCloskey, bends over, probably advising him. The timer seated in the foreground is Clarence Cranmer. The policeman was a familiar and necessary figure on fight nights. Again, the audience is crowded with portraits. The atmosphere is a bit hazy with tobacco smoke, though not enough to obscure details. Cranmer told me that at the Eakins memorial exhibition in 1917 he overheard some artists complaining about the murky air. "I felt like telling them," he said, "that 5,000 men and boys had been smoking cigars, cigarettes, and pipes through a good many rounds."

This time the bout is taking place not in the immediate foreground but in the middle distance. But Billy Smith's figure is the center of interest: under the strong overhead light falling on the ring it stands out against the darkened audience. The fact that our viewpoint is further removed from this center allows space for several new elements in the composition: the ring with its ropes and corner post, the timer in his chair. The ring's near side, in deep shadow, is a strong dark band running diagonally away; the ring with its three figures is like the prow of a ship aimed at the vertical mass of the balconies—a powerful thrust that creates depth. The timer's figure is a solid fixed form countering this movement. All these elements, and the skillful handling of the light, make the painting one of Eakins' most fully realized designs of forms in deep pictorial space. The absence of any attempt to represent action makes the subject better suited for him than *Taking the Count;* and *Between Rounds* is entirely free of the awkwardness of the big picture.

When one examines the painting closely one is surprised at how translucently and thinly it is painted. Almost everywhere the canvas weave is visible under the pigment, except where light-toned forms are built up, as in Billy's body. Yet when one stands back, every form is solid and weighty. With all its translucent technique, the painting possesses ample substance. Eakins by this time had achieved command of construction in values and color without loading on pigment as he had in some earlier canvases.

Salutat is probably the third in the fight series, started after *Between Rounds* but finished earlier, in 1898, whereas the latter is dated 1899. Billy Smith, again the chief actor, is leaving the arena after winning his match and raising his right hand to acknowledge the crowd's applause. On the original frame (now lost) Eakins carved DEXTRA VICTRICE CONCLAMANTES SALVTAT (The victorious right hand salutes the shouters). The scene being at the exit, the audience is close by, and includes larger portraits: in the first and second

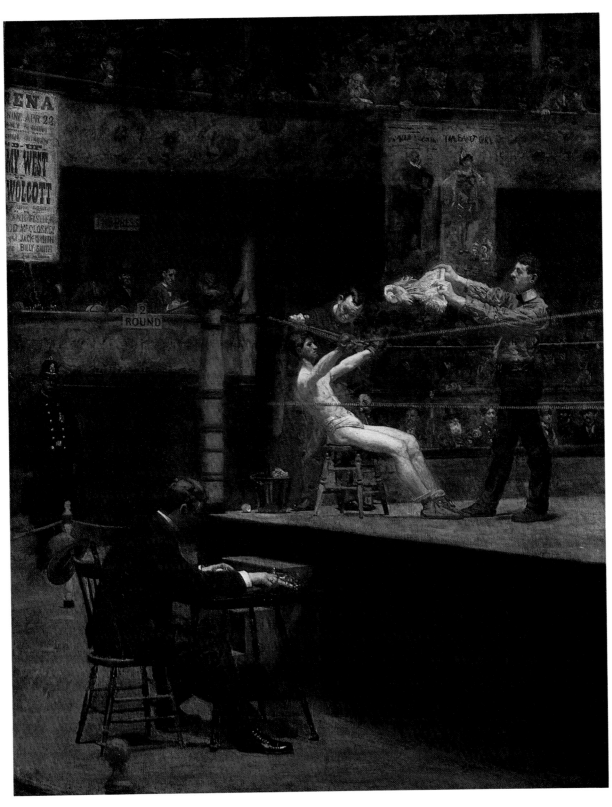

213. BETWEEN ROUNDS
1899. Oil. 50¹/₈ × 39⁷/₈. G 312
Philadelphia Museum of Art; Gift of Mrs. Thomas Eakins
and Miss Mary Adeline Williams

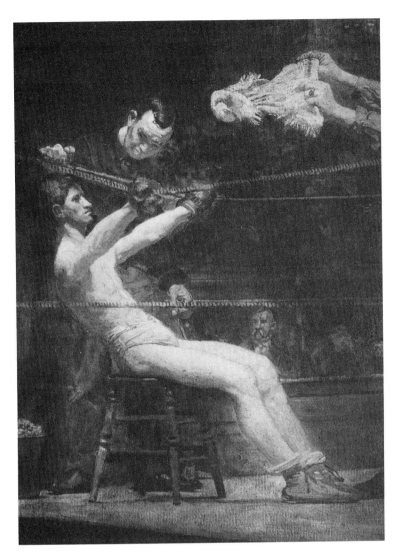

214. BETWEEN ROUNDS: DETAIL

rows, Cranmer, Jordan, and Bregler; behind, at the extreme right, Benjamin Eakins.

Between Rounds shows the whole arena, but *Salutat* is a close-up, with a close-up's concentration. Billy's lean muscular body (Eakins' fourth-largest seminude or nude, next to *Wrestlers*) is neither graceful nor heroic, and the angle from which it is seen, from behind, is unconventional. But it is one of Eakins' finest achievements in figure-painting. Every muscle and tendon is modeled roundly and with precision. The fine curve from the right heel up through the torso, and the second curve of the uplifted arm, show no trace of art-school formulas, but the subtlety of truth. All three foreground figures,

seen against the background of the audience, have the quality of high relief sculpture. The composition has an unobvious balance. Billy's figure is the dominant form; the two seconds, separated from him and close together, are also strong forms but do not compete. Instead of his frequent pyramidal construction, the design is one of upright forms moving horizontally across the picture—a friezelike arrangement basically similar to that of *The Agnew Clinic,* which it also resembles in the isolation of the principal figure. It is interesting to compare the painting with the fine study that Eakins gave to Sadakichi Hartmann, later owned by Mr. and Mrs. James H. Beal. In it the seconds

215. BILLY SMITH
1898. Oil. 21 × 17. G 315
Wichita Art Museum, Wichita, Kansas; Roland P. Murdock Collection

216. THE TIMER
1898. Oil. 21 × 17. G 316
Mrs. Harry Rubin

are not together, the three figures are equal distances apart; whereas in the final composition, by placing the seconds together and separating them from Billy's figure, Eakins gave it ample space and prominence.

In *Salutat* there is no strong directed light or deep shadow, as in *Between Rounds*; the light is clear but diffused. Solidity and relief are achieved without pronounced chiaroscuro. The color is quiet, with no brilliant notes: a general tonality of warm grayed brownish golden, as in *Between Rounds*. The flesh-tones of the three principal figures are not ruddy but pale (boxing is an indoor sport).

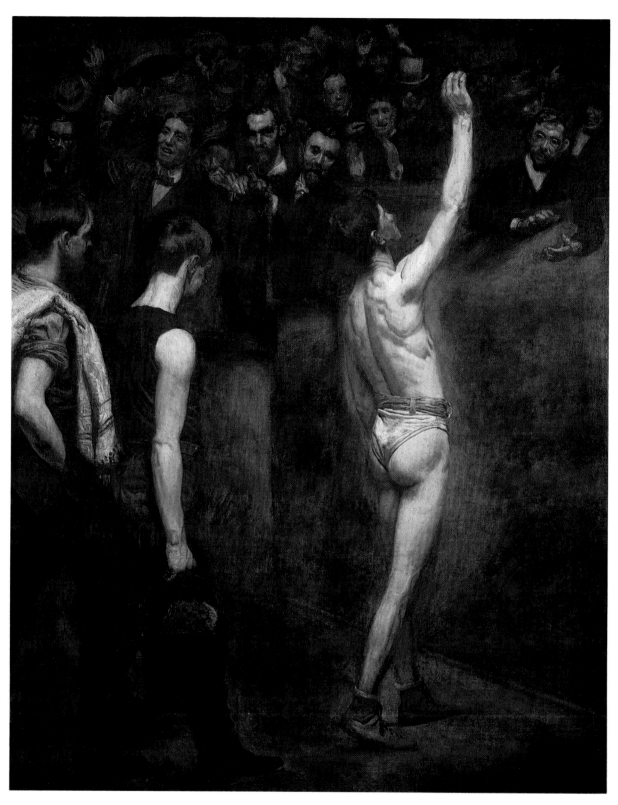

217. SALUTAT
1898. Oil. 49¹/₂ × 39¹/₂. G 310
Addison Gallery of American Art, Phillips Academy,
Andover, Massachusetts; Gift of Thomas Cochran

218. STUDY FOR "SALUTAT"
1898. Oil. 20 × 16. G 311. Museum of Art, Carnegie Institute, Pittsburgh;
Gift of Mr. and Mrs. James H. Beal, 1981

Salutat was exhibited four times in the next five years. Shown at the Pennsylvania Academy in January 1899, it failed to please the few critics who noticed it. *The Art Collector* said: " 'Salutat,' by Tom Eakins, is hardly the representative canvas of that strong anatomist. . . . The audience is too obtrusive. Eakins has brought them so far forward as to give the impression that both victor and audience might easily shake hands. The coloring also would lead one to suppose the fight took place in broad daylight. . . . The technic and close observance of the lines of anatomy are in the same style as of old, always

coarse, never beautiful, but often true." Priced at $1,200, it did not find a purchaser during his lifetime.

When *Between Rounds* was exhibited in the next year's Pennsylvania Academy annual, the reviewer of the *Collector and Art Critic*, one W. P. Lockington, wrote: "Feeding the new popular taste 'Between Rounds' is a realistic emanation at the hands of Thomas Eakins. You all know, however, that he can do better." (He said of another painting in the same exhibition: "For the 'Gulf Stream' by Winslow Homer I must live long enough to overcome my prejudice. . . . The abject fear at the near approach of the sharks is well interpreted, but all else is theatrical and unpleasant.")

Eakins put a price of $1,600 on *Between Rounds* in this exhibition, the highest price he had so far asked. The Academy evidently considered buying it, and Harrison Morris must have tried to get Eakins to lower the price, for he wrote Morris: "I think I shall not change the price of Between Rounds, to wit, $1600." No purchase took place. He did not exhibit it again until 1914, when he priced it at $8,000—again without a taker.

In the spring of 1899 Eakins tackled another ring sport, wrestling. Cranmer helped select two wrestlers as models, probably at the Quaker City Athletic Club, of which he was a member. Eakins wrote him on May 19: "Dear Clarence, I am going to start the wrestling picture on Monday at half past two. I wish you could find it convenient to be at the studio and help us with advice as to positions and so forth." The large painting, four by five feet, shows one wrestler pinning another to the floor with a half nelson and a crotch hold. The faces of both are red from exertion. The scene is a gymnasium; in the background are two men, one clothed (probably a referee), the other wearing a jock; and an athlete at a rowing machine.

Probably because the wrestlers could not have held their positions for any length of time, Eakins used photography as an aid. The painting is one of the few cases in which he copied one of his photographs for an entire composition. Two photos (Hendricks: *Photographs,* 230 and 231) show the men wrestling in the Chestnut Street studio. Evidently after they reached positions that he liked, he posed them on a low platform or model stand, and photographed them (H 229); this photo he copied in the painting. But some changes were made. In the painting the top wrestler is bending further over his victim: his head is lower, more of his back is visible, and his shoulder presses more tightly on the other's chest—a more effective pose. Eakins did not copy the photo as exactly as he had that for the 1882 watercolor *Drawing the Seine.*

The painting is one of his most complete representations of the male body, and one of his most ambitious attempts to portray bodies in action. In the latter aim it cannot be said to succeed. What it portrays is arrested action, without the sense of movement that the subject demands. The style, like that of *Taking the Count,* is uncharacteristically labored and tight. Details are overempha-

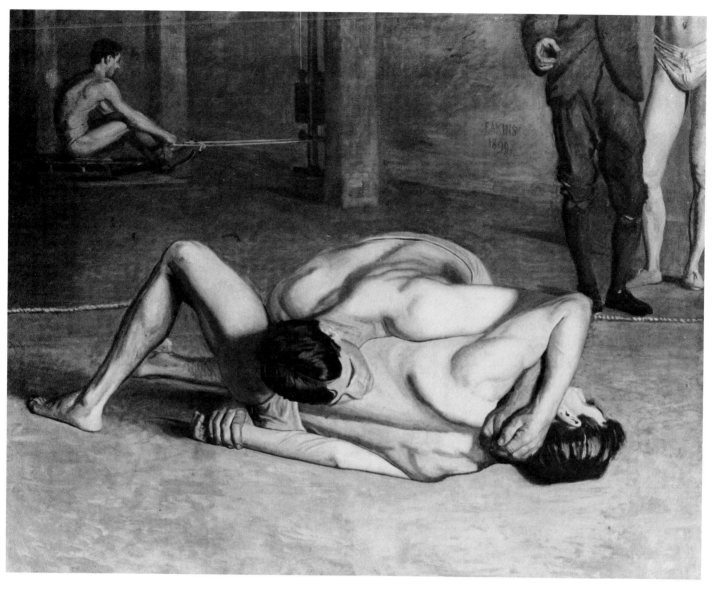

219. WRESTLERS
1899. Oil. 48³/₈ × 60. G 317
Columbus Museum of Art, Columbus, Ohio; Derby Fund Purchase

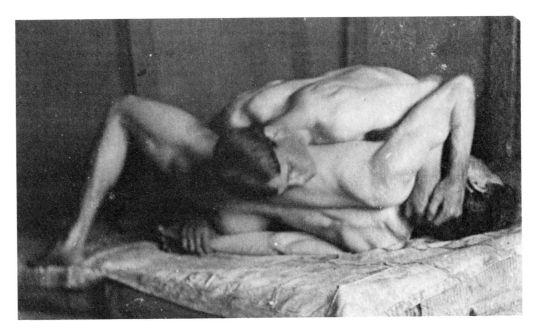

220. Wrestlers. Photograph by Eakins. 1899. Hirshhorn
Museum and Sculpture Garden, Smithsonian Institution

221. WRESTLERS
1899. Oil. 40 × 50^{1}/$_{16}$. G 319
Philadelphia Museum of Art; Bequest of Fiske and Marie Kimball

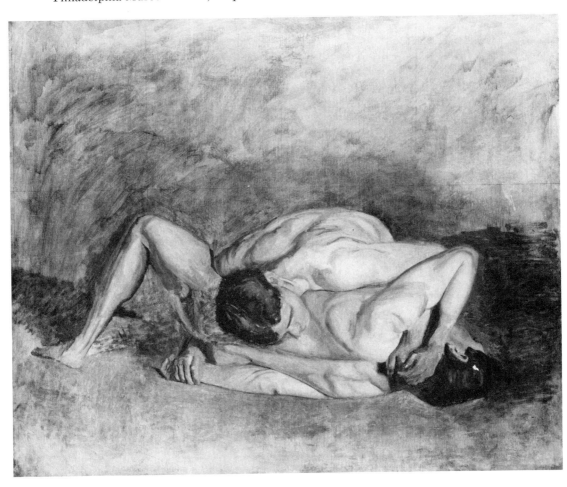

sized; individual muscles distract from the large forms of the bodies. The modeling is curiously soft in places where it should be clear-cut. The style is more linear than usual with him, as in the sharp outlines of the upper man's body against the other's, and the other's body against the floor. This unusual linear quality is something that he himself had condemned in his teaching. There is little color: a general gray-brown tonality, almost monochrome, like a photograph.

An unfinished version in the Philadelphia Museum, only a little smaller than the final painting, shows the wrestlers in almost identical positions, against a blank background. It is unlike his usual studies: much larger, and not tentative. Its raison d'être is puzzling; it could be a study for the final picture, or an abandoned version of it. A comparison of the two paintings is revealing. The unfinished canvas is not labored, overdetailed, soft, or linear. Painted freely and freshly, it conveys the sensation of action, muscular tension, movement. A large part of this sensation comes from the actual brushwork: the brushstrokes are full of energy; they are alive in themselves, a direct physical language. This vitality of brushwork (analogous to the "action painting" of our times) was lost in the overfinishing of the larger version. A puzzling feature of Eakins' technical methods is that some pictures on which he worked a long time, such as *The Concert Singer*, became stronger and deeper as he worked on them, whereas others lost their initial vitality.

The faults of *Wrestlers* were probably caused primarily by his attempt to picture action; but also by his undertaking too large and ambitious a painting, relying too much on the photograph, and overfinishing. As with *Taking the Count*, there is no record of his exhibiting it. And when he was elected to the National Academy of Design three years later, he gave it to them as his "diploma picture."

<center>V</center>

After the rejection of *The Agnew Clinic* by the directors of the Pennsylvania Academy in 1891, Eakins did not exhibit there for two years. But in 1892 Harrison S. Morris was made managing director and started energetically promoting the venerable institution, particularly its annual exhibitions. "When I began at the Academy," he wrote in 1930, "Eakins was in exile. He had committed a sin against the laws of the nude, had impiously touched a nerve of the conventions, and was in outer darkness. I had known him very well, and had felt the bold appeal of his vigorous painting: the attachment which his lovable nature had won from his students, and the force of his intellect. . . . I felt his value to the Academy. A city with Eakins living in it detached from its Fine Arts Academy was a Hamlet-less farce. You might as well try to run a wagon on three wheels. . . . Eakins was far more essential than all the Directors put together—yet they held him off. . . .

"I felt at once the lost motion of the Academy without Eakins, and I set out to win him back; not to the classes—prejudice and superior virtue were too thick for that—but to have the favor of his presence, to see him often, and to feel his passive influence. He gave me so much a share of his regard, that before long he asked me to pose for my portrait, which I did."

It was probably in answer to a request from Morris for biographical information, including his honors, that Eakins wrote on April 23, 1894: "I was born in Philadelphia July 25th, 1844. I had many instructors, the principal ones Gérôme, Dumont (sculptor), Bonnat.

"I taught in the Academy from the opening of the schools until I was turned out, a period much longer than I should have permitted myself to remain there.

"My honors are misunderstanding, persecution, and neglect, enhanced because unsought."

Doubtless because of Morris' efforts to draw him out of his isolation, Eakins began to exhibit again at the Academy in December 1894. Thereafter he was represented in every annual exhibition throughout his life, showing there much more often than anywhere else in the 1890s. In early 1897 the Academy made its first purchase of a work by him, *The Cello Player*, bought from its annual show for $500, his asking price. Morris had probably tried to bargain, for Eakins wrote him: "The purchase of my *Cello Player* would be however a very simple transaction, as you have my price, and I would not think it at all fair to ask one price and take another." As we have seen, he gave half the amount to Hennig for posing. This was his second museum purchase, and the first since 1879. Perhaps it was a sense of satisfaction at this acquisition that led him to break a five-year abstention from the Society of American Artists exhibitions and to show the picture as owned by the Pennsylvania Academy—in spite of its having been seen in New York the year before at the National Academy.

As the years passed, Eakins' breach with the Academy was more or less healed, at least publicly. But there was never any possibility of his again having a voice in the affairs of the institution and its school. The position of director of the school, held by him, had been abolished. In the middle 1890s, with Eakins living in the city, in his creative prime, and no longer involved in teaching at the Art Students' League of Philadelphia, the Academy transported the pleasant academic painter Joseph De Camp all the way from Boston, in Pullmans, every week for two days of teaching. After his health failed, in 1896, William Merritt Chase was imported from New York to teach for the next thirteen years—longer than Eakins' ten years.

In the 1880s and 1890s the American art establishment was dominated by the New Movement generation, now middle-aged and conservative. Except for a few outstanding individuals, mediocrity reigned. Most established artists, avoiding the vulgar actualities of American life—the city, the factory, the farm, the masses—devoted themselves to the world of the middle and upper classes: pleasant people and places, the family and the home, American womanhood, summer resorts, the idyllic aspects of nature, sunlight and youth and pretty faces. Impressionism had reached these shores, but in the United States had become academic. The artistic qualities most generally esteemed were an eye for light and atmosphere and visual appearances, a gift for decorative pattern and pleasing color, and a clever brush. These standards governed exhibitions, awards, museums' and collectors' acquisitions, membership in artists' societies, and critical writing.

The prevailing tendencies of American painting were counter to everything that Eakins stood for. Form, construction, realism, and unidealized character were of less importance than attractive surface qualities. In the big national exhibitions his paintings must have looked severe, indoor, dark, and completely lacking in charm. Most of them now were portraits, not of the fashionable and beautiful but of scientists, professors, and women without glamour. His technical strength and anatomical knowledge were respected, but seemed old-fashioned virtues.

In the ten or so years following 1886, his exhibiting was at its lowest ebb. Until 1894 he showed only once in the Pennsylvania Academy annuals; and from 1886 until 1902 only three times in the Society of American Artists and five times in the National Academy. The new Art Club of Philadelphia included him in about half of its annuals, and there were scattered showings outside of Philadelphia. Whether this decline in his appearances in the major national annuals was the result of his being rejected, or not submitting works, we have no way of knowing; his 1892 letter of resignation from the Society of American Artists suggests the former.

Abroad, he had had three pictures in the Internationale Kunstaustellung in Munich in 1883. In the Paris Exposition Universelle of 1889 he was represented by two oils, *The Veteran* and the portrait of Professor Barker, and the 1878 watercolor *Negro Boy Dancing*—a curious combination. The two top *grand prix* awards in the United States section went to Sargent and Gari Melchers, gold medals to four others, silver medals to fourteen, bronze medals to thirty-nine, and honorable mentions to twenty-four: total awards, eighty-three; none to Eakins.

That year he submitted to the Salon in Paris three paintings: *The Crucifixion, Mending the Net,* and *The Writing Master.* Remembering his difficulties

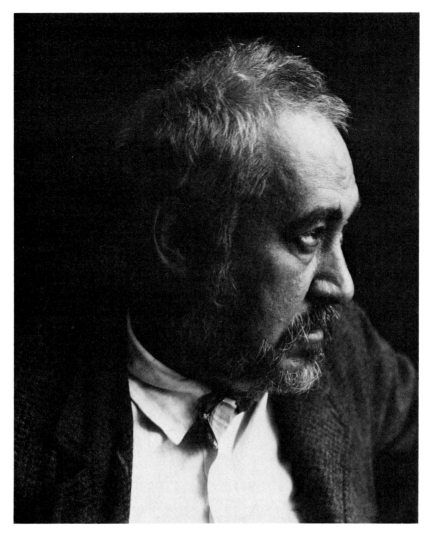

222. Thomas Eakins. Probably about 1900. Photographer unknown
Seymour Adelman Collection

in getting his pictures back through United States customs in the 1870s, he wrote the Secretary of the Treasury reciting the story. "I shall want to bring back one of these pictures, a portrait of my father," he said, "and the other two also unless fortunately they be sold abroad. Now kindly inform me how I can have my pictures back with the least trouble to myself." *The Writing Master,* titled *Le calligraphe,* was accepted for the 108th Salon, that of 1890; his name was given as "Eakins Thomas." The other two paintings were not accepted or sold.

He was to be more fortunate in the huge international expositions that were becoming major events in the United States. The most important one

Thomas Eakins

since the Centennial was the World's Columbian Exposition in Chicago in the summer of 1893. Elaborate programs for architecture, monumental sculpture, and mural painting made the theatrical "White City" the biggest artistic extravaganza so far staged in the country. An army of architects, sculptors, and muralists was involved: Saint-Gaudens called it "the greatest meeting of artists since the fifteenth century." The Art Palace contained an international exhibition of 9,000 pictures, of which over 800 were American.

Eakins had no part in the preparations, nor was he a member of the eight-man Pennsylvania Jury of Selection for Paintings in Oil, although several now-forgotten Philadelphians were. However, the jury had the judgment and the courage to select ten paintings by him: the *Gross* and *Agnew* clinics; the portraits of Barker, Marks, Miss Van Buren, and O'Donovan; *Home Ranch, The Crucifixion, Mending the Net,* and *The Writing Master.* (The last three were those submitted to the Salon three years earlier.) When the Pennsylvania Academy held a three-week preliminary exhibition of works destined for the Fair, it was the first time that *The Agnew Clinic* was shown in an art exhibition except at Haseltine's; for *The Gross Clinic,* the first time in fourteen years; and the first that the two clinic paintings were shown together. In Chicago, Eakins was among thirteen painters with the largest number of works (Inness and Homer had fifteen each). In addition, *The Concert Singer* was hung in the Pennsylvania State Building. There were no top prizes, only a single grade of bronze medals with a diploma, which went to fifty-seven Americans, including Eakins—his first award since 1878 and the last until 1900. (It was Winslow Homer's first award.)

In May 1896 Eakins had his first and only one-man exhibition, at Earle's Galleries in Philadelphia. Opening on May 11 with a private view and continuing "for a limited time," the show contained twenty-nine works, about half of which were portraits. No catalogue or even a list of the works has been found. The only information about the show comes from four Philadelphia newspaper reviews, one of which states that fourteen paintings were portraits, and the rest were "pictorial compositions," "a number of landscapes" [sic], and "a few sketches"; and also "reproductions of Mr. Eakins' two famous portraits of Dr. Gross and Dr. Agnew." Seventeen works can be identified (some tentatively) from these reviews: *The Pair-oared Shell,* 1872; *Pushing for Rail,* 1874; *The Zither Player,* watercolor, 1876, or the similar oil, *Professionals at Rehearsal,* 1883; *William Rush,* 1877; *Shad Fishing at Gloucester,* 1881; a portrait of Benjamin Eakins, perhaps *The Writing Master,* 1882; *Professor Barker,* 1886; *Talcott Williams,* 1889; *Thomas B. Harned,* 1891; *Home Ranch,* 1892; *Frank Hamilton Cushing,* 1895; *Mrs. Cushing,* 1895; *James MacAlister,* about 1895; *Captain Joseph Lapsley Wilson,* about 1895; *Harrison Morris,* 1896; *Lucy Lewis,* about 1896; and one of the portraits of William H. Macdowell. Judging by these and by the reference to "pictorial compositions," which must have

been earlier pictures, the exhibition was a small retrospective. One account reported that "the majority of these [works] have been seen before."

The *Daily Evening Telegraph* and the Philadelphia *Record* gave the show short favorable reviews, both speaking particularly of *Frank Hamilton Cushing.* The *Inquirer,* in a brief account, said: "Mr. Eakins has the faculty of reproducing literally the characteristics of his sitters, with the result that his portraits are often brutally like his models. Although Mr. Eakins' work may lack ideality and color sense, it certainly does not lack strength, and the astounding knowledge of anatomical form, which makes him such an able instructor, is clearly felt."

Only Eakins' friend and champion Riter Fitzgerald of the Philadelphia *Evening Item* (whose portrait the artist had painted the previous year) showed any great interest in the exhibition. In a long front-page review, appreciative if curiously ambivalent, he wrote: "It is the fashion to say that Eakins is 'brutally frank,' that he had too high a regard for Art to idealize or etherealize his subjects.

"All of which translated into plain every day English means that he paints his subjects as he finds them, imperfections, blemishes and all.

"This is all very well from 'an Art for Art's sake' standpoint, but in the progressive work-a-day world of the present time, the portrait painter, the same as everyone else, must trim his craft to the trade winds.

"It is easy to comprehend what fate would befall the fashionable photographer who neglected to doctor his negatives and paint out all imperfections.

"The people demand idealization, and if they don't get it at one shop they will bend their footsteps to another.

"This applies to the studio of the artist as well as the rooms of the photographer."

He went on to criticize the Cushing portrait for its "surplus of detail" and insufficient "depth to the background," and to praise the portrait of young Lucy Lewis, which "is the line which Mr. Eakins must cultivate if he wants to make a pecuniary as well as an artistic success.

"There is a partial idealization of a very pretty subject, which could have been carried very much further with profit. . . .

"It is as yet an unexplored region for him."

Fitzgerald closed this tongue-in-cheek piece by calling Eakins "one of the foremost painters of the times."

Of the seventeen identified pictures in the exhibition, none was sold; since there is no record of sales of any others at this time, evidently no works in the show found purchasers. In the record of his works kept by Eakins and Mrs. Eakins, with information about their exhibitions, the Earle exhibition is not listed. In my conversations with Mrs. Eakins in the 1930s she made only passing mention of the show, and produced no catalogue of it. The lack of sales and

the meager critical reception must have made his only one-man exhibition a chilling experience for both of them.

Since his pictures appeared less frequently in national exhibitions, they received less attention from the critics; and they included none as controversial as the *Gross* and *Agnew* clinics or *The Crucifixion*. The level of American art criticism had not improved since the 1870s. Usually the reviewers gave him only passing mention, generally favorable but sometimes negative. Paintings of the caliber of *The Cello Player, The Artist's Wife and His Setter Dog, Salutat,* and *Between Rounds* came in for captious and supercilious comments.

A different note was sounded by Eakins' friend the erratic, heterodox critic

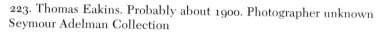

223. Thomas Eakins. Probably about 1900. Photographer unknown
Seymour Adelman Collection

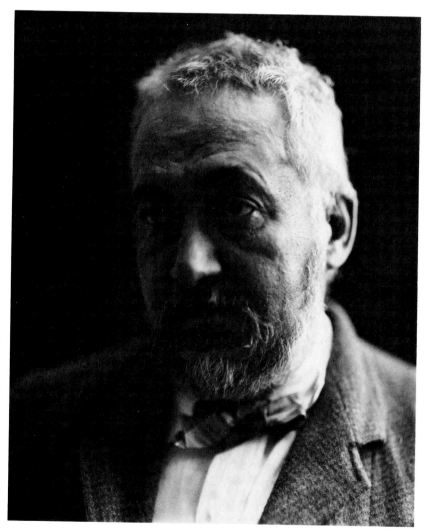

Sadakichi Hartmann, who was publishing his own eight-page monthly, *The Art News*, in New York. "Philadelphia can be proud of possessing Thomas Eakins," he wrote in April 1897. "Among our mentally barren, from photograph working, and yet so blasé, sweet caramel artists, it is refreshing, like a whiff of the sea, to find at least one rugged, powerful personality like Thomas Eakins. How crude his art is at times we see in the startling effect of blood in Dr. Gross's right hand. Eakins can never hide the calm and keen, perhaps brutal observation of his anatomical researches. How grotesque his art can be we find out in looking at the lean anatomical study of Christ on the Cross—the strangest and strongest Crucifixion ever made in this country."

We have less information about Eakins' asking prices from the middle 1880s on because exhibition catalogues did not give prices as often as in the 1870s. Also many of his exhibits now were portraits, some lent by the sitters and not for sale. In the years 1886 to 1899 the highest amount he is known to have asked was $1,200 for *The Crucifixion* in 1893 and for *Salutat* in 1899 (the same as for *The Crucifixion* and *The Pathetic Song* fifteen or more years earlier)—the largest recorded figure before 1900. *The Concert Singer* was priced at $1,000 in 1893 and 1895, *Mending the Net* and *Home Ranch* at $800 in 1893 (for the former, the same price as in 1882), *The Cello Player* at $500 in 1896. So his prices in these years still remained moderate; as far as we can tell, at the same levels as in the early 1880s.

As to amounts actually paid: in April 1886 he received $150 for the full-length portrait of his friend Dr. Horatio C. Wood, who for some reason did not take possession of it, but in November that year bought the 1882 watercolor *Mending the Net* for $75, half its previous asking price. In May 1886 Frank Waller, president of the Art Students' League of New York, paid $150 for a portrait of his aunt Miss Sophie Brooks. In July 1887 A. B. Frost's wife gave the same amount for the sketch version of the portrait of her husband painted the previous year. In June 1888 Professor William D. Marks, Eakins' colleague on the Muybridge Commission, paid $100 toward a price of $250 for the 1874 oil *Starting out after Rail;* whether he paid the balance we do not know. In 1887 Edward Hornor Coates bought plaster and bronze casts of the two Scott reliefs for $200. The J. B. Lippincott Company in 1886 paid $100 for photographing and illustrating *The Artist's Wife and His Setter Dog.* So in the four years, 1886 through 1889, after Eakins had lost his Pennsylvania Academy salary, his total income from commissions and sales was probably less than $1,100.

The $750 for *The Agnew Clinic*, it is said, was not paid in full until ten years after 1889, with 3 percent interest added. In the 1890s he received commissions for four portraits: Professor George W. Fetter in 1890; Joshua Ballinger Lippincott (from a photograph) in 1892; Dr. DaCosta in 1892; and Dr. Daniel G. Brinton about 1899; there are no records of what he was paid for

them. For his half of the Walt Whitman portrait he received a small amount. In 1897 the Pennsylvania Academy bought *The Cello Player* for $500, half of which he gave to Rudolph Hennig. In 1899 Fairman Rogers commissioned a black and white version of *A May Morning in the Park* as a frontispiece for his book *A Manual of Coaching*, lending the 1879 painting for Eakins to copy; there is no record of the amount paid.

If we assume that Eakins received about $3,500 for the Brooklyn Memorial Arch sculptures and about $2,800 for the Trenton reliefs, and that the four commissioned portraits ranged from $400 each to $700, the total returns for the decade of the 1890s would be about $10,500—probably somewhat less. Of this, $6,300 would be the estimated fees for his sculpture. This would still be the largest income so far for his work as painter and sculptor.

For his teaching at the Art Students' League of Philadelphia he took no salary. Lecturing in other schools brought in only modest fees, and it practically ceased after 1895. He must have been as dependent as ever on his father's income and the Mount Vernon Street home. (But to Samuel Murray, from a poor family, Eakins was comfortably off; he never had to worry about money, Murray told me, he had no financial sense about his pictures, and he could go off on bicycle trips whenever he wanted to.)

In the late 1880s and the 1890s Eakins' obscurity was at its deepest. A Philadelphian, without a New York dealer, he was not a part of the increasingly dominant New York art world. Having resigned from the Society of American Artists and not having yet been elected to the National Academy, he belonged to no professional organization. Some of his most important paintings, in particular the two great clinic compositions, were in nonartistic institutions and seldom seen by the art public. In younger years he had often encountered opposition; now he suffered a worse fate: neglect.

The strength of Eakins' character is shown by the fact that in spite of lack of recognition and adequate financial returns he continued to paint with the same uncompromising realism, and in the fourteen years from 1886 through 1899 produced some of his strongest works: to name only a few, *Dr. Wood, Marks, The Artist's Wife and His Setter Dog, Miss Jordan, Cowboys in the Bad Lands, The Agnew Clinic, Miss Van Buren, The Concert Singer, Cushing, The Cello Player, Rowland, Salutat,* and *Between Rounds.*

17. The New Century

O N DECEMBER 30, 1899, as the century was closing, Benjamin Eakins died, in his eighty-second year. Throughout his long life his relation to his son had remained as exceptional and as close as in Tom's boyhood. A sterling character, dignified and courteous, widely esteemed, he was much more conventional than Tom, but through good times and bad he had stood by his son. Without his support, moral and material, it is doubtful whether even so strong a character as Eakins would have been able to keep on painting as he did. "If you had known old Benjamin Eakins," Samuel Murray said, "you wouldn't give Thomas Eakins any credit."

He had had a green old age; father and son had continued to share outdoor activities, boating and swimming and bicycling, at the boathouse on the Cohansey Creek at Fairton, and at Avondale until 1897. Benjamin had experienced the same personal tragedies as his son: the illness and untimely death of his wife; Margaret's death, and Caroline's; Tom's estrangement from his sisters; the Academy affair; his son's lack of material success as an artist (Benjamin did not live to see his later recognition). How these events affected him we have no way of knowing; we do not know what his relation to Caroline was after her break with her brother, or to Frances after Ella's suicide.

After his father's death Eakins kept up his friendship with Benjamin's hunting and boating companions George Morris and William R. Hallowell, who shared ownership of the boathouse. In 1901 and 1904 he painted their portraits: that of Morris included a small image of a sailboat, and an inscription: HANC · EFFIGIEM / CARISSIMI · PATERNI · AMORIS · SOCII / PINXIT · BENIAMINI · EAKINS · FILIVS / A · D · MCMI / PHILADELPHIAE (This portrait of his father's most dear companion was painted by Benjamin Eakins' son in 1901 in Philadelphia).

Benjamin left an estate of about $90,000: "personal property" of $80,000, real estate of $10,000. His income had included "ground rents" on nine properties in the city. His will, signed April 15, 1899, bequeathed his "gold watch and chain" to his namesake, Benjamin Eakins Crowell, and his "household goods and wearing apparel" to Thomas; the residue was divided into three

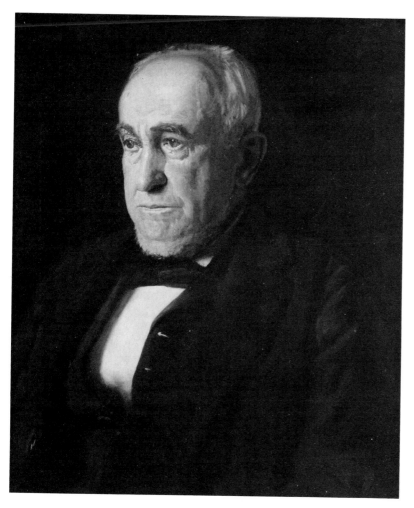

224. BENJAMIN EAKINS
Probably middle or late 1890s. Oil. 24⅛ × 20. G 324
Philadelphia Museum of Art; Gift of Mrs. Thomas Eakins
and Miss Mary Adeline Williams

equal parts, for Thomas, Frances, and the children of Caroline. The Mount Vernon Street house was to be part of Thomas' share if he wanted it; he did. Frances' third was to be held in trust, the income paid to her "for her sole and separate use free from the debts control and engagements of her present or any future husband. . . . Having loaned my son-in-law William J. Crowell various sums of money, I direct that the amount thus due and owing to me shall be included in [Frances'] share, . . . with the understanding that no interest shall be charged upon the same up to the time of my decease." The executors were Thomas Eakins, William H. Eberle, and the Fidelity Insurance, Trust, and Safe Deposit Company.

Thomas Eakins' third would thus be in the neighborhood of $30,000, in-

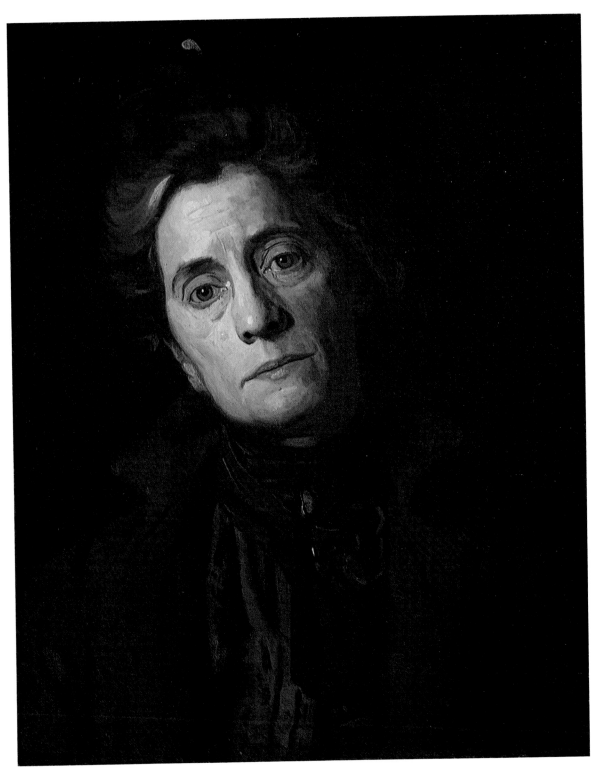

225. MRS. THOMAS EAKINS
Probably about 1900. Oil. 20$^1/_8$ × 16$^1/_8$. G 325
Hirshhorn Museum and Sculpture Garden, Smithsonian Institution

cluding 1729 Mount Vernon Street, valued at $7,500. The approximately $22,500 in stocks, bonds, mortgages, and other real estate would be worth several times that today—not a large amount, but producing enough income for him and Susan to live securely and modestly.

In October 1900 Eakins and Murray gave up the Chestnut Street studio, and Eakins moved his working quarters back to Mount Vernon Street, turning the fourth-floor attic on the front of the house into a studio. His former studio on the back of the house became a workshop (including Benjamin's lathe that he had drawn in high school). Murray rented a studio at 2219 Chestnut Street. Eakins offered to lend him $2,500 to furnish the place, but Murray declined it. "Eakins swore," Murray later wrote, so he finally accepted the loan, which he paid back in a year. In 1908 Murray bought a house farther out in West Philadelphia, at 3324 Lancaster Avenue, where he was to live thenceforth. (Eakins lent him the money to buy it.) But the two men continued to see almost as much of each other as in the past.

Aunt Eliza Cowperthwait had died the same year as Benjamin, on January 2, so Thomas and Susan were now alone in their home.

<center>II</center>

Among the Benjamin Eakinses' closest friends had been Abigail and Samuel Hall Williams, who lived on a farm at Fairton near the boathouse. (As a hungry young man, Thomas on his way to the boathouse would call to Mrs. Williams, "Abigail, what are you having for supper tonight?") The oldest Williams daughter, Mary Adeline, born and brought up in Fairton, had attended school in Philadelphia, where she became one of Margaret Eakins' best friends; they were the same age. (She was also Will Crowell's second cousin.) When she was thirteen, Eakins had written Fanny from Paris: "How did you like little Addie Williams? She is a pretty little girl & I guess just as good as she is pretty, or she belies her blood. We owe a great deal to her father & mother for their unvarying and disinterested kindness to us whenever we have been there and to little Addie too. Try to make her welcome whenever she comes to town." In 1930 Miss Williams told me that Tom Eakins, who was nine years older, "was like a big brother to me." After her mother died in 1873, one day when she was visiting 1729 Mount Vernon Street, on Tom's easel was a small fine portrait of Abigail Williams that he had painted for her, from a photograph.

Addie Williams never married. After Margaret Eakins' death in 1882 Benjamin invited her to live at Mount Vernon Street, but she declined (perhaps because she was still in her twenties and Tom was unmarried). She was musical, but she had to neglect the piano to make her living as a seamstress: sewing shirts at Wanamaker's and making corsets for a Mme. Murney. After six years in Chicago with one of her five brothers, in the late 1890s she returned to Philadelphia and Mme. Murney.

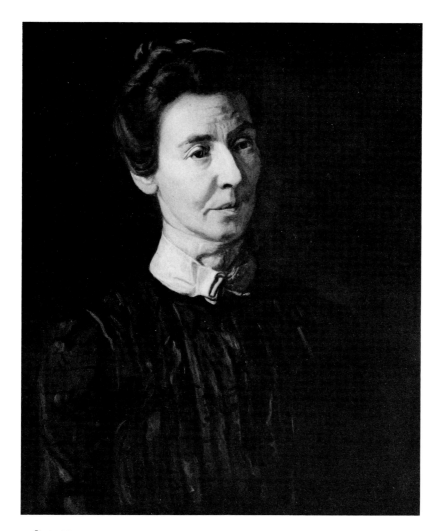

226. MISS MARY ADELINE WILLIAMS, or WOMAN IN BLACK
1899. Oil. 24 × 20. G 323
The Art Institute of Chicago

Eakins wrote her frequently, in Chicago and after her return. An 1898 letter invited her to bring her sewing and spend the afternoon with Susie; he would like to photograph her head. He invited her for New Year's dinner with them. He wrote asking about visiting a mutual friend, whether to go by trolley or bicycle; about taking her and Susie to a show, and again to the circus; to tell her that "Jamie Dodge is going to explain to his workmen and friends the principles of moving photographs and will show the very latest improved apparatus"; inviting her to go with him to the Academy to see Sargent's portrait of a Wertheimer.

In the spring of 1899, when she was forty-five, he painted her portrait. (On

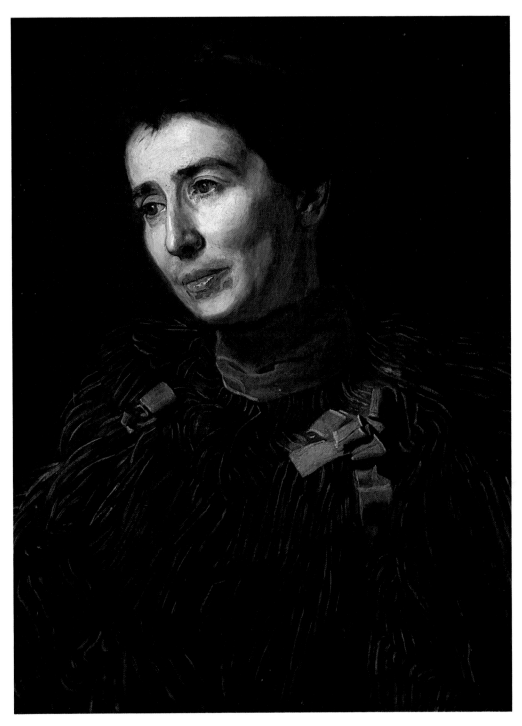

227. ADDIE
Portrait of Mary Adeline Williams
Probably 1900. Oil. 24$^1/_8$ × 18$^1/_8$. G 333
Philadelphia Museum of Art; Gift of Mrs. Thomas Eakins
and Miss Mary Adeline Williams

April 27 she wrote that she had to work a night that he wanted her to pose; could he work on the picture next day, Sunday?) In the painting her characterful, spinsterish, rather anxious face, slightly frowning, is seen in unsparing light that reveals every fold: a powerful, relentless portrait—an old and cherished friend portrayed without a trace of softening.

After Benjamin's death the Eakinses asked her to live with them; and this time she accepted, in 1900. She was to remain at Mount Vernon Street the rest of their lives, until after Susan's death in 1938. On my visits to the house in the early 1930s the two elderly women (Addie was two years younger) seemed like sisters, ready with memories and facts about Tom.

The year she began living with them Eakins painted a second portrait of her, now known as *Addie.* Her face, though not beautified, is less austere, more relaxed, half-smiling: a kindly woman, wise, gentle, and warm, with a sense of humor—as I found her to be. Instead of the severe black shirtwaist with a high tight white collar in the earlier picture, she wears a full fluffy dress, black but with red stripes and ribbons, and a red choker around her neck. It is one of his most sympathetic, intimate portraits of a middle-aged woman.

Mrs. Eakins, looking at the first portrait with me, commented that when it was painted Addie was not yet living with them and was "rather worried"; the second was painted after she came and was "more relaxed and more tender." She said she had been very glad to have Addie join them; and in a letter to me she wrote, "after 1900 when Miss Williams became a beloved companion in our house."

Gordon Hendricks, discussing the difference between the portraits, wrote: "The natural thing to believe is that love came into Addie's life. That idea is taken for granted by one relative I met: 'You know, of course, that Uncle Tom made love to Addie Williams.'" When I was talking in 1930 with one couple friendly with the Eakinses, the husband spoke of a ménage à trois, but his wife caught him up and said, "You don't actually know that it was a ménage à trois." This was the only suggestion of such a relationship that I heard from Eakins' friends, most of whom were quite frank about sexual matters. There is no question of the deep mutual affection of Eakins and Addie Williams; but for reasons already given I find it difficult to think of him as a participant in an extramarital affair—especially in his own house.

About 1903 Addie's married sister Annie, twelve years younger, stayed at Mount Vernon Street while recovering from an operation. Eakins painted her portrait, in a dressing gown, her dark hair hanging in two long braids down her front. He would carry her up to his fourth-floor studio to pose. Giving the portrait to her sister, he inscribed it: "To Addie from Tom of Annie."

When the new century began, Eakins was in his fifty-sixth year, vigorous physically, though overweight, and in his prime creatively. The next few years were to be among the most productive of his life, and to include major works. With the exception of his return to the William Rush theme in 1908, his pictures were to be entirely portraits.

Mrs. William D. Frishmuth was a collector of musical instruments, of which she had given about 1,100 to the Museum of Science and Art of the University of Pennsylvania. In Eakins' portrait—eight by six feet, his fourth largest painting—she is surrounded by twenty pieces from her collection; instruments from many countries and historic periods, with all kinds of functions and forms: serpent, cornemuse, raffia harp, pochette, bagpipe, bowl lyre, gong, panpipes, lutes, drums, even a hurdy-gurdy. Her left hand rests on a viola d'amore in her lap; the index finger of her right hand presses down firmly on a key of an eighteenth-century English piano. Obviously a woman of strong character, proud of her possessions but willing to share them with others. Homely in face, she wears a formal black dress, high-necked, long-sleeved, and full-skirted, swathing her ample body from head to foot; around her neck is a six-strand pearl necklace—real ones, we may be sure. Gazing in front of her with a meditative, abstracted expression, she is like an enigmatic goddess presiding over a somber, cluttered cave. The picture is a very dark one: against the near-blacks and deep grays and browns, the only light tones are her face and hands and bright blue scarf. Yet her figure and every instrument are clearly defined. As massive as the Rock of Gibraltar, her black-clad body forms a pyramid surmounted by her formidable face. Certainly Eakins did not flatter her, but there is so much power and substance in her face and figure that she dominates the assemblage of varied forms and the whole pictorial space. Out of this unlikely material Eakins has created one of his richest, most monumental designs.

That the painting was constructed in three dimensions as exactly as his earliest works is proved by a set of perspective drawings (present whereabouts unknown) which Eakins gave next year to his friend and colleague Leslie W. Miller, president of the Philadelphia School of Industrial Art, himself a teacher of perspective. Thanking him, Miller wrote: "I shall take pleasure in showing them to such students as are likely to understand and appreciate the lessons which they embody."

In spite of her stern appearance Mrs. Frishmuth must have been an understanding and patient woman to endure the many sittings that the big painting must have required. Although she did not purchase it, she must have agreed to its being hung with her collection at the University Museum, through Eakins' friend Stewart Culin of the museum staff.

228. MRS. WILLIAM D. FRISHMUTH, or ANTIQUATED MUSIC
1900. Oil. 97 × 72. G 338
Philadelphia Museum of Art; Gift of Mrs. Thomas Eakins
and Miss Mary Adeline Williams

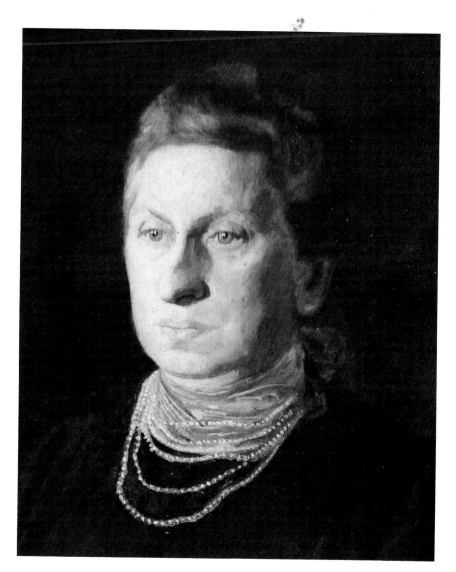

229. MRS. WILLIAM D. FRISHMUTH: DETAIL

When the picture was exhibited soon after it was painted, at the Pennsylvania Academy in January 1901, Eakins titled it *Antiquated Music.* After this showing and one in Minneapolis the same year, it went on loan to the University Museum. In 1906, after Culin had left Philadelphia, Eakins told the University that he wished to exhibit it at the National Academy of Design. "He was told that if he removed the picture from the walls," Mrs. Eakins wrote the University in 1919, "he would not be permitted to return it to the Museum. Of course Mr. Eakins removed the picture. It now hangs in my parlor."

A different kind of sitter was Mrs. Joseph W. Drexel, whose portrait Eakins

230. MRS. WILLIAM D. FRISHMUTH: DETAIL

began the same year. Born Lucy Wharton, of an old Philadelphia family, a descendant of Governor Thomas Mifflin (whose portrait with his wife is one of Copley's finest works), married to a banking Drexel, and mother-in-law of Newport's social arbiter Harry Lehr, she was prominent in American and European society. She had presented a collection of fans to the University Museum, and Eakins conceived a portrait of her that would be a companion piece to *Antiquated Music* (though not quite as large), showing her holding a fan in each hand and surrounded by other fans. It would undoubtedly have been one of his most colorful compositions. Meeting her through Culin, he asked her to

pose. The picture was started in her house, but after a very few sittings, when the canvas was only blocked in, she said that she could not spare more time to pose, and suggested that her maid sit for her; she also offered to pay Eakins. He replied: "Dear Madam, I feel very sorry with innocent intentions to have been the cause of so much discomfort to you, but trust that you have now recovered from your bad cold.

"I cannot bring myself to regard the affair in the light of a business transaction.

"The commission was sought by me, because even long before I was presented to you I felt that a worthy and beautiful composition picture could be made of the giver of fans to the Museum, but a portrait of you that did not resemble you, would be false, have no historic value, and would not enhance my reputation.

"Your other alternative is not agreeable.

"I cannot accept money for which I give no equivalent.

"I would much prefer to look upon my attempt as an unfortunate one and a trespass upon your complacency.

"I enjoyed my visits to you very much, and beg your pardon sincerely.

"May I ask that your people will at their convenience send to me my belongings?"

I V

The same year that he created the dark mysterious complexity of *Antiquated Music,* Eakins painted another far different portrait, of his brother-in-law Louis N. Kenton, who was briefly married to Susan's sister Elizabeth. (Eakins called it simply *Portrait of Louis N. Kenton;* it is now known as *The Thinker.*) A plain-looking man with pince-nez, lean and ungainly, in a sober black suit, stiff starched collar, and high black shoes, he stands with his hands in his pockets, head bowed, gazing down in front of him as if working out a problem. Every rumple of his unfashionable suit is precisely delineated. By contrast with the rich diversity of musical instruments surrounding Mrs. Frishmuth, he stands in a bare room, against a bare wall, on a bare floor. Nothing could be more prosaic.

The light, unlike that in *Antiquated Music,* is clear and strong, unusually so for Eakins. The figure, silhouetted against the fully lighted wall and floor, is situated in a definite space, though a minimal one. The interest is focused entirely on the man, especially that remarkable head—remarkable not for personality but for sheer physical existence, uncompromising bony character, and sculptural form. Strangely, his body, though as strongly characterized, is not as roundly modeled, except for his shoes. Perhaps Eakins aimed to give maxi-

231. THE THINKER
Portrait of Louis N. Kenton. 1900. Oil. 84 × 42. G 331
The Metropolitan Museum of Art; Kennedy Fund, 1917

232. THE THINKER: DETAIL

mum substance to the head by not giving as much to the rest of the figure. The difference does not strike one as a defect—on the contrary. Although the pose is absolutely static, there is movement in the forms themselves, from the feet up through the body to the down-bent head, creating a strong linear pattern. The color scheme is of the utmost simplicity, with only four main colors: flesh tones; black hair, suit, and shoes; white collar; and warm grayed yellow-ocher wall and floor.

With all its commonplace subject and total realism, *The Thinker* has acquired a symbolic value wider than its actual subject: here is contemporary man, with no advantage of handsomeness, attire, or prestige—but thinking

man. In its completely different way, the painting has attained a meaning as universal as Rodin's *Penseur*.

Eakins' full-length portraits of standing men have many parallels with those of Velázquez: complete realism, concentration on character, naturalistic depiction of light, fundamental austerity of style. The Kenton portrait is especially close to Velázquez. For example, *Pablo de Valladolid* in the Prado: with all the differences in character and pose, there are striking similarities: dark figures silhouetted against lighted plain backgrounds; simplified color schemes of black, grays, and light warm ocher; even the cast shadows on the floor. Eakins had an exceptional visual memory, and he may well have remembered this and other of Velázquez's full-length male portraits. But there is no hint of pastiche, as with Whistler and Manet; Eakins' portraits were based on a relation to visual reality as direct as the Spaniard's.

He must have thought well of the Kenton portrait: from 1900 to 1916 he exhibited it at least thirteen times; it became one of his most frequently shown works. (Curiously, he listed it four times as owned by Mrs. Kenton, twice by Kenton, and four times without ownership. In the end it remained at Mount Vernon Street.) In spite of its unsparing realism it was one of his first works to be appreciated by a younger generation of critics. Charles H. Caffin wrote in 1901: "We may find it ungainly in composition, certainly without any superficialities of beauty; but its intense realism and the grasp which it suggests of the subject's personality, render the picture one of notable fascination." The next year he described it as "proving, at first, distasteful by reason of its frank realism, but gradually growing upon one's interest, and with further intimacy becoming extraordinarily fascinating."

V

One of Eakins' most congenial professional friends was Leslie W. Miller, president of the School of Industrial Art (now the Philadelphia College of Art). An active, public-spirited man, a founder of the Art Club of Philadelphia and its vice-president, and secretary of the Fairmount Park Art Association, he was a prominent figure in the city's art world. He had begun his career as a portrait-painter; he had published *The Essentials of Perspective* in 1887; so he and Eakins had much in common. Genial, lively, and open-minded, he understood and appreciated his colleague, as his letters to me show. In Eakins' full-length portrait, painted in 1901, he stands addressing an audience, a paper in one hand; behind him is a screen, and beyond it a view of a gallery hung with drawings.

Eighteen-year-old Charles Sheeler, studying "applied art" in the school, witnessed the painting of the portrait. "One day a stocky little man [sic], gray-haired and gray-bearded, passed through our workroom. His trousers were tucked into short leather boots and fitted so snugly as to make the braces over

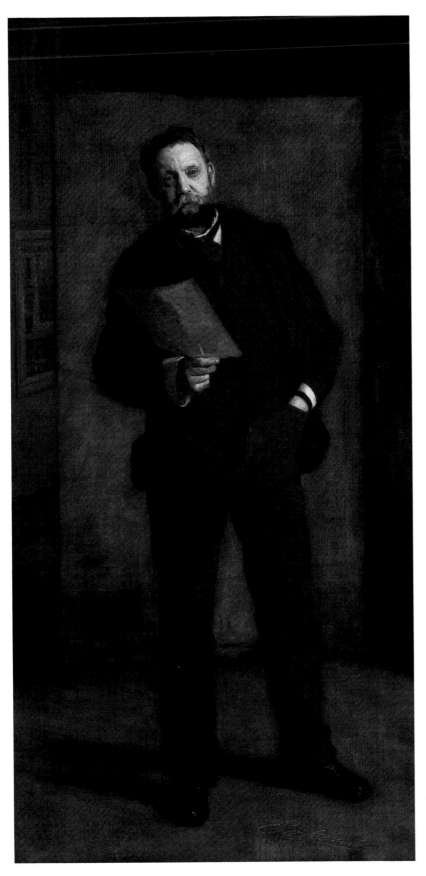

233. PROFESSOR LESLIE W. MILLER
1901. Oil. 88 × 44. G 348
Philadelphia Museum of Art; Gift in memory of Edgar Viguers Seeler
by Martha Page Laughlin Seeler

his dark sweater superfluous. Neither his appearance nor his manner offered a clew as to the reason for his visit. A few days later he returned and passed to the life-class room, just beyond where we were working. Knotholes in the board partition were used at intervals and permitted us to satisfy our curiosity. The stocky little man was beginning a portrait of the principal of the school, Leslie Miller, and before long the plan of the picture was indicated. The subject was to be portrayed standing easily with one hand in his trouser pocket and the other holding a manuscript from which he raised his eyes as if to direct them toward an audience. As the artist's work continued we witnessed the progress of a perspective drawing which was made on paper and then transferred to the canvas, to account for charts of ornament receding into the background—those charts which we knew only too well. This careful procedure

234. SIGNATURE FOR "PROFESSOR LESLIE W. MILLER"
Drawn in perspective. 1901. 13⁷/₁₆ × 16⁷/₁₆. G 349A
Hirshhorn Museum and Sculpture Garden, Smithsonian Institution

Thomas Eakins

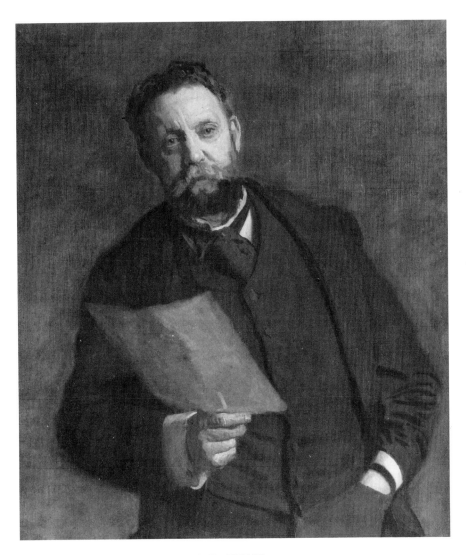

235. PROFESSOR LESLIE W. MILLER: DETAIL

led us to the conclusion that the man, whoever he was, couldn't be a great art-
ist, for we had learned somewhere that great artists painted only by inspira-
tion, a process akin to magic.

"Several months were thus consumed; then came a day, as we discovered
through the convenient knotholes, when another perspective drawing was
made and transferred to the canvas, on the floor and to one side. The letters
spelled Eakins. The name was not familiar to us."

This perspective drawing for the signature, "Eakins 1901," now in the
Hirshhorn Museum, is the only one surviving of presumably about twenty
such drawings for signatures inscribed on floors in his portraits. On paper,

drawn in ink and pencil, it is written in flowing Spencerian style. The signature and date were first drawn flat, then squared off, and projected in perspective. The final result was transferred to the floor in the painting, probably by tracing.

Miller, looking directly at us, with a friendly expression, wears a rumpled suit with a short jacket and wonderfully baggy pants—clothes which, he wrote me, "I never would have worn facing an audience." He stands in an easy, informal pose, his left hand in his pocket, his feet wide apart—a stance that gives a feeling that he could shift it at any moment, conveying a sense of vigorous life. The lines of his figure, bending somewhat toward the left, create a movement of forms more pronounced than in any of Eakins' previous standing portraits. The composition is deeper three-dimensionally than in earlier portraits with objectless backgrounds: the pictorial space extends back to the screen and then into the farther gallery. The different lines of direction are varied, almost imperceptibly: the screen is not exactly parallel to the picture plane, and its wing at the right produces another directional line, as does the receding wall of the gallery. Even the cast shadows on the floor follow different directions. These subtle variations were undoubtedly worked out in the careful preparatory perspective drawing described by Sheeler.

The color is quiet and limited in range, prevailingly warm and somewhat grayed, with light golden flesh tones and warm ocher and gray background tones, all subtly varied; there are no strong positive notes anywhere. In terms of the candy-box sweetness of much American painting of the time, the color could be called dirty, but it is a welcome dirtiness, a fine unsweetened color harmony. This is a painting austere in style, restricted in color, simple in its component parts, but strongly and sensitively constructed: a mellow creation, deeply satisfying not for any surface beauties but for fundamental design in form and space.

Eakins evidently gave the portrait to Miller, but he liked it well enough to borrow it seven times for exhibitions in the next six years. It was awarded the Proctor Prize at the National Academy of Design in 1905, and the Medal of the Second Class at the Carnegie Institute in 1907. On the latter occasion a reviewer, comparing it to Gaston La Touche's saccharin *The Bath*, which received the Medal of the First Class, wrote: "The sobriety of Thomas Eakins stands out in startling contrast. A critic says of him, 'he is long on psychology, but short on colour.'"

VI

In the early 1900s Eakins painted a series of portraits of the Catholic clergy. His youthful violent antiCatholicism had disappeared. In the 1870s he had known and liked Philadelphia's first archbishop, James Frederick Wood, and had persuaded him to pose for a full-length portrait. The archbishop,

among other achievements, had been responsible for building the Seminary of St. Charles Borromeo at Overbrook outside the city, the most important institution of Catholic higher education in the country's third largest diocese.

Although his anticlericalism had abated, Eakins remained an agnostic. Cardinal Dennis Dougherty, who as a young bishop had sat for a portrait in 1902, wrote later: "He told me he was a man who didn't believe in the divinity of Christ; whether or not he was an atheist I have not heard. He seemed to be an amiable character." His only religious work, *The Crucifixion*, was notable not for religious feeling but for its intense realistic picturing of a human being *in extremis*. But the fact that he had undertaken a subject so seldom attempted by his American contemporaries suggests an interest in religion not expressed in his written or oral statements.

This involvement with the clergy came about chiefly through Catholic-born Murray, who was receiving commissions for monuments to prominent prelates, and modeling portraits of the clergy, especially those connected with St. Charles Seminary. For several years, starting in the 1890s, the two artists often bicycled out to Overbrook on Sunday mornings to spend the day at the seminary. It was a pleasant ride of about six miles through Fairmount Park to the impressive stone building situated in open fields. They were cordially received and invited to stay for Sunday dinner. Eakins enjoyed the liturgy; "tradition has it," Evan Turner says, "that he was particularly fond of attending the late-afternoon service of Vespers and listening to the Seminarians sing the Latin chants." He also liked the way they waited on table for each other. For several years he lent *The Crucifixion* to the seminary.

His relations with the clergy were human rather than religious. The men he chose to paint were not parish priests but men of intellect and achievement: teachers, scholars, writers, editors, and administrators; several had studied in Rome. Many were of Irish birth or descent: four had been born in Ireland, three or four others were of Irish descent. In certain ways they were less puritanical than their Protestant counterparts. (He does not seem to have had friends among Protestant ministers, as he had in other professions, or to have painted any of them.) His preference for the Catholic clergy was perhaps linked to his alienation from the WASP social establishment of Philadelphia. And the traditional richness and beauty of Catholic vestments contrasted with the drab black and gray of middle-class laymen of the period.

In the early 1900s he painted fourteen portraits of thirteen members of the clergy; nine of these were done in 1902 and 1903. They included six full-length figures and three three-quarters or half-lengths. Two of the largest were of the successive apostolic delegates from the Vatican to the United States. Among his sitters were a cardinal, two archbishops, two bishops, two monsignors, two doctors, two reverends, and a mother superior. Seven were alumni of St. Charles Seminary, and four were or had been members of the faculty; on

the other hand, four had no connection with the seminary, except as visitors. Most were to go on to higher rank after he painted them; several had not yet been made monsignors. Bishop Edmond F. Prendergast was to become Philadelphia's third archbishop. Even more prophetic was his selection of Dennis J. Dougherty, still in his thirties and just appointed bishop of distant Nueva Segovia in the Philippines; he was to succeed Prendergast as archbishop of Philadelphia, and to be created cardinal—a career prefigured by his serious face and determined chin.

All of Eakins' portraits of the clergy were evidently done at his request, not commissioned. Dr. Hugh T. Henry, a leading Catholic scholar, wrote me in 1930: "You are doubtless aware that Mr. Eakins painted such portraits . . . simply out of love of his art, and not because his sitters requested him to paint the portraits. Certainly that was true in my case, for he asked me to sit for him, offered me the completed work as a gift, and only at my suggestion presented it to the American Catholic Historical Society. . . . I think it was true in the other cases. I understand that Mr. Eakins, in his late life, had received a bequest that made his living secure, and that he continued painting simply *con amore* of his art."

When he asked Dennis Dougherty to sit for his portrait, the newly created bishop said that he did not have much money and could pay only $50. Whether Eakins accepted it is not known. There is a tradition, though no proof, that he received $50 for the portrait of the rector of St. Charles Seminary, Patrick J. Garvey; but this does not seem in the character of either man.

The highest ranking prelate when painted was Sebastiano Cardinal Martinelli, second apostolic delegate to the United States, whose portrait was done at the cardinal's residence in Washington in the spring of 1902. Seated in a wood-paneled room, he wears the black robes of the Order of Hermits of St. Augustine, one hand holding the biretta of cardinal red. At the upper left appears an escutcheon, the Augustinian Shield. Two surviving perspective drawings with mathematical computations show how exactly the pictorial space was planned. In the keen, precise characterization of the Italianate face, and in depth of color and completeness of realization, this is one of the strongest in the series of Catholic portraits. Eakins gave it to the Catholic University of America in Washington, but exhibited it (as owned by the University) five times in 1902 to 1904; it was his most widely exhibited Catholic portrait.

Three years later, in the spring of 1905, Martinelli's successor, Archbishop Diomede Falconio, was painted, also in the Washington residence. Sixty-two, his career had been quite different. Sent from Italy in his early twenties as a missionary to the United States, he had become an American citizen and at twenty-six had been appointed president of St. Bonaventure College and Seminary—one of the youngest college presidents in American history. In the portrait he wears the silvery gray robes of the Franciscan Order. An escutcheon appears at the upper right. His grave, rugged face, strong in character, has

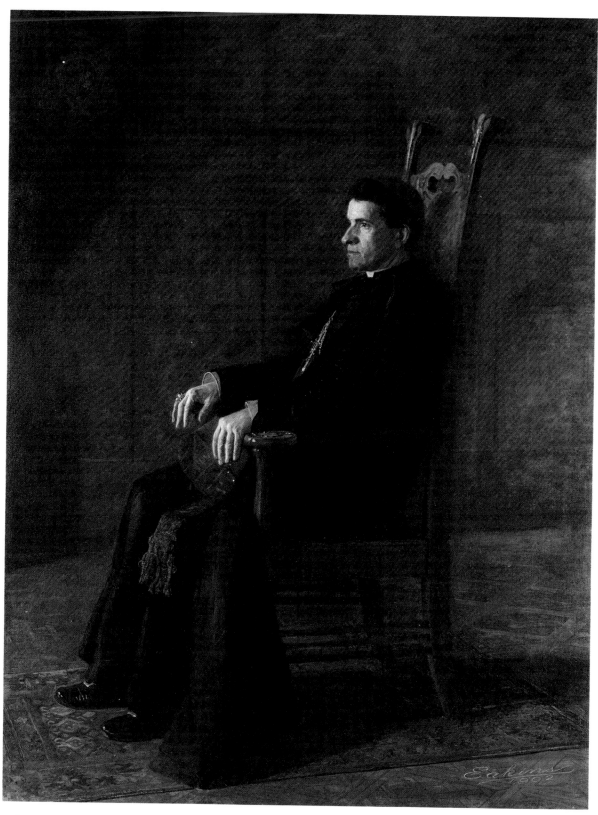

236. HIS EMINENCE SEBASTIANO CARDINAL MARTINELLI
1902. Oil. 79¼ × 60. G 361
The Armand Hammer Collection

237. ARCHBISHOP DIOMEDE FALCONIO
1905. Oil. 72⅛ × 54¼. G 425
National Gallery of Art; Gift of Stephen C. Clark, 1946

an expression of meditation and revery; one feels a presence. Aside from the face and hands, the figure is broadly painted, indeed not entirely finished, especially in the vestments. This is not felt as a defect; rather it makes one wish that Eakins more often left well enough alone. Clarence Cranmer told me that the picture was "almost finished, but Falconio never claimed it—didn't like it." It was the only one of Eakins' Catholic portraits that he did not give to the sitter or an institution. Although he placed on the back a Latin inscription, as he had on the Martinelli portrait, there is no record that he ever exhibited it.

The oldest ecclesiastic he portrayed was Archbishop William Henry Elder of Cincinnati, then eighty-four, a picturesque figure in the American hierarchy. As bishop of Natchez, Mississippi, from 1857 to 1880, he had endeared himself to the people of the state by his devotion and courage, especially during the Civil War and the Union occupation. In 1864 the federal post commandant had ordered that in all churches, prayers should be said for the President of the United States. The bishop refused to obey and was arrested, tried, and convicted; but the military court's decision was wisely overruled in Washington. Since 1883 he had been archbishop of Cincinnati. How he came to be painted by Eakins is not known; he had visited Overbrook only occasionally; the faculty may have suggested him as a subject. On December 15, 1903, Eakins wrote his former pupil Frank W. Stokes: "I have just finished in Cincinnati a full length, life sized portrait of the venerable Archbishop Elder which I did in one week." Two weeks later: "I think it is one of my best. Harrison Morris solicited it for our Academy [annual exhibition]." Shown in early 1904, it won the Academy's Temple Gold Medal. The archbishop is seated, clad in a black house cassock with violet sash and buttons, and wearing a violet biretta. His face is pictured with no evasion of his age; especially honest and fine is the painting of his misshapen old hands. Eakins presented it to Elder; after the latter died in October 1904, it passed from archbishop to archbishop in their official capacities.

Most of Eakins' Catholic sitters, like Martinelli, Falconio, and Elder, were depicted simply posing, and without accessories. But Dr. Henry, author, editor, hymnologist, and authority on church music, largely responsible for the quality of the seminary music, is shown in the robes of a doctor of letters, translating the *Poems, Charades and Inscriptions* of Leo XIII, whose portrait hangs on the wall. A Latin inscription speaks of the pope as *Cygni Vaticani,* the "Swan of the Vatican."

The Very Reverend John J. Fedigan, born in Ireland, provincial of the Order of St. Augustine in the United States and former president of Villanova College, stands with his hand resting on a drawing board with a rendering of the Monastery of St. Thomas he had built at the college. (The gray stone building, in the heavy-handed style of the 1870s, is painted with the veracity and exactitude of an Edward Hopper.)

One of Eakins' particular friends among the clergy was James Patrick Turner, of whom he painted two portraits. In the first, probably done about 1900 when Turner was secretary to Archbishop Ryan of Philadelphia, he is in plain black clerical garb: an intelligent, sensitive, homely man wearing pince-nez; the modeling of his head and hand makes this one of Eakins' most sculptural head and bust portraits. About six years later, after he had become vicar-general of the diocese and a monsignor, a full-length canvas pictured him officiating at a funeral in the Cathedral of Saints Peter and Paul, clad in red vestments, his plain unflattered face a few years older.

Eakins' Catholic sitters in general accepted their portraits with better grace than did many lay sitters. Perhaps their religion diminished personal vanity. The Reverend Philip R. McDevitt, superintendent of Philadelphia parish schools, wrote him: "Father Fisher is very much pleased with the picture" and asked if he could find time to see whether it was properly hung. Fedigan wrote: "I was up at the College and I saw the painting now hung in the Monastery and in better light I think tho of course I don't care where it is hung so long as I am not hung with it." When the portrait of Archbishop Elder was shipped to him in Cincinnati, his coadjutor Bishop Henry Moeller wrote Eakins: "The work is good and of a high order. Some who have seen the picture do not like the Archbishop's expression, but that was not your fault. You gave the Archbishop the expression he had while you were doing the work."

The only commissioned portrait of a prominent Catholic, a layman, was of James A. Flaherty, Grand Knight of the Philadelphia Council of the Knights of Columbus. Even though the Knights felt that the picture made him look too old and severe, their committee wrote: "We wish to extend to you our thanks for the life-like portrait which you have produced of that gentleman."

Different was the reception of the portrait of Dr. Patrick J. Garvey, rector of St. Charles Seminary. Born in Ireland, Garvey was a strict disciplinarian and a terror to many young seminarians. As even one of his colleagues wrote: "Dr. Garvey was not . . . a man of transparent amiability. His personality was complex and opaque. His glance was coolly appraising; his humor, acid. He was quick to puncture the pretensions of the self-important and the illusions of the ingenuous. . . . Somewhat forbidding in his outward appearance, he was capable of the most delicate thoughtfulness of others." These traits are apparent in the stern face recorded by Eakins. Murray wrote me in 1931: "Mr. Eakins admired Dr. Garvey very much and I think Dr. G. liked Mr. E. too, but had no appreciation of the kind of work Mr. Eakins did." After Garvey received the portrait he hid it under his bed, and for years it was assumed, even by Murray, that it had been destroyed. Not until 1959 did it come to light, in a closet of St. Michael's Church in Philadelphia, of which Garvey's nephew had been pastor.

A month after Garvey's death in 1908 Eakins wrote the Reverend Herman J. Heuser of the seminary: "I do not know that it is generally known that I

238. ARCHBISHOP WILLIAM HENRY ELDER
1903. Oil. 66⅛ × 45⅛. G 374
Cincinnati Art Museum; Purchase, 1978

239. REVEREND JAMES P. TURNER
About 1900. Oil. 24 × 20. G 347
Saint Charles Borromeo Seminary, Philadelphia

240. MONSIGNOR JAMES P. TURNER
About 1906. Oil. 88 × 42. G 438
Collection of the Mercy Catholic
Medical Center of Southeastern Pennsylvania

painted Dr. Garvey. I hope the painting has been found and hung in the seminary.

"I cared much for Dr. Garvey and feel his loss."

Mary Patricia Waldron, Mother Superior of the Convents of the Sisters of Mercy in Philadelphia and Merion, a remarkable woman, was pictured in a half-length portrait: in her late sixties, in the black and white robes of her order, seated, her hands clasped in front of her. Mother Patricia appreciated and accepted the portrait, and sent Eakins a small check (about $60) with a note: "Presented to Mr. Thomas Eakins. With kind regards and sincere thanks." But after her death in 1916 the sisters, who disliked the picture, got a Philadelphia painter, William Antrim, to paint "a more pleasing portrait," using a photograph they liked. They gave Eakins' portrait to Antrim, who used the stretcher and discarded the Eakins canvas in the attic of his studio. When the building was demolished, the canvas disappeared. All that remains is Eakins' small study in the Philadelphia Museum. In 1930, trying to find the portrait, and not knowing this history, I had a protracted correspondence with the sisters, who stated that the Antrim portrait was the only one they ever had. Their last letter concluded: "Hoping this information may serve to remove any mistaken ideas you may have formed on the subject, I remain, Sincerely, in J.C., Sister Raphael."

Another portrait which may have been disposed of was that of Bishop (later Archbishop) Edmond F. Prendergast. Again, a small sketch indicates that it was a half-length figure, in violet vestments, seated, his hands in front of him. In 1931 Murray told me that he had heard "from a reliable source" that it had been destroyed; he later wrote that it was "superb." However, since Murray also believed that Garvey's portrait had been destroyed, it is to be hoped that the Prendergast one may some day be found.

Non-art institutions do not always take good care of the works of art in their possession. When *The Crucifixion* was lent to St. Charles Seminary it was badly damaged and had to be repaired by Eakins and his former pupil Le Roy Ireland. The 1877 portrait of Archbishop Wood, a major early work, was, when I saw it at Overbrook in 1930, in fundamentally sound condition but needed cleaning. The seminary turned it over to an incompetent "restorer" who cleaned off the glazes and repainted the picture in house-painter style. In the 1970s Theodor Siegl, conservator of the Philadelphia Museum, who knew Eakins' technique better than anyone else, did everything that could be done; but the only uninjured parts are the hands and to some extent the face. What the painting would look like if it had been properly cleaned can be seen from the small brilliant study for it at the Yale University Art Gallery.

As early as the 1870s Eakins had placed Latin inscriptions on certain paintings: sometimes in the picture itself, as in *The Chess Players;* sometimes on the frame, as in *The Agnew Clinic;* more often on the backs. *The Crucifixion*

241. DR. PATRICK J. GARVEY
1902. Oil. 24 × 20. G 485
Saint Charles Borromeo Seminary, Philadelphia

had been inscribed on the verso: CHRISTI EFFIGIEM EAKINS PHILADEL-PHIENSIS PINXIT MDCCCLXXX. Altogether, eighteen paintings bear such inscriptions, which were usually executed in authentic Roman style, in capital letters, sometimes running the words together without punctuation, or sometimes running over from one line to another. In 1930 a plaster cast of a Latin inscription still hung on a wall of his studio.

Five of the Catholic portraits bear such inscriptions, giving salient facts about the sitters. In Latinizing the citations he probably called on the Reverend Herman Heuser, a distinguished professor at St. Charles Seminary, founder and editor of the *American Ecclesiastical Review.* In 1908, when Eakins was doing a portrait of Dr. Lucy L. W. Wilson, he wrote Dr. Heuser: "I am painting the portrait of a lady to give to her little son who is studying Latin. I would like very much if you would write in inscriptional Latin for me this sentence. 'Thomas Eakins painted this likeness of David H. Wilson's mother and gave it to him in token of affection.'"

18. Growing Recognition

FROM THE LATE 1890S Eakins began to receive growing recognition from the art establishment: juries, artists' societies, publications, and critics.

In 1896 the Carnegie Institute in Pittsburgh held its first large international exhibition of paintings. Eakins submitted three earlier oils: an 1870 rail-shooting scene, probably *Pushing for Rail, The Writing Master,* and *Home Ranch.* The last was rejected; the other two were accepted but for some reason not hung. (Winslow Homer's *The Wreck* won a top medal and $5,000.)

Though Eakins was not included in the next two internationals, he was in every succeeding show except one from 1899 through 1912. During those years he exhibited at the Carnegie more than at any other institution except the Pennsylvania Academy—usually recent and major works. In 1907 the Leslie W. Miller portrait was awarded the Medal of the Second Class and $1,000. (Besides the Medal of the First Class, given to Gaston La Touche's confection *The Bath,* there were four lower awards to artists now forgotten.) This was the first year except 1904 that Eakins could have received a prize, for in previous years he himself had been on the juries of awards, whose works "did not compete for honors."

On the other hand, several of his entries were rejected by the American juries of admissions, made up of fellow artists, which selected the shows after the 1896 one: *The Art Student* and *Music* in 1904; *Elizabeth R. Coffin* in 1911; and unidentified portraits in 1909 and 1913. The 1908 version of *William Rush,* now in the Brooklyn Museum, was rejected the year it was painted.

Beginning with the second international, the juries of awards, consisting of ten painters of whom two had to be Europeans, were elected by votes of the exhibiting artists, who received from the Carnegie Institute ballots listing fifty or so painters willing to serve. (For five years Winslow Homer received the highest number of votes; he served the first year but declined to do so again until 1901. Thereafter he refused to have his name put on the ballot.) Eakins served on the juries of awards five times—in 1899, 1900, 1901, 1903, and 1905

242. Thomas Eakins, October 1905
Photograph by Conrad Frederic Haeseler, Philadelphia
Museum of Art, Carnegie Institute, Pittsburgh

—more than any other artist in those years; a sign of growing respect from his fellow artists. Among his colleagues were La Farge, Blashfield, Chase, Alexander, Benson, Cox, Weir, Hassam, and Henri. When Homer was on the jury in 1901 it was the only time, as far as we know, that the two met. There is no record of what they said to each other—if anything, for both were men of few words.

In 1902 the National Academy of Design elected Eakins an Associate, on March 12; and two months later, on May 14, a full Academician—the only member, it is said, ever elected Associate and Academician in the same year. The first election was unanimous, the second by a large majority. The action was tardy, for most of his fellow members of the New Movement had long since been made Academicians: Homer in 1865, La Farge in 1869, Martin in

1874, and Saint-Gaudens, Shirlaw, and Weir in the 1880s. O'Donovan had become an Associate in 1878 and Bill Sartain in 1880; neither, however, were to become full Academicians. But Eakins had exhibited at the Academy only five times since 1882, and not at all from 1897 until 1902. Perhaps his two major paintings in the annual in early 1902, *Louis N. Kenton* and the *The Dean's Roll Call* (the latter illustrated as the frontispiece of the catalogue), had something to do with his election. From 1904 until his death he showed at the Academy every year except two; and at the Society of American Artists from 1902 until 1906, when the two bodies, no longer distinguishable, were merged. In the Academy's 1905 annual, *Leslie W. Miller* was awarded the Proctor Prize of $200 for the best portrait in the exhibition.

Academy Associates were required to give the institution portraits of themselves. His self-portrait (frontispiece to Volume I), painted when he was in his late fifties, is not only one of his finest head and bust likenesses, but a revealing human document; in the direct look of his remarkable eyes one can see strength, penetrating intelligence, and a touch of ironic humor.

As the years passed, his relations with the Pennsylvania Academy became less embittered, at least publicly. From 1901 he served four times on its juries of selection and hanging committees for painting. Despite his decided opinions on art, "he was a most tolerant man when on a jury," the Academy's curator Gilbert Sunderland Parker recalled. When all of John Sloan's entries were rejected in 1909, the young rebel noted: "Thomas Eakins' opinion is the only one on the jury that's worthwhile. I would like to know how he voted on them."

From 1894, Eakins exhibited in every Pennsylvania Academy annual thereafter throughout his life—more than anywhere else. The exhibits included his most important recent works, often three, four, or five at a time. In January 1904 the jury for the 73rd annual awarded him the Temple Gold Medal, one of the art world's top prizes, for the portrait of Archbishop Elder. Asked to come to the Academy to receive the medal from Edward Hornor Coates, who had requested his resignation in 1886 and who was now president, he appeared with Murray, both on bicycles and in cycling clothes. Murray told me: "I remember Mr. Eakins' exact words; he said: 'I think you've got a heap of impudence to give me a medal.'" He said to Murray, "Follow me." They rode up to the United States Mint; Eakins threw the medal down on the counter and asked, "How much can I get for this?" After some delay because of their suspicious appearance, the clerk gave him about $73. Returning home, he laid the money on a table and said, "Sue, here's my Temple Gold Medal."

In a more formal communication he wrote the committee on exhibitions: "I acknowledge the receipt of the Temple Gold Medal, and in thanking you assure you of my appreciation of the motives which led to the establishment of the prize."

In the first decade of the century Eakins' works were exhibited more

widely and generally than in any previous period. Besides the annual exhibitions of the Pennsylvania Academy, the Carnegie Institute, and the National Academy of Design, he was represented frequently in the Art Institute of Chicago and in exhibitions in St. Louis, Detroit, Minneapolis, and other Midwestern cities. When the Corcoran Gallery in Washington began its annuals and biennials in 1907, he showed in all of them. This expansion was in contrast to his meager exhibiting in the 1880s and early 1890s; it indicated a growing acceptance by the art establishment, and his own reviving interest in having his work seen by the public. Most of his major paintings were exhibited soon after they were finished, in some cases several times. And his pictures began to be illustrated in exhibition catalogues.

He was well represented in the huge international expositions that were becoming a popular feature of American life. At the Pan-American Exposition in Buffalo in 1901 he received his most important award so far: a gold medal for the 1886 portrait of Professor Barker. His former pupil the Canadian painter George A. Reid, who represented Canada on the jury, recalled: "At the closing meeting when the list of honours were being finally decided, I found that Eakins was being left out. I addressed the Jury and said that I had taken only a minor part in the awards to United States artists, . . . but as a pupil of Eakins I wanted to make an appeal for him, and prophesied that the day would come when his name would be among the leaders of American painters. Beckwith supported me and Kenyon Cox agreed. Eakins was put among the highest awards."

For the Louisiana Purchase Exposition in St. Louis in 1904 he was on the advisory committee for Philadelphia, and seven of his most important paintings were shown, including the *Gross* and *Agnew* clinics—the first time either of the big pictures had been in an art exhibition since the 1893 Chicago World's Fair. *The Gross Clinic* was given a gold medal, its first award, and the *Agnew* was illustrated full-page, with an explanation of the subject. On the other hand, in the 1901–02 South Carolina Inter-State and West Indian Exposition at Charleston, where gold medals were handed out to twelve American painters, silver medals to fifty, and bronze to eight, he received none.

So from 1900 on he was given a fair number of awards, of varying rank and importance: seven from 1900 to 1907. Compared to more popular contemporaries, they were fewer, and they came relatively late in his life. To none of them did he attach much importance, leaving the medals lying around the studio among his painting materials.

In 1908 he was elected to the prestigious National Institute of Arts and Letters, the American counterpart of the Institut de France. At this time there was an annual membership fee of five dollars. In reply to the notification he wrote the treasurer: "Although I had the honor of an invitation to join your Institute of Arts and Letters, I did not feel that I could afford to and made no application. Will you kindly scratch off my name?"

With his increased exhibiting and awards, the critics paid somewhat more attention to him. But the average reception remained much as before. In most exhibition reviews he was given only passing mention, not generally unfavorable, but only as one of many names. Paintings now ranked among his chief works were disregarded, merely mentioned, or subjected to carping criticisms —in contrast to the adulation heaped on popular favorites of the day. Typical was the comment by the *Art Interchange* reviewer of the Society of American Artists show in 1902: "Thomas B. Eakins' large portrait of Cardinal Martinelli is serious work, but has little distinction. The position of the hands is stiff and undignified." (This writer further distinguished himself by saying: "Albert Ryder . . . does scant justice to himself with the 'Siegfried' he shows here. The distribution of line, lights and shades gives the general impression of an octopus in a flurry. It lacks the breadth, subtlety and dramatic quality of Ryder's art.")

During Eakins' lifetime not a single article was published on him as a painter.

However, a few more intelligent younger critics were emerging, particularly in the American section of the London-based *International Studio*. One of its most perceptive reviewers was Charles Caffin, who at first was dubious about Eakins, speaking of his "prosaic style, direct and literal, with scarce a particle of suggestion," but who became more favorable, won over in particular by the Kenton portrait. In an article on contemporary American portrait painters in 1904 he praised Eakins more highly than any older portraitist, particularly his "masterpiece," *The Gross Clinic:* "There is no other painter in this country, few elsewhere, who could have treated the same subject at once so realistically and so pictorially."

The early 1900s saw the publication of the first general books on American art since those of G. W. Sheldon and S. G. W. Benjamin in the 1870s and 1880s. The earliest was Sadakichi Hartmann's two-volume *History of American Art,* 1902. He was the first to single out Homer and Eakins as leading figures of native art. In an expansion of what he had written about Eakins in 1897, he said: "We now come to that phase of art which was the realisation of what all the men since 1828 had struggled for, the beginning of a native art, and which is best represented by Winslow Homer and Thomas Eakins. Both are still working to-day, and their work has rather increased than lost in interest. . . . They asserted themselves long before the appearance of the so-called new school of 1878. . . . Nearly every one who looks at [*The Gross Clinic*] exclaims, 'How brutal!' And yet it is only the brutality the subject demands. Our American art is so effeminate at present that it would do no harm to have it inoculated with just some of that brutality. . . . Eakins, like Whitman, sees beauty in everything. He does not always succeed in expressing it, but all his pictures impress one by their dignity and unbridled masculine power. . . . His work may here and there be too severe to be called beautiful,

but it is manly throughout—it has muscles—and is nearer to great art than almost anything we can see in America."

Though Caffin did not include Eakins in *American Masters of Painting*, 1902, in his fuller *Story of American Painting*, 1907, he like Hartmann linked Eakins and Homer as leading realists. After discussing the realistic movement in France, particularly Courbet, and then Gérôme and Bonnat, he wrote: "Of both these men Thomas Eakins was a pupil. . . . [He] came back [from France] with an eye trained to precise observation, and a hand skilled in precision of drawing. In these particulars he is a master; beyond them he has shown no disposition to travel; he is as coldly and dispassionately analytical as Gérôme at his strongest, as unflinchingly exact as Bonnat. Under the former's influence he produced his masterpiece, [*The Gross Clinic*]. . . . Equally objective are the portraits of men. . . . One of the most remarkable examples is the *Portrait of Louis N. Kenton;* . . . a picture that in its matter-of-factness and in its disregard of the elegancies of line, and of the persuasiveness of colour and tone, might be charged with ugliness, but as the record of a human individual is extraordinarily arresting and satisfactory. Considered from the more general standpoint of a work of art, it might be the better for some of those tricks of grace in which our young students nowadays are drilled to be proficient. Let us grant it, but with the amendment, that here is an instance where a picture may be superior to a mere work of art; that there is in Eakins a capacity broader and deeper than that of simply being an artist. He has the qualities of manhood and mentality that are not too conspicuous in American painting."

Thus, after almost three decades of critical neglect or derogation since the days of his champions of the 1870s, Earl Shinn and William Clark, Eakins was beginning to receive his due.

But these affirmative opinions were still exceptional. The general art-establishment judgment was expressed by Samuel Isham, A.N.A., in his monumental *History of American Painting*, 1905, the most thorough survey so far. After devoting nine pages to Sargent, he gave half a page to Eakins as a product of the limited painting training of the École des Beaux-Arts, contrasted with the painterly training of Carolus-Duran, Sargent's teacher. "The consequence was much tedium for the sitters and much wofully prosaic work. Even when the work was admirable, as in the case of Alfred Q. Collins or Thomas Eakins, the lack of painterlike training told terribly. . . . Eakins with a like grasp of the personality of his subjects, . . . yet fails of the popular appreciation that he merits because of his neglect of the beauties and graces of painting. . . . The artist seems to say, 'Here is the man, what more do you want?' but the paint is apt to be laid on inelegantly. . . . The eye longs for beauty of surface, richness of impasto, or transparent depths of shadow. . . . Compare his work with that of Beckwith and see how much more effective was the training given by Carolus-Duran."

Even though recognition came late and was less than that given to more popular painters, Eakins evidently was not indifferent to it. Following his awards and jury services in the early 1900s, he produced many more works than he had in the 1890s. Particularly in 1903 and 1904 he painted about twice as many pictures as in his most productive previous years: in 1903, about twenty-five; in 1904, about twenty-seven. After 1904, when he had passed the age of sixty, his output returned to more usual numbers.

With very few exceptions his works of these years were portraits. Although a considerable proportion of the increase consisted of head and bust canvases, these years also saw some of the best of his larger portraits: in addition to those of Mrs. Frishmuth, Kenton, Miller, and the Catholic clergy, were those of Mrs. Greenewalt, William Kurtz, Hedda van den Beemt and Samuel Myers (*Music*), Rear Admiral Melville, Professor Forbes, John B. Gest, A. W. Lee, Elizabeth Burton, and Helen Parker (*The Old-fashioned Dress*). In this culminating phase of a creative career of forty years, he showed undiminished vitality.

Next to *The Agnew Clinic* the most congenial major commission he ever received was for a portrait of venerable William Smith Forbes of Jefferson Medical College, professor of anatomy and clinical surgery for twenty years. In 1867 Forbes had been the chief author of the Anatomy Act of Pennsylvania. The surgical butchery he had witnessed in military hospitals during the Crimean War in 1855 and the American Civil War had convinced him that most surgeons did not know enough anatomy, through a lack of adequate material for dissection. He had been appointed, along with Gross and Agnew, to draw up the act—one of the best in the country, and a model for many similar laws.

The portrait, painted in the spring of 1905, was presented to Jefferson Medical College by the classes of 1905–1908. Probably as with *The Agnew Clinic* the committee expected a conventional portrait, but Eakins produced a composition which, like *Agnew* and *Gross*, pictured the professor in an amphitheater lecturing to his students, who sit on rising tiers of benches. His left hand rests on a copy of the Anatomy Act; beside it is a human skull. On the amphitheater wall a Latin inscription, represented as if carved in the wood, outlines his part in the act. He is a portly old gentleman, almost bald, wearing a formal suit, starched wing collar, and highly polished shoes: a dignified elder portrayed with a sense of his past achievements. Especially moving is the painting of his old hands. The portrait has a mellowness quite different from the drastic realism of the Gross and Agnew paintings.

A category of sitters unusual for Eakins was that of military men, a few of whom he painted: handsome General Cadwalader in 1880; Joseph Lapsley Wilson, Captain of the fashionable First City Troop of Philadelphia, in 1895; and Colonel Alfred Reynolds, cousin of Susan Eakins, in 1905.

243. PROFESSOR WILLIAM SMITH FORBES
1905. Oil. 84 × 48. G 422
Medical College of Thomas Jefferson University, Philadelphia

244. WILLIAM B. KURTZ
1903. Oil. 52 × 32. G 378
Mr. and Mrs. Daniel W. Dietrich II

In 1903 a new commandant of the League Island Navy Yard in Philadelphia was appointed: Rear Admiral Charles D. Sigsbee, who had been captain of the *Maine* when she was blown up in Havana Harbor in 1898, and who had been advanced three numbers in rank for heroism on that occasion. He also had invented new methods and apparatus for deep-sea exploration and had written a book on the subject. Eakins may have met him through their mutual friend Mrs. Willard Parker, whose daughter Helen was to be the subject of *The Old-fashioned Dress*. The year he was appointed Eakins asked him to pose, did a head and shoulders portrait in the League Island barracks, and gave it to him. Sigsbee responded: "I have intended writing you concerning the portrait. I have delayed chiefly because I desired to get criticisms of my friends. Please let me say that there is one judgment that is common to all:—'The man who painted that picture is an *artist.*' . . . The possession of a work from your brush gives me great pleasure. I had no idea until you gave me the picture that it was intended to be a gift. I feel very piratical in accepting so much of your time and talent. Just the same I shall continue to be very proud of the gift. . . . I expect to remain at League Island for some time yet, and trust you will understand that my latch-string trails your way."

It may have been Sigsbee who suggested as a subject another rear admiral, and a picturesque one: George W. Melville, naval engineer and member of three Arctic expeditions. He had been chief engineer of the ill-fated *Jeannette* expedition of 1879–1881, when the ship was caught in the ice for twenty-one months and finally crushed. In command of one of three small boats, he had brought his men safely to the continent of Asia, then returned to search for his shipmates but found only their bodies. His book *In the Lena Delta* had told the story in clear, forceful language. For his heroism Congress had awarded him a gold medal and advanced him fifteen numbers. As Chief of the Bureau of Steam Engineering, he had superintended the designing of engines for 120 ships, introducing many innovations. He had retired in 1903, at sixty-two. A man of extraordinary courage and physical strength, he was an imposing figure, over six feet, with a massive body, leonine head, and long white hair and full beard.

In September 1903 a Mr. George C. Stout of Philadelphia wrote Colonel Thomas A. Prince, U.S. Marine Corps: "Do you know Melville well enough to give a letter of introduction to him to a friend of mine who is, I think, the best portrait painter in America, and who wishes to paint the Admiral without cost. He has painted two of our most famous paintings of surgical clinics in Philadelphia, has also painted Sigsbee and a number of other notables. I shall be very glad to help him get at Melville if I can. . . . The painter's name is Thomas Eakins. Will you send the letter to me?"

Eakins did two portraits of Melville. In the first he stands turned somewhat left, in full dress uniform, his epaulets and collar bearing the two stars of a rear admiral, his chest decorated with three medals, including the one awarded by

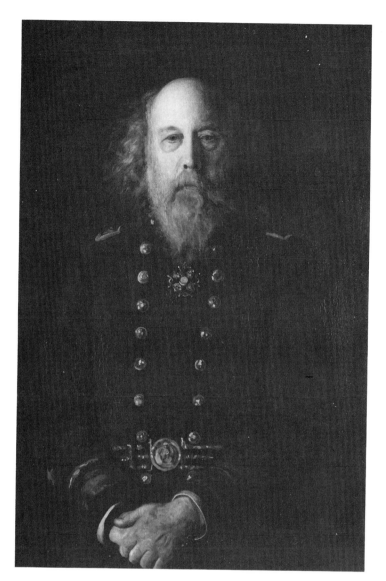

245. REAR ADMIRAL GEORGE W. MELVILLE
1905. Oil. 40 × 27. G 420
Private Collection

Congress. His head is magnificent, but the rest of him is less impressive; for one thing, he has a definite paunch, which his pose does nothing to minimize; his left hand in his belt is formless; and his epaulets and medals are too obviously conspicuous—a display uncharacteristic of Eakins.

Perhaps because of these shortcomings, the next year Eakins painted a second, somewhat smaller portrait, also not commissioned, picturing him full-face, his strong rough hands clasped in front, his epaulets replaced by simple shoulder straps, and only a single medal, the order of St. Stanislaus, the high

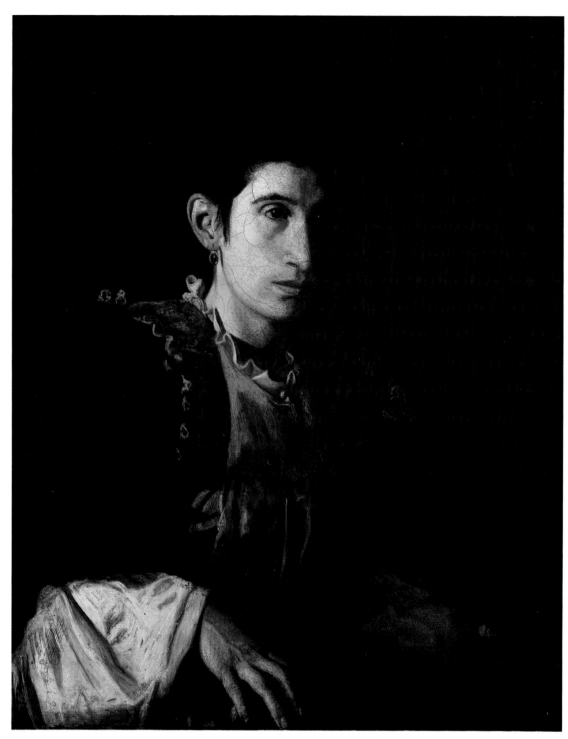

246. SIGNORA GOMEZ d'ARZA
1902. Oil. 30 × 24. G 360
The Metropolitan Museum of Art; George A. Hearn Fund, 1927

247. SIGNORA GOMEZ d'ARZA: DETAIL

Russian order. The concentration now is on the hands and the remarkable face, with high domelike forehead, flowing hair, and somber, brooding eyes fixed on us. This figure, looming out of the dark background, has a phantasmal presence. It is one of Eakins' most romantic portraits. He seems to have preferred it: he showed it in the 1907 annual exhibition of the American Art Society, Philadelphia, where it appeared as number one in the catalogue, was illustrated on the first page, and was awarded the Society's Gold Medal. The first portrait was probably not exhibited until some years later, in 1912.

From 1900 to 1910 Eakins painted only about a third as many women as men. The fourteen Catholic portraits accounted in part for the preponderance of males. The female portraits, however, included some outstanding ones, such as those of Mrs. Frishmuth, Addie, Signora d'Arza, Mrs. Greenewalt, Mrs. Mahon, Elizabeth Burton, Miss Pue, and Helen Parker.

Mary Hallock Greenewalt was a distinguished concert pianist and a pioneer in correlating sound, light, and color; she was later to design an instrument with a pianolike keyboard which varied the color and light during a musical performance. She was thirty-two when Eakins painted her in 1903, a

beautiful dark woman with a strong, intense face, gazing directly at us; her rose-violet silk gown, low-necked and sleeveless, leaves bare her shoulders and arms and chest. The superb lines of her body, running from her hands lying in her lap up through her arms and shoulders to her strong head, create a sequence of flowing forms modeled with the utmost largeness and plasticity. This is one of Eakins' most sculptural portrayals of the human figure, either clothed or nude. Such a portrait does not need rosy flesh or false glamour. His admiration for her (and hers for him) is manifested also by the fact that he recorded her name in a Latin inscription on the back of the canvas: one of only two for his portraits of women.

Elizabeth L. Burton was an artist, probably in her middle twenties; the Burtons lived next door to the Eakinses. The portrait of her, done in 1906, is a little under life-size, unusual for Eakins. Her face is somewhat homely but characterful; her strong hands are very alive. Evidently a young woman of decided spirit, as her letters prove. When the painting was acquired by the Minneapolis Institute of Arts in 1941, the museum bulletin published some unflattering comments on her looks, mentioning her "ungainly hands." She wrote the Institute: "I am not a vain woman and what you say of the plainness of my face I have always recognized. But . . . 'ungainly hands' I must protest. I have an unusually large thumb for a woman of my size—developed by much hard work in drawing and modeling."

The sittings lasted some time and were interrupted; then she married Alexander Johnston and went to live in the Far East, British North Borneo. So the picture was not quite finished—but none the worse for that. After she left, Eakins gave it to her mother. "His way of giving the portrait was equally characteristic of his generous, loving heart," Mrs. Johnston wrote in 1935. "After I had gone so far away to live, Mother wrote me that Mr. Eakins appeared at our home one afternoon with the picture under his arm, handed it to her and said with his usual gentle simplicity, 'I thought you might like to have it Mrs. Burton, now that Elizabeth has gone.'"

Eakins wrote her in June 1907: "I am sorry the portrait was never finished but it was not your fault nor mine either. . . .

"I take it that the portrait I painted of you is half mine and half yours. I have given my half to your mother.

"I wish I had had two or three more sittings on it so that I might have pulled it together more, but your mother will excuse any artistic shortcomings, and will only consider the likeness. . . .

"Our whole Spring has been wet and cold, but now it is real summer. I suppose your climate is hot, perhaps hot and moist.

"I suppose you might go in to swim without much of a bathing suit.

"Susie wishes to be remembered."

At sixty-three he had not lost his interest in female nudity.

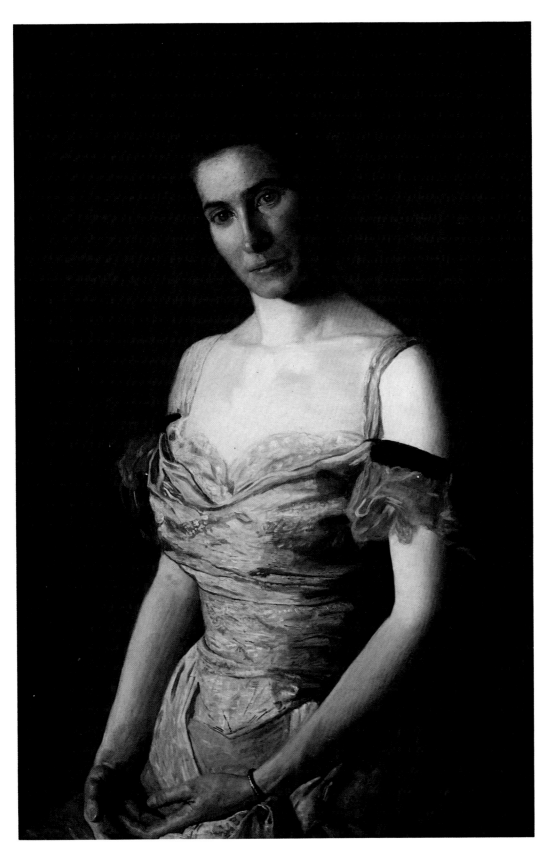

248. MRS. MARY HALLOCK GREENEWALT
1903. Oil. 36 × 24. G 380
Wichita Art Museum, Wichita, Kansas; Roland P. Murdock Collection

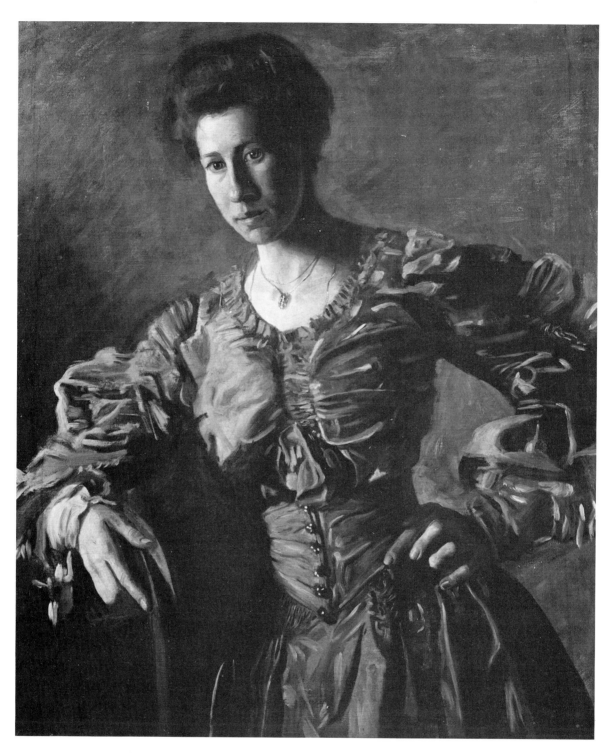

249. MISS ELIZABETH L. BURTON
1906. Oil. 30 × 25. G 428
The Minneapolis Institute of Arts; The William Hood Dunwoody Fund

In the course of his career Eakins painted about 145 medium-size head and bust portraits: head and shoulders only, without hands or accompanying objects, and against empty backgrounds—in other words, portraits of heads. Their usual size was twenty-four by twenty inches. These 145 or so amounted to about a third of his total lifetime production of finished oils. In the 1870s there had been about 10, in the 1880s about 12, in the 1890s about 40. In the decade of 1900 to 1910 their number more than doubled, to about 85. Particularly in 1903 and 1904 he produced about 37.

Except for a very few commissioned ones, these head portraits were mostly of friends, acquaintances, relatives (his and Susan's), and his pupils and ex-pupils. He asked almost all the sitters to pose, and gave (or offered) them the portraits. Hence in general they were personal documents, tokens of friendship, and many were inscribed "To my friend." Within their limits of modest size and simple composition they include some of his finest portrayals of character.

The quality of these head portraits depends to a considerable extent on the qualities of the sitter: his or her character, mind, occupation, and looks; and still more on Eakins' empathy with the man or woman. Although few of the sitters were eminent, with many their qualities and their relations with him were such as to call forth fully his gifts of understanding and revealment. To mention only a few: Benjamin Eakins, Susan, Addie, William Macdowell, James P. Turner, Clara Mather, Mrs. Mahon, Louis Husson, Mrs. Douty, and Dr. and Mrs. Parker.

But these personal qualities were less present in many sitters for his head portraits of the 1890s, and the more numerous ones of the 1900s. They were good people, who interested him enough for him to ask them to pose; but too often they were not out of the ordinary in themselves or in his relations to them. His selection of them was often casual; sometimes on first meeting a person he would ask him or her to sit. They were portrayed with his habitual honesty and command of character, but otherwise they were not particularly interesting as subjects. His choice was limited too much to his immediate personal environment.

The head portraits of these later years have an element of repetitiveness, of formula: similar poses of head and shoulders, similar lights and shadows, similar blank backgrounds, and the same size canvases. Though often masterfully painted likenesses, they have no further interest as compositions, as more complex works of art. They present no exploration of new themes or forms, no creative inventiveness. There was no loss of skill or strength, only a strict limitation in scope. He was concentrating on producing good character studies: a kind of routine exercise, as if to keep his hand in, like a musician practicing scales.

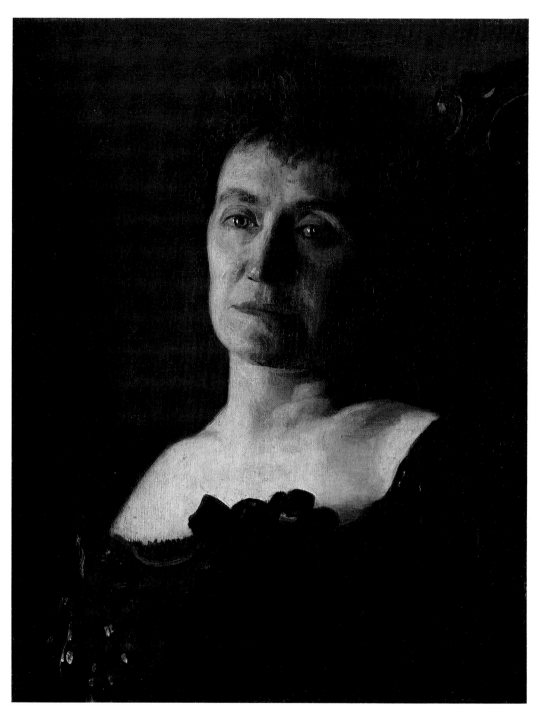

250. MRS. EDITH MAHON
1904. Oil. 20 × 16. G 407
Smith College Museum of Art, Northampton, Massachusetts

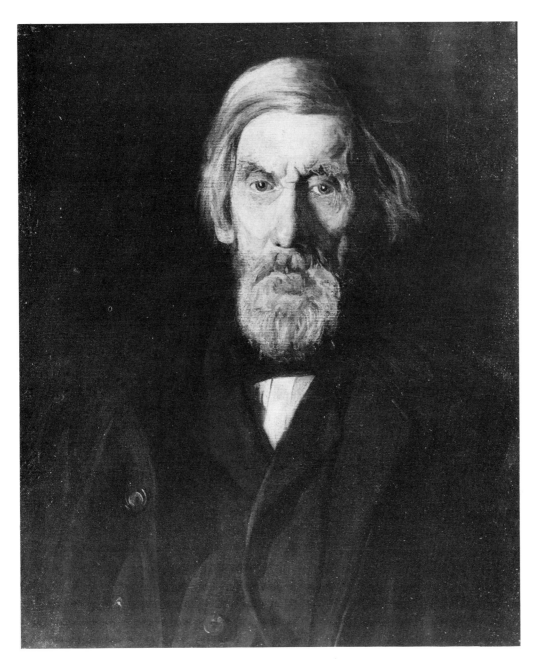

251. WILLIAM H. MACDOWELL
Probably 1904. Oil. 24 × 20. G 416
Memorial Art Gallery of the University of Rochester;
Marion Stratton Gould Fund

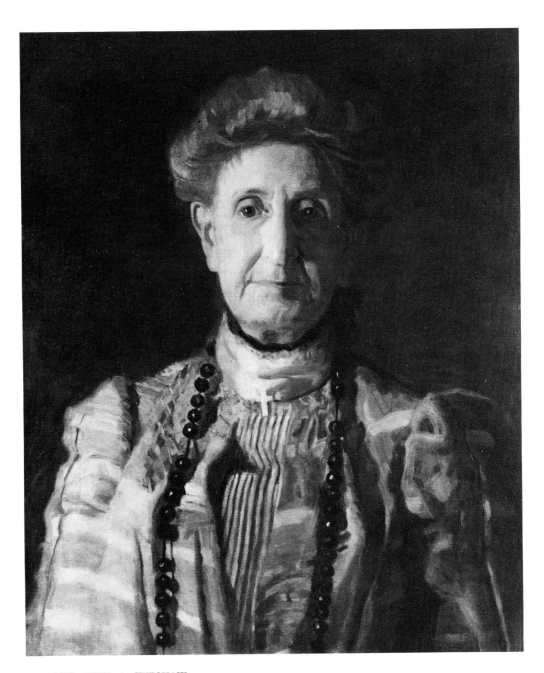

252. MRS. ANNA A. KERSHAW
1903. Oil. 24 × 20. G 382
Private Collection

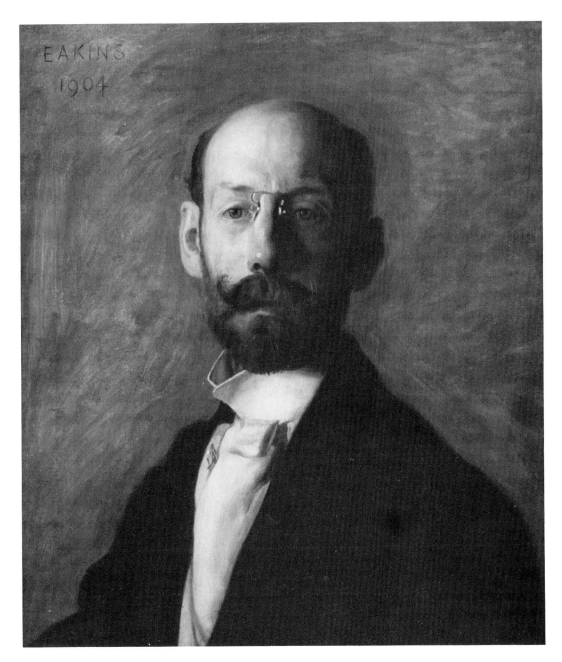

253. FRANK B. A. LINTON
1904. Oil. 24 × 20¼. G 406
Hirshhorn Museum and Sculpture Garden, Smithsonian Institution

His continuing desire to paint these head portraits, his constantly asking people to pose, had reached the dimensions of an obsession. He no longer had to worry about making a living; he was free to paint anything he wanted to. One remembers his early genre scenes; the outdoor pictures of rowing, sailing, hunting; the historical and Arcadian subjects; *The Swimming Hole;* the prizefighting pictures. One asks: why not more works calling on his mastery of the whole human body—not just the head? It is sad to see such powers expended on such limited material.

He was of course relatively elderly when he painted the majority of these head likenesses; he was sixty in 1904. But think of Monet in his middle seventies beginning his great water-lily series; of Renoir at the same age combating arthritis and launching himself into sculpture; of Homer producing his greatest marines and most brilliant watercolors in his sixties and seventies.

IV

William Merritt Chase was the chief teacher at the Pennsylvania Academy school from 1896 to 1909. Six years younger than Eakins, Chase was his opposite in every respect. Versatile and eclectic, he painted many aspects of American life, indoors and outdoors, with a keen eye and a skillful brush. He was a phenomenally active, popular teacher, not only in Philadelphia but in New York and at his Long Island summer school; a leader of the New Movement, and president of the Society of American Artists from 1885 to 1895, years during which Eakins, repeatedly rejected, had finally resigned. In person he was a dandy, with carefully tended moustache and Vandyke beard, gold-rimmed pince-nez with a flowing black ribbon, cutaway, spats, top hat, and always a fresh carnation in his buttonhole.

Samuel Murray told me that Chase cautioned his students not to paint like Eakins, holding him up as a "horrible example" of trying to "model in paint"; he repeated this accusation in a letter to Henry McBride. On the other hand, Harrison Morris, who knew Chase well, wrote: "We never heard him utter a hard word about a fellow artist or his work." In Murray's statements I suspect a pro-Eakins, anti-Chase bias.

In any case, the two painters were friends. Eakins gave Chase his large unfinished *Sailing* of the 1870s, inscribing it "To his friend William M. Chase / Eakins," and the 1883 oil *Arcadia,* also unfinished. According to Murray, Chase was often in Eakins' studio. He was a crack shot with the revolver, as was Eakins. Murray said they rigged up a shooting gallery in the cellar, with an iron sheet to stop the bullets. The sportswriter Clarence Cranmer told me the same story; he heard that Chase could hit a fifty-cent piece at fifty paces.

About 1899 Eakins and Chase painted each other's portraits and exchanged them. Eakins' of Chase, inscribed "To my friend William M. Chase," is a head and shoulder likeness. With his trim beard, carnation, glasses, and black rib-

254. WILLIAM MERRITT CHASE
c. 1899. Oil. 23⁷/₈ × 20. G 330
Hirshhorn Museum and Sculpture Garden, Smithsonian Institution

bon, he looks successful, complacent, and a bit pretentious. There is none of the brio of Sargent's portrait of Chase the dashing technician holding his palette and brush, painted about three years later. Chase kept the three canvases that Eakins gave him. But Chase's portrait of Eakins, it seems beyond doubt, was later destroyed by Mrs. Eakins.

Eakins' opinion of Chase as an artist and a teacher had reservations. For John Singer Sargent he had a more unqualified admiration. And Sargent, thirteen years his junior, had at least heard of Eakins, and seems to have respected him. In May 1903 he spent four weeks in Philadelphia, staying with his friend Dr. J. William White, whom Eakins had pictured fourteen years earlier in *The Agnew Clinic* as Agnew's chief assistant. White was not only a leading surgeon, successor to Agnew at the University of Pennsylvania, but an amateur athlete, boxer, and swimmer, a bon vivant, and a host to celebrities, including artists. For Sargent this visit was a busy time, fulfilling portrait commissions and being wined and dined. Asked by his hostess what Philadelphia artists he would like to meet, he said, "There's Eakins, for instance." The reply was, "And who is Eakins?"

Murray told me that Sargent and Eakins had mutual admiration and saw much of each other in Philadelphia; that Sargent was often in Eakins' studio; that they were to paint each other's portraits, but that one day when the younger artist was in the studio a cable was brought to him, and he said that a member of his family was ill and he had to return to England. Murray also told Margaret McHenry that the two painters used to explore the foreign quarters in South Philadelphia, admiring the beauty of the young Jewesses and Italians. Like many of Murray's stories, all of this has to be taken with a large grain of salt. Mrs. Eakins told me that she did not remember ever meeting Sargent and did not think he came to the Mount Vernon Street house (where Eakins' studio was after 1900). Sargent's stay in the city was a crowded one, painting portraits of Mr. and Mrs. Joseph Widener, Dr. S. Weir Mitchell, James Whitcomb Riley, and other notables; and being lionized. At the end of the four weeks Dr. White wrote his future biographer, Agnes Repplier: "I have lived in what seems to have been a whirl—though a pleasant one—for a month. Sargent came here four weeks ago today, and goes to New York this afternoon, to sail on Saturday for Gibraltar. . . . There have been dinners, and late hours, and less exercise than usual. . . . His work here has been splendid. Mitchell's portrait is superb; but he, Sargent, thinks (and Thomas Eakins, John Lambert, and other artists agree with him) that the best thing he did in Philadelphia is an oil sketch of Mrs. White." Instead of returning to England, as Murray said, Sargent sailed for Spain, to relax and paint watercolors. His three months in America (the first two in Boston and Washington) had produced about twenty portraits, which are said to have earned him around $60,000.

Next spring, that of 1904, Eakins began a portrait of Dr. White, evidently

Thomas Eakins

not a commission. The surgeon was a busy man, and about to go abroad. On May 2 he wrote: "Every minute of my time in the interval will be taken. I'll be glad to see you in the morning, but I feel sure that it w'd be nicer to wait until fall, & start afresh then.

"I don't *think* that this time you've done what you started to do—though, of course, my opinion is not worth much."

The sittings were not resumed, however, and in 1905 Eakins sent the portrait as a gift to Sargent in London. The latter wrote him in February 1906: "My dear Eakins, I don't know how long it is since your portrait of Dr. White has been here, nor how long my thanks have been overdue. Please accept them now that I have returned from a six [?] months' absence and found the picture which gives me great pleasure. It is a capital likeness of a great friend and a specimen of your work which I am delighted to possess. I also bear in mind your kindness in wishing to offer it to me. Yours cordially, . . ."

Not having Eakins' address, Sargent forwarded this letter to White, who wrote Eakins: "I was surprised to find that you had sent the portrait without taking another turn at it. I feel sure that—as a portrait—you could have improved it. So far as the technique goes I am not a competent judge, although my impression is most favorable. I could not, however, bring myself to like the exact expression you had given me, and hoped that you would be able to change it a little. Perhaps, however, I am entirely wrong about this and you may be right. . . . I am afraid I may have seemed unappreciative, and I certainly should have made more effort to give you the extra sittings that I felt you could use to advantage. . . . You have at least been spared the further infliction of my visits."

The portrait has disappeared. In 1930 I wrote Sargent's sister Emily, and Christie's of London, who had made the inventory of Sargent's property after his death in 1925, but they had no record of it.

<center>V</center>

In the 1900s Eakins kept up his outdoor life, though less strenuously than in youth and early manhood. A bicycle was still his favorite means of transportation in the city and surrounding country. He was now part-owner of the boathouse on Cohansey Creek, shared with his father's friends George Morris and William Hallowell; and he and Murray went there often on Sundays. Murray recalled to Margaret McHenry that on hot summer nights Eakins would open the doors and sleep naked on a cocoa mat, oblivious of who might be passing.

By his late fifties he had put on a good deal of weight. Like many men who have led active physical lives in earlier years, he neglected his body in middle and old age. He had always had a big appetite. Murray told me that he used to drink an enormous amount of milk, a quart with every meal (which seems physically impossible) and eat two or three spoonfuls of sugar before a meal.

Even Mrs. Eakins admitted, "There was a time when Mr. Eakins was quite stout." Once when he and Murray were setting off on bicycles, Eakins' rear bulging over the seat, she drew a caricature of them on the blackboard; they photographed the drawing, and Miss McHenry used it as the frontispiece of her book. Nevertheless he remained a powerful man. Mrs. Nicholas Douty recalled that when he was painting her portrait in 1910 he used to climb the four flights of stairs to the studio every morning with two scuttles of coal.

Few artists have been so extensively photographed as Eakins: young, middle-aged, and old; clothed, in a bathing suit, and nude. Everyone around him seems to have used his camera. Murray showed me several photographs (most of them now in the Hirshhorn Museum) of Eakins, Murray, and George Morris bathing in front of the boathouse, all three naked: Eakins heavy but strong, with a big belly; Morris white-haired, with a great nose; Murray comparatively slim. In one photo Eakins turns to look back at the camera with a broad grin; in the next he strides into the water with a huge splash.

David Wilson, son of Eakins' friend Lucy L. W. Wilson, remembered that about 1908 the Eakinses and Murray and his fiancée, Jennie Kershaw, would visit the Wilsons' country place and swim in their private pool; and that after everyone had retired to dress, Eakins would return, pull off his bathing suit, and swim alone, naked. Mrs. Eakins told me that once when he and she were walking in Fairmount Park they came upon a lot of boys swimming naked. Eakins posted himself as a lookout to warn them if the cops came.

In portrait photographs of the 1900s his face has become heavy, with deep folds around his determined mouth with its full projecting underlip. His close-cropped disorderly hair and sparse beard and moustache are grizzled but not yet white. His dark eyes look at us directly, impassively, as if weighing us, and without illusions.

Several people with whom I talked, particularly women, described his appearance at this age unflatteringly: "like a bear"; "rough, like a St. Bernard dog"; "like a gorilla"; "'that thick' through"; "when he sat down he sat down all of a heap." Even Mrs. Addicks described him as "sallow, with stubby gray hair, a fat belly, ugly; he *looked* dirty, though he wasn't. He was not attractive to women." Several persons who had not known him in his younger days were not aware that he had been an active outdoor man; he seemed sedentary and soft to them. But most of these people were women, young when they knew him, speaking about a man twice their age; and some of them were quite conventional.

19. Later Portraits

EAKINS' GROWING REPUTATION in the early 1900s brought some increase in portrait commissions. From 1902 to 1905 he received commissions for ten portraits: in 1902 John Seely Hart, deceased, from a photograph; in 1903 Walter Copeland Bryant and James A. Flaherty; in 1904 Robert C. Ogden, Mrs. James G. Carville, and Mrs. Kern Dodge (two versions, the first being found unsatisfactory); in 1905 Professor Forbes, John B. Gest, and A. W. Lee. Except for the Ogden, Forbes, Gest, and Lee portraits, these were head and bust likenesses. We do not know what he was paid for most of them; judging by his known prices, probably a few hundred dollars.

On the other hand, in sales, as distinct from portrait commissions, there is no record of a sale from 1897, when *The Cello Player* had been bought for $500, until 1914—seventeen years. Before 1900 his highest known asking price for paintings had been $1,200, for *The Crucifixion, The Pathetic Song,* and *Salutat,* none of which had been sold. In 1900, probably encouraged by increasing recognition, he priced *Between Rounds* at $1,600, but found no purchaser.

In portrait-painting a singular episode occurred in 1904. The painter Frank Wilbert Stokes, who had been a pupil of Eakins in 1878 and later of Gérôme, was a specialist in scenes of the Arctic and Antarctic, more interesting as meteorological documents than as works of art. For many years he lived and worked in New York, at 3 Washington Square North, where several artists were fellow tenants, including Edward Hopper for fifty-four years.

In the summer of 1903, when Stokes was calling on his former teacher in Philadelphia, Eakins offered to paint his portrait, and gave it to his mother; he then painted Stokes's mother and gave him the portrait. While the first was being done, the two men discussed Eakins' prices, and Stokes advised Eakins to ask much higher ones. He also felt that Eakins should paint more New Yorkers and suggested his patron and benefactor, Robert Curtis Ogden, partner of John Wanamaker and head of Wanamaker's big New York department store. Ogden, a native of Philadelphia, sixty-seven, was a philanthropist, con-

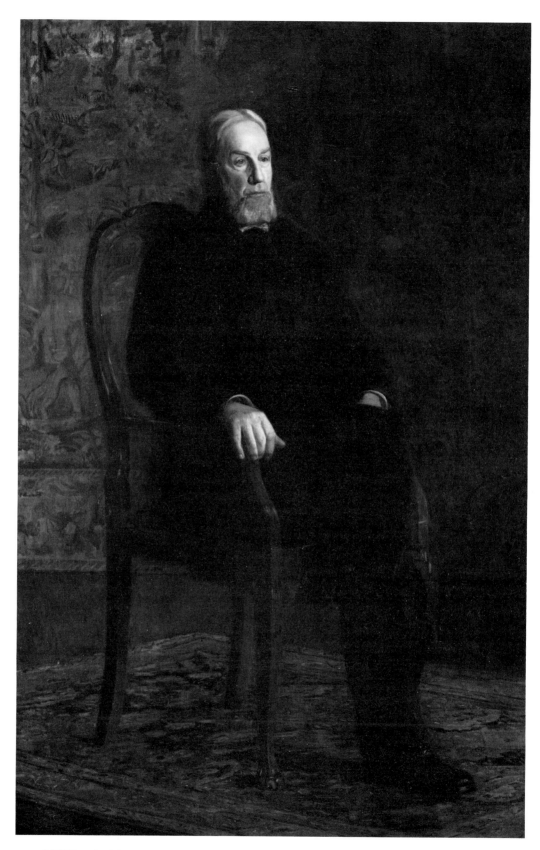

255. ROBERT C. OGDEN
1904. Oil. 72¼ × 48⅜. G 394
Hirshhorn Museum and Sculpture Garden, Smithsonian Institution

cerned particularly with Negro education in the South: president of the Southern Education Board and of the board of trustees of Hampton Institute, trustee of Tuskegee Institute, a director of the Union Theological Seminary, and author of *Sunday School Training*. Altogether, a public-spirited, worthy gentleman.

In December 1903 Stokes reported to Eakins that he had "succeeded in obtaining [Ogden's] consent to sit for his portrait here in New York, and you are to paint it at your regular price. . . . I am delighted to be able to write that I have succeeded for I believe that you will make a fine portrait of this truly noble man and noble subject." He offered Eakins the use of his Washington Square studio.

Eakins replied: "I am very grateful to you for getting me an important portrait to do, and not less for allowing me the use of your studio. I think maybe I wont be too much in your way." Two weeks later, reporting that he had written Ogden for an appointment to arrange sittings, he repeated: "I am very thankfull to you for getting the commission."

The full-length portrait, painted between mid-January and mid-March 1904, shows Ogden in a sober black suit, seated against the background of a tapestry, with an Oriental rug under his feet. (Evidently Eakins wanted to provide a setting befitting a merchant prince.) His face, with a long nose, determined mouth, white hair, clean-shaven upper lip, and square beard, is that of an old-fashioned businessman: one of Eakins' strongest characterizations, if in no way ennobled.

Eakins took special care with preparations and execution. Stokes told me in 1930 that before the sittings began, Eakins placed the chair in position and drew the whole composition in perspective. He painted his usual small oil study, which he later gave to Stokes. The painter Gifford Beal recalled that he saw Eakins painting the full-size canvas, and that he had drawn squared chalk lines on the tapestry so that Ogden's head could be located against it exactly, and that on the wall facing the sitter he had drawn a small square with diagonals on whose intersection Ogden was supposed to keep his eyes fixed. (When I published this in my 1933 book on Eakins, Mrs. Eakins objected, writing: "Eakins never used any such methods"; Murray and Bregler also protested. If he did in this case, it was evidently exceptional.) After working on the full-size portrait, for some reason he became dissatisfied with it and painted a second version.

Ogden, who had had to be persuaded by Stokes to pose, seems to have disliked the portrait almost from the start. Stokes told me that Eakins would not let Ogden see it while it was being painted, but that one morning Ogden walked past the easel, looked at it, and said, "Nobody ever looked like that." Eakins said "Sit down!" Ogden laughed and obeyed.

Then came the question of payment. There are two versions of this:

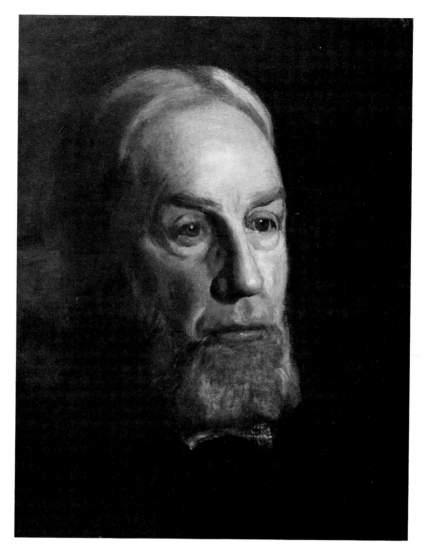

256. ROBERT C. OGDEN: DETAIL

Stokes's, told to me; and Eakins' and Ogden's letters. Both accounts agree that there was nothing in writing. Stokes had acted as middleman. According to his story, he had taken Eakins to see Ogden, they had settled details of sittings, but there had been no mention of the price. Afterward, Eakins at first didn't want to charge for the portrait, Stokes said, but Ogden insisted on paying for it. Finally Eakins gave Stokes a price of $500, although Ogden wanted to pay more. Later, when Stokes spoke to Eakins about this, the latter turned on him and said, "I said my price is $500, didn't I?" (Stokes's version so far.)

After the portrait was finished in mid-March, Eakins wrote Stokes that he had arranged to have a frame-maker come to the studio "to put the picture in its frame so that Mr. Ogden can see it." He continued: "I stopped in at

Thomas Eakins

Knoedlers to see the Chartran [a fashionable French portraitist] work and also some very bad work by another foreigner.

"They get very high prices.

"If in your social visits you hear of portraits to be painted bespeak some for me on a business basis say twenty or twenty-five per cent. Do you know I think an artist having a chance to see patrons could do no greater favor to them and to art itself than to show them how they can get their money's worth and not be cheated by the unscrupulous picture dealer."

To resume Stokes's version: Eakins sent Ogden a bill for $1,500. Stokes was much perturbed: he had arranged the whole thing, there was no written agreement, and Ogden was his patron. The merchant was willing to pay the bill to avoid argument, but Stokes insisted that he not do so, asked Ogden to give him a check made out to Eakins for $500, and went to Philadelphia to call on him at Mount Vernon Street. From the top-floor studio Eakins sent a reply, through a servant, that he was too busy to see him. Stokes sent the servant back with a message that it was something important. The answer via the servant was that nothing that Stokes could say would be important. Ogden paid $1,500. Stokes saw Eakins only once more, on a street in Philadelphia, wheeling his bicycle. He stopped him and said, "That was a dirty trick you played." Eakins looked "sheepish," but rode off without saying anything. (All this according to Stokes.)

That there actually was a disagreement about the price is shown by a letter from Ogden to Eakins: "I had a check drawn for your bill, but have not sent it as Mr. Stokes desires to speak with me concerning it." He added a handwritten postscript: "I may ask him to repeat to you the conditions under which I consented to sit for the portrait." In another letter he said that "the expressed intention to pay any bill that [you] rendered did not imply any opinion as to the propriety of the sum named."

To these letters Eakins replied: "Mr. Stokes called upon me last summer and as sitters were slack, I offered to make a study of his head. This was for his mother and I next painted his mother's head for him.

"While painting him we had discussions about my prices. He advised me to ask much higher prices for my things or people would not value them. He thought I should paint some New York people, and in his gratitude he would try to get some for me and he suggested you as one that should be painted and that he might get.

"As I did not know you at all, you will see the initiative did not come from me but from Mr. Stokes.

"I certainly did not authorize him to fix any price upon my work, nor did I suppose that after I had from you an appointment that I was still dealing with Mr. Stokes. He had offered me the free use of his studio but I paid him $40 for it.

"Although it seems you insisted with Mr. Stokes that the portrait was to be

painted on a commercial basis, it looks to me exactly like a professional order from a gentleman to an artist to a physician or a lawyer.

"The fee is mostly I believe fixed by the professional person at the close of his labors.

"When I had become acquainted with you, I remember speaking very frankly of my affairs, telling you that a very large proportion of my important works had been given away or sold at nominal prices.

"My work has been so divergent in character and so novel, and so much of it has gone directly to institutions that its commercial value is indeterminate and I admit I was sorely puzzled to know just what to charge you.

"I asked some of the best figure painters and reduced considerably the sum mentioned by them.

"I also learned the prices of Madrazo and Chartran both painting in New York. They get $6000 for full lengths and certainly do not paint better than I do.

"My reputation among artists is very good. I am a member of the National Academy and have had awards by international juries in the last three World's Fairs including Paris.

"From the commercial importance that Mr. Stokes attached to the painting of your portrait, I should have been willing to paint it for nothing or for any price that you yourself might have fixed, but I can recognize in Mr. Stokes only one who brought together the producer and the consumer: I would have hoped to the advantage of each.

"From the very beginning of my work Mr. Stokes assumed towards me a patronizing air and a spirit of criticism which his own accomplishments in art do not warrant. He was quite angry that I did not exaggerate the length of your upper lip, that I did not change the color of your hand and of your beard. In his artistic ignorance he wanted me several times to change my whole composition and pointed out to me a hundred errors which I know existed only in his untrained imagination. He was provoked that I consulted another than himself as to where I should get a frame. Finally he criticised my price, which comes with very ill grace from one who sold a color sketch for $5000 which I do not think would resell in any picture store in the world for ten dollars. . . .

"Near the end of your letter you write that the expressed intention to pay any bill that I rendered did not imply any opinion as to the propriety of the sum named. Now the writing of that sentence if it means anything to me means that you may have outside of your intention to pay me some reason which may imply impropriety.

"Else it is a gratuitous insult. May I suggest what I think to be your duty? It is to inform yourself at your leisure as to the value of large portraits. The best painters in the country belong to your club the Century and there are many picture stores along Fifth Avenue which would take orders for portraits.

"If after consultation you still believe I have overcharged you I will give you back so much of the money as will bring the sum within your own opinion of propriety and honesty."

Ogden answered: "I notice your remark concerning a probable or possible 'gratuitous insult' contained in a phrase of my letter to you. This expression clearly implies that you regard me as capable of such action. That being so, further discussion is not necessary and the incident is closed."

Nevertheless, he consented at Eakins' request to lend the portrait to an exhibition at the Century Association. This resulted in another letter from him to Eakins: "My portrait was displayed in the position of honor at the May exhibition of the Century Association. My entire family and my circle of close friends, except the two persons referred to in my letter to you of April 5th, had no knowledge of the picture until they saw it at the Century. They, therefore, made its acquaintance with entirely open minds and free from any influence that would limit original and independent opinion. It does not meet approval.

"As I do not now find any proper place in which to dispose of it, I desire to ask whether I may send it to your address with my compliments."

"In answer to your letter of May 13th," Eakins replied, "I would say that I have no room at home for so large a picture. I wish to exhibit it in New York in the good light of an Academy of Design or Society of American Artists annual exhibition. I have heard it well spoken of by artists, and think it may possibly grow upon your family and friends rather than wane. In any event I will dare advise you to keep the portrait until you may have from some other artist a better one or one that pleases more."

Ogden kept the portrait but put it in storage, where it was when I examined it in 1930. It is now owned by the Hirshhorn Museum. The unfinished first version was left by Eakins with Stokes, who turned it over to one of Ogden's daughters, who appears to have destroyed it. Eakins' portrait of Stokes, given to his family, was destroyed by them as "not a good likeness." The one of Stokes's mother was eventually sold by him to the Canajoharie Library and Art Gallery.

As to rights and wrongs: from Ogden's letters and Stokes's story it is evident that Stokes had given Ogden a price of $500; and it seems probable that Eakins had named this figure to Stokes. Eakins had no money sense, and he may not have realized that Stokes would give this figure to Ogden as a definite price. In his satisfaction at receiving the commission for "an important portrait" he may not have paid much attention to finances. Then he saw and priced portraits by Chartran, Madrazo, and others, whose works he considered bad. A financial failure himself, he had been advised by Stokes in the beginning to charge more. In the end he may possibly have forgotten the $500 figure when sending Ogden, a rich man, the bill for $1,500—a small sum compared to the prices of fashionable portraitists.

None of the three men involved in this sorry affair can be said to emerge with much credit: Stokes, officious, protective of his patron, and telling a story possibly colored by self-interest; Ogden, rejecting an excellent honest portrait of himself, objecting to a very modest price, making no allowances for misunderstanding, and in general not displaying much of the Christian virtue of charity; and Eakins, muddled about money, at best, and at worst, uncharacteristically opportunistic.

II

In the next four years Eakins painted portraits of five Philadelphia and Pennsylvania businessmen, of which four were commissioned.

John B. Gest, eighty-one, had been president of the Fidelity Trust Company, which commissioned his portrait in 1905 for $700. Active in business and charitable affairs, he was a trustee of the University of Pennsylvania, the Presbyterian Hospital, and the Historical Society of Pennsylvania. In the half-length portrait he sits staring in front of him, hands clasped in his lap. With his strong old features, white hair and beard, cold calculating eyes, and tightly clenched hands (the right holding the left as if to keep it from escaping), he looks more like the archtypical stonyhearted banker than the benevolent public figure that was one side of his nature. In its intense realization of character this is one of Eakins' most uncompromising portraits. Yet there is no record of negative reaction from either the sitter or the bank, and in 1930 it was still hanging in their offices. Eakins himself evidently thought well of it, for he borrowed it twice for national exhibitions the year after it was painted.

Asbury W. Lee was the leading citizen of the town of Clearfield in central Pennsylvania (1910 population 5,081): organizer of the Clearfield Lumber Company, the Clearfield National Bank, the Clearfield Trust Company, and Clearfield's water, telephone, and power companies. He also had some interest in art; in 1904 he had been elected a member of the Art Club of Philadelphia, and it was probably through the club that he met Eakins, and in 1905 commissioned a portrait, like that of Gest, half-length, showing the hands. A powerful face: strong aquiline nose, iron jaw, deep lines of determination around the mouth, steely, piercing eyes. He looks every inch the ruthless businessman: a predator, witch-burner, hanging judge; and yet he was a builder, an organizer, a public-spirited citizen of his home town. Certainly there is energy and willpower in that face, recorded with a truth as unyielding as the face itself.

In spite of his resolute appearance, Lee could not tolerate the portrait, and refused to accept it. In September 1905 he wrote Eakins: "You will receive the Painting back from Washington addressed Mary E. Lee, Mt. V. I may make a suggestion when I am down soon. While not accepted by me I send you a check for $200. anyway.

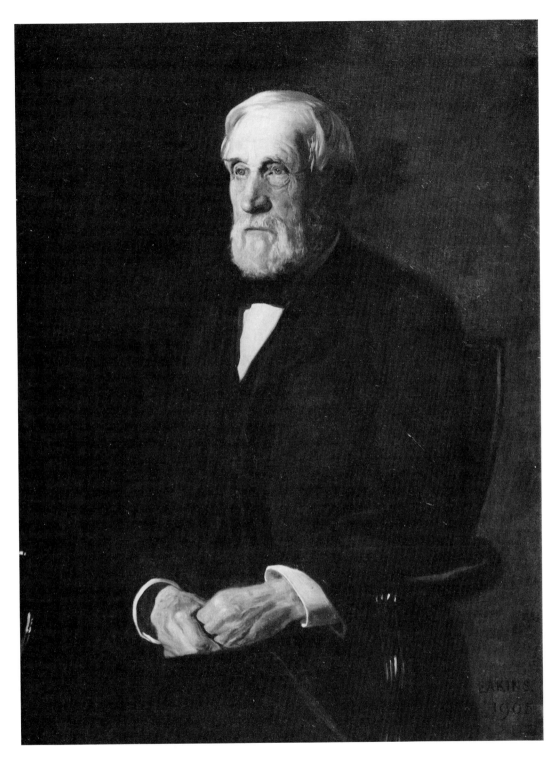

257. JOHN B. GEST
1905. Oil. 40 × 30. G 426
The Fidelity Bank, Philadelphia

"In a general way, my daughter liked it."

It seems unlikely that the agreed price had been as low as $200, for a portrait a little larger than the Gest one, for which $700 had been paid. There is no record that Eakins ever exhibited the picture.

Two portraits of elderly Philadelphia businessmen, done in 1906, failed to please their families. That of seventy-three-year-old Richard Wood, manufacturer of iron products and a director of the Provident Mutual Life Insurance Company, was a personal commission. "To put it frankly," wrote one of his fellow directors, a friend of Eakins, "Mr. Eakins was given the task of painting a portrait of probably the ugliest man in Philadelphia, and has certainly succeeded. A very strong, grim, determined face." It hung for a time in the company office, but Wood's brother felt that it was "entirely too severe," and had another portrait painted by Lazar Raditz, with whom Eakins' canvas was left. In this case, unlike that of Mother Patricia Waldron, after considerable correspondence in 1930 the Eakins portrait was finally located.

The likeness of another iron manufacturer, Edward S. Buckley, was not so fortunate. It was a gift by the painter to Buckley, seventy-nine, member of an old Philadelphia family. His daughter wrote me in 1930: "It was so unsatisfactory that we destroyed it not wishing his descendants to think of their grandfather as resembling such a portrait."

Edward A. Schmidt, a rich Philadelphia brewer, president of C. Schmidt & Sons, director and officer of national, regional, and state brewers' associations, was in his middle forties when he commissioned Eakins in 1908 to paint his portrait: why, how, or for how much we do not know. Shown three-quarters length, he stands with hands clasped in front: round head, heavy features, low forehead, short blunt nose, jowls; eyes gazing downward straight ahead; an absolutely vacant expression. It is not one of Eakins' most interesting portraits, but neither was the subject. However, perhaps because it had been a commission, he borrowed it from Schmidt for exhibitions at the Pennsylvania Academy in 1909 (one of only two works by him), and the Carnegie Institute in 1910 (his only work).

Needless to say, Schmidt and his friends did not like the portrait, and made this plain to Eakins. It was probably at Eakins' request that John W. Beatty, director of the Carnegie, wrote the painter a letter stating that the portrait had been "given a position on the honor line" and that "the Trustees are grateful to you for your valued contribution." Eakins forwarded this letter to Schmidt or to his friend Otto C. Wolf, who was acting as the former's spokesman. Wolf replied: "This confirms what I have always been willing to concede, and that is, whatever criticism may be made of the picture as a portrait, it certainly as a work of art occupies a high rank. Unfortunately the expression of Mr. Schmidt's countenance as shown in your portrait, is so different from his usual one, that many of his friends who have seen the picture, have passed adverse

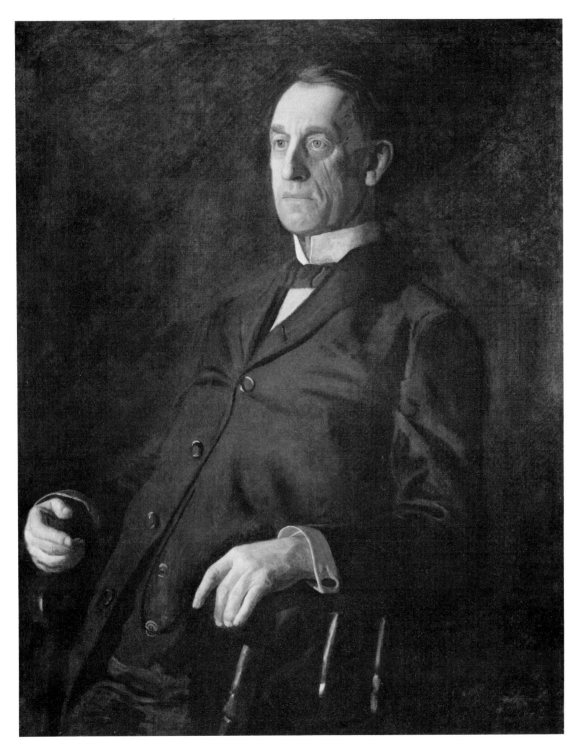

258. ASBURY W. LEE
1905. Oil. 40 × 32. G 427
Reynolda House Museum of American Art, Winston-Salem, North Carolina

criticisms upon the likeness; and you must concede that after all, it is intended as a portrait and not as an evidence of art only.

"I send herewith a photograph recently taken of Mr. Schmidt, which gives a more natural expression and pose, and which may serve you as a copy for your new painting.

"After you have outlined and worked in the principle part of the work, Mr. Schmidt will give you the necessary sittings in order to get flesh tints &c. Kindly advise me by letter whether this suggestion meets with your approval."

Whether Eakins had agreed to paint another portrait, as he had for Dr. DaCosta, is not known. In any case, he did not do so. When he asked Schmidt to lend the picture again, for the Art Institute of Chicago annual exhibition in 1911, the latter replied: "As this portrait has been so unfavorably criticized by my friends since it has been in my possession, I would not consider exhibiting it. I have had no opinion from any of my friends that the portrait is a likeness of me, although the style and character of the work has been favorably commented on."

When in 1930 I saw the portrait at Schmidt's mansion in suburban Radnor, it was in a coat-closet under the stairs. The butler and a footman helped me carry it out on to the lawn in daylight. I asked them if it was a good likeness of their master; they agreed that it was.

There is no question that Eakins' relatively few portraits of businessmen, aside from his personal friends, show less empathy with them than with his professional sitters: scientists, physicians, teachers, musicians, fellow artists, and the clergy. But there was no element of satire in his attitude toward his businessmen sitters, and no trace of caricature in his style. Caricature is a form of subjective expression that involves fantasy, exaggeration, distortion, pictorial license—all foreign to Eakins, whose viewpoint and style were almost purely objective. These late portraits of businessmen were, as always, uncompromisingly truth-telling; and hence, because of the men themselves, among the most devastating portraits he ever painted. And most of the men seem to have been as touchy about unidealized portraits as women—in fact, more so, in their open expressions of dislike or their rejections of the pictures.

III

Eakins' last portraits of young women were those of Eleanor Pue, 1907, and Helen Parker, 1908, both painted at his request. I have already described how he met Miss Pue at a party, stared at her, and asked "to make a little painting of your head"; how many times she posed; how he admired the bones of her shoulders and chest, saying "Beautiful bones!"; and how he urged her to pose nude. David Wilson Jordan told me that she was "a pretty, elf-like, witchlike person—but Eakins brought out all the witch." In the small head and bust

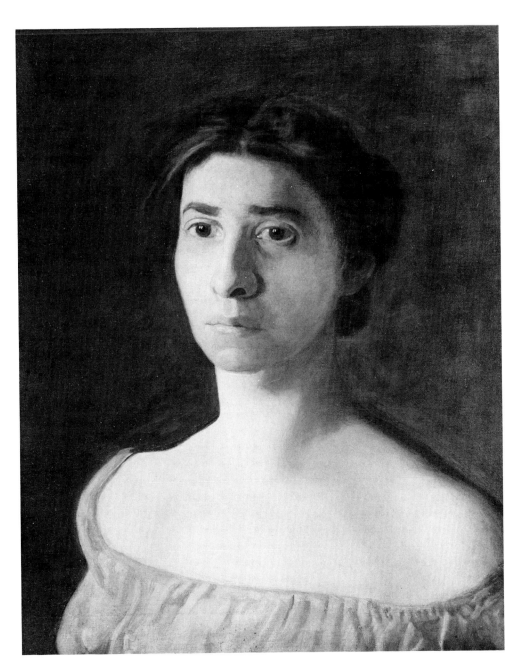

259. MISS ELEANOR S. F. PUE
1907. Oil. 20 × 16. G 455
The Virginia Museum of Fine Arts, Richmond

portrait she has a long nose, a rather low forehead, and a dusky complexion with greenish shadows; her shadowed chin contrasts startlingly with her white neck; altogether, her face has a strange, eldritch quality. She wears a very low-necked dress, baring a wide expanse of shoulders and chest. She looks sad and anxious, her eyes seem pleading; perhaps she was tired of posing and of being pressed to do so nude.

On the other hand, the face, shoulders, and bosom are painted with the breadth and largeness of form that Eakins achieved in modeling the parts of the female body that were visible in that day. The painting reveals a sculptural sense freer than in earlier works, more "abstract" in a sense; a purity of plastic quality that comes to some artists in old age (with Eakins, late and not often). Curiously, the picture has a neoclassic flavor that reminds one of Ingres—a comparison Eakins would not have cared for. Also, as sometimes with Ingres, there is an odd awkwardness, a primitivism—that of an artist shunning slick visual painting, and striving for basic form. Small and simple as the portrait is, it suggests developments that Eakins did not live to achieve more fully.

But by conventional standards of beauty, it was almost a caricature. Miss Pue hated it. In 1930 when she (then Mrs. Farnum Lavell) showed it to me, she said that when it was exhibited at the Pennsylvania Academy in 1908 her friends called it "The Goddess of Murder."

Helen Montanverde Parker, a student in Leslie W. Miller's School of Industrial Art, was in her early twenties in 1908, the daughter of Kate Parker, a well-known silhouette artist who cut profiles of many prominent Philadelphians, including Eakins. The Parkers were active socially and knew many people in the arts. "Mr. Eakins painted Helen's picture in 1908 and put on it a world of work," her mother wrote in 1947. "She posed about thirty-five times; two and three hours at a time, and wore my grandmother's old white silk and pearls." Between sittings she would leave the dress in the studio, and Eakins, Susan, and Addie would "pore over it, examining every stitch." As with Eleanor Pue, the low neckline leaves bare much of her shoulders and chest. She has a long neck with a small head perched on it, protruding eyes, eyebrows arched as if in surprise, a pursed mouth, receding chin, and rather bony chest with prominent collarbones. Her lifeless right hand rests on the back of the Victorian mahogany armchair that had appeared in many portraits; her left arm hangs limply by her side. She is gazing in front of her, not at us, with a vacant, almost idiotic stare; the poor girl looks half-witted. (She had been posing a long time.) Altogether, a wooden figure, like a mannequin—which indeed she was, the beautiful dress appearing more important than the gauche girl. As in Miss Pue's portrait, there is a strong contrast between the darkish tonality of her face and her pale neck and chest, especially where the shadowed chin appears against the neck, a contrast that produces the grotesque appearance of her head being separated from her neck. The same contrast was true of some portraits of other women of those years.

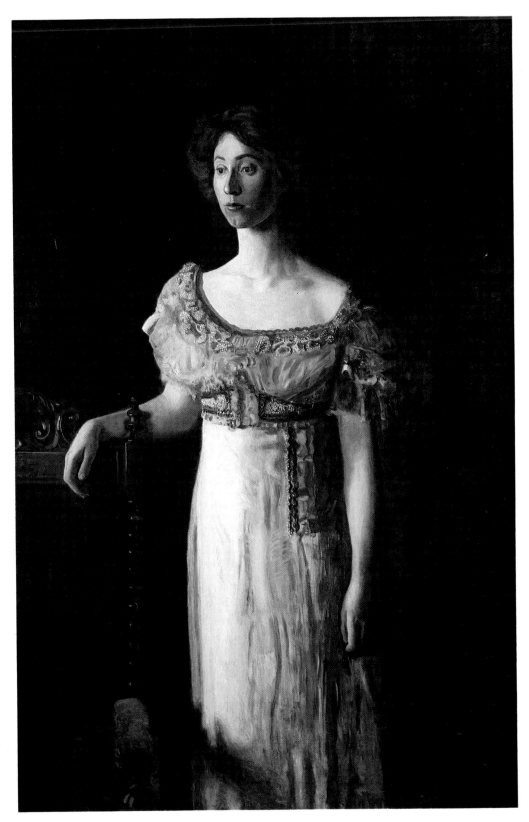

260. THE OLD-FASHIONED DRESS
Portrait of Helen Montanverde Parker. 1908. Oil. 60¹/₈ × 40³/₁₆. G 457
Philadelphia Museum of Art; Gift of Mrs. Thomas Eakins
and Miss Mary Adeline Williams

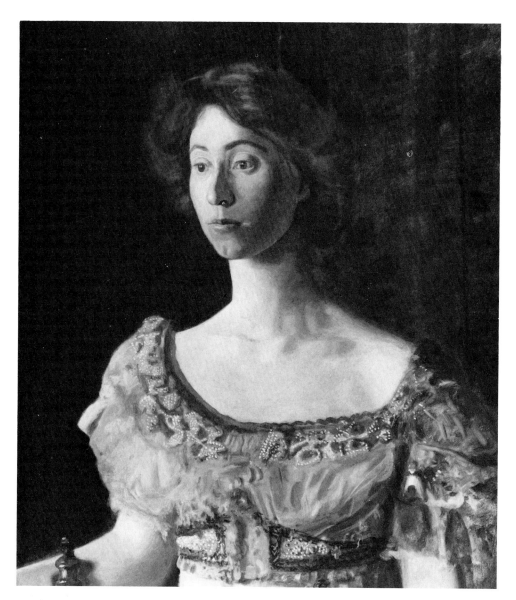

261. THE OLD-FASHIONED DRESS: DETAIL

A photograph of Helen Parker about the same time (not by Eakins) shows an aristocratic, intelligent, perhaps bluestocking young woman, looking straight at us, and not vacantly—on the contrary, with an alert, amused expression. The same small head and long neck, aquiline nose, and protruding eyes: Eakins' portrait was physically accurate, but the gaucheness has been intensified to the point of idiocy. (The photograph shows her in an almost identical pose, but wearing a hat and coat; the dress and chair are not the same. Gordon Hendricks suggested that she may have showed the photo to Eakins and he may have adopted the pose.)

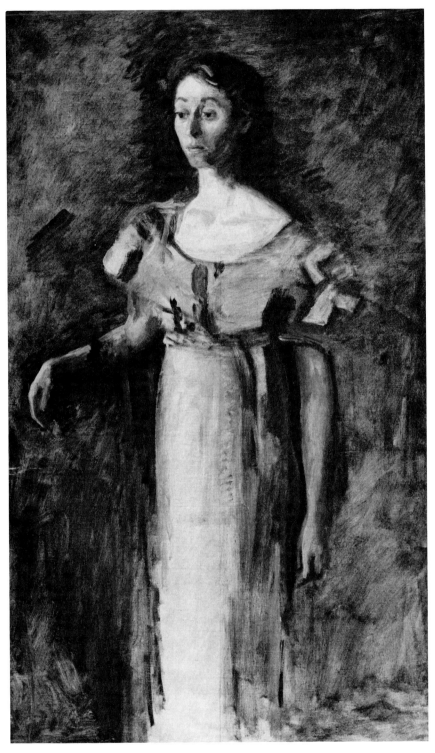

262. STUDY FOR "THE OLD-FASHIONED DRESS"
1908. Oil. 36 × 22. G 459
Mr. and Mrs. Daniel W. Dietrich II

Margaret McHenry in the 1940s reported that Helen Parker, by then Mrs. Helen Parker Evans, told her that she "had been disconcerted while posing because he would not make her 'just a little pretty' but kept saying, 'You're very beautiful. You're very beautiful,' while reveling in her neck bones and making her 'really small and dainty nose more and more bulbous.'" When she was eighty-four, in 1969, she wrote Sylvan Schendler: "Thomas Eakins was not interested in my face—(I have always felt a sense of being decapitated) but he was fascinated by my clavicles and the dress. . . . I read the other day that we only know one percent of what was happening to us in our youth. I truly look as if I did not rate that high. I was born in 1885—should have known enough to wear a little intelligent expression."

When the portrait was first exhibited, at the Pennsylvania Academy in January 1910, at the opening, her mother recalled, "Helen looked, in rich dark yellow satin, topaz jewels, and hair ornaments, lovely that night. . . . [The portrait] created a great deal of comment." Helen Parker Evans wrote Schendler: "I *cried* the first time I saw it at the Academy." This was the only time Eakins showed it, as far as we know. He called it simply *Portrait of a Lady;* the present title, *The Old-fashioned Dress,* appeared in 1928.

This was Eakins' next to last portrait larger than head and shoulders. He took extra pains with it, making two oil studies: one in his usual small scale; the other on canvas, three by two feet, an unusually large study. This, and his many sessions on the full-size portrait, show that despite its unflattering character he took a special interest in it.

20. Old Age

IN 1908, IN HIS SIXTY-FOURTH YEAR, Eakins returned to the theme he had pictured when he was thirty-two: William Rush carving his allegorical figure of the Schuylkill River. Since his 1876 and 1877 versions (ills. 61, 64) he had painted the female nude only a few times, as far as we know: in two little studies for other works, in a woman's figure in the oil *Arcadia* (ill. 102), and in four undated studies of single figures—a small production for an artist so deeply devoted to the nude.

The new painting of Rush carving, finished in early 1908, is much larger than the 1877 one: thirty-six by forty-eight inches as compared to twenty by twenty-six. Its elements are mostly the same: Louisa Van Uxem, nude, standing on an identical wood block, a big book on her shoulder, her back to us; a chaperon sitting beside her, sewing; Rush carving his *Nymph;* his statues of Washington and *The Schuylkill Freed;* even the same carved scroll on the floor. All the essential features of the legend are retained. But this time the sculptor, instead of wearing a long-sleeved coat with brass buttons, wears a sleeveless workman's jerkin, he is shorter and stockier, and he is scowling; carving is hard work. The chaperon is not a finely dressed white gentlewoman but a Negress with a bandanna on her head, seated in a plain wooden chair instead of an upholstered Chippendale one. Missing is an engaging prominent feature of the 1877 picture, Miss Van Uxem's discarded clothes. Altogether, this is a less elegant, more workmanlike representation of the theme.

The model is different in character and pose. Instead of slender, graceful Nannie Williams, this is a robust young woman. Nannie had stood in the pose of the *Nymph,* her left leg bent and her left hip dropped, bringing out the flowing lines of her body. This woman stands bolt upright, legs straight, both feet flat on the block. Though Nannie's back had been to us, she had been turned slightly left; this woman turns her back almost completely. Her figure is much larger than the one in the 1877 painting, not only because of the larger canvas but because she is closer to us, filling almost the whole height of the picture. With the reduced role for the chaperon and the omission of the discarded

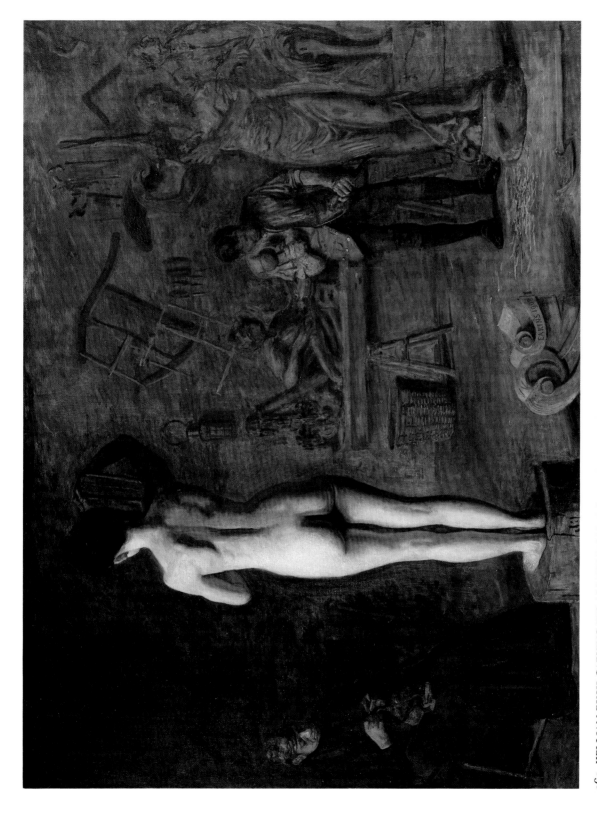

263: WILLIAM RUSH CARVING HIS ALLEGORICAL FIGURE OF THE SCHUYLKILL RIVER
1908. Oil. 36⁷/₁₆ × 48⁷/₁₆. G 445
The Brooklyn Museum; Dick S. Ramsay Fund

clothes, she dominates the composition. In the earlier picture the light had been subdued and Nannie's back had been in shadow; this woman's body is fully and strongly lighted, with deep shadows cast by her shoulder blades, the groove of her backbone, and the division of her buttocks. Against the dark background of the workshop her figure stands out in startling relief, projecting toward us with the roundness and solidity of a trompe-l'oeil painting. Not as graceful as Nannie, her bone structure clearly revealed, her body is alive and vigorous, giving a sense of strength and mobility. Eakins' mastery of the nude had never been more fully displayed.

The composition is reversed from that of the 1877 work: Louisa Van Uxem and the chaperon have been moved from the right to the left; Rush and his *Nymph* have been transferred from the left background to the right, nearer to us and larger, with more space around them; even the scroll has been moved to the center. Compared to the 1877 composition's richness of elements, its harmony and balance, the 1908 composition is stark and odd, with the dominant figure of the model so far left of center, and the chaperon crowded into the lower left corner; one feels that if the whole left third of the picture were moved somewhat nearer the center the design would have more balance. Yet it has its own kind of idiosyncratic balance, including a closer relation between the model and the sculptor, whose two figures form a trapezoid. This late composition seems to show that the mastery of multiform design that Eakins had demonstrated in *The Swimming Hole* had not gained in ease and richness through the years, as it might have with more practice. Yet, with all its relative awkwardness, this is one of his most powerful paintings featuring the nude.

The color range is limited to three main colors: the golden tones of the woman's body, the warm browns of the shop, and the blues of Rush's and the chaperon's clothes. There are no bright notes anywhere. Absent are the delightful varied colors of Louisa Van Uxem's garments in the 1877 picture. But there is a wide range of values: the nude body against the dark background presents one of the strongest tonal contrasts in all Eakins' work.

Several small oil studies show that he originally planned to place the wooden *Nymph* nearer the foreground, with the sculptor at its right, but wisely reversed their positions. Full-scale individual studies of Rush and the chaperon were also painted, and squared off for transfer to the final canvas.

Eakins submitted the painting to the Carnegie Institute's annual exhibition in April 1908, writing John W. Beatty of the Institute: "I found a frame at Cassidy's that suited the Rush picture. I therefore had Cassidy get my pictures and box them instead of Haseltine." The other painting was the head and bust portrait of the Reverend James P. Turner. The understanding was that only one work could be accepted. The jury, with the usual reaction to Eakins' more exceptional and important works, accepted *Turner* and rejected *Rush*. There is

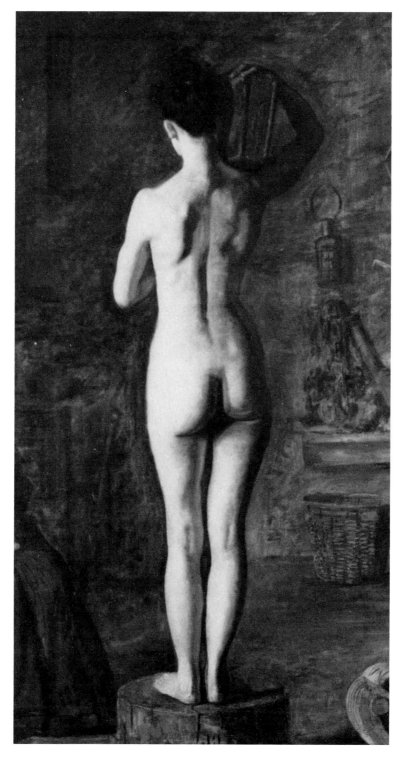

264. WILLIAM RUSH CARVING HIS ALLEGORICAL FIGURE
OF THE SCHUYLKILL RIVER: DETAIL

no record of the latter being exhibited in his lifetime. It was not included in the large memorial exhibitions in 1917 and 1918; and its first showing was not until 1930. In 1939 the Brooklyn Museum's curator of painting, John I. H. Baur, had the judgment and imagination to purchase it.

Probably soon after finishing this *Rush Carving* Eakins began two more paintings on the theme of the sculptor and his model, but entirely different in concept and composition. Both were the same size as *Rush Carving*, three by four feet, and both were to remain unfinished. In the one that probably came first, now known as *William Rush and His Model*, the woman is facing us, stepping down from the stand, while the sculptor helps her, with every mark of respect. She is a mature woman, heavier than the model in the finished painting, with broad hips, full breasts, and sturdy legs. Her face is definitely that of a specific individual—who, is unknown; she does not appear in any of his portraits, and she was probably a professional model. One foot still on the stand, she is higher than the sculptor, who bends over toward her, holding her hand to steady her. Although his clothes (sleeveless jerkin and rolled-up shirt sleeves) are the same as those of Rush in the finished picture, the figure does not resemble his. (Mrs. Eakins told me that the actual model was an Italian actor and fencer.) He is heavily built, thick through the middle, with a round head, short neck, and powerful arms. Although his face is not visible, his figure strongly resembles Eakins' own.

This resemblance suggests that Eakins, in his admiration for Rush, and for Louisa Van Uxem's courage in posing nude (as he evidently believed), was identifying himself with Rush, and was expressing his respect for an artist who had defied convention and for a woman who was willing to make her body visible for his art—an idea which, with its accompanying frustrations, had obsessed him for years. Certainly he felt a close kinship with the older artist, and he may well have consciously substituted his own figure for Rush's. If so, this is a strange, revealing conception: his lifelong, dominating love of the human body, repressed by the prudery of his environment, combined with his own strict realism, finding expression in this uniquely individual fantasy.

Here, for the first time, with one minor exception, Eakins pictured a nude woman facing us. In the Rush paintings of 1876 and 1877, in *Arcadia*, in the 1908 *Rush Carving*, and in all but one of his few small studies of the female nude, the women had had their backs to us. (So had most of the men in *The Swimming Hole*.) But he had finally freed himself from this self-imposed taboo.

Another universal taboo, which he now disregarded, was that against representing pubic hair. In nineteenth- and early-twentieth-century painting—even in France—whether realistic or idealistic, academic or nonacademic, this natural and not unattractive feature of the human body had generally been ignored, even when the mons veneris was clearly delineated. Eakins, writing

265. WILLIAM RUSH AND HIS MODEL.
Probably 1908. Oil. 36 × 48. G 451
Honolulu Academy of Arts; Gift of Friends of the Academy, 1947

to his father from Paris in 1868 and expressing his disgust of the idealized female nudes in the Salon, had said: "When a man paints a naked woman he gives her less than poor Nature herself did. I can conceive of few circumstances wherin I would have to make a woman naked but if I did I wouldn't mutilate her for double the money." I can think of no other meaning for this than the idealizing omission of pubic hair. In any case, in the only known earlier study of a nude woman facing us it is not omitted; and in these two late unfinished paintings on the Rush theme it has its natural and proper place.

In *William Rush and His Model* the woman's figure is almost completed; the sculptor's is not. Her body is even more fully lighted than in the composition of Rush carving, and the painting of light on her flesh is beautifully executed: the full light and the highlights on her breasts, belly, and upper thighs, and the halftones on the forms rounding away from the light. In preparation he had painted a full-scale oil study of her figure alone, with only an indication of the sculptor's hand holding hers. This is the only extant study for the large canvas.

One peculiar feature of *William Rush and His Model* is a carved wood scroll projecting up in the immediate foreground, hiding part of the sculptor's legs. There had been similar scrolls, probably specimens of his ship carvings, lying on the floor in the previous Rush paintings, but this one is upright, large, and conspicuous. It is a striking form, with an African or South Pacific look, and a phallic suggestion. Its prominent position and its relation to the figures present an enigma.

The rest of the canvas is blank: gray-brown paint scumbled over the surface, with no forms indicated. It seems likely that Eakins intended to include other elements, such as Rush's *Nymph*, but for this there is no evidence.

The other unfinished painting on this theme—probably the second one—shows the model only, in the same action of stepping down from a stand, her left hand held up, with a sketchy indication of another hand holding it, but no sculptor pictured. Except for her figure the canvas is blank, covered with a thin gray-brown wash. Whereas the model in the other version is almost full-face, this one, though seen from the front, is turned a little to the left, showing more of a curve in her left hip and leg and more of an angle in her bent right leg, and in general more movement in the lines of her body. Again she is a mature woman with a generous figure, her face that of a definite individual, but not the one in the other version. Though less finished, her figure is roundly and solidly constructed, with the bigness, the grasp of the forms of the body as a whole, and its rhythms, that made Eakins a master of the nude.

Two studies show what he intended for the final composition. In one small sketch, in addition to the model stepping down, another woman holds a white cloak to cover her, while the sculptor (a younger, taller, and thinner man, his legs not hidden by a carving) helps the model. In the right background are two indications of Rush's *Nymph*, evidently experiments in placing it. It is a sum-

266. WILLIAM RUSH AND HIS MODEL: DETAIL

267. STUDY FOR "WILLIAM RUSH AND HIS MODEL"
Probably 1908. Oil. 24 × 20. G 452
Private Collection

268. WILLIAM RUSH'S MODEL: CENTER AREA
Probably 1908. Oil. 36 × 48 overall. Center area, 36 × 25. G 453
Caroline and Sheldon Keck

269. STUDY FOR "WILLIAM RUSH'S MODEL"
Probably 1908. Oil. 14½ × 10½ overall. G 439
Philadelphia Museum of Art; Gift of Mrs. Thomas Eakins
and Miss Mary Adeline Williams

mary sketch, and Eakins undoubtedly would have improved on it: for example, the sculptor is much taller than the model, and too dominant. A larger, more detailed study shows only the model and her female attendant. If he had completed the full-scale painting as planned, with three figures, with the model in a more effective pose than in the other full-scale version, and with the interior of the shop, including Rush's *Nymph,* it would have been one of his major figure paintings. But he never carried it further.

These three late Rush paintings and the numerous studies for them were Eakins' last nonportrait figure compositions. None of them show any signs of declining powers.

270. STUDY FOR "WILLIAM RUSH'S MODEL"
Probably 1908. Oil. 20$\frac{1}{8}$ × 14. G 454
Hirshhorn Museum and Sculpture Garden, Smithsonian Institution

Thomas Eakins

As a young man Eakins had been confident of future success and of being able to make a living by his art. In his letters to his father from Paris he had written: "I could even now earn a respectable living I think in America painting heads." Again: "That Pettit or Read get big prices does not in the least affect me. If I had no hope of ever earning big prices I might be envious." And again: "One terrible anxiety is off my mind. I will never have to give up painting, for even now I could paint heads good enough to make a living anywhere in America. I hope not to be a drag on you a great while longer."

Back in America, during his early professional career he had fully expected to make a reputation and to sell his pictures. He had exhibited them as widely as he could, putting reasonable prices on them. His letters to Earl Shinn in 1875 had shown complete belief in his own worth and coming success. "The anxiety I once had to sell is diminishing. My works are already up to the point where they are worth a good deal and pretty soon the money must come." Starting *The Gross Clinic*, he wrote Shinn: "It is very far better than anything I have ever done. . . . I have the greatest hopes of this one."

We recall his naive incomprehension when *The Schreiber Brothers* was turned down by the National Academy in 1875. But the first great blow, or series of blows, must have been the rejection of *The Gross Clinic* by the Centennial art committee, the violent critical attacks on it, its segregation in the Pennsylvania Academy exhibition of 1879, and the infinitesimal price finally paid for it, $200. An equal blow must have been the later rejections of his other major composition, *The Agnew Clinic*, by the Pennsylvania Academy and the Society of American Artists. Until the end of his active career his paintings were subject to refusal by art juries, including such outstanding works as *Cushing, Music, The Art Student*, and the 1908 *William Rush Carving*. And until the last three years of his life, the critics, with a few exceptions, either ignored his exhibits or treated them with uncomprehending negativism.

Throughout Eakins' life he received few commissions for portraits and sold few other paintings. From various sources it is possible to assemble a lifetime account of the commissions he did receive and the works that were sold, and what he was paid for them. These sources are two ledgers recording individual works, kept by him and Mrs. Eakins; his itemized journal of receipts and expenditures in the five years 1883 through 1887, owned by Mr. and Mrs. Daniel W. Dietrich; prices published in exhibition catalogues; his letters and those of others; and information from Mrs. Eakins in 1930 and 1931.

From the above we can say with fair certainty that during his entire career he received only twenty-five or twenty-six portrait commissions: one or two in the 1870s, seven in the 1880s, four in the 1890s, twelve in the 1900s, and one in the 1910s. The increase in the 1900s was accompanied by rejections or negative receptions of five commissioned portraits.

For paintings other than portraits, such as *A May Morning in the Park*, he was given five commissions. Five illustrations were commissioned in the late 1870s and early 1880s. In sculpture, there were the two small reliefs ordered but rejected by James P. Scott, the two horses on the Brooklyn Memorial Arch, and the two reliefs on the Trenton Battle Monument.

As for sales as distinct from commissions, the sources record the sales of only twenty works during his lifetime: in the 1870s four oils and two watercolors; in the 1880s four oils, two watercolors, and casts of the two Scott reliefs; in the 1890s two oils; in the 1900s nothing; in the 1910s four oils.

As to the amounts received, the sources furnish reliable information on a majority of the transactions. Where definite figures are not known, estimates can be made based on the known figures. The totals by decades, in round numbers, are: in the 1870s, $1,100; in the 1880s, $5,000; in the 1890s, $10,500 (over half of which is the estimated amount from the Brooklyn and Trenton sculptures); in the 1900s, $7,500; in the 1910s, $7,000. So his total lifetime income from painting and sculpture (not including teaching) was about $31,000.

But it was not just financial success that Eakins must have wanted, though undoubtedly he would have welcomed it. He evidently had no great desire for money per se. He painted his largest composition, *The Agnew Clinic*, for the agreed price of a single figure, $750. He had little pecuniary sense about his work, at least in later years; Murray said that if a visitor to his studio liked a picture, Eakins would sometimes offer to give it to him, or if asked the price, would say, "I don't know. A hundred dollars? What do you think it's worth?"

More than money, he must have wanted to be recognized, to be given more portrait commissions, to have his pictures seen and bought, to have a functional relation to the community to which he was so attached. Nor was it the scarcity of commissions that must have been frustrating so much as the scarcity of those worthy of his powers. Commissions for men like Agnew, DaCosta, and Forbes were in the minority; more often they were for businessmen like Ogden, Lee, Schmidt, and Richard Wood, or for deceased persons to be painted from photographs, of whom he executed five commissions.

As a matter of fact his commissioned portraits were not necessarily better than the noncommissioned ones—indeed often not as good as those of individuals he liked or admired, and chose to paint. Almost all his finest portraits were uncommissioned: to select only a few, those of Gross, Rand, his own wife with Harry, Weda Cook as *The Concert Singer*, Cushing, Rowland, Mrs. Frishmuth, Kenton, Miller, Mrs. Greenewalt, Signora d'Arza. In the major exceptions, those of Agnew and Forbes, he went far beyond the usual limits of portrait commissions.

The reasons why he was not a popular portraitist have been fully discussed, but for us today it is hard to understand why his early outdoor and sporting scenes, domestic genre, and historical pictures failed to sell, or to sell

more than a few. These works, like those of Mount, Bingham, Eastman Johnson, and young Winslow Homer, are among the most attractive native American art of the nineteenth century. But Eakins' genre paintings lacked Mount's bucolic humor, Bingham's frontier flavor, Johnson's genial storytelling, or Homer's reserved idyllic poetry. He was portraying the familiar everyday life of citydwellers, indoors and outdoors, without romance, picturesqueness, humor, or nostalgia. His realism, command of character, and mastery of form and three-dimensional design had little appeal to the nineteenth-century American public.

There is no question that Eakins felt deeply his lack of recognition, and that in later years he was a saddened and disillusioned man. In 1906, answering a request for advice about studying art, from a young pupil of John Wallace, George Barker of Omaha, he wrote: "I am sorely puzzled to answer your letter. If you care to study in Philadelphia, you could enter the life classes of the Pennsylvania Academy of the Fine Arts and I could give you advice as to your work and studies, or you might go to Paris and enter some life classes there. Nearly all the schools are bad here and abroad.

"The life of an artist is precarious. I have known very great artists to live their whole lives in poverty and distress because the people had not the taste and good sense to buy their works. Again I have seen the fashionable folk give commissions of thousands to men whose work is worthless.

"When a student in your evident state of mind went to Papa Corot for advice, the old man always asked how much money he had. When the boy offered to show his sketches and studies the old man gently pushed them aside as being of no consequence.

"P.S. I am not connected with the Pennsylvania Academy and my advice would be contrary to nearly all the teaching there.

"I have no classes of my own."

In those years he seems to have thought often of his student days in Paris. When he painted young Eleanor Pue he talked about them, looking back with pleasure, recalling what good times the students had, and telling some broad student jokes. Alice Kurtz Whiteman wrote me: "He taught me a song in French which he learned as a student in the Latin quarter of Paris, and I still remember parts of it and the tune." In 1965 she repeated it to Sylvan Schendler; it was the nonsense ditty about the "petit navire / Qui n'avait (ja, ja) jamais navigué." And in 1970 she still remembered it clearly enough to sing it for the film *Eakins*.

Hearing in 1907 of the death of his Paris schoolmate Ernest Guille, he wrote Louis Cure: "Je suis vivement touché de la mort de ce pauvre Guille. Il était toujours si gentil, si spirituel.

"Je pense toujours à lui et à toi, quand je pense à la France, ce qui m'arrive très souvent.

"J'ai toujours des nouvelles de Sartain, mais je ne le voie pas si souvent

qu'autrefois car il n'enseigne pas le dessin à Philadelphie cette année. On me dit qu'il se porte bien et qu'il vend ses tableaux.

"Je te serre affectueusement la main."*

The letter was returned with the envelope marked: "Incomplet. Retour à l'office."

<div align="center">III</div>

After he passed his sixty-seventh year, 1910–11, Eakins' health began to fail. His physical strength and energy, retained till then in spite of overweight, declined year by year. His legs weakened, and he had to be helped about. He became lethargic and would fall asleep in company. His eyesight, always so clear, was increasingly affected; but he disliked wearing glasses. Photographs of him in the 1910s show him very stooped, his head sunk on his chest, his face masklike, without animation.

The nature of his illness is not clear. Murray and Jordan spoke of kidney trouble, Mrs. Eakins of jaundice. Murray also told Margaret McHenry that he had been poisoned by drinking milk adulterated with formaldehyde at the boathouse on the Cohansey in 1911. In the nineteenth century the chemical was used as a preservative in milk until its use was prohibited by law. Murray said that he himself had been poisoned but had escaped ill effects by bicycling home fast, perspiring profusely, and drinking whiskey en route. Mrs. Eakins also said that her husband had drunk poisoned milk and had never been well again, but she gave no details. It is true that he did drink excessive quantities of milk, and some at the boathouse may have been adulterated. But it is hard to believe that the effects would have lasted for five years; it seems likely that there were other causes for his failing health. It may simply have been age, but it sounds more like some incapacitating illness, or a combination of several. (He had an excellent personal physician, Dr. Henry Beates, Jr., president of the State Board of Medical Examiners, whom he painted a three-quarter-length portrait of in 1909, titled *The Medical Examiner.*)

When he went out now it was with his wife or Murray. The latter kept in constant touch, coming to Mount Vernon Street or bringing Eakins to his house on Lancaster Avenue, a pleasant place still in the open country. The older man spent much time here, lying on a couch in the studio and watching the sculptor work. But he still wanted to go places; he would say, "Murray, let's go out."

In November 1912 a big exhibition of historic portraits was held in Lancas-

* I am keenly touched by the death of poor Guille. He was always so nice, so witty.

I always think of him and of you, when I think of France, which happens to me often.

I always have news of Sartain but I do not see him as often as in former times, for he does not teach drawing in Philadelphia this year. They tell me that he is well and that he sells his pictures.

I press your hand affectionately.

ter, the old capital of Pennsylvania, featuring artists and sitters associated with Lancaster County. Dr. Agnew having been born in the county, *The Agnew Clinic* was borrowed from the University of Pennsylvania and hung in the place of honor. In spite of illness and doctors' orders, Eakins insisted on making the long trip to attend the opening. "The writer happened to be present at the opening of this exhibition," wrote Helen W. Henderson of the Philadelphia *Inquirer*, "and remembers how Mr. Eakins, supported by his faithful and life-long friend, Samuel Murray, made the heroic effort of being present on this occasion. There was a great crush of provincial folk, for the affair was warmly supported by the Lancasterians, many of whom had lent family portraits. Eakins entered the room with Samuel Murray and spent a happy hour in the exhibition looking at the old American portraits there assembled and seemed gratified with the conspicuous placing of his own great picture. No one recognized him, and it was only after the authorities had been informed of his presence that he received an ovation and departed early for the long trip back to Philadelphia in the night."

When the critic Henry McBride visited Mrs. Eakins a year after her husband's death, "I asked what she considered the most comforting experience of the artist's career, and she replied unhesitatingly: 'The reception given to him in the city of Lancashire in 1912. . . . They were very kind to him and he always spoke afterward of the pleasure they had given him.'"

Once, at his insistence, Murray took him to New York, to the Metropolitan Museum. Eakins was happy to be out; it was an adventure. They took a cab to the museum from Pennsylvania Station; while Murray was paying the fare, Eakins watched him closely. In the museum Murray got a wheelchair and they went through the galleries; Murray didn't think that Eakins saw much, but he enjoyed it immensely. When they were leaving, Murray started to hail a cab, but Eakins stopped him, saying it cost too much; they would take the Madison Avenue trolley. The younger man had to lift the older one up into the streetcar and almost carry him inside. The car was crowded, but a passenger gave Eakins his seat. He looked up at Murray and said, "What an awful town to live in!"

David Wilson Jordan told me that when he returned from a stay in Europe in the 1910s and brought his new wife to visit Mount Vernon Street, Eakins kept falling asleep in the middle of the conversation. And Elizabeth Burton Johnston recalled: "In November 1913 my husband and I came home [from Borneo] for a brief visit, and saw Mr. and Mrs. Eakins at their home. He had failed so that I was deeply shocked and grieved. He kissed me, said a few words about the 'old days,' and fell asleep in his chair."

Speaking of these years of illness and declining strength, Mrs. Eakins said to me: "Mr. Eakins was a sad man." Later, regretting this, she added: "He was a silent man, not sad exactly, but disappointed—he had had blows. . . . There

was sadness underneath; he had not been able to do what he wanted to do." She recalled that he would sometimes quote Dante in Italian: a passage about the poet walking through crowds, sad, with all the people looking at him and being shocked; but as soon as he had passed by, they forgot him. He must have been remembering Gérôme's *Dante* which he had described so minutely in a letter to Fanny in 1869. "I was so sorry that I couldn't understand it," Mrs. Eakins said.

In early 1914 his old friend Weda Cook Addicks wrote asking him if she could have her portrait, *The Concert Singer*, probably for her son Allen. He replied: "I was very glad to have your note. I cannot however part with the picture. It must be largely exhibited yet. I have many memories of it, some happy, some sad.

"Your boy can see it any time. Probably it will be his some day but not now.

"I have been very sick but the physician assures me that I will recover."

The handwriting is uncertain and irregular, quite unlike his former firm style. He did exhibit the painting twice in the next two years. But he did not bequeath it to Allen Addicks.

Into 1910 Eakins' painting had showed no loss of power. That year he did the strong uncompromising portrait of Mrs. Nicholas Douty and four head and bust portraits of the Parker family: Dr. Gilbert Lafayette Parker, his wife, and their sons, Gilbert Sunderland Parker and Ernest Lee Parker. Gilbert was curator of paintings at the Pennsylvania Academy, and Ernest was a picture restorer who was later to succeed his brother at the Academy. Probably because of these mutual artistic interests Eakins was particularly close to all four.

But after 1910 he did no more painting, with the exception of two canvases. In 1912 or 1913 Alexander Smith Cochran, a wealthy carpet manufacturer who was forming a collection of presidential portraits with the advice of Thomas B. Clarke and Charles Henry Hart, was seeking a portrait of President Hayes. Hart asked Eakins about his 1877 portrait, and he replied: "I do not believe it was destroyed. It is probably coarse but not without merit and might serve as a basis for something better." He and Susan went to the Union League to look for it, but were told that there was no record of it. This was a great blow to him, she told me. "How I wished," she said, "that we had never gone down there!"

Clarke commissioned him to paint a second portrait, from a photograph. Head and shoulders, without hands, it follows the photograph closely. Mrs. Eakins told me that because he was not feeling well she herself did a good deal of painting on it. Under the circumstances, it is not one of his strongest portraits.

A more ambitious work, started probably in 1913 or 1914, was a full-length portrait of the brain specialist Dr. Edward Anthony Spitzka, then professor of general anatomy at Jefferson Medical College. Why Eakins, ill as he was, at-

271. MRS. NICHOLAS DOUTY
1910. Oil. 24 × 18¾. G 468
Cummer Gallery of Art, Jacksonville, Florida

tempted it is a mystery; that it was commissioned seems unlikely. The doctor, dressed in black, with a low priestlike collar, was shown standing, against a dark background, holding a plaster cast of a human brain. Mrs Eakins told me that her husband "couldn't get it to go right," and finally asked her to try her hand on the brain cast. She painted it carefully and he said it was good; but it remained the only finished part of the picture. The head, painted by him, is laid in broadly, in a style quite unlike his usual decided brushwork: in touches of varicolored pigment, rather tentative—the style of a man who had lost some of his sureness. Yet it has a quality of massiveness, of concentration on the large structure more than on specific features; it is more "abstract" than his finished works. The physician's black spectral figure can be conceived as symbolizing the power of the human brain, but with a penetrating sense of human mortality. It was his last painting; as Mrs. Eakins wrote me, "the last bit of firm work my husband felt he could do." Years later, a vandalizing dealer cut the canvas down to a head and bust portrait, getting rid of the cast, and of Eakins' whole concept.

IV

In 1910 Eakins was represented in only three museums or public art collections. The Smith College Museum owned the oil *In Grandmother's Time*, purchased from him in 1879; he had given the Metropolitan Museum *The Chess Players* in 1881; and the Pennsylvania Academy had bought *The Cello Player* in 1897. In 1900 Harrison Morris had failed to persuade him to reduce his price on *Between Rounds*. As far as we know, no other public art institution had made a move to acquire anything by him.

In New York the foremost collector of contemporary American painting, George A. Hearn, the department store owner and trustee of the Metropolitan Museum, had begun donating pictures to the museum; in 1906 he had established a fund of $150,000 for purchasing works by living Americans. By 1910 the Metropolitan, making up for years of neglect of American art, was actively acquiring paintings through the Hearn Fund. Hearn had full control of the Fund and did most of the buying. He had been a leading collector of Homer, but he had never bought anything by Eakins.

In early January 1910 Harrison Morris wrote Bryson Burroughs, who the year before had become the museum's curator of paintings: "Today, that able and now ageing American Painter, whom we all revere for distinguished work, Thomas Eakins, came in to see me to ask about recent purchases for the American Department of your galleries. I told him to write you and that I would also.

"To my mind Eakins stands in a very significant position as the incentive of much of the native art which is best developed today. As a teacher he stamped himself forever on our production. As an artist he has been uneven, but when he does a true one it is a masterpiece.

272. DR. GILBERT LAFAYETTE PARKER
1910. Oil. 24 × 20. G 469
Private Collection

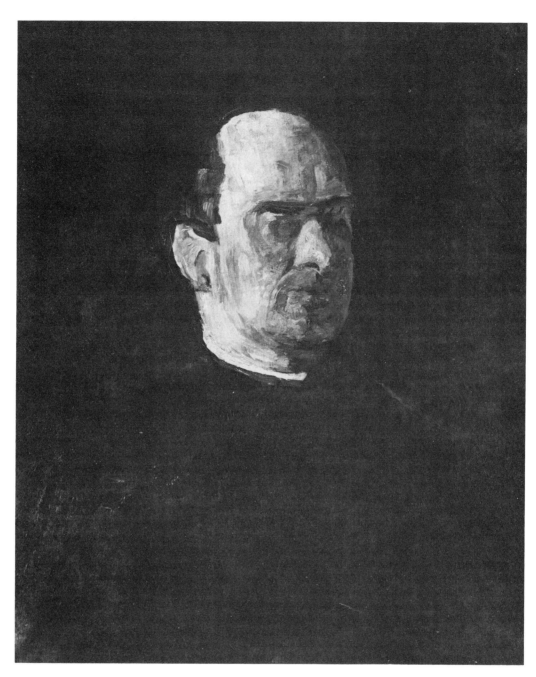

273. DR. EDWARD ANTHONY SPITZKA
About 1913. Oil. 30 × 25. G 474
Hirshhorn Museum and Sculpture Garden, Smithsonian Institution

"Why should the Metropolitan Museum not secure now, while he is still alive, one of those enduring examples.

"I simply lay this hint in your reach and hope you or Mr. Hearn will grasp it.

"If you think I had better write Mr. Hearn I will gladly do so."

Burroughs replied: "I should advise you by all means to write to Mr. Hearn and interest him in the matter as his cooperation is most essential. In the meanwhile I will speak to him of Eakins' work, when the opportunity occurs.

"We have a very good little picture by Eakins 'The Chess Players' which he gave to the Museum in 1881."

On January 12 Eakins himself wrote Burroughs: "I have always felt inadequately represented in the Metropolitan Museum. Hearing that the Museum was now buying some American pictures I have hopes that something of mine may be included." No purchase resulted. Burroughs was later to become an active champion of Eakins; but he was still new in his position, and Hearn's approval was necessary.

Eakins wrote Burroughs on April 17: "It is my intention to visit New York shortly and I wish to see you. Are you likely to be at the Museum in the morning say around ten o'clock?" The meeting took place a month later, when Burroughs wrote a memorandum: "Mr. Eakins wished to call the Museum's attention to a picture by Ribera. He will ask the owners to send it here to be inspected. He also wishes to offer (for sale) a large painting by himself 'The Crucifixion.'"

The "Ribera" is a mystery; it came from a Philadelphia warehouse, but the names of "the owners" are not recorded; the price was "$10,000 or $12,000." In June, Eakins wrote Burroughs: "Have you opened the box containing the Spanish picture? Does the picture meet your expectations?" Evidently it did not, for Burroughs recommended that it be declined. Eakins' *Crucifixion*, price not recorded, was also declined. It was an unfortunate choice: his only essay in a traditional religious subject offered to a museum rich in old masters on the same theme. Perhaps he naively thought that the subject would be in its favor.

So he continued to be represented in only three museums.

<center>V</center>

From 1909 on Eakins exhibited less than in previous years, chiefly at the annual shows of the Pennsylvania Academy, the Carnegie Institute, the National Academy, the Corcoran Gallery, and the Art Institute of Chicago, as well as in the big international expositions. His exhibits were now perforce no longer current works but those of the past. Several times he reached far back to such favorites of his as *The Pair-oared Shell, Pushing for Rail,* and *Starting*

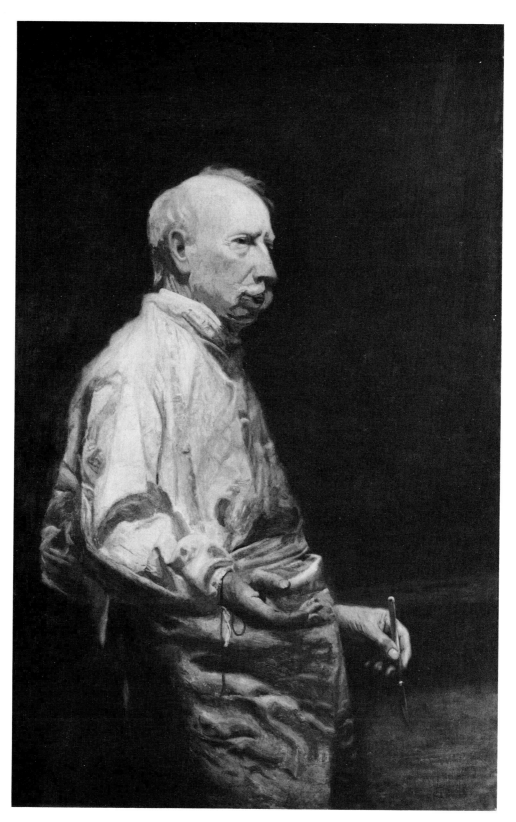

274. DR. D. HAYES AGNEW: STUDY
1889. Oil. 49 × 31½. G 237
Yale University Art Gallery;
Bequest of Stephen Carlton Clark, B.A. 1903

out after Rail of the early 1870s, *Elizabeth at the Piano* and *The Spinner* of the later 1870s, and *The Crucifixion,* 1880.

Among the paintings which had accumulated in his studio was his 1889 oil study of Dr. Agnew's figure: an unusual study, life-size and quite finished, though not as fully realized as in the painting. Murray told me that one day he found it behind a radiator, and suggested that Eakins sell it. A friend said he would like to have it; Eakins offered to give it to him, but the man insisted on paying for it, so Eakins quoted a price of $100. The friend left it to be called for. A few days later a German artist appeared, saying that the friend had asked him to look at it. When Eakins brought it out, the German broke into roars of laughter and asked, "Is he paying a hundred dollars for that?" When he left, Eakins turned the canvas to the wall and said that the buyer couldn't have it no matter how much he paid; and in fact it was never sent for.

However, he decided to exhibit it, first at the National Academy annual in 1913, where it was hung in the "morgue," then at the Pennsylvania Academy's annual, opening February 8, 1914. Aside from portrait commissions, he had not sold a picture since 1897. He told Murray that he was going to put a good stiff price on it: $4,000 (more than twice any previous known asking price). At the Philadelphia show it was the first illustration in the catalogue.

For some reason—the unpredictable vagaries of popular opinion—in Philadelphia the picture "created a sensation," and Eakins was hailed as "the dean of American painters." The Philadelphia *Inquirer* called it "certainly the most important canvas in the exhibition. . . . This massive and powerful portrait, done by the master in the very height of his career, will one day be amongst the most treasured possessions of some great American museum. . . . It compares with the masterpieces of all time." Two weeks later the *Inquirer* wrote: "Undeniably [it] has proven the sensation of the exhibition. . . . It will stand always with the great things of the world. . . . It is understood that museums are already bidding against each other for the possession of this masterpiece. A room devoted to the works of Thomas Eakins should have a place in any new museum which the city of his birth may erect. It is hoped that the directors of the Academy will not allow this canvas to leave the institution." The Philadelphia *Press* reported that it "is valued at $25,000., or at least that is the price at which it has been insured."

Actually the only known bidder was Dr. Albert C. Barnes, millionaire inventor of the antiseptic Argyrol, who was forming his collection of international modern art, with the guidance of William Glackens and Robert Henri. Barnes offered $3,500, which Murray urged Eakins to accept; but Eakins refused to budge, and on February 24 Barnes paid $4,000. Less the Academy's 15 percent commission, Eakins received $3,400—more than double what he had received for any other painting in his entire life. (A newspaper reported that "the price paid for the painting, may, when revealed, prove sensational. One rumor makes it $50,000.")

Henri wrote Barnes: "Congratulations! I was cursing the luck that no big museum was forth coming with the sense or courage to buy Eakins great masterpiece and was very much tempted to get into print about it, hopeless as the case might be. Now I am happy that you have it and that it has found place in a collection in which there are so many of the best works by men who like Eakins have seen the way before them and have dared to follow it.

"Eakins has pursued his course no matter what the fashion has been.

"I think your purchase of his work is more significant than the purchase of a hundred old masters."

Barnes, sending this letter to Eakins, wrote him: "A few days ago two of the best informed men on art, who are themselves painters of international reputation as masters, stood in front of your Agnew portrait and lauded it very highly.

"One of them said that it was worthy to hang among the best Velasquez's in the Prado where it would hold its own in quality. The other said that he considered it the greatest portrait ever painted by an American.

"I am delighted to get the painting, and place it in a collection which has few superiors in the world."

With the years, however, Barnes's opinion of Eakins—though not of his own collection—cooled. In his 1925 book *The Art in Painting* he wrote: "Eakins was essentially a school painter who created nothing truly original." In 1944 he sold the Agnew study, which is now owned by the Yale University Art Gallery.

A nonprofessional opinion of the painting was repeated to me by Eakins' former student Thomas Eagan. During the Academy exhibition he noticed an old woman in a black bonnet looking at the picture a long time. Talking with her, he found that she was a former servant of Dr. Agnew's, with a fine brogue. He asked her whether she thought it was a good likeness, and she said: "Sure, it couldn't be better even if he was to do it over again!"

Reporters went up to Mount Vernon Street to interview Eakins. "In a large, commodious, old-fashioned house at 1729 Mt. Vernon Street," wrote the reporter for the *Press*, "lives Thomas Eakins, dean of American painters. Mr. Eakins is considered to be the foremost living American painter. . . .

"Sitting in his studio, . . . Mr. Eakins, who is seventy years old, but vigorous and enthusiastic about his art as he was in the days when he studied painting under Jerome in Paris and sculpture under Dumont, in 1867, chatted on the present and future of American art, the sources of inspiration and the subjects which the American painter and art students should seek. Contrary to the prevailing notion that an artist must seek to perfect his work and training abroad before he can assume a place in the world of art, Mr. Eakins took occasion to deny this entirely.

"'If America,' he said, 'is to produce great painters and if young art students wish to assume a place in the history of the art of their country, their first

desire should be to remain in America, to peer deeper into the heart of American life, rather than to spend their time abroad obtaining a superficial view of the art of the Old World. In the days when I studied abroad conditions were entirely different. The facilities for study in this country were meager. There were even no life classes in our art schools and schools of painting. Naturally one had to seek instruction elsewhere, abroad. To-day we need not do that. It would be far better for American art students and painters to study their own country and portray its life and types. To do that they must remain free from any foreign superficialities.

"'Of course, it is well to go abroad and see the works of the old masters, but Americans must branch out into their own fields, as they are doing. They must strike out for themselves, and only by doing this will we create a great and distinctly American art.'

275. Eakins in his 1729 Mount Vernon Street studio
Probably c. 1910. Photographer unknown
Seymour Adelman Collection

"Mr. Eakins, asked as to who in his opinion was the greatest American painter, replied that to Winslow Homer belonged that place. 'Whistler,' he said, 'was unquestionably a great painter, but there are many of his works for which I do not care.'

"On the point of the new impressionistic, futurist and cubist movements in art Mr. Eakins laughed these away. 'They are all nonsense,' he said, 'and no serious student should occupy his time with them. He who would succeed must work along the beaten path first and then gradually, as he progresses, try to add something new but sane, something which arises out of the new realities of life and not out of the hysterical imaginations of pathological temperament.'"

In next year's Pennsylvania Academy annual his unfinished full-length portrait of Mrs. Talcott Williams (unfinished because she had refused to continue posing) was hung in the place of honor in one gallery, and won renewed praise. The *Inquirer* described it as "among the most distinguished works of a painter whose place in the history of American art cannot be too strongly insisted upon. . . . The portrait is profoundly impressive."

Undoubtedly as a result of the windfall sale of the Agnew study, during the next two years Eakins increased his asking prices several times over. In 1914 *Between Rounds*, priced at $1,600 in 1900, was raised to $8,000; *The Concert Singer*, $1,000 in 1895, to $5,000; and *The Bohemian*, $800 in 1913, to $2,000. That year the head and bust portrait of Henry O. Tanner was priced at $1,500, and *William Rush Carving* (probably the 1877 version) at $5,000. The following year the unfinished portraits of Mrs. Williams and Kern Dodge were valued at $3,000 and $2,500; the head and bust portrait of Elizabeth R. Coffin at $5,000; *The Veteran* at $2,000; and *The Crucifixion*, which in 1893 had been $1,200, was raised to $10,000—the highest price he ever asked, as far as we know. Next year *The Spinner*, a study for the 1878 *Courtship*, was exhibited five times priced at $3,000.

In spite of all the journalistic hoopla about the Agnew study and its sale, none of the works shown at these increased prices found buyers. Perhaps because of this, in February 1916, for the Pennsylvania Academy's 111th annual, Eakins priced three early paintings more modestly: *The Pair-oared Shell*, 1872, at $2,500; *Pushing for Rail*, 1874, at $800; *Starting out after Rail*, 1874, at $500; and a more recent oil, *Music*, 1904, at $1,500. All except the first were sold. *Starting out after Rail* was bought by the Philadelphia portrait painter Janet Wheeler; *Music* by George H. McFadden of Philadelphia; and the small but beautifully painted *Pushing for Rail* by the Metropolitan Museum.

The previous year J. Alden Weir had been elected president of the National Academy of Design, and thus became an ex officio member of the Metropolitan's purchasing committee for the Hearn Fund. (Hearn had died in 1913.) After visiting the Pennsylvania Academy show, Weir wrote Bryson Bur-

roughs, calling the committee's attention to a "picture by Thos. Aikens I think it is called 'Hunting the rice birds'" and to one by Daniel Garber. "These two pictures I most heartily recommend. This latter picture [the Eakins] was painted some thirty or more years ago but one of great beauty." When Burroughs proposed that the committee should pass on the two works, Weir wrote him: "In the case of the Thomas Eakins picture there seems to me great danger that it might be bought which would be unfortunate for the Metropolitan Museum. . . . I think if you saw it you would not feel like running any risk." On Burroughs' recommendation the museum purchased it on April 17 for $800.

In 1917, after Eakins' death, Weir wrote Mrs. Eakins that he had recognized the painting, from a description by Eakins' friend Dagnon-Bouveret, as having been exhibited in the Salon in the 1870s. "The remarkable character of the figures made me realize it was the one he spoke of. I told Eakins this, which pleased him very much."

These three sales in 1916 must have given Eakins some satisfaction in his last few months. But in the case of the Metropolitan's purchase the satisfaction was not unmixed. On April 23 he sent Burroughs a letter (in Mrs. Eakins' hand; he could no longer write): "A letter from you informs me that the Metropolitan Museum has bought my picture 'Pushing for Rail.'

"I thank you very much for the kindly interest you have taken in my work. I sincerely wish the Museum had chosen a larger and more important picture, such as 'The writing master.' The portrait of Henry A. Roland of the Johns Hopkins University. Prof. George Barker of the University of Pennsylvania—and others."

On April 25 the Art Club of Philadelphia, where Eakins had exhibited frequently in the 1890s and early 1900s, elected him an honorary member. "I trust we may see you here soon," wrote the secretary, "and that you will often use the Club." An honor even more ironical was to come soon after his death, when the National Association of Portrait Painters, the portraitists' establishment, limited to thirty members, elected him an honorary member (deceased).

VI

In 1916, when Eakins was in his seventy-second year, his strength deserted him, and he became housebound. According to Murray, he did not suffer much, but "he sort of went to pieces"; when he tried to get out of bed his legs would give way; he would smile ruefully and speak of "my poor pins." He never complained. "If there ever was a saint, it was Mr. Eakins in his last illness," Murray said. The younger man came to see him almost every day, and would carry him pick-a-back downstairs, and after dinner lead him to lie on a couch in the living room. Once when the dinner bell rang and Eakins started in the wrong direction for the dining room, Murray realized that he was

going blind. They would talk about past happenings, such as the prizefights they had seen. When Murray was about to leave, Eakins would say, "Murray, come again tomorrow. I'm kind of lonesome."

Billy Smith, the fighter in *Between Rounds* and *Salutat,* who was devoted to Eakins, came often to see him and to give him a rubdown. Nicholas Douty would come to sing for him. In January 1916 there was an unexpected pleasure when his old friend Harry Moore, who since their days in France and Spain had lived mostly abroad, returned to Philadelphia to get away from wartime Paris. When the two men met they threw their arms around each other; and Moore returned often, the two conversing in writing or sign language.

Eakins was confined to his room only at the end, in June 1916, and only for ten days. Murray helped to nurse him. Eakins would ask him to hold his hand, and Murray would sit beside him, talking, until he fell asleep. On Sunday morning, June 25, Murray came to relieve Mrs. Eakins, and told her to go down and get some breakfast. He began talking to Eakins, making jokes. After a while he noticed that Eakins did not reply and that he was breathing more and more slowly. He died about one o'clock that afternoon. In a month he would have been seventy-two.

In accordance with his wishes there were no religious service and no flowers; next day his friends gathered at the house to say farewell. Afterward, according to his instructions, his body was cremated. Mrs. Eakins' brothers William and Walter Macdowell were present, and the six pallbearers: Murray, Thomas Eagan, Harry Moore, Louis Husson, Gilbert Sunderland Parker, and Dr. Frederick Milliken. The ashes were brought back to his home, where they were kept until after Susan Eakins' death in 1938, when Murray and Addie Williams' niece Mrs. Rodman took the ashes of both to be buried together in Woodland Cemetery in West Philadelphia. In the Eakins family plot, on heights overlooking the Schuylkill River, no stone marks the grave of Thomas and Susan Eakins.

In 1933, when I sent Murray my book on Eakins, he wrote: "What a story it recalls to me of the journey through the years until the sorrowful June day of 1916. The last for the dearest friend I ever knew."

21. Posthumous Fame

EAKINS' WILL, signed on May 10, 1915, was simple. After bequeathing his "personal and household effects" to Susan, he left the remainder of his estate in trust, with three-quarters of the income to be paid to her and one-quarter to Addie Williams. On the death of either, the entire income was to be paid to the survivor. After the deaths of both women, the principal of the trust was to be distributed to their heirs in the same proportion. There was no bequest to Murray, who no longer needed financial help. Susan was appointed sole executrix and trustee.

The total appraised value of the estate was $33,805.61, about 10 percent more than he had inherited from his father. The many paintings that had remained on his hands were considered to be a part of the trust, not personal belongings; their entire appraised value was $2,860. The individual valuations make strange reading today, even allowing for the fact that appraisers of artists' estates customarily undervalue their works (fortunately for their widows); for example: *William Rush Carving* and *The Swimming Hole*, $25 each; *Mending the Net*, $35; *Between Rounds* and *Salutat*, $50 each; *The Concert Singer*, $150; *Elizabeth at the Piano*, $200; *Rowland*, $250; *The Crucifixion* and *Mrs. Frishmuth*, $400 each, the highest figure.

Within a few months of Eakins' death a movement was started for a memorial exhibition at the Pennsylvania Academy. In February 1917 Helen W. Henderson of the Philadelphia *Inquirer*, who had written admiringly of Eakins and had also published a history of the Academy, proposed the idea to its president, John Frederick Lewis. She later wrote him: "I remember very clearly and painfully our conversation on the subject. . . . You then said that you had told Mrs. Eakins that she could have the gallery at some time when there was nothing else there, as you had 'no doubt that the *poor woman needed money*,' and when I explained to you that Mr. Eakins' will amply provided for her welfare you said that in that case you took no further interest in the matter."

In New York, at the Metropolitan Museum, things were different. Bryson Burroughs had become a firm believer in Eakins' importance. He had written a perceptive article on *Pushing for Rail* for the museum *Bulletin*. He himself was a painter as well as a curator, and this and subsequent writings on Eakins showed an artist's insight. He conceived the idea of a memorial exhibition at the Metropolitan, and in Philadelphia he discussed the project with Gilbert Sunderland Parker, curator of paintings at the Pennsylvania Academy, friend and admirer of Eakins. Parker would like to have had the Academy hold a memorial show but realized that this was hopeless; he agreed to help Burroughs.

In February 1917 Burroughs wrote the Metropolitan's director, Edward Robinson, proposing the exhibition. "In case the Trustees are not familiar with Eakins' work I shall be glad to look up reproductions," he said. As to the gallery to be used, "it should not be a large one." (This diffidence was probably caused by uncertainty about the reception of his proposal.) But Robinson was favorable, as were key trustees. Burroughs asked Parker to borrow photographs and reproductions from Mrs. Eakins, and she sent the few she had, with a short list of works that would be available. "Very few of Mr. Eakins' pictures have been photographed," she wrote Burroughs. He replied: "The photographs seen all together are to me most convincing of Mr. Eakins' rare powers. I admire his work very enthusiastically!" In April the trustees agreed to hold the exhibition the following fall.

Based on this scant material and on his memory, Burroughs sent Parker a tentative list of twenty-four oils. "Not all of the pictures are known to me," he wrote, "some I know from reproductions and some from memories which are more or less vague, consequently . . . I rely on you to correct and add to the list." Parker held several consultations with Mrs. Eakins, who revised the list. Returning it, Parker asked how many works were desired. Burroughs replied: "The room . . . is not a large one, about 42 by 30 feet, . . . so I don't suppose we could show more than twenty-five or thirty pictures." But later, after a day in Philadelphia with Parker and Mrs. Eakins (evidently the first time he had seen the paintings in her house), he spoke of a "large gallery," and on July 17 wrote her: "The large gallery that I hoped for is to be used for the Eakins Exhibition which will open on Monday, November fifth and last one month." She answered: "I am very glad to know that the large gallery will be used, I confess I felt rather disheartened at the idea of a small exhibition."

In Philadelphia again in August, Burroughs, Mrs. Eakins, and Parker agreed on a selection of works owned by her: forty-one oils and six watercolors. Burroughs wanted to include the fine 1880s portrait of her with the setter Harry, but she refused: "I prefer that my portrait would not be in the exhibition." Her pictures were to be supplemented by some from other collections. Parker was of invaluable help in locating owners, getting insurance valuations, and arranging for collecting and transporting the paintings. But the sec-

retary of the Pennsylvania Academy, in response to the Metropolitan's request for the loan of their *Walt Whitman* and *The Cello Player*, wrote Robinson: "Our Board of Directors . . . are very averse to loaning paintings by deceased artists, and I have no reason to think that they would reverse their policy in the case of works by the late Thomas Eakins." Burroughs had to plead with the Academy to lend, which they finally agreed to do.

In the meantime, the Metropolitan's secretary, Henry W. Kent, had asked several critics and artists to write articles on Eakins for the museum *Bulletin*. Mariana Van Rensselaer, who had written sympathetically about him in the 1880s, declined because "I only know about his pictures as having seen some that greatly interested me—about twenty years ago!" Kenyon Cox sent a forthright answer: "I'm afraid I can't, for once, comply with your request for a tribute to Eakins. The fact is that my sympathy with his work is so very imperfect that it would be very difficult for me to write anything that would please you or your audience. Eakins cared nothing for those qualities of painting that mean *art* to me. He was a scientist—and while I admire a few things of his I hate most of them and *love* none."

Burroughs wrote Sargent, then in Boston: "I take the liberty of writing you to ask if you would be willing to write a paragraph or so in appreciation of Mr. Eakins' work, something which we could publish in our Bulletin. I was told by one of Mr. Eakins' friends that you liked his work." Sargent replied: "I regret very much not being able to comply with your request about writing about the Thomas Eakins work—not that I do not admire the fine early examples of it—but I do not like writing for publication." In the end, the *Bulletin* carried two articles, by Harrison Morris and the painter John McLure Hamilton; Eakins had done portraits of both.

The Metropolitan exhibition, which opened November 5, 1917, consisted of sixty works: fifty-four oils and six watercolors. Forty-four pictures, almost three-quarters of the show, were owned by Mrs. Eakins, and included such major paintings as *Elizabeth at the Piano, Turning the Stake*, the 1877 *Rush, The Crucifixion, The Swimming Hole, The Concert Singer, Rowland, Between Rounds, Salutat*, and *Mrs. Frishmuth*. From other owners came sixteen pictures, including the two great clinic paintings. Missing, on the other hand, were a good many other important works which Mrs. Eakins and Parker had probably forgotten. Nevertheless, this was by far the fullest showing of Eakins' art so far, and the first opportunity to see and judge his life work. The catalogue illustrated every picture, and Burroughs' introduction was the most understanding and thoughtful critique since those of Earl Shinn and William Clark in the 1870s.

Burroughs was well aware that Eakins was still little known and his art was not likely to have a wide appeal to the public, so that extra artistic support was needed. For this he turned to Robert Henri, leader of the antiacademic group

of urban realists—Glackens, Sloan, Luks, and Shinn—all ex-Philadelphians and admirers of Eakins. A month before the show was to open he wrote Henri: "It will be a magnificent show and I know that you are interested as well as others to see the exhibition a public success. There is no doubt about the artistic success I feel assured but because Eakins is not very well known generally there is a danger that the exhibition may miss fire from lack of publicity. I am therefore writing you to ask if you will do what you can to boom the show. Would it be terribly against your convictions to write a letter to one of the papers pointing out the interest of the occasion and your rating of Eakins as an artist, or something like that? And could you get Glackens and Sloan or any others of his distinguished pupils [sic] to do likewise? I should be extremely disappointed to see the thing a public fizzle just for lack of knowledge about Eakins' importance."

Henri wrote from Santa Fe, enclosing a long statement full of generous enthusiasm, beginning: "Thomas Eakins was a man of great character. He was a man of iron will and his will was to paint and to carry out his life as he thought it should go. This he did. It cost him heavily but in his works we have the precious result of his independence, his generous heart and big mind." Sending the statement to Burroughs, he said: "Eakins has always been a great man to me and I wish I cd really write something worthy. I have made however this humble effort but have directed it to the students of the Art Students League and will send a copy there where I believe the Secretary will type it and in that way spread copys among the students. . . . As to the copy I enclose for you do with it as you see fit." Burroughs sent it to the *New York Times*. Henri, writing Burroughs again, said, "Isn't it a pity it couldn't have happened years ago!"

Cecilia Beaux, appealed to by Burroughs, wrote from Gloucester, Massachusetts: "It is a great trial to me that I am tied fast here and may not haunt the gallery & revive my memories of Eakins. My consolation is that I know all of them by heart and often have certain passages in mind when I am *trying* to make light fall on the superimposed substances of a bony articulation. Sombre, & what many *now* will call dust-colored as his pictures are, Eakins was enamoured of the Idea of Light and Shadow."

Mrs. Eakins had cooperated fully in all details of the exhibition, often expressing to Burroughs her gratitude for "your interested and enthusiastic efforts for the exhibition." After the show was hung but before it opened, he invited her to come to New York to see it. "At home again," she wrote next day, "I want to write to you, how wonderful the visit to the Museum and to you, was to me. I think I can hardly express, the impression that filled me and remains with me, of the beauty and elegance of your arrangement of my husband's pictures in that splendid room."

Six days later: "Here I am asking just one more card [of invitation] sent and

that to Billy Smith. You will wonder, who is Billy Smith. He's the naked figure that lightens up the center of the picture 'Between Rounds' & the hero in the 'Salutat.' . . . So devoted to my husband. . . . Do you wonder that I want him to know he was not forgotten. He will not be able to go, I am sure, he is one of the great list of work people, who never know when they may have an idle hour."

Henry McBride, art critic of the New York *Sun*, the most sophisticated and prophetic critic of the time and a leading champion of international modernism, was an intimate friend of Burroughs and shared his high opinion of Eakins. In the artist's lifetime he had singled out his few works shown in New York, including the *Agnew* study hung in the "morgue" at the National Academy. Now, expressing wholehearted admiration, he devoted his page on three successive Sundays to the exhibition. "The name of Eakins is unfamiliar to the present art public," he wrote. "Nevertheless Eakins is one of the three or four greatest artists this country has produced, and his masterpiece, the portrait of Dr. Gross, is not only one of the greatest pictures to have been produced in America but one of the greatest pictures of modern times anywhere." McBride did not stop his discerning commentary with the Metropolitan exhibition; he was to continue it for years in his "Modern Art" articles in *The Dial*.

Other reviews of the memorial show were more reserved but favorable, with some dissents. For the first time Eakins' art received something like adequate press coverage. The show, however, had a succès d'estime, not a popular one. It left a deep and lasting impression on some artists and critics, but attendance was small, and the thousand catalogues failed to sell out; some were still available in 1930.

Out of the exhibition the Metropolitan bought two major paintings: *The Writing Master* from Mrs. Eakins and *The Thinker* from her sister, Mrs. Kenton.

In the Philadelphia *Inquirer* Helen Henderson published a glowing review of the New York show: "This is the Philadelphian whom Philadelphians have never thought it worth while to honor. New York, the first to recognize the unappreciated genius of which last year deprived America, has spared no pains to make of this atoning memorial exhibition a just and fitting tribute to a man who, through long years of the most conscientious work, labored with no tribute but his own satisfaction. For the great artist whom Philadelphia could have claimed, the great teacher of art, . . . was set aside and ignored by the city."

Sending her review and McBride's first article to John Frederick Lewis, "fearing that they may otherwise escape your attention," she wrote: "I hope you know that the initiative with regard to this splendid showing of the master's work came entirely from the management of the Metropolitan Museum. . . . I believe that there is nothing that the Academy can ever do now to

wipe out the memory of its negligence in this particular instance—as well as in many others—You have allowed New York to show you what should have been our immediate impulse. What I do hope is that the big lesson of such a disgrace will not utterly escape you."

In subsequent articles she continued to hammer away at New York's initiative and Philadelphia's neglect. What with her pressure, and probably that of others (undoubtedly Gilbert Parker's), the Pennsylvania Academy finally yielded and agreed to take the Metropolitan exhibition. Parker must have been doing more research, for the Academy show, opening December 23, was more than twice as large as the New York one: 139 as against 60. The 79 additional works included many studies and sketches from Mrs. Eakins, but also capital works that had not been shown in New York: among others, the portraits of Dr. Brinton and of his wife, David Wilson Jordan, his sister Letitia, Dr. DaCosta, Leslie Miller, Professor Forbes, and Dr. Holland (*The Dean's Roll Call*). In New York the only Catholic portrait had been Mrs. Eakins' of Falconio; now those of Martinelli, Elder, and *The Translator* were added. In genre the additions included *Starting out after Rail, The Courtship, The Pathetic Song, Professionals at Rehearsal,* and *Music.* Addie Williams lent her second portrait; and, doubtless Mrs. Eakins' idea, Billy Smith the study of himself for *Between Rounds.* Eakins' self-portrait, which should have been seen in New York, was included; but still not the painting of Mrs. Eakins and Harry. Parker produced a well-illustrated if disorganized catalogue with a sympathetic introduction by himself.

Burroughs planned to see the Philadelphia show and to visit Mrs. Eakins. That he probably did so, and that she probably asked his advice about selling pictures, is suggested by her letter to him in January 1918: "I am following your advice. You are certainly my friend, and also a good Dutch uncle, which pleases me very much. No, I am not rich, or I would not have sold 'The Writing Master'—but I feared that nothing would sell. I was in debt, and when the handsome sum was realized, I felt that I would like to spare a little, and my Dutch uncle has shown me how, and your ancient niece is grateful."

The only works purchased from the two memorial exhibitions were the two bought by the Metropolitan. After the Academy show closed, the eighty-two pictures lent by Mrs. Eakins were returned to 1729 Mount Vernon Street, where they rejoined the large majority of Eakins' life works still owned by her —some hung, but most stacked in his studio, many still unframed.

II

After the memorial shows there was a pause in the growth of Eakins' reputation. It was a year or so before Mrs. Eakins took any action about exhibiting or selling her pictures. Then she asked her husband's friend the sportswriter

Clarence Cranmer to help her sell two paintings. Cranmer was a complete amateur in artistic matters; that she asked his help shows how unsophisticated she was in the art world. One of his first moves was to request from the Pennsylvania Academy "a small list of Art Academies in the country, who might be interested." Cranmer was to act as her agent for fifteen years or more; and with experience to become an effective one.

In 1920 Gertrude Vanderbilt Whitney, who was holding exhibitions of liberal artists in her New York studio, sponsored an exhibition of contemporary and recent American painters to be shown at the twelfth Esposizione Internazionale in Venice, the Grafton Gallery in London, and in Sheffield and Paris. Although mostly of works by living artists, the exhibition also included some by Ryder, Twachtman, and Robinson, and six or so paintings by Eakins, including *The Concert Singer, Between Rounds,* and the early *William Rush.* The critic Forbes Watson, who was unofficial adviser to Mrs. Whitney and her assistant Juliana Force, and who accompanied the show in Venice as American commissioner, wrote later: "Not once but innumerable times, I came upon groups of foreigners standing in front of the Eakins pictures roaring with laughter. . . . If the name of Courbet had been attached to these canvases, the entire attitude of the foreigners would have been different. But Eakins was an American." When the exhibition returned it was shown at the Whitney Studio in November 1921.

The first fully professional handling of Mrs. Eakins' pictures did not come until the spring of 1923, when the astute Parisian dealer Joseph Brummer, who had opened a New York gallery, put on the first sizable dealer's exhibition since the ill-fated 1895 one-man show at Earle's Galleries. Brummer induced Burroughs to write a short piece for the catalogue, and himself wrote recalling the Metropolitan show: "That memorable collection at the Museum convinced me that in Thomas Eakins America had added another name to the line of the great artists." Two and a half years later, in November 1925, Brummer staged a larger exhibition. And he arranged to have both exhibitions shown in museums in other cities. In 1927 Brummer was succeeded by the Babcock Galleries as the New York dealer for Mrs. Eakins, and later for her estate.

Burroughs' acquisitions of Eakins' works for the Metropolitan did not end with the two from the memorial exhibition. In 1923 he purchased from Mrs. Eakins the portrait of her with Harry, which she had declined to let him include in the 1917 show, doubtless because of its personal associations. "I had intended never to part with it & had it hidden away," she wrote him. "Now it seems best, that I should accept always an opportunity to place my husband's pictures, and what better place could be than the Met. Museum, and what greater pleasure, than to have had you interested to have it there." At the same time the museum bought the black and white drawing of *The Gross Clinic*

made in 1876 for reproduction. Two years later Burroughs wisely purchased five of the not-too-numerous watercolors; two years after that, *Signora Gomez d'Arza* became the twelfth work to enter the museum's collection.

Renewed exposure of Eakins' work in the 1920s brought widening recognition: first from liberal artists such as Henri, Glackens, and Bellows, and from liberal, modern-minded critics. McBride was joined by Forbes Watson, now editor of *The Arts,* the magazine supported by Mrs. Whitney; by Walter Pach, who in 1923 published an article, "A Grand Provincial"; and by Frank Jewett Mather, Suzanne La Follette, and myself. In 1923 Alan Burroughs, son of Bryson Burroughs, wrote for *The Arts* two articles on Eakins, as artist and man, which were the most complete accounts to date. He had visited Mrs. Eakins and seen the pictures in her house, and had brought with him the painter and photographer Yasuo Kuniyoshi to photograph them—ending, as daylight waned, on the roof of the house. The next year young Burroughs published in *The Arts* a "Catalogue of Works," drawn up in consultation with Mrs. Eakins, listing 343 pictures—necessarily incomplete and with some errors, nevertheless the first.

In a comment accompanying Alan Burroughs' first article, Watson said: "Why every museum in America has not already paintings by Eakins is inexplicable. . . . With half a dozen men of intelligence writing about him, with the most distinguished curator in the country backing him, with a great museum buying his pictures, we find the museums throughout the country accumulating, together with good things, the work of commercial time-servers and neglecting the work of Eakins entirely. Clever Mr. Brummer has seen the light."

But by the mid-1920s museums and collectors were beginning to buy works, directly from Mrs. Eakins or through dealers. In 1925 the Fort Worth Art Association acquired *The Swimming Hole.* In 1928 Thomas Cochran bought *Elizabeth at the Piano,* and in 1929, *Salutat,* both of which he later gave to Phillips Andover Academy. In 1928 the Cleveland Museum acquired the large *Biglin Brothers Turning the Stake.* That year *Taking the Count* and the oil study *John Biglin in a Single Scull* were sold to Francis P. Garvan, and four years later were given to Yale. In 1928 the painter Reginald Marsh, then Bryson Burroughs' son-in-law, purchased the portraits of Archbishop Falconio and General Grubb, and the Brooklyn Museum finally bought the big Cushing portrait. In 1929 the Worcester Museum acquired two oil studies, of Dr. Gross and *The Spinner.* And works from owners other than Mrs. Eakins were being bought by museums: for example, *Letitia Wilson Jordan* from her brother David, by the Brooklyn Museum in 1927. The most active private collector, then and later, was Stephen C. Clark, who purchased *Kathrin* and *Rowland* from Mrs. Eakins in the late 1920s, and continued to collect paintings from other sources into the 1940s—altogether ten or more works.

Susan Eakins had always hoped that her husband's works could be seen in depth in some public institution. In 1917 she had written Burroughs: "It has been my hopeless wish, that at whatever Institution Mr. Eakins' pictures might create interest, that it would be possible that a group of them would be desired. . . . I think of a group of pictures by Mr. Eakins as valuable to serious students."

In Philadelphia there were periodic attempts to rouse interest in having a permanent public gallery of Eakins' works. Henri backed the idea; in 1919 he wrote: "It would be a fine thing for Philadelphia, for America, for all of us and future generations if an Eakins gallery were to be established in Philadelphia. If they would only repeat the dimensions of that splendid room which held the Eakins exhibition at the Metropolitan." But nothing happened. As late as 1929 not a single institution in Philadelphia, as far as is known, had made a move to acquire any picture by Eakins, by either purchase or gift. In 1925 Cranmer wrote the curator of paintings of the Pennsylvania Museum of Art, Arthur E. Bye, asking if the museum would buy a painting, suggesting the portrait of Mrs. Frishmuth. The reply was that there were no "funds for the purchase of any paintings at all."

In July 1927 Burroughs wrote Mrs. Eakins that Cranmer had written about a movement under way to acquire a collection of Eakins' works for Philadelphia, "which I am very glad indeed to hear. I hope Philadelphia has at last waked up to the appreciation of her greatest artist. . . .

"Mr. Cranmer's letter brings up a long cherished ambition of mine which I want to write you about.

"When more space is allotted to the paintings galleries I am very anxious to install three special galleries, one to be devoted to your husband's work, one to Winslow Homer and one to John Sargent. . . .

"Mr. Cranmer's letter reminds me that I ought to write you so that the possibility of the Thomas Eakins Gallery in the Metropolitan Museum may enter into your consideration in the ultimate placing of Thomas Eakins' works which belong to you.

"I am astonished and disappointed that the public recognition of his genius has not yet taken place. That it will come some day I am as sure as that morning follows night but it may not be during your or my lifetime. . . . I want to suggest to you that if you could arrange your will so that a number of his pictures could become the property of this Museum after your death we could be sure that the usefulness of his work would be perpetuated." But nothing came of this plan, either in her will or in the Metropolitan's galleries.

Mrs. Eakins sometimes seemed reluctant to sell her pictures, or she held them for prices that Cranmer considered unrealistically high, but that today

would be absurdly low. In 1929 he wrote that she "withheld the majority with the hopes they would remain here" [in Philadelphia]. At one point she was thinking of leaving them in the Mount Vernon Street house as a memorial to her husband.

Until the late 1920s the Pennsylvania Academy was the only public art collection of any importance in Philadelphia. The collections of the Pennsylvania Museum, housed in the Centennial Exhibition's gloomy art gallery in Fairmount Park, were chiefly of the applied and decorative arts, with a few paintings. But in the early 1920s the museum began to build with city funds a new building on Fairmount. (In the 1930s its name was changed to the Philadelphia Museum of Art.)

The director of the museum from 1925 was brilliant, energetic Fiske Kimball. Before coming to Philadelphia he had asked William Ivins of the Metropolitan for suggestions about future activities; Ivins had said: "Go to see the widow Eakins." This Kimball did. The following year the huge Sesqui-Centennial Exposition in Philadelphia exhibited fourteen pictures by Eakins, lent by her. "I went to see Cranmer," Kimball recalled, "and said I would like to own an Eakins myself, particularly *The Wrestlers* [the large unfinished version, included in the exhibition]. . . . He said he would find out the price. It was $400. I bought it. . . . Later, when people asked Mrs. Eakins how she happened to give the collection to our Museum she said 'Other museum directors came and admired the pictures. Fiske Kimball came and bought one.'"

The Pennsylvania Museum opened its grand impressive building in 1928. In November 1929 Kimball called on Mrs. Eakins to discuss the future of her collection. A few days after his visit she wrote Samuel Murray: "Mr. Fiske Kimball has offered to place all of the Eakins works, Pictures, Sketches, Drawings, Sculpture, in the Penna. Museum.

"*Do not tell anyone;* it is not settled yet, but the offer is exactly what I want, and had hoped to accomplish some way. Mr. Kimball is very interested, and presents fine ideas. . . .

"I just send you a short note, as I want you particularly to know about it. Addie and I think it the finest opportunity, and glad we can keep the pictures in Philadelphia."

In the end the gift, made in the names of Mrs. Thomas Eakins and Miss Mary Adeline Williams, was of fifty oils, one watercolor, eight student drawings and one other drawing, the five wax models for the 1877 *William Rush*, the two Scott reliefs in bronze, and three other bronze reliefs. The oils included at least fifteen major paintings, and many studies for these and other works. It was a magnificent gift, unmatched until the Edward Hopper bequest to the Whitney Museum of American Art in 1968. In March 1930 the Pennsylvania Museum staged a large exhibition of the works given, supplemented by others from Mrs. Eakins' collection and by some loans from other owners, in-

cluding the *Gross* and *Agnew* clinics. At the same time, Henri Gabriel Marceau, the museum's curator of fine arts and its future director, who had organized the show, published in the museum *Bulletin* a catalogue of all known works, totaling 373 items.

The next month the new Museum of Modern Art in New York, on the initiative of its young director, Alfred H. Barr, held an exhibition of Homer, Ryder, and Eakins, as the three Americans of their period who had a special meaning for the new generation. From 1930 on, Eakins was increasingly recognized as being in the front rank of native artists: in histories of American art, exhibitions, museums, private collections, and the art market. The process was helped by the publication in 1933 of my book, *Thomas Eakins: His Life and Work*, with its catalogue raisonné of 515 known works.

Now that Eakins was generously represented in the chief Philadelphia museum, Mrs. Eakins no longer held back sales of her pictures, through the Babcock Galleries and other New York dealers. For assistance in taking care of her paintings she turned to Charles Bregler, who had studied under Eakins for perhaps as many as eight or nine years: possibly four or five at the Pennsylvania Academy and four and a half at the League. Devoted to his master's memory, he had faithfully recorded his classroom sayings, which Forbes Watson published in *The Arts* in 1931. Although not a trained restorer, he was a careful craftsman, and even succeeded in the delicate operation of sawing apart the rectos and versos of wood panels that had been painted on both sides. Mrs. Eakins relied on him completely, and he became her unofficial curator. She also gave him several paintings.

Susan Macdowell Eakins died at 1729 Mount Vernon Street on December 27, 1938, aged eighty-seven. In the twenty-two years that she had survived her husband she had done everything possible to preserve his works and his memory; she had also been able to give more time to her own painting. After her death Addie Williams continued to live in the house until the following June, when it was sold to settle the estate; her niece Mrs. Rodman then took her to Washington. She died on May 14, 1941, also at the age of eighty-seven.

The Fidelity-Philadelphia Trust Company, succeeding trustee of Eakins' estate and executor of Susan Eakins', turned over to the Babcock Galleries what were considered all the salable paintings, and they were gradually sold over the next two decades. However, a great many other things—studies, sketches, some finished canvases, perspective drawings, juvenile works, photograph negatives, Eakins' letters, and other memorabilia—were evidently left in the house, and were taken possession of by Bregler, who preserved every least object related to Eakins. Many of them were lent by him to the extensive Thomas Eakins Centennial Exhibition at the Philadelphia Museum in 1944.

Some time thereafter Bregler placed most of his collection on consignment

with M. Knoedler & Company in New York, from whom it was purchased by Joseph Katz of Baltimore, an advertising man and art collector. After his death in 1958 his collection came on the market again, and in 1961 it was acquired by Joseph Hirshhorn, who for some years had been an enthusiastic collector of Eakins' works. Four years later he purchased Samuel Murray's extensive assemblage of Eakins' sketches, studies, photos, and personal material. Together with paintings obtained from other sources, the Hirshhorn Museum's Eakins collection numbers well over a hundred examples in all mediums. Between the Washington and Philadelphia museums, Eakins' art and life are represented in depth.

With all these happenings the financial value of his paintings increased year by year—in the 1970s, phenomenally. For a 1970 exhibition *The Gross Clinic*, for which he was paid $200, was insured for $1,000,000, and *The Agnew Clinic*, $750 in 1889, for $500,000. In auction sales at Parke Bernet in New York in 1970 *Cowboys in the Bad Lands*, which Eakins had given to John Hemenway Duncan, brought $210,000, the highest auction price up to then for an American painting. In 1978 *Archbishop Elder*, given by Eakins to the archbishop, brought $265,000, setting three records: for an Eakins; for an American portrait; and for a twentieth-century American painting. As Henri had said in 1917, "Isn't it a pity it couldn't have happened years ago!"

Through the years the Mount Vernon Street neighborhood and the old house deteriorated sadly. In 1968 Seymour Adelman of Philadelphia, collector, writer, close friend of Mrs. Eakins, and dedicated champion of Eakins, bought the house, gave it to the city, and raised $200,000 to renovate it as a community art center. Today, under the auspices of the Philadelphia Museum, 1729 Mount Vernon Street is a busy art school serving the neighborhood and the whole city—a living memorial to a great artist and a great teacher.

22. The Artist and His Art

THOMAS EAKINS WAS THE STRONGEST, most profound realist in nineteenth- and early-twentieth-century American art. His realism was total: with rare exceptions, every subject was drawn from the world around him, every figure was a portrait of an individual, every scene a real place, every object an actual one. These realities were pictured objectively, with no overt expression of subjective emotion. His vision was close to the normal, without romantic license or impressionistic veiling of forms.

But underlying this pure realism was the greatest constructive strength among American painters of his century. His paintings were completely three-dimensional, constructed in exact mathematical perspective. There were no flat passages in them. Forms were in the round, solid and weighty; they possessed powerful substance—the most powerful among painters of his time. This gift for substance was inborn, present in his earliest student drawings and continuing throughout his life. The human figure, the central motif of his art, was constructed with complete anatomical understanding; but his understanding was not mere academic correctness, as with most American figure painters; it was deep-seated physical empathy with the human body. His figures are alive; they convey sensations of energy, mobility, muscular tension or repose.

Eakins' art was counter to the concern with appearances that was a major trend of his period, in both impressionism and the visual naturalism of the Sargent kind. For him the real world was one of substantial forms, to be translated into substantial plastic forms. He did not merely depict the visual aspect of things; he recreated their physical existence. Beneath his intellectual, scientific methods lay deep sensory apprehension of physical matter. His feeling for form was basically sensuous; it gave his forms inner life, plasticity, and sculptural largeness.

For him a painting was a physical creation, but one that had its own order: its three-dimensional structure, the relations of its forms to one another, and to the space that contained them. This was more than correct representation of

external reality: it was design of round forms in deep space. All elements in the painting were related to the picture plane, the actual two-dimensional surface of canvas or panel, on which with pigment, tone, and color he created a three-dimensional pictorial world. This world had a unity within which all elements were contained, and out of which forms did not project nor space recede. Backgrounds were not just vacant space but the ground on which forms were constructed. There were no holes in this ground; conversely, forms did not project so far as to lose their relation to it.

Within the bounds of realism, what Eakins created was formal design. He appears to have arrived at this not by aesthetic theorizing or study of the masters, but by an unusual combination of a natural plastic sense and thorough scientific study of the forms and space of the real world. How conscious his design was, we do not know; his statements about artistic matters were confined to naturalistic problems, with little or no reference to purely formal qualities. But it is hard to believe that he did not give thought, deep thought, to design, even without consciously formulating his ideas. His letters about the Rowland portrait afford glimpses of his thinking as he worked out problems on the canvas. The marked improvements in design between the 1876 and 1877 versions of *William Rush*, and between *Taking the Count*, on one hand, and *Between Rounds* and *Salutat*, on the other, demonstrate clearly how he perfected his designs; so do the progressive stages of his small studies for paintings, compared with the final works.

It was this creation of plastic form and of design that distinguished him from the many proficient naturalistic painters of the period. There are superficial resemblances between his art and that of the conservative French artists he admired, such as Gérôme and Bonnat, but in artistic essentials the differences are basic. With all their extraordinary representational skill, it is impossible to discover in their works the plastic powers of the great French creators, from Ingres and Delacroix to Degas and Renoir.

In Eakins' style from the very first it is hard to identify influences of other art. His artistic preferences have been discussed: the Greeks; Velázquez, Ribera, and Rembrandt; Gérôme, Bonnat, Regnault, Fortuny; in later years, some of the French independents; and among Americans, Homer. Of all these, the closest parallels were to Velázquez and Rembrandt. With the Spanish master his affinity was fundamental, without the element of imitation as with Whistler and Manet; his relation to reality was as firsthand as Velázquez's. With Rembrandt the parallels were their sense of character and their mastery of light; a few of Eakins' more romantic portraits such as those of Schenck and William H. Macdowell were definitely Rembrandtesque. But in his work as a whole there was nothing like the influences of Millet on Hunt, Corot on Inness, or the Venetians and Delacroix on La Farge: unmistakable influences, confirmed by the Americans themselves. Unquestionably Eakins

learned much from certain naturalistic painters of the past and of his own time, but it was chiefly in technical matters. The more basic fact is that his art had an exceptionally direct relation to reality, and that it was the product of thorough study of natural forms.

Eakins' art was essentially original. With all his academic training and his experience of Spanish painting in the Prado, when it came to his own work nothing stood between him and the motif in nature: witness his first outdoor painting in America, *Max Schmitt*. In such early works his eye was as innocent as that of a primitive, seeing his subjects as if they had never been painted before—as indeed many of them had not been. But this directness was combined with structural and technical knowledge far beyond any primitive's.

Up to the middle 1880s Eakins had dealt with a variety of subjects: portraits, domestic life, outdoor activities, occasional nudes, a few imaginative themes, and his great drama of medical science, *The Gross Clinic*. After 1886 he abandoned these varied subjects, except occasionally, and devoted himself almost entirely to portraiture. Among the few exceptions were the cowboy pictures of 1888 and 1892, the two monumental sculpture commissions of 1892–93, the prize fight and wrestling scenes of 1898–99, and the three William Rush paintings of 1908.

This change in subject matter involved changes in purely artistic elements: space, light, color, and design. His multifigure compositions such as *The Gross Clinic, Turning the Stake, The Chess Players, William Rush, The Pathetic Song,* and *The Swimming Hole* had produced designs much more complex than single-figure portraits. His outdoor scenes of rowing, sailing, hunting, fishing, and swimming had represented men in action, not statically posing; they had included the forms of nature and of man-made objects such as bridges, sailboats, and racing shells; and they had incorporated space as an essential factor in design, not subordinated to the single figure as in portraits. The outdoor scenes had involved complex elements of open-air light, color, and weather. His last outdoor painting, *Cowboys in the Bad Lands,* had been the most luminous and high-keyed of all his works, suggesting what his color might have become if his art had not gone indoors. And portrait-painting meant abandoning, with a few exceptions, the semi-nude figure as in his rowing pictures, and the nude as in *Rush* and *The Swimming Hole.* Depicting the human body had called forth his fullest gifts as a plastic artist, his most sensuous realization of form, and some of his richest designs. Altogether, his giving up varied subject matter resulted in a diminution of the artistic elements at his disposal.

In portraits Eakins achieved a different kind of design—not multiform but centered on the single static figure, usually against a plain objectless background. It was design of central forms, strongly modeled and powerful in substance. In the figure, and particularly in the head, was concentrated sculptural

form so strong as to dominate the whole pictorial space. In some major portraits the composition was enriched by objects related to the sitter's work or interests: scientific apparatus in the portraits of Rand, Marks, and Rowland; ethnological artifacts as in those of Cushing and Culin; Mrs. Frishmuth's musical instruments; Mrs. Drexel's fans. In such portraits, as in his two great clinic paintings, he extended portraiture beyond its usual limits, producing works that in form and design are among the foremost creations of American art.

On the other hand, portraiture, great as he made it, imposed limitations. It did not provide the full formal possibilities of which he was capable. His average head and bust likenesses, with all their strength of characterization, offered no opportunity for design. His proliferation of them, especially in later years, seems almost an acknowledgment of defeat of larger aims. In spite of lack of major commissions, he could have created, on his own, multifigure compositions such as those of Gross and Agnew (the former, after all, had not been commissioned). He could have continued to picture contemporary life, outdoors and indoors, and broadened his subject matter, as his twentieth-century successors were to do. He could have more freely painted the human body not covered by the all-concealing clothes of the period. Had he carried on the varied content of his earlier years, he might have more often achieved, in addition to the strength and substance of his portraits, a richness of form and design beyond any American contemporary. As it was, his potentialities as a plastic artist and designer too seldom reached full realization.

These limitations in content, and consequently in formal creation, can be ascribed partly to his character as an artist: his strict realism, his adherence to the actualities around him, and his failure to transcend his environment. These personal limitations, combined with the limitations of his period and place, thwarted development of the freer side of his nature.

There is no doubt that Eakins' art suffered from lack of recognition and from opposition to him as artist and teacher. Any artist, no matter how strong, is to some degree affected by his relation to the society of which he is a part. If he is a realist like Eakins, drawing his content from his community, and if like Eakins he is deeply attached to that community, negative response can do great harm. Although independent in his thinking and his art, he was not by nature a rebel; he wanted to be accepted and to play his part in American society. It was only after repeated rejections that he became alienated.

Eakins' rejection by the social and art establishment was more injurious to him than the hostility of French officialdom was to the nineteenth-century antiacademic artists of France. A lone individual in his native city, he was not part of a group like the French impressionists, who though facing opposition had the companionship of their fellows. Philadelphia was not Paris, nor even New York. And though the impressionists had hard times in their early years,

288

Thomas Eakins

most of them received recognition in later years—more than did Eakins, whose small measure of recognition came too late to have much effect on the development of his art. Nineteenth-century America had frustrated a superbly gifted artist.

But to say that he did not realize his full potentialities is to recognize the extent of those potentialities, and the degree to which he did realize them. In spite of limitations—and what artist is free of them?—Eakins' achievement was monumental. He was our first major painter to accept completely the realities of contemporary urban America, and from them to create powerful, profound art. He brought to maturity the native realistic tradition that began with the colonial limners, was continued by Copley, Charles Willson Peale, Earl, Mount, Bingham, and young Winslow Homer, and was to reach full development in the realistic art of our century. In portraiture alone Eakins was the strongest American painter since Copley, with equal substance and power, and added penetration, depth, and subtlety. By his time portrait-painting in America had lost most of its artistic vitality and had declined to a utilitarian trade. Eakins made it once more a major art. And in pure form and design he was the most creative American of his century—except his opposite in every other respect, Albert Ryder.

Although Eakins was an innovator in realistic depiction of the American scene, he was never an innovator in artistic language. His art was independent of current international movements—indeed, counter to them. During his lifetime European art, followed in the United States after a time-lag of a decade or more, was evolving through impressionism and postimpressionism to fauvism, cubism, abstraction, and the other modern movements. In relation to these movements his art could be called anachronistic. He was a representational painter and a nonacademic traditionalist. It may seem paradoxical that Eakins, Ryder, and Homer, who today appear the most creative painters of their period, and the closest to contemporary taste, were so little involved in the movements of their time. But this had been true of many of the most original Americans of the nineteenth century, who had been notable more for vigorous naturalism or romantic personal expression than for innovations in basic artistic concepts. Most such innovations had originated abroad and had been transmitted by individuals more impressionable and sophisticated but not generally as creative. The most enduring American art has not always been in accord with the changing currents of its time; more often it has come from the deeper springs of individual and national character.

Chronology

1844	Thomas Cowperthwait Eakins born July 25 at 4 Carrollton Square, Philadelphia, oldest child of Benjamin Eakins, writing master and teacher, and Caroline Cowperthwait Eakins.
1848	Sister Frances born.
1850	Brother Benjamin born; lived only four months.
1853	Entered Zane Street Grammar School, having previously been taught at home. Sister Margaret born.
1857	After family had lived in three homes in Philadelphia, his father on July 11 bought a house at 1725 Washington Street (later 1729 Mount Vernon Street). Graduating with high grades from Zane Street Grammar School, Eakins was admitted on July 11 to the Central High School of Philadelphia, known for its advanced curriculum and emphasis on science. During four years he was in the upper level of his class, with high marks in mathematics, sciences, and French. Studied drawing all four years, receiving a grade of 100 each year.
1861	Graduated July 11 with B.A. degree, ranked fifth of fourteen in class. Worked with his father teaching penmanship and engrossing documents, probably for several years.
1862	In September competed for position of professor of drawing, writing, and bookkeeping at Central High School; not accepted. October 7, registered at the Pennsylvania Academy of the Fine Arts to draw from antique casts and attend lectures on anatomy.

1863 February 23, admitted "to draw from the life model, and attend the lectures on anatomy" at the Academy. Probably continued to study there through the 1865–66 season, drawing but not painting.

Probably Attended anatomical courses at Jefferson Medical College, Phila-
1864–65 delphia, in Practical Anatomy under Dr. Joseph Pancoast, and in Anatomy under Dr. William H. Pancoast.

1865 Sister Caroline born, late January.

1866 September 22, sailed from New York for Le Havre, on steamship *Pereire*. In Paris by October 2. Applied for admission to the École Impériale et Spéciale des Beaux-Arts under Jean Léon Gérôme; admitted October 29. Studied from the nude, but only drawing for five months. Rented a room at 46 rue de Vaugirard.

1867 Permitted to begin painting, March 21. In late September moved to studio at 64 rue de l'Ouest, to paint independently, while continuing to attend École. Visited Paris Exposition Universelle several times; no mention of the art exhibitions in his letters. With high school classmates William Sartain and William J. Crowell went on walking trip in Switzerland, late July to early September.

1868 Studied sculpture under Augustin Alexandre Dumont at École, beginning March 5; length of study unknown. Moved to 116 rue d'Assas, July. His father and sister Frances came to Paris, July 4, and left July 13 for Italy, where he joined them August 1 in Genoa. They traveled through Italy, including Naples, Rome, Florence, and Venice; Germany, including Munich and Heidelberg; then Belgium; returning August 31 to Paris; his father and sister left for home, September 9. In December he returned to Philadelphia for Christmas, and remained over two months.

1869 Sailed from New York, March 6, arriving at Brest, March 16. In August studied for a month in the private class of Léon Bonnat. Letters to his father about work at the École showed increasing self-confidence. Late November: "I feel now that my school days are at last over." November 29, left Paris for Spain, arriving at Madrid, December 1; spent three days and two nights there, visiting the Prado and discovering Spanish painting. Left Madrid, December 3 for Seville, arriving December 4. Was soon joined by Gérôme classmate Harry Moore.

1870	William Sartain joined them in Seville, early January. Late January, Eakins started his first complete composition, *A Street Scene in Seville;* worked on it at least three months. Probably in May, the three made a nine-day horseback excursion to Ronda. In late May, Eakins left Seville for Paris, probably stopping in Madrid longer than before, studying paintings in the Prado, and writing notes on them. In Paris by June 1; visited the Salon and made notes on paintings. Left Paris, June 15. Home in Philadelphia by early July. He never went abroad again.
	In a top-floor studio at 1729 Mount Vernon Street, began painting domestic genre and portraits of his sisters and their friends. Probably 1870–71: *Home Scene, Margaret in Skating Costume, Elizabeth Crowell and Her Dog.*
1871	First known rowing painting, *The Champion Single Sculls* (*Max Schmitt in a Single Scull*); exhibited at Union League of Philadelphia, April; first known exhibition. Pennsylvania Academy closed until 1876.
1872–75	Many oils and watercolors of rowing, sailing, and hunting subjects.
1872	His mother died, June 4. His sister Frances married William J. Crowell, August 15; settled in Mount Vernon Street house; three children born 1873, 1876, and 1877. First full-scale portrait, of Kathrin Crowell, his future fiancée. *The Pair-oared Shell.*
1873–82	Painted twenty-four known watercolors: outdoor scenes, indoor genre, historical genre, fishing on the Delaware River.
1873	*The Biglin Brothers Turning the Stake.* Sent a watercolor of a rower to Gérôme, who replied encouragingly, May 10. Studied anatomy again at Jefferson Medical College, 1873 and 1874.
1874	Became engaged to Kathrin Crowell. In April began teaching evening drawing classes, Philadelphia Sketch Club, without pay, continuing until Pennsylvania Academy reopened, 1876. Exhibited for the first time in American Society of Painters in Water Colors (later American Water Color Society); showed there every year except two through 1882. *The Sculler,* watercolor, sold for $80, his first sale. In May sent a second watercolor and two oils to Gérôme, who replied complimenting him. *The Schreiber Brothers, Start-*

ing out after Rail (oil and watercolor), *Sailboats Racing, Pushing for Rail, Whistling Plover* (oil and watercolor). *Professor Rand,* first portrait of a well-known person.

1875 *Elizabeth at the Piano. Portrait of Dr. Gross (The Gross Clinic)* begun late March or early April, still being worked on in October. Two oils of hunting scenes shown in Paris Salon, May. Four more oils sent to Gérôme, early 1875; *Whistling Plover* sold through Goupil, Paris, $60. In March submitted *Schreiber Brothers* to annual exhibition of National Academy of Design; rejected.

1876 Submitted four oils and two watercolors to art exhibition of the Centennial Exhibition, Philadelphia, opening May 10; all accepted except *Portrait of Dr. Gross.* Exhibited it at Haseltine Galleries, Philadelphia, late April; finally shown in Centennial in the U.S. Army Post Hospital. *Chess Players. Baby at Play.* First version, unfinished, of *William Rush Carving His Allegorical Figure of the Schuylkill River.* Pennsylvania Academy school reopened in fall; volunteered as unpaid assistant to Christian Schussele, Professor of Drawing and Painting, and as demonstrator of anatomy for anatomy lectures.

1876–81 Five oils and five watercolors of early nineteenth-century domestic life, probably inspired by Centennial.

1877 In late March dissatisfied Academy students formed Art-Students' Union with Eakins as teacher, without pay. May 15, Academy directors resolved that Schussele must not delegate his teaching; Eakins left Academy life class for the Union. Exhibited for the first time in the National Academy of Design. June, first known commission, from Union League of Philadelphia, for portrait of President Rutherford B. Hayes, $400; begun in the White House, September; accepted by the League, paid for and hung, but because of criticisms, removed and sent to Hayes, 1880; now lost. *Archbishop Wood.* Second *William Rush.* William and Frances Crowell settled on farm in Avondale, Pennsylvania, where in the next sixteen years they produced seven more children. The Crowell family and Avondale became an important part of Eakins' life.

1878 March, Academy directors rescinded 1877 resolution; Eakins returned to Academy as Schussele's assistant, without pay; in the fall became Assistant Professor of Painting and Chief Demonstrator of

Anatomy, still without pay. March, showed in first exhibition of new liberal Society of American Artists. Became interested in Eadweard Muybridge's experiments in motion photography. Drew two illustrations for *Scribner's Magazine;* one more in 1879, and two in 1881. First award: silver medal of Massachusetts Charitable Mechanics' Association for two watercolors. *Portrait of Dr. Gross* bought by Jefferson Medical College, $200.

1879 Kathrin Crowell died April 6. March, *Dr. Gross* exhibited by Society of American Artists, New York; violently attacked by the press. April, Pennsylvania Academy exhibited Society exhibition, but segregated *Gross.* Eakins began correspondence with Muybridge. *A May Morning in the Park (The Fairman Rogers Four-in-hand)*, one of the earliest paintings to accurately depict horses in motion, commissioned by Rogers, $500. Schussele died August 21. September 8, Eakins appointed Professor of Drawing and Painting at $600 a year, later increased to $1,200. Article on Pennsylvania Academy school by William C. Brownell in *Scribner's Magazine* (September) presented fullest account of Eakins' teaching. Smith College bought *In Grandmother's Time*, $100.

1880 Delivered first of his perspective lectures at Pennsylvania Academy, March. Elected to Society of American Artists, May. Commenced photography about 1880. Two commissioned portraits of Gen. George Cadwalader, $250 each. *The Crucifixion*, his only religious painting.

1881 Began to teach and lecture on anatomy twice a week at Students' Art Guild of Brooklyn Art Association, $100 a month; probably continued through the 1884–85 season. *The Pathetic Song.* Series of four oils and three watercolors of shad-fishing on the Delaware River at Gloucester, N.J., 1881–82. Gave *The Chess Players* to the Metropolitan Museum.

Early *The Meadows, Gloucester*, his only full-scale pure landscape, and
1880s many small landscape sketches, probably in the Gloucester area.

1882 Drew up plan for reorganizing Pennsylvania Academy school; appointed Director, March; promised future doubling of $1,200 salary; did not receive it. *The Writing Master.* Sister Margaret died December 22.

1883	Probably early 1883, commissioned to model two small reliefs, *Spinning* and *Knitting*, by James P. Scott, who refused to accept them. *Professionals at Rehearsal* commissioned by Thomas B. Clarke. Series of Arcadian oils and reliefs probably begun summer 1883, continuing into 1884. Fairman Rogers, his strongest supporter in Pennsylvania Academy, resigned as a director, November.
1884	Married Susan Hannah Macdowell, January 19; moved to studio at 1330 Chestnut Street, Philadelphia, where they lived two and a half years. Muybridge began pioneer motion photography at University of Pennsylvania, late spring; Eakins appointed to supervisory commission; by June was himself photographing figures in motion, using more advanced technical methods. *The Swimming Hole*, commissioned by Edward Hornor Coates, begun in summer; finished 1885.
1885	Continued motion photography, late March into early fall. Beginning in November, gave twelve lectures on anatomy each season at Art Students' League of New York, continuing through spring 1889. Because of teaching, lecturing, and motion photography, produced few works this year. Sister Caroline married his pupil George Frank Stephens.
1886	Because of opposition to his teaching methods, probably including exposure of completely nude male model in women's life class, Pennsylvania Academy directors asked him to resign, which he did February 9. Protesting students organized Art Students' League of Philadelphia, February 18, with him as Instructor, without salary; first session February 22. Samuel Murray joined school, November. Eakins returned with his wife to live at 1729 Mount Vernon Street, July; but kept 1330 Chestnut Street as his studio until 1900. *Professor Barker. Professor Marks. The Artist's Wife and His Setter Dog*, probably early 1886. Exhibited little 1886–1890.
1887	Produced little, probably as result of trauma of Pennsylvania Academy affair. Met Walt Whitman, probably in spring, and began his portrait. In summer spent two and a half months on B-T Ranch near Dickinson, Dakota Territory, returning to Philadelphia, October 20, with two Western horses which he left at Crowell farm, Avondale.

1888 Finished *Whitman*, April. *Letitia Wilson Jordan.* October, finished *Cowboys in the Bad Lands*, his last outdoor subject. In fall began anatomy lectures at National Academy of Design, New York, continuing through spring 1895. University of Pennsylvania published *Animal Locomotion: The Muybridge Work at the University of Pennsylvania*, with essay by Professor Marks, written partly by Eakins, describing his method and cameras.

1889 Spring, students of University of Pennsylvania School of Medicine commissioned portrait of Dr. D. Hayes Agnew, $750. *The Agnew Clinic*, Eakins' largest painting, completed in three months; presented to School, May 1. Samuel Murray became his assistant in his studio. Anatomy lectures at Art Students' League of New York discontinued after complaints about his methods. Sister Caroline Stephens died November 30.

1890 *Professor Fetter* commissioned by students of Girls' Normal School. *The Concert Singer* begun; completed 1892. *Miss Van Buren*, about 1890. Exhibited *The Writing Master* in Paris Salon.

1891 Exhibited at Pennsylvania Academy, January, for first time since 1885, but *The Agnew Clinic*, invited by the artists' jury, was rejected by the directors on a technicality. Lectured on anatomy at Woman's Art School of Cooper Union, New York, 1891–1898. Through sculptor William R. O'Donovan was commissioned to model horses for equestrian statues of Lincoln and Grant on Soldiers' and Sailors' Memorial Arch, Brooklyn. Grant's horse finished April 1892, Lincoln's probably 1892 or 1893. Portrait of O'Donovan, 1891 or early 1892.

1892 Whitman died March 26; Eakins an honorary pallbearer. Resigned from Society of American Artists, May 7, after three years' rejections of his paintings, including *The Agnew Clinic*. Four pictures of Franklin L. Schenck as a cowboy, singing. Commissioned to model two reliefs for Trenton Battle Monument; completed 1894. Destroyed commissioned portrait of Dr. DaCosta, unsatisfactory to sitter.

1893 *Dr. DaCosta*, second version. Last season of Art Students' League of Philadelphia, 1892–93. Eleven paintings, including the *Gross* and *Agnew* clinics, exhibited at World's Columbian Exposition, Chicago; received bronze medal, first award since 1878.

1894	Delivered paper "The Differential Action of Certain Muscles Passing More than One Joint" before weekly meeting of Academy of Sciences, Philadelphia, May 1; published in Academy *Proceedings,* 1894. Began to exhibit again in Pennsylvania Academy annuals, continuing in every one throughout his life. *Frank Hamilton Cushing,* 1894 or 1895; rejected by Pennsylvania Academy jury.
1895	*Riter Fitzgerald. John McLure Hamilton.* Anatomy lectures at National Academy discontinued after 1894–95 season, after complaints about his methods. Anatomy lectures at Drexel Institute, Philadelphia, canceled in mid-March because of his showing a completely nude male model before a mixed class. Lecturing on anatomy ceased after 1894–95 season, except at Cooper Union.
1896	*The Cello Player.* Assisted Samuel Murray, 1896–97, with ten overlife-sized statues of biblical prophets for Witherspoon Building, Philadelphia. May, first and only one-man exhibition, Earle's Galleries, Philadelphia: 29 works; none sold. November, exhibited in first Carnegie Institute international exhibition; and again in 1899 through 1912, except 1904.
1897	February, Pennsylvania Academy purchased *The Cello Player,* $500. His oldest niece, Ella Crowell, who had studied at the League, committed suicide on July 2. Her father unjustly blamed Eakins' influence on her, and forbade his visiting the family and Avondale. *Professor Rowland* begun in July, finished late 1897.
1898	Three prizefight paintings: *Taking the Count, Between Rounds* (begun 1898, finished 1899), *Salutat.* End of lecturing at Cooper Union.
1899	*Wrestlers. The Dean's Roll Call. David Wilson Jordan.* About 1899: *Stewart Culin.* Served for first time on Carnegie Institute international jury of awards; again in 1900, 1901, 1903, 1905. His father died December 30.
1900	Childhood friend Mary Adeline Williams came to live at 1729 Mount Vernon Street. October, Eakins and Murray gave up Chestnut Street studio. Eakins converted fourth-floor attic of Mount Vernon Street house into studio. *Antiquated Music (Mrs. Frishmuth). The Thinker.* Received an honorable mention, Exposition Universelle, Paris. About 1900 he and Murray began Sunday visits to Seminary of St. Charles Borromeo, Overbrook, Pennsylvania. In

the early 1900s he painted fourteen portraits of thirteen members of the Catholic clergy, nine of them in 1902 and 1903.

1901 January, served on Pennsylvania Academy annual exhibition jury for first time since 1879; again in 1903, 1906, and 1909. *Professor Miller*. Gold medal, Pan-American Exposition, Buffalo, for *Professor Barker*.

1902 Elected Associate of National Academy of Design, March 12; full Academician, May 14. From 1904 exhibited at Academy every year except two, and at Society of American Artists, 1902 to 1906, when Society and Academy were merged. *Cardinal Martinelli*, painted in Washington, spring. *Very Rev. John J. Fedigan. The Translator. Msgr. James F. Loughlin.*

1903 With increasing recognition, produced many more works (all portraits) than in the 1890s, particularly in 1903 and 1904. *Mrs. Greenewalt. William B. Kurtz. Bishop Prendergast. Mother Patricia Waldron. Archbishop Elder*, painted in Cincinnati.

1904 *Robert C. Ogden. Dr. White. Music.* January, *Archbishop Elder* awarded Temple Gold Medal, Pennsylvania Academy. Exhibited seven paintings in Universal Exposition, St. Louis, including the *Gross* and *Agnew* clinics; awarded gold medal for former.

1905 *Professor Forbes* commissioned by students of Jefferson Medical College. *Archbishop Falconio*, painted in Washington. *John B. Gest. Asbury W. Lee* (paid for but refused). Awarded Thomas R. Proctor Prize, National Academy of Design, for *Professor Miller*.

1906 *Elizabeth L. Burton*. Assisted Murray with statue of Commodore Barry for Independence Square, Philadelphia. Father-in-law, William H. Macdowell, died August 7.

1907 *Dr. William Thomson* (two versions). Awarded medal of second class, Carnegie Institute, for *Professor Miller*; gold medal, American Art Society of Philadelphia, for *Rear Admiral Melville*.

1908 *William Rush Carving His Allegorical Figure of the Schuylkill River*; rejected by Carnegie Institute jury. Probably 1908, two unfinished versions of the Rush theme, now titled *William Rush and His Model* and *William Rush's Model. Edward A. Schmidt. The Old-fashioned Dress.*

1909	*The Medical Examiner (Dr. Henry Beates, Jr.).* Decreased production.
1910	Head and bust portraits of Mrs. Nicholas Douty and of four Parkers.
1911	Health began to fail. No more known works until 1912 and 1913–14.
1912	November, attended opening in Lancaster, Pennsylvania, of exhibition of historical portraits featuring *The Agnew Clinic,* and received an ovation. Probably late 1912, received commission for second portrait of President Hayes; painted from a photograph, with Mrs. Eakins' assistance.
1913 or 1914	*Dr. Spitzka,* full-length; helped by Mrs. Eakins; unfinished. Becoming increasingly blind and infirm.
1914	Study of Dr. Agnew, 1889, exhibited at Pennsylvania Academy, February, purchased by Dr. Albert C. Barnes for $4,000, more than double the amount paid for any other painting in his lifetime. Extravagant publicity; newspaper interviews. Increased asking prices, 1914 and 1915; no sales.
1915	Unfinished portrait of Mrs. Talcott Williams (c. 1891) hung in place of honor, Pennsylvania Academy annual exhibition.
1916	February, exhibited three early paintings and *Music* (1904) in Pennsylvania Academy annual, moderately priced; three sold; *Pushing for Rail* bought by Metropolitan Museum. Elected honorary member, Art Club of Philadelphia, April. Confined to his room for ten days, he died on June 25. No religious service. His body was cremated.
1917	November 5: the Metropolitan Museum of Art opened a memorial exhibition, the first opportunity to see his life work. December 23 the Pennsylvania Academy, yielding to pressure, opened a larger memorial exhibition.
1930	Mrs. Eakins and Miss Williams gave the Pennsylvania Museum (now the Philadelphia Museum of Art) a collection of seventy works.
1938	Susan Macdowell Eakins died on December 27.

Bibliography

This Bibliography does not list all published references to Thomas Eakins, numbering several thousands, many of which are brief or passing mentions. The aim has been to give references of some substance and at least moderate length. Additional references to specific subjects, especially in newspapers and magazines, are given in the text and the notes to the text. Newspaper references, with some exceptions, are during Eakins' lifetime. Exhibition catalogues published in hardcover as well as paperback editions are listed under "Books." The place of publication of books and magazines is New York unless otherwise stated.

BY THOMAS EAKINS

The Differential Action of Certain Muscles Passing More than One Joint. Proceedings of the Academy of Natural Sciences of Philadelphia, 1894, vol. 45, p. 172–180. Philadelphia, 1894. Illustrated with drawings by Eakins reproduced in linecut. A 9-page reprint was made for Eakins; 100 copies.

MONOGRAPHS ON THOMAS EAKINS

Flexner, James Thomas. *Thomas Eakins.* The Metropolitan Museum of Art Miniatures, 1956. 24 color ills.

Goodrich, Lloyd. *Thomas Eakins: His Life and Work.* Whitney Museum of American Art. 1933. 73 black and white ills.

—— *Thomas Eakins.* Published for the Whitney Museum of American Art by Praeger Publishers, 1970. 42 ills., 8 in color. Hardcover edition of the catalogue of the Thomas Eakins Retrospective Exhibition, Whitney Museum of American Art, 1970.

Hendricks, Gordon. *The Photographs of Thomas Eakins.* Grossman Publishers, 1972. 291 black and white ills.

—— *The Life and Works of Thomas Eakins.* Grossman Publishers, 1974. 361 ills., 55 in color.

Hoopes, Donelson F. *Eakins Watercolors.* Foreword by Lloyd Goodrich. Watson-Guptill Publications, 1971. 46 ills., 32 in color.

McHenry, Margaret. *Thomas Eakins who painted.* Privately printed for the author, Oreland, Pa., 1946. One black and white ill.

McKinney, Roland. *Thomas Eakins.* Crown Publishers, 1942. 72 ills., 8 in color.

Porter, Fairfield. *Thomas Eakins.* George Braziller, 1959. 89 ills., 16 in color.

Rosenzweig, Phyllis D. *The Thomas Eakins Collection of the Hirshhorn Museum and Sculpture Garden.* Washington: Hirshhorn Museum, 1977. 169 ills., 6 in color. Also published in softcover edition.

Schendler, Sylvan. *Eakins.* Boston: Little, Brown and Company, 1967. 158 black and white ills.

Siegl, Theodor. *The Thomas Eakins Collection.* Philadelphia: Philadelphia Museum of Art, 1978. Introduction by Evan H. Turner. 172 black and white ills.; and cover in color. Softcover.

Thomas Eakins: 21 Photographs. Atlanta, Ga.: The Olympia Galleries, Ltd., 1979. Foreword by Joseph A. Seraphin. Introduction by Seymour Adelman.

See also EXHIBITION CATALOGUES: ONE-MAN

BOOKS

Adams, J. Howe. *History of the Life of D. Hayes Agnew, M.D., L.L.D.* Philadelphia, 1892. P. 332–335, 341.

Adelman, Seymour. *The Moving Pageant: A Selection of Essays*. Lititz, Pa., 1977. "Thomas Eakins: Mount Vernon Street Memories," p. 153–177.

American Art Portfolios, Series One. 1936. Lloyd Goodrich, "Thomas Eakins," p. 40–42.

American Paintings in the Museum of Fine Arts, Boston, vol. 1. Boston, 1969. P. 101–103.

Animal Locomotion, The Muybridge Work at the University of Pennsylvania, The Method and the Result. Philadelphia, 1888. Facsimile reprint, Arno Press, 1973. William Dennis Marks, "The Mechanism of Instantaneous Photography," p. 9–33. The description of Eakins' apparatus, p. 9–14, was written by him.

The Artist in America. Compiled by the Editors of *Art in America*. 1967. P. 12, 13, 22, 119, 126–128, 131.

Art Studies for an Editor: 25 Essays in Memory of Milton S. Fox. 1975. John Wilmerding, "Peale, Quidor, and Eakins: Self-Portraiture as Genre Painting," p. 291–300.

Baigell, Matthew. *A History of American Painting*. 1971. P. 167–175.

Barker, Virgil. *A Critical Introduction to American Painting*. 1931. P. 34, 35.

—— *American Painting: History and Interpretation*. 1950. P. 651–662, 666–668.

Baur, John I. H. *Revolution and Tradition in Modern American Art*. Cambridge, Mass., 1951. P. 3, 86, 87, 99.

—— *American Painting in the Nineteenth Century: Main Trends and Movements*. 1953. P. 19.

Beaux, Cecilia. *Background with Figures: Autobiography of Cecilia Beaux*. 1930. P. 95–98.

Benjamin, S. G. W. *Art in America: A Critical and Historical Sketch*. 1880. P. 208–210.

Bennett, Ian. *A History of American Painting*. London and New York, 1973. P. 131–133, 137–139.

Boas, George, ed. *Courbet and the Naturalistic Movement*. Baltimore, 1938. Charles H. Sawyer, "Naturalism in America," p. 118, 119, 122–124.

Book of American Figure Painters. Philadelphia, 1886. Introduction by M. G. Van Rensselaer.

Boswell, Peyton. *Modern American Painting*. 1939. P. 47, 48, 51, 52, 142, 147.

Bowers, David F., ed. *Foreign Influences in American Life*. Princeton, N.J., 1944. Donald Drew Egbert, "Foreign Influences in American Art," p. 123, 124.

Brooks, Van Wyck. *The Times of Melville and Whitman*. 1947. P. 443–445.

—— *John Sloan: A Painter's Life*. 1955. P. 11, 13, 14, 37, 125.

Brown, Milton W. *American Art to 1900: Painting, Sculpture, Architecture*. 1977. P. 420, 488, 489, 500, 502–525, 528, 532, 533.

Burroughs, Alan. *Limners and Likenesses: Three Centuries of American Painting*. Cambridge, Mass., 1936. P. 41, 190, 191, 199–203.

Burt, Nathaniel. *The Perennial Philadelphians*. Boston, 1963. P. 295–297, 301, 323, 324, 331–333.

Caffin, Charles H. *The Story of American Painting*. 1907. P. 230–233.

Cahill, Holger, and Alfred H. Barr, Jr., eds. *Art in America in Modern Times*. 1934. P. 21–23.

Cairns, Huntington, and John Walker, eds. *A Pageant of Painting from the National Gallery of Art*, vol. 2. 1966. P. 484. Quotation from Ben Shahn, *The Shape of Content*, 1957.

Canaday, John. *Mainstreams of Modern Art*. 1959. P. 312–320.

—— *What Is Art?: An Introduction to Painting, Sculpture, and Architecture*. 1980. P. 78–80.

Clark, Eliot. *History of the National Academy of Design*. 1954. P. 173, 174, 176.

Cohen, George M. *A History of American Art*. 1971. P. 111–113.

Coke, Van Deren. *The Painter and the Photograph, From Delacroix to Warhol*. Albuquerque, N. Mex., 1975. P. 43–45, 156–158, 162, 163, 165, 308.

Corcoran Gallery of Art. *A Catalogue of the Collection of American Paintings*, vol. 1. Washington, D.C., 1966. P. 147.

Cortissoz, Royal. *American Artists*. 1923. "Thomas Eakins," p. 77–82.

Craven, Thomas. *A Treasury of Art Masterpieces, From the Renaissance to the Present Day*. 1939. P. 236.

—— *Story of Painting*. 1943. P. 230, 231.

Davidson, Abraham A. *The Story of American Painting*. 1974. P. 54, 55, 62, 81, 91, 94, 95.

Davidson, Marshall B., and the Editors of *American Heritage*. *The American Heritage History of the Artists' America*. 1973. P. 176, 177, 204–209.

Deák, Gloria-Gilda. *Profiles of American Artists Represented by Kennedy Galleries*. 1981. P. 51, 52.

Dorra, Henri. *The American Muse*. 1961. P. 18, 19, 22, 23, 29. Hardcover edition, with changes in text, illustrations, and page numbers, of the catalogue of the exhibition of this title, Corcoran Gallery of Art, 1959; and of *Art in America*, vol. 47, Summer 1959, p. 20–23.

Dunbar, Elizabeth. *Talcott Williams, Gentleman of the Fourth Estate*. Brooklyn, 1936. P. 215, 216.

Eliot, Alexander. *Three Hundred Years of American Painting*. 1957. P. 138–148.

Faison, S. Lane, Jr. *A Guide to the Art Museums of New England*. 1958. P. 37, 38, 69, 139, 140.

—— *Art Tours and Detours in New York State*. 1964. P. 19, 116, 179.

—— *Williams College Museum of Art: Handbook of the Collection*. Williamstown, Mass., 1979. #46.

Flexner, James Thomas. *A Short History of American Painting*. Boston, 1950. P. 64–67, 72. Also published in paperback as *The Pocket History of American Painting*, 1950.

—— *Nineteenth Century American Painting*. 1970. P. 226–239.

—— and the Editors of Time-Life Books. *The World of Winslow Homer, 1836–1910*. 1966. P. 135, 139–143, 144–151.

Freedgood, Lillian. *Great Artists of America*. 1963. P. 76–94, 110. Also published in paperback, 1966.

The Freeman Book. 1924. Walter Pach, "A Grand Provincial," p. 256–261. Reprinted from *The Nation*, April 11, 1923.

Gerdts, William H. *The Great American Nude: A History in Art*. 1974. P. 118–124, 158.

—— *The Art of Healing: Medicine and Science in American Art*. Birmingham, Ala., 1981. P. 62–70, 93–95.

Goldwater, Robert, and Marco Treves. *Artists on Art*. 1945. P. 353–355, 472, 473.

Goodrich, Lloyd. *American Watercolor and Winslow Homer*. Minneapolis, 1945. P. 33–35. Hardcover edition of the catalogue of the exhibition of this title, Walker Art Center, 1945.

—— *Three Centuries of American Art*. 1966. P. 10, 44, 45. Hardcover edition of the catalogue of the exhibition, "Art of the United States, 1670–1966," Whitney Museum of American Art, 1966.

—— *Raphael Soyer*. 1972. P. 209, 210, 238, 246.

Graham, F. Lanier. *Three Centuries of American Painting, from the Collection of the M. H. De Young Memorial Museum and the California Palace of the Legion of Honor*. San Francisco, 1971. P. 28, 53.

Green, Samuel M. *American Art: A Historical Survey*. 1966. P. 404–411.

Hamilton, George Heard. *19th and 20th Century Art: Painting, Sculpture, Architecture*. 1970. P. 109–113.

Hartmann, Sadakichi. *A History of American Art*, vol. 1. Boston, 1902. P. 189, 200–207. New rev. ed., New York, 1932; one-vol. ed., New York, 1934.

Hawkes, Elizabeth H. *American Painting and Sculpture, Delaware Art Museum*. Wilmington, Del., 1975. P. 52, 54, 80, 81.

Hendricks, Gordon. *Eadweard Muybridge, The Father of the Motion Picture*. 1975. P. 111, 113–114, 157, 159, 160, 161, 203, 205.

Henri, Robert. *The Art Spirit*. 1923. P. 86–88, 125, 126.

Hills, Patricia. *The Painters' America: Rural and Urban Life, 1810–1910*. 1974. P. 84, 85, 92, 94, 95, 97, 125. Hardcover edition of the catalogue of the exhibition of this title, Whitney Museum of American Art, 1974.

The Hirshhorn Museum and Sculpture Garden. 1974. Abram Lerner, "Introduction," p. 20; Linda Nochlin, "The 19th Century," p. 66–73; Catalogue, p. 686–689.

Homer, William Innes. *Robert Henri and His Circle*. Ithaca, N.Y., 1969. P. 4, 21–27, 83, 176–179.

Hoopes, Donelson F. *American Watercolor Painting*. 1977. P. 61, 62, 196.

Hunter, Sam. *Modern American Painting and Sculpture*. 1959. P. 13, 14, 23, 24, 115.

—— *American Art of the 20th Century*. 1972, 1973. P. 21–24.

Ingersoll, R. Sturgis. *Henry McCarter*. Cambridge, Mass., 1944. P. 15–18, 22.

Isham, Samuel. *The History of American Painting*. 1905, 1927. P. 504, 525, 526.

Kent, Rockwell, ed. *World-Famous Paintings*. 1939, 1947. Plate 94.

Kimball, Fiske, and Lionello Venturi. *Great Paintings in America*. 1948. P. 176, 177.

Kouwenhoven, John A. *Made in America*. 1948. P. 178–181.

LaFollette, Suzanne. *Art in America*. 1929. P. 177, 178, 184–190, 216, 332.

Larkin, Oliver W. *Art and Life in America*. 1949, 1960. P. 277–279, 282, 303.

Lipman, Jean, and Helen M. Franc. *Bright Stars: American Painting and Sculpture since 1776*. 1976. P. 92, 94.

Lynes, Russell. *The Art-Makers of Nineteenth Century America*. 1970. P. 358–375, 439.

Mather, Frank Jewett, Jr. *Estimates in Art, Series II*. 1931. "Thomas Eakins," p. 201–231. Reprinted from *International Studio*, Jan. 1930.

——, Charles Rufus Morey, and William James Henderson. *The American Spirit in Art*. (*The Pageant of America*, vol. XII). New Haven, 1927. P. 51, 57, 58, 93, 96.

Mathews, Marcia M. *Henry Ossawa Tanner, American Artist*. Chicago, 1969. P. 24–30, 32, 50–52.

Mathey, François. *American Realism: A Pictorial Survey from the Early Eighteenth Century to the 1970s.* 1978. P. 87–91, 93–95, 98.

Matthiessen, Frank O. *American Renaissance.* 1941. P. 604–610, 613, 635.

Maytham, Thomas N. *Great American Paintings from the Boston and Metropolitan Museums.* 1971. P. 16.

McBride, Henry. *The Flow of Art: Essays and Criticisms of Henry McBride.* Selected, with an Introduction, by Daniel Catton Rich. 1975. P. 5, 22, 130–142, 384.

McCoubrey, John W. *American Tradition in Painting.* 1963. P. 33–38, 43, 44, 118, 123.

—— *American Art, 1700–1960: Sources and Documents.* Englewood Cliffs, N.J., 1965. "Thomas Eakins: On His Teaching Methods," p. 150–155. (Quotations from W. C. Brownell's article in *Scribner's,* 1879, and Fairman Rogers' article in *The Penn Monthly,* 1881.)

McLanathan, Richard. *The American Tradition in the Arts.* 1968. P. 94, 339–345.

—— *Art in America: A Brief History.* 1973. P. 69, 137, 157, 159–164.

Mendelowitz, Daniel M. *A History of American Art.* 1960. P. 422–424.

The Metropolitan Museum of Art. *19th-Century America: Paintings and Sculpture.* 1970. Introduction by John K. Howat and John Wilmerding. Text by John K. Howat and Natalie Spassky, #154–158. In cloth and paper editions.

Morgan, H. Wayne. *Unity and Culture: The United States, 1877–1900.* (The Pelican History of the United States, vol. 4.) 1971. P. 94, 95.

Morris, Harrison S. *Confessions in Art.* 1930. P. 8, 24, 30–36, 70, 129, 146, 170.

Mumford, Lewis. *The Brown Decades.* 1931. P. 31, 189, 190, 210–220.

—— *Interpretations and Forecasts, 1922–1972.* 1972. "Eakins: Painter and Moralist," p. 75–81. Reprinted from *The New York Review of Books,* Sept. 21, 1972.

Myron, Robert, and Abner Sundell. *Art in America: From Colonial Days through the Nineteenth Century.* 1969. P. 138–140, 146.

Neuhaus, Eugen. *The History and Ideals of American Art.* Stanford University, Calif., 1931. P. 174.

Newhall, Beaumont. *The History of Photography from 1839 to the Present Day.* 1949. P. 108, 109.

Novak, Barbara. *American Painting of the Nineteenth Century.* 1969. P. 108, 109, 183, 191–210, 230.

—— *Nature and Culture: American Landscape and Painting, 1825–1875.* 1980. P. 261, 263.

O'Donnell, Rev. George E. *St. Charles Seminary, Philadelphia.* Philadelphia, 1964. P. 223.

Pach, Walter. *Ananias, or the False Artist.* 1928. P. 37, 249–251.

—— *Queer Thing, Painting.* 1938. P. 17, 18, 30, 58, 63–66, 313, 322.

Parry, Ellwood. *The Image of the Indian and the Black Man in American Art, 1590–1900.* 1974. P. 147–152, 161–163.

Pennell, Joseph. *The Adventures of an Illustrator.* Boston, 1925. P. 50–52.

Perlman, Bennard B. *The Immortal Eight: American Painting from Eakins to the Armory Show (1870–1913).* 1962. P. 28–34.

Phillips, Duncan. *The Artist Sees Differently,* vol. 1. 1931. P. 102.

Pierson, William H., Jr., and Martha Davidson, eds. *Arts of the United States: A Pictorial Survey.* 1960. E. P. Richardson, "Painting of the Federal Period and Nineteenth Century," p. 75.

Pollack, Peter. *The Picture History of Photography.* 1969. Ch. 18, "Muybridge and Eakins: Photography of Motion," p. 212–223.

Portmann, Paul. *Amerikanische Malerei.* Zurich, 1977. P. 76–83.

Price, Vincent. *The Vincent Price Treasury of American Art.* Waukesha, Wisc., 1972. P. 146–151.

Protter, Eric. *Painters on Painting.* 1963. P. 147, 148.

Prown, Jules David. *American Painting from Its Beginnings to the Armory Show.* 1970. P. 85, 91–96, 107, 117, 119, 130. John Walker, "Introduction," p. 11–14.

Reed, Henry M. *The A. B. Frost Book.* Rutland, Vt., 1967. P. 29.

Richardson, Edgar Preston. *The Way of Western Art, 1776–1914.* Cambridge, Mass., 1939. P. 129–133.

—— *American Romantic Painting.* 1944. P. 31, 32.

—— *Painting in America: From 1502 to the Present.* 1956, 1965. P. 313, 317–319, 328.

Robb, David M. *The Harper History of Painting: The Occidental Tradition.* 1951. P. 882–888.

—— and J. J. Garrison. *Art in the Western World.* 1932, 1935, 1953. P. 654–657.

Rourke, Constance. *Charles Sheeler, Artist in the American Tradition.* 1938. P. 14–16, 184–186.

Sarton, May. *Journal of a Solitude.* 1973. P. 60, 61.

Sellin, David. *The First Pose: 1876: Turning Point*

in *American Art: Howard Roberts, Thomas Eakins, and a Century of Philadelphia Nudes*. 1976. First published in *Annual Report, Board of Trustees, Fairmount Park Art Association,* 1973; reprinted, revised, in Philadelphia Museum of Art *Bulletin*, Spring 1975, vol. 70, nos. 311–312.

Shahn, Ben. *The Shape of Content*. Cambridge, Mass., 1957. P. 61–63.

Shoolman, Regina Lenore, and Charles E. Slatkin. *The Enjoyment of Art in America*. Philadelphia, 1942. P. 682–684.

Soyer, Raphael. *Homage to Thomas Eakins, etc.* 1966. P. 15, 16, 19, 23, 117, 121, 168, 176.

Stebbins, Theodore E., Jr. *American Master Drawings and Watercolors*. 1976. P. 168, 169, 187–193. Hardcover edition of the catalogue of the exhibition of this title, Whitney Museum of American Art, 1976.

St. John, Bruce, ed. *John Sloan's New York Scene*. 1965. Introduction by Helen Farr Sloan. P. 238, 279, 608.

Taylor, Joshua C. *The Fine Arts in America*. Chicago, 1979. P. 123–125.

Tighe, Mary Ann, and Elizabeth Ewing Lang. *Art America*. P. 143, 149–157, 356.

Traubel, Horace. *With Walt Whitman in Camden*. 4 vols. For details, see Notes to present book, Chapter 12.

——, Richard Maurice Bucke, and Thomas B. Harned, eds. *In re Walt Whitman*. Philadelphia, 1893. P. 144, 297, 322, 389.

200 Years of American Sculpture. 1976. Wayne Craven, "Images of a Nation in Wood, Marble and Bronze," p. 71. "Thomas Eakins," p. 269, 270. Hardcover edition of the catalogue of the exhibition of this title, Whitney Museum of American Art, 1976.

Walker, John. *Paintings from America*. Baltimore, 1951. P. 30, 31.

—— and Macgill James. *Great American Paintings from Smibert to Bellows, 1729–1924*. 1943. P. 11–13.

Wichita Art Museum. *Catalogue of the Roland P. Murdock Collection*. Wichita, Kans., 1972. Text and notes by George P. Tomko, p. 54–61.

Williams, Hermann Warner, Jr. *Mirror to the American Past: A Survey of American Genre Painting, 1750–1900*. Greenwich, Conn., 1973. P. 187, 188, 220–226.

Wilmerding, John. *A History of American Marine Painting*. Boston, 1968. P. 225–228.

—— *Winslow Homer*. 1972. P. 93.

—— *American Art*. Harmondsworth, Middlesex, England, 1976. P. 137–141, 254, 255.

—— ed. *The Genius of American Painting*. 1973. Richard J. Boyle, "The Second Half of the Nineteenth Century," p. 156–159, 162, 164.

—— *American Light: The Luminist Movement, 1850–1875: Paintings, Drawings, Photographs.* 1980. P. 49, 148–150, 215, 217, 218, 253, 287, 288. Hardcover edition of the catalogue of the exhibition of this title, National Gallery of Art, 1980.

—— *American Masterpieces from the National Gallery of Art*. 1980. P. 15, 16, 114, 115, 116, 170.

—— *Audubon, Homer, Whistler and Nineteenth-Century America*. P. 13, 14, 83, 84.

Young, Dorothy Weir. *The Life and Letters of J. Alden Weir*. New Haven, Conn., 1960. P. 193, 194.

Young, Mahonri Sharp. *American Realists, Homer to Hopper*. 1977. P. 62, 63.

ENCYCLOPEDIAS, BIOGRAPHICAL DICTIONARIES, BIBLIOGRAPHIES, ETC.

American Art Annual. Washington: American Federation of Arts. From vol. 1, 1898, through vol. 12, 1915. Vol 13, 1916, obituary, with photograph portrait.

Appleton's Cyclopedia of American Biography. Vol. 2, 1898, p. 288.

Arts in America: A Bibliography. Washington: Archives of American Art, Smithsonian Institution, 1979. Bernard Karpel, ed. Vol. 2, "Painting: Nineteenth Century," p. I-701, 702, 714, 715.

Baigell, Matthew. *Dictionary of American Art*. 1979. P. 108, 109.

Bénézit, E. *Dictionnaire des Peintres, Sculpteurs, Dessinateurs et Graveurs*. Paris, 1924. Vol. 2, p. 197. A. Jolain, "Thomas Eakins." Reprinted 1976, vol. 4, p. 90, 91.

The Britannica Encyclopedia of American Art. Chicago, 1973. Lloyd Goodrich, "Thomas Eakins," p. 154–156.

Champlin, John Denison, Jr., and Charles C. Perkins. *Cyclopaedia of Painters and Painting*. 1888. Vol. 2, p. 1.

Clement, Clara Erskine, and Laurence Hutton. *Artists of the Nineteenth Century and Their Works*. Boston, 1879. Vol. 1, p. 232. Reprinted, St. Louis, 1969.

Dictionary of American Biography. Vol. 5, 1930, p. 590–592. William Howe Downes, "Thomas Eakins."

Encyclopedia Britannica. Chicago, 1974. Vol. 5, 1118–1120. J. D. Pro, "Thomas Eakins."

Encyclopedia of Painting. Bernard Myers, ed. 1955. P. 162, 163.

Encyclopedia of World Art. 1961. Vol. 4, cols. 536–538. Lloyd Goodrich, "Thomas Eakins."

———— Vol. 1, 1959, cols. 291–300. Lloyd Goodrich, "Americas: Art Since Columbus, (Section C), 1865 to the Armory Show."

The Index of Twentieth Century Artists. College Art Association. Vol. 1, no. 4, Jan. 1934, p. 49–59. "Thomas Cowperthwait Eakins—Painter." Supplements: vol. 1, no. 12; vol. 2, no. 12.

Kindlers Malerei Lexikon. Zurich: Kindler Verlag, 1965. Vol. 2, p. 213–216. A. Neumeyer, "Thomas Eakins."

McGraw-Hill Dictionary of Art. Vol. 2, 1969, p. 313. Damie Stillman, "Thomas Eakins."

National Cyclopedia of American Biography. Vol. 5, 1894, p. 421.

Praeger Encyclopedia of Art. Vol. 2, 1971, p. 581.

Thieme, Ulrich, and Felix Becker. *Allgemeines Lexikon der Bildenden Künstler.* Leipzig: E. A. Seemann. Vol. 10, 1914, p. 280. Edmund von Mach, "Thomas Eakins."

Who's Who in America. From vol. 1, 1899–1900, through vol. 12, 1915.

EXHIBITION CATALOGUES: ONE-MAN

The Metropolitan Museum of Art. "Loan Exhibition of the Works of Thomas Eakins." 1917. Introduction by Bryson Burroughs. 60 ills.

Pennsylvania Academy of the Fine Arts. "Memorial Exhibition of the Works of the Late Thomas Eakins." 1917–18. Introduction by Gilbert Sunderland Parker. 80 ills., two portraits.

Joseph Brummer Galleries, New York. 1923. Statements by Bryson Burroughs, Robert Henri, and Joseph Brummer.

Pennsylvania Museum of Art. "Thomas Eakins, 1844–1916." 1930. *Pennsylvania Museum Bulletin,* vol. 25, March 1930. Henri Gabriel Marceau, "An Exhibition of Thomas Eakins' Work." Reprints of Gilbert S. Parker's introduction to the 1917–18 Pennsylvania Academy exhibition, and portions of Lloyd Goodrich's article in *The Arts,* Oct. 1929. Marceau, "Catalogue of the Works of Thomas Eakins." 8 ills.

Museum of Modern Art. "Sixth Loan Exhibition: Winslow Homer, Albert P. Ryder, Thomas Eakins." 1930. Lloyd Goodrich, "Thomas Eakins." 10 ills.

The Fifty-sixth Street Galleries, New York. 1931. Statement by Henry McBride.

The Baltimore Museum of Art. "Thomas Eakins: A Retrospective Exhibition of His Paintings." 1936. Clarence W. Cranmer, "Prefatory Note." R. J. McKinney, "Foreword." 9 ills.

Kleemann Galleries, New York. 1937. Foreword by Walter Pach.

Philadelphia Museum of Art. "Thomas Eakins Centennial Exhibition." 1944. *Philadelphia Museum Bulletin,* vol. 39, May 1944. Lloyd Goodrich, "Thomas Eakins, 1844–1916." Henri Marceau, "Note on the Exhibition." Eakins' letter to his mother, Nov. 8, 1866. 17 ills.

M. Knoedler & Company, New York. "Loan Exhibition of the Works of Thomas Eakins, Commemorating the Centennial of His Birth." 1944. W. F. Davidson, "Introduction." Lloyd Goodrich, "Thomas Eakins" (reprinted from *Philadelphia Museum Bulletin*). 48 ills. of paintings, 2 in color; 11 ills of photographs and personalia.

Carnegie Institute, Department of Fine Arts. "Thomas Eakins Centennial Exhibition." 1945. Introduction by Lloyd Goodrich, reprinted from *Philadelphia Museum Bulletin.* 15 ills.

The American Academy of Arts and Letters: The National Institute of Arts and Letters. 1958. Foreword by Leon Kroll.

National Gallery of Art. "Thomas Eakins: A Retrospective Exhibition." 1961. Exhibited later at the Art Institute of Chicago, 1961–62, and the Philadelphia Museum of Art, 1962. Lloyd Goodrich, "Thomas Eakins," pp. 9–32. 97 ills., 1 in color.

Philadelphia Museum of Art. "Eakins in Perspective: Works by Eakins and His Contemporaries, in Addition to Memorabilia." 1962. A supplement to the National Gallery exhibition.

The Corcoran Gallery of Art. "The Sculpture of Thomas Eakins." 1969. Introduction by Moussa M. Domit. 33 ills. of Eakins' works, and 7 additional ills.

Pennsylvania Academy of the Fine Arts. "Thomas Eakins: His Photographic Works." 1969. Foreword by William B. Stevens, Jr. Preface and text by Gordon Hendricks. 82 ills.

Saint Charles Borromeo Seminary, Overbrook, Pa. 1970. Text by Evan H. Turner.

Whitney Museum of American Art. "Thomas Eakins Retrospective Exhibition." 1970. Text by Lloyd Goodrich. 42 ills., 8 in color. Published also in hardcover as *Thomas Eakins.*

Olympia Galleries, Philadelphia. "The Olympia Galleries Collection of Thomas Eakins Photographs." 1976. Text by Ronald J. Onorato. 11 ills.

Sotheby Parke Bernet, New York. "The Olympia Galleries Collection of Thomas Eakins Photographs." 1977. 21 ills.

North Cross School Living Gallery, Roanoke, Va. "Thomas Eakins, Susan Macdowell Eakins, Elizabeth Macdowell Kenton." 1977. Introduction by Betty Tisinger. David Sellin, "Eakins and the Macdowells and the Academy." 70 ills., 5 in color.

Brandywine River Museum, Chadds Ford, Pa. "Eakins at Avondale; and Thomas Eakins: A Personal Collection." 1980. Foreword by James H. Duff. William Innes Homer, "Eakins, the Crowells, and the Avondale Experience." James W. Crowell, "Recollections of Life on the Crowell Farm." Essays by six graduate students of the University of Delaware. Ann Barton Brown, "Thomas Eakins: A Personal Collection." (The collection of Mr. and Mrs. Daniel W. Dietrich II.) 44 ills., 2 in color.

Olympia Galleries, Philadelphia. "Photographer Thomas Eakins." 1981. Essay by Dr. Ellwood C. Parry, III. Catalogue Notes by Dr. Robert Stubbs. 49 ills.

Philadelphia Museum of Art. "Thomas Eakins: Artist of Philadelphia." 1982. Exhibited later at the Museum of Fine Arts, Boston, 1982. Preface by Jean Sutherland Boggs. Darrel Sewell, "Thomas Eakins: Artist of Philadelphia." 144 ills., 24 in color.

EXHIBITION CATALOGUES: GENERAL

Albright Art Gallery: The Buffalo Fine Arts Academy. "Fifty Paintings, 1905–1913." 1955. Robert Goldwater, "Introduction."

American Federation of Arts and United States Information Agency. "Hundert Jahre Amerikanische Malerei, 1800–1900." Munich, 1953. John I. H. Baur, "Einführung."

Archives of American Art, Washington. "From Reliable Sources." 1974.

The Baltimore Museum of Art. "From El Greco to Pollock: Early and Late Works." 1968. Edited by Gertrude Rosenthal. Abram Lerner, "Thomas Eakins."

The Bowdoin College Museum of Art. "The Portrayal of the Negro in American Painting." 1964. Text by Sidney Kaplan.

The Brooklyn Museum. "The Triumph of Realism." 1967. Axel von Saldern, "Introduction."

Brown University, Department of Art. "The Classical Spirit in American Portraiture." 1976.

Corcoran Gallery of Art. "American Processional: 1492–1900." Text by Elizabeth McCausland.

The Museum of Fine Arts, Houston. "Nature and Focus: Looking at American Painting in the 19th Century." 1972. E. A. Carmean, Jr., "Nature and Focus."

M. Knoedler & Company, New York. "The Protean Century, 1870–1970." 1970. Sam Hunter, "Introduction."

The Metropolitan Museum of Art. "Life in America." 1939.

——— "The 75th Anniversary Exhibition of Painting and Sculpture by 75 Artists Associated with the Art Students League of New York." 1951. Lloyd Goodrich, "Thomas Eakins." (Reprinted in "The Hundredth Anniversary Exhibition of . . . 100 Artists . . . ," The Kennedy Galleries, New York, 1975.)

——— "The Heritage of American Art: Paintings from the Collection of The Metropolitan Museum of Art." 1975. John K. Howat and Natalie Spassky, "Introduction." Catalogue and Biographies by Mary Davis.

Museum of Modern Art. "American Painting and Sculpture, 1862–1932." 1932. Holger Cahill, "American Art, 1862–1932."

——— "Twentieth Century Portraits." 1942. Text by Monroe Wheeler.

——— "The Natural Paradise: Painting in America 1800–1950." 1976. Essays by Barbara Novak, Robert Rosenblum, John Wilmerding.

National Portrait Gallery, Washington. "American Portrait Drawings." 1980. Text by Marvin Sadik and Harold Francis Pfister.

Pennsylvania Academy of the Fine Arts. "The Thomas B. Clarke Collection of American Pictures." 1891.

——— "The One Hundred and Fiftieth Anniversary Exhibition." 1955. Joseph T. Fraser, Jr., "Foreword." Lloyd Goodrich, "Thomas Cowperthwait Eakins."

——— "Susan Macdowell Eakins, 1851–1938." 1973. Seymour Adelman, "Recollections." Susan P. Casteras, "Susan Macdowell Eakins."

——— "Thomas P. Anshutz." 1973. Text by Sandra Denney Heard.

——— "The Pennsylvania Academy and Its Women, 1850 to 1920." Text by Christine Jones Huber.

———— "In This Academy." 1976. Doreen Bolger, "The Education of the American Artist." Louise Lippincott, "Thomas Eakins and the Academy."

Pennsylvania State University. "Pennsylvania Painters." 1955. Text by Harold E. Dickson.

———— "Masterworks by Pennsylvania Painters in Pennsylvania Collections." 1972. Selected and annotated by Harold E. Dickson.

Philadelphia Museum of Art. "The Art of Philadelphia Medicine." 1965. Charles Coleman Sellers, "Conventions of Medical Portraiture."

———— "Philadelphia: Three Centuries of American Art: Bicentennial Exhibition." 1976. Evan H. Turner, "Foreword." Darrel Sewell, "Introduction." Text by Darrel Sewell, Theodor Siegl, and others.

———— "Philadelphia: Three Centuries of American Art: Selections from the Bicentennial Exhibition." 1976.

The Fine Arts Museums of San Francisco. "American Art: An Exhibition from the Collection of Mr. and Mrs. John D. Rockefeller 3rd." 1976. Text by E. P. Richardson.

Smithsonian Institution Traveling Exhibition Service, Washington. "American Art in the Making: Preparatory Studies for Masterpieces of American Painting, 1800–1900." 1976. Text by David Sellin.

The Tate Gallery, London. "The John Hay Whitney Collection." 1960. Text by John Rewald.

Art Gallery of Toronto. "American Painting, 1865–1905." 1961. Text by Lloyd Goodrich.

University of Michigan Museum of Art, Ann Arbor. "Art and the Excited Spirit: America in the Romantic Period." 1972. Organized by David Carew Huntington, assisted by Edward A. Molnar.

University Art Museum, Berkeley, Calif. "The Hand and the Spirit: Religious Art in America, 1700–1900." 1972. Text by Jane Dillenberger and Joshua C. Taylor.

Whitney Museum of American Art. "American Genre: The Social Scene in Paintings and Prints." 1935. Text by Lloyd Goodrich.

PERIODICALS: LIFETIME

The American Architect and Building News

May 10, 1879, p. 149. Reviews of the National Academy of Design 54th Annual Exhibition and the Society of American Artists 2nd exhibition.

Dec. 25, 1880, p. 303. Mariana G. Van Rensselaer, "The Philadelphia Exhibition.—II."

May 20, 1882, p. 231. Mariana G. Van Rensselaer, review of the Society of American Artists supplementary exhibition.

The American Art Review, Boston

Vol. 1, part 1, 1880, p. 173. "Pennsylvania Academy of the Fine Arts."

———— p. 261. S. G. W. Benjamin, "Society of American Artists: Third Exhibition."

Vol. 1, part 2, 1880, p. 363. Eakins' election to the Society of American Artists.

Vol. 2, part 1, 1881, p. 110. S. R. Koehler, "Second Annual Exhibition of the Philadelphia Society of Artists."

———— p. 206. J. B. Millet, "Boston Art Club, Twenty-Third Exhibition."

Vol. 2, part 2, 1881, p. 28. S. G. W. Benjamin, "National Academy of Design: Fifty-Sixth Exhibition."

———— p. 72. S. G. W. Benjamin, "Society of American Artists: Fourth Annual Exhibition."

Vol. 2, part 2, 1881, p. 122. "Pennsylvania Academy of the Fine Arts: Fifty-second Annual Exhibition."

The Art Amateur

Vol. 1, July 1879, p. 27, 28. Edward Strahan [Earl Shinn], "The National Academy of Design."

Vol. 2, April 1880, p. 90. Review of the Society of American Artists exhibition.

Vol. 2, May 1880, p. 116. Edward Strahan, "The Metropolitan Museum of Art."

Vol. 4, Dec. 1880, p. 6. Edward Strahan, "Exhibition of the Philadelphia Society of Artists."

Vol. 4, March 1881, p. 72. "Greta's Boston Letter: The Art Club's Exhibition."

Vol. 4, May 1881, p. 115. E.S. [Earl Shinn], "The Pennsylvania Academy Exhibition."

Vol. 5, July 1881, p. 24. "An Extraordinary Picture Collection."

Vol. 6, Dec. 1881, p. 6. Edward Strahan, "Works by American Artists Abroad: The Second Philadelphia Exhibition."

Vol. 6, Jan. 1882, p. 26. Edward Strahan, "The Philadelphia Society of Artists: Third Annual Exhibition."

Vol. 6, Feb. 1882, p. 72, 74. Clarence Cook, "The Water Color Society's Exhibition."

Vol. 7, June 1882, p. 2. "The American Artists' Supplementary Exhibition."

Vol. 8, Dec. 1882, p. 8. Sigma [Earl Shinn], "Pennsylvania Academy Exhibition."

Vol. 9, Feb. 1883, p. 65. Edward Strahan, "Dumas' Art Annual."

Vol. 10, Jan. 1884, p. 32–34. Sigma, "A Philadelphia Art School." [The Pennsylvania Academy].

Vol. 14, Jan. 1886, p. 32. "An Object-Lesson in Artistic Anatomy."

Vol. 17, June 1887, p. 5. "The Society of American Artists."

Vol 24, Dec. 1890, p. 9–12. Ernest Knaufft, "The Academy of Fine Arts."

The Art Collector

Vol. 9, Feb. 1, 1899, p. 102. Mitschka, "Pennsylvania Academy of Fine Arts Exhibition as Seen and Heard."

The Art Interchange

Vol. 2, March 19, 1879, p. 42. "The Society of American Artists."

Vol. 2, May 14, 1879, p. 79. "The Academy Exhibition."

Vol. 4, Feb. 18, 1880, p. 32. Editorial.

Vol. 15, Dec. 3, 1885, p. 152. "Art Notes and News."

Vol. 16, Feb. 27, 1886, p. 69. "C" [probably William Clark], "Philadelphia Letter."

Vol. 16, March 13, 1886, p. 86. "C." "Philadelphia Letter."

Vol. 16, June 19, 1886, p. 195. "C." "Philadelphia Letter."

Vol. 48, May 1902, p. 110. "The Society of American Artists Exhibition."

The Art Journal, American edition

New Series, Vol. 3, June 1877, p. 189, 190. D.C.M., "Spring Exhibition at the Philadelphia Academy of Arts."

Vol. 4, Jan. 1878, p. 30, 31. D.C.M., "Art in Philadelphia."

Vol. 4, March 1878, p. 91, 92. John Moran, "The American Water-Colour Society's Exhibition."

Vol. 4, April 1878, p. 127. "Art-Matters in Philadelphia."

Vol. 4, May 1878, p. 151–159. S. N. Carter, "The Academy Exhibition."

Vol. 5, May 1879, p. 156–158. S. N. Carter, "Exhibition of the Society of American Artists."

Vol. 6, May 1880, p. 155. S. N. Carter, review of the Society of American Artists exhibition.

Vol. 6, June 1880, p. 261. Article on William Sartain.

Vol. 7, March 1881, p. 95. "The American Water-Color Society."

Vol. 7, May 1881, p. 157, 158. "American Art Gallery." (Review of the Society of American Artists exhibition.)

———— p. 158. "The National Academy of Design."

Vol. 7, July 1881, p. 221. "American Pictures at the Metropolitan Museum."

Vol. 7, Nov. 1881, p. 352. The Brooklyn Art Guild engaging Eakins as a teacher.

Vol. 8, June 1882, p. 190. "Academy of Design"; "The Society of American Artists."

The Art News. "Published Every Month by Sadakichi Hartmann"

Vol. 1, no. 2, p. 4. Hartmann, about Eakins.

Brush and Pencil, Chicago

Vol. 6, June 1900, p. 130, 131. F. B. Sheafer, "American Art in Paris."

The Collector and Art Critic

Vol. 2, no. 7, p. 121. W. P. Lockington, "The Pennsylvania Academy's Annual Exhibition."

The Critic

Vol. 44, Jan. 1904. Charles H. Caffin, "Some American Portrait Painters," p. 34.

Harper's New Monthly Magazine

Vol. 58, March 1879. S. G. W. Benjamin, "Present Tendencies of American Art," p. 495.

Harper's Weekly

Vol. 25, Dec. 10, 1881, p. 827, 828. "The Philadelphia Art Exhibition."

The International Studio, London and New York

Vol. 14, Oct. 1901, p. xxxii. Charles H. Caffin, "The Picture Exhibit at the Pan-American Exposition."

Vol. 15, Dec. 1901, p. xlii. Charles H. Caffin, "Sixth Annual Exhibition at the Carnegie Institute, Pittsburgh, Pa."

Vol. 15, Feb. 1902, p. lxi. Charles H. Caffin, "Seventy-seventh Annual Exhibition of the National Academy of Design."

Vol. 19, May 1903, p. cxxv. Charles H. Caffin, "Exhibition of the Society of American Artists."

Vol. 22, March 1904, p. ccxxxix. Charles H. Caffin, "Pennsylvania Academy Exhibition."

Vol. 25, March 1905, p. v. Charles H. Caffin, "The Pennsylvania Academy Exhibition."

Vol. 26, Sept. 1905, p. 261. Sadakichi Hartmann, article on Charles W. Hawthorne.

Vol. 28, June 1906, p. xiv. David Lloyd, "The Exhi-

bition of the Pennsylvania Academy of the Fine Arts."

Vol. 31, June 1907, p. c. Arthur Hoeber, "The Carnegie Institute of Pittsburgh."

Vol. 52, March 1914, p. iv. W. H. de B. Nelson, "Pennsylvania Pre-eminent."

Vol. 52, May 1914, p. 245. "E.C.," "Philadelphia."

The Jeffersonian. Published by the Jefferson Medical College, Philadelphia

Vol. 17, Nov. 1915. Charles Frankenberger, "The Collection of Portraits Belonging to the College."

The Magazine of Art, London and New York

Vol. 10, 1887, p. 37–42. Charles De Kay, "Movements in American Painting: The Clarke Collection in New York."

McClure's Magazine

Vol. 5, Oct. 1895, p. 419–432. Cleveland Moffett, "Grant and Lincoln in Bronze."

The Nation

Vol. 18, March 12, 1874, p. 172. Earl Shinn, review of the American Society of Painters in Water-Colors 7th Annual Exhibition.

Vol. 20, Feb. 18, 1875, p. 119. "The Water-Color Society Exhibition, II"; probably by Shinn.

Vol. 24, Feb. 15, 1877, p. 108. Review of the American Society of Painters in Water-Colors 10th Annual Exhibition.

Vol. 26, Feb. 28, 1878, p. 156, 157. "Eleventh Exhibition of the Water-Color Society."

Vol. 26, April 11, 1878, p. 251. "The Lessons of a Late Exhibition. Society of American Artists."

Vol. 26, May 30, 1878, p. 364. "National Academy of Design Exhibition."

Vol. 28, Feb. 6, 1879, p. 107. "The American Water-Color Society's Exhibition."

Vol. 28, March 20, 1879, p. 207. Review of the Society of American Artists 2nd Exhibition; probably by Shinn.

Vol. 28, May 22, 1879. Review of the National Academy of Design 54th Annual Exhibition.

Vol. 30, April 1, 1880, p. 258. "The Society of American Artists: Modern American Tendency."

Vol. 30, April 8, 1880, p. 275. "The Metropolitan Museum."

Vol. 32, March 31, 1881, p. 230. "Fifty-sixth Annual Exhibition, National Academy of Design—Part II."

Vol. 32, March 31, 1881, p. 230. "Fifty-sixth Annual bition of the Society of American Artists."

Vol. 32, April 21, 1881, p. 285. "Fifty-sixth Annual Exhibition of the National Academy of Design—II."

Vol. 44, May 12, 1887, p. 415. "The Society of American Artists."

The Old Penn Weekly Review, Philadelphia

Oct. 30, 1915. "The Unidentified Student in the Agnew Clinic."

The Penn Monthly, Philadelphia

Vol. 12, June 1881, p. 453–462. Fairman Rogers, "The Schools of the Pennsylvania Academy of the Fine Arts."

Putnam's Monthly and The Reader

Vol. 4, Sept. 1908, p. 707–710. Annie Nathan Meyer, "Two Portraits of Walt Whitman."

Scribner's Monthly Illustrated Magazine

Vol. 18, Sept. 1879, p. 737–750. William C. Brownell, "The Art Schools of Philadelphia."

Vol. 20, May 1880, p. 1–15. William C. Brownell, "The Younger Painters of America. First Paper." On Eakins, p. 4, 11, 12, 13.

Vol. 20, June 1880, p. 314. "Society of American Artists."

PERIODICALS: FROM JUNE 1916

The American Art Journal

Vol. 1, Spring 1969, p. 104–114. Gordon Hendricks, "The Eakins Portrait of Rutherford B. Hayes."

Vol. 3, Fall 1971, p. 103. Gordon Hendricks, letter to the Editor.

Vol. 5, May 1973, p. 20–45. Ellwood C. Parry III and Maria Chamberlin-Hellman, "Thomas Eakins as an Illustrator, 1878–1881."

American Art Review, Los Angeles

Vol. 3, July–August 1976, p. 127–140. Ronald J. Onorato, "Photography and Teaching: Eakins at the Academy."

American Artist

Vol. 16, March 1952. Parker Tyler, "Magic Realism in American Painting," p. 42.

Vol. 20, Nov. 1956, p. 28–33, 61–63. Jacob Getlar Smith, "The Enigma of Thomas Eakins."

Vol. 39, March 1975, p. 56–61, 65–67. Tom C.

Williams, "Thomas Eakins: Artist and Teacher for all Seasons."

Vol. 41, Jan. 1977, p. 78, 79. Bernard Dunstan, "Looking at Paintings."

Vol. 44, Feb. 1980, p. 66, 67. Bernard Dunstan, "Looking at Paintings."

American Collector

Vol. 13, July 1944, p. 4, 6, 7, 13, 17. Thomas Hamilton Ormsbee, "Thomas Eakins, American Realist Painter."

American Magazine of Art; later Magazine of Art

Vol. 26, May 1933, p. 267, 268. Will Hutchins, review of Lloyd Goodrich, *Thomas Eakins.*

Vol. 27, Feb. 1934. E. M. Benson, "The American Scene," p. 53, 55.

Vol. 27, June 1934, p. 350. Clarence W. Cranmer, "Eakins and the Passing Scene."

Vol. 30, July 1937, p. 402–409. Bryson Burroughs, "An Estimate of Thomas Eakins."

Vol. 32, Nov. 1939, p. 614–621. Lloyd Goodrich, "An Eakins Exhibition."

Vol. 36, Jan. 1943, p. 28–29. Charles Bregler, "Photos by Eakins: How the Famous Painter Anticipated the Modern Movie Camera."

Vol. 37, May 1944, p. 162–166. Lloyd Goodrich, "Thomas Eakins Today."

Vol. 38, March 1945. Robert Goldwater, "Art and Nature in the 19th Century," p. 106, 107.

Vol. 39, Nov. 1946. Frank Jewett Mather, Jr., "The Expanding Arena," p. 300, 301.

Antiques

Vol. 92, Nov. 1967. Axel von Saldern, "European and American realists of the late nineteenth century," p. 698, 701, 702.

Vol. 104, Nov. 1973, p. 836–839. Synnove Haughom, "Thomas Eakins' portrait of Mrs. William D. Frishmuth, Collector."

Vol. 108, Dec. 1975, p. 1182–1184. Synnove Haughom, "Thomas Eakins' *The Concert Singer.*"

Vol. 121, March 1982, p. 690–693. Ephraim Weinberg, "The Art School of the Pennsylvania Academy."

Aperture, Millerton, N.Y.

16:3. 1972. 27 pages. Lincoln Kirstein, "Walt Whitman & Thomas Eakins: A Poet's and A Painter's Camera-Eye."

Apollo, London and New York

Vol. 67, April 1958. Marvin D. Schwartz, "News and Views from New York," p. 143.

Vol. 93, Jan. 1971. "Art Across the USA: Thomas Eakins at the Whitney," p. 64, 65.

Art and Archaeology

Vol. 21, April–May 1926, p. 175, 176. Dorothy Grafly, "Events and Portents of Fifty Years."

The Art Bulletin

Vol. 19, Dec. 1937, p. 580–591. Wallace Spencer Baldinger, "Formal Change in Recent American Painting."

Vol. 51, March 1969, p. 57–64. Gordon Hendricks, "Thomas Eakins's *Gross Clinic.*"

Vol. 58, June 1976, p. 311–312. John Wilmerding, review of Gordon Hendricks, *The Life and Works of Thomas Eakins.*

The Art Digest; later Arts Digest, Arts and Arts Magazine

Vol. 4, March 15, 1930, p. 8. "Philadelphia Sees 60 Pictures by Eakins."

Vol. 6, March 15, 1932, p. 4. "In the Louvre."

Vol. 6, Aug. 1, 1932, p. 8. "Eakins for Boston."

Vol. 7, Feb. 15, 1933, p. 14. "Eakins, American Realist."

Vol. 7, March 1, 1933, p. 22. Review of Lloyd Goodrich, *Thomas Eakins.*

Vol. 12, Dec. 1, 1937, p. 15. "Cherchez la Femme."

Vol. 13, July 1, 1939, p. 3. "Peyton Boswell Comments: 900% Eakins Preferred."

Vol. 14, Oct. 1, 1939, p. 14. "Last of Eakins."

Vol. 14, Nov. 1, 1939, p. 10. "Two New York Shows Trace Art of Thomas Eakins, American Master."

Vol. 15, Nov. 1, 1940, p. 23. "Merely Custodians."

Vol. 15, Nov. 15, 1940, p. 4. Charles Bregler, "Eakins' Permanent Palette."

Vol. 15, June 1, 1941. Donald J. Bear, "Santa Barbara Outlines U.S. Art History," p. 12.

Vol. 15, July 1, 1941, p. 16. "Wichita Purchase Unfolds an Eakins Drama."

Vol. 18, April 15, 1944, p. 5, 20. M.R. [Maude Riley], "Philadelphia Honors Eakins with Centennial Exhibition."

Vol. 18, June 1, 1944, p. 7, 27. Margaret Breuning, "New York Views Art of Eakins in Comprehensive Exhibition."

Vol. 28, Jan. 1, 1954. Clement Greenberg, "Some Advantages of Provincialism," p. 81.

Connaissance des Arts, Paris

No. 254, April 1973. Carl Baldwin, "Le Penchant des Peintres Américains pour le Réalisme," p. 115, 116.

The Connoisseur, London

Vol. 114, Dec. 1944. Helen Comstock, "The Connoisseur in America," p. 113, 114.
Vol. 176, Feb. 1971. Joseph T. Butler, "The American way with art. Thomas Eakins: His Photographic Works," p. 136, 137.
Vol. 176, March 1971. Joseph T. Butler, "The American way with art: Thomas Eakins," p. 206, 207.

Current Opinion

Vol. 63, Dec. 1917, p. 411–413. "Thomas Eakins: Another Neglected Master of American Art."

The Dial

Vol. 72, Feb. 1922, p. 221–223. Henry McBride, "Modern Art."
Vol. 74, May 1923, p. 529–531. Henry McBride, "Modern Art."
Vol. 80, Jan. 1926, p. 77, 78. Henry McBride, "Modern Art."

The Fine Arts

Vol. 20, May 1933, p. 18–20. Walter Pach, "American Art in the Louvre."
Vol. 20, June 1933, p. 54, 59. Virginia Nirdlinger, review of Lloyd Goodrich, *Thomas Eakins*.

Fine Arts Journal

Vol. 35, Dec. 1917. Henry McBride, "Exhibitions at New York Galleries."

The Freeman

Vol. 7, April 11, 1923, p. 112–114. Walter Pach, "A Grand Provincial." Reprinted in *The Freeman Book*, 1924.

Gazette des Beaux-Arts, Paris

Vol. 73, April 1969, p. 235–256. Gerald M. Ackerman, "Thomas Eakins and His Parisian Masters Gérôme and Bonnat."

Gentry

No. 20, Fall 1956, p. 65–73. "Eakins."

Harper's Bazaar

No. 2828, Aug. 1947, p. 138, 139, 184. Adam Emory Albright, "Memories of Thomas Eakins."

Horizon

Vol. 6, Autumn 1964, p. 88–105. John Canaday, "Familiar truths in clear and beautiful language."

The International Studio,
London and New York; later *The Studio*

Vol. 60, Dec. 1916. "Gallery Notes," p. lxvi.
Vol. 94, Dec. 1929. M.M. [Morty Mann], "In the Galleries," p. 94, 96.
Vol. 95, Jan. 1930, p. 44–49, 90, 91. Frank Jewett Mather, Jr., "Thomas Eakins's Art in Retrospect." Reprinted in *Estimates in Art, Series II*, 1931.
Vol. 96, June 1930. M.M., "In the Galleries," p. 70.
Vol. 98, March 1931, p. 67, 74. M.M., "Exhibition, 56th Street Galleries."
The Studio, vol. 155, Jan. 1958. Eliot Clark, "New York Commentary," p. 183, 184.

Jefferson Medical College Alumni Bulletin,
Philadelphia

Vol. 16, Summer 1967, p. 2–12. Ellwood C. Parry III, "Thomas Eakins and The Gross Clinic." P. 13–20: Elinor Donahue, "Basketball, DaCosta and a Jefferson Tradition."

Journal of the Archives of American Art

Vol. 8, April 1968, p. 20. Review of Sylvan Schendler, *Eakins*.
Vol. 12, no. 4, 1972, p. 15–22. Garnett McCoy, "Some Recently Discovered Thomas Eakins Photographs."

Life

Vol. 16, May 15, 1944, p. 72–77. "Thomas Eakins."
Vol. 71, July 23, 1971, p. 54–58. "The Camera Eye of Thomas Eakins."

The Literary Digest

June 7, 1930, p. 19, 20. "Our Veritable Old Masters."

The London Studio, London

Vol. 5, June 1933, p. 365. Review of Lloyd Goodrich, *Thomas Eakins*.

Mademoiselle

July 1951. Henry Steele Commager, "What is American?" p. 33.

The Massachusetts Review, Amherst, Mass.

Vol. 7, Winter 1966. Sidney Kaplan, "The Negro in the Art of Homer and Eakins."

The Nation

Vol. 106, Feb. 21, 1918, p. 217, 218. N.N., "The Thomas Eakins Exhibition."

Vol. 214, May 15, 1972, p. 630–632. Lincoln Kirstein, "Aid and Comfort to Eakins."

The New Leader, East Stroudsburg, Pa.

Nov. 7, 1966, p. 30, 31. James R. Mellow, "In the American Grain."

The New Yorker

May 17, 1930. Guy Pène du Bois, "The Art Galleries."

New York Magazine

Vol. 3, Sept. 28, 1970, p. 50. John Gruen, "Rational Visionary."

The New York Review of Books

Sept. 21, 1972, p. 3–5. Lewis Mumford, "Thomas Eakins, Painter and Moralist." Reprinted in *Interpretations and Forecasts*, 1972.

The New York Sun

Nov. 4, 11, 25, 1917. Henry McBride, reviews of the Eakins Exhibition at the Metropolitan Museum of Art. Reprinted in McBride: *The Flow of Art*, selected by Daniel Catton Rich, 1975, p. 130–142.

Old Penn Weekly Review, Philadelphia

April 1931, p. 170, 171. "The Unidentified Student in the Agnew Painting."

The Outlook

Vol. 117, Nov. 21, 1917, p. 452. "This Week: Thomas Eakins."

Parnassus

Vol. 2, March 1930, p. 20, 21, 43. Francis Henry Taylor, "Thomas Eakins—Positivist."

Vol. 3, May 1931. Audrey McMahon and Virginia Nirdlinger, "A Perspective View of the New York Art Season," p. 43.

Vol. 4, Feb. 1932. Margaretta M. Salinger: "Three Shows and the American Tradition," p. 20, 21.

Vol. 5, Feb. 1933. Forbes Watson, "Gallery Explorations," p. 4, 5.

Vol. 6, April 1934, p. 28. A. Philip McMahon, review of Lloyd Goodrich, *Thomas Eakins*.

Vol. 9, April 1937. Margaret Breuning, "Current Exhibitions," p. 41.

Vol. 11, Nov. 1939, p. 8–10. Virgil Barker, "Imagination in Thomas Eakins." Roger Gilman, "American Tastes in Painting," p. 6.

Partisan Review

Vol. 11, Summer 1944. James Johnson Sweeney, "Art Chronicle: The Bottles Were O'Donovan's," p. 335–337.

The Pennsylvania Gazette, Philadelphia

Vol. 62, June 1964, p. 32, 33. Joan Woollcott, "Search for a Missing Masterpiece."

The Pennsylvania Magazine of History and Biography, Philadelphia

Vol. 55, no. 2, 1931. Joseph Jackson, "The Author of the Poem, 'If I Should Die To-night,'" p. 190.

Philadelphia Inquirer

July 2, 1916. "Thomas Eakins, Dean of Artists" (obituary).

Philadelphia Public Ledger

June 27, 1916. "Thomas Eakins, Noted Artist, Dies at Home in this City."

Photo Bulletin

No. 89, June 1971, p. 820–827. "Belated Tribute to a Troubled Artist."

WFMT Perspective, Chicago

Vol. 10, Dec. 1961, p. 3. "Thomas Eakins: The Art of What Is."

Winterthur Portfolio, Chicago

Vol. 15, Summer 1980, p. 139–149. Elizabeth Johns, "Drawing Instruction at Central High School and Its Impact on Thomas Eakins."

MUSEUM BULLETINS

Addison Gallery of American Art

1936, p. 13–17. Lloyd Goodrich, "Paintings by Thomas Eakins in the Addison Gallery Collection."

Baltimore Museum of Art. Baltimore Museum of Art News

Vol. 19, Dec. 1955, p. 6–15. James D. Breckenridge, "Thomas Eakins' Portrait of Mrs. Samuel Murray."

Museum of Fine Arts, Boston

Vol. 30, Dec. 1932, p. 80, 81. Philip Hendy, "Four Established Painters."

Vol. 34, Feb. 1936, p. 11, 12. C. C. Cunningham, "A Sporting Picture by Thomas Eakins."

Vol. 41, Dec. 1943, p. 60. Barbara N. Parker, "The Dean's Roll-call by Eakins."

Vol. 58, nos. 313, 314, 1960, p. 105, 106. E.A.S. [Eleanor A. Sayre], "Perspective Drawing for John Biglen in a Single Scull."

The Brooklyn Museum.
The Brooklyn Museum Quarterly

Vol. 14, April 1927, p. 38–40. H.B.T. [Herbert B. Tschudy], "Thomas Eakins."

Vol. 19, Oct. 1932, p. 152, 153. "Museum Notes."

Carnegie Institute. *The Carnegie Magazine*

Vol. 4, Feb. 1931, p. 280, 281. "New Patrons Art Fund Paintings."

Vol. 19, May 1945, p. 35–39. John O'Connor, Jr., "Thomas Eakins, Consistent Realist."

Vol. 26, June 1952, p. 202, 203. John O'Connor, Jr., "The Pittsburgh International."

Art Institute of Chicago

Vol. 21, Nov. 1927, p. 101, 102. D.C.R. [Daniel Catton Rich], "'Music' by Thomas Eakins."

Vol. 34, March 1940, p. 37–40. Frederick A. Sweet, "Two Paintings by Thomas Eakins."

Cincinnati Art Museum

Vol. 4, Feb. 1954, p. 15. E.H.D., "Recent Additions to the Collections of the Museum."

Cleveland Museum of Art

15th Year, no. 1, Jan. 1928, p. 7–9. W.M.M. [William M. Milliken], "Memorial Exhibition of Paintings by Thomas Eakins, Albert P. Ryder, and J. Alden Weir."

Corcoran Gallery of Art

Vol. 5, Feb. 1952. Lloyd Goodrich, "The Painting of American History, 1775 to 1900."

The Detroit Institute of Arts

Vol. 12, Nov. 1930, p. 21–23. Clyde H. Burroughs, "A Portrait by Thomas Eakins."

Vol. 14, April 1935, p. 86–88. Clyde H. Burroughs, "A Painting by Thomas Eakins."

Vol. 16, May 1937, p. 131–134. E. P. Richardson, "Two Portraits by Thomas Eakins."

Art Association of Indianapolis,
John Herron Art Institute

Vol. 27, July 1940, p. 28–32. Wilbur D. Peat, "The Pianist by Thomas Eakins."

The Metropolitan Museum of Art

Vol. 11, June 1916, p. 132. B.B. [Bryson Burroughs], "A Picture by Thomas Eakins."

Vol. 12, Aug. 1917, p. 177. "Coming Exhibitions of Paintings."

Vol. 12, Oct. 1917, p. 198–200. B.B., "Thomas Eakins." (Same as the Introduction to the Loan Exhibition catalogue, omitting the biographical part. Reprinted in *American Magazine of Art*, Jan. 1918.)

Vol. 12, Nov. 1917, p. 218–222. J. McLure Hamilton and Harrison S. Morris, "Thomas Eakins: Two Appreciations."

Vol. 13, Jan. 1918, p. 25. B.B., "Purchase of Two Paintings by Eakins."

Vol. 18, Dec. 1923, p. 281–283. B.B., "Thomas Eakins."

Vol. 23, Jan. 1928, p. 29, 30. J.M.L. [Josephine M. Lansing], "A Portrait by Thomas Eakins."

Vol. 27, July 1932, p. 170–173. Bryson Burroughs, "The Taste of Today in Masterpieces of Painting before 1900."

Vol. 29, Sept. 1934, p. 151–153. Bryson Burroughs, "An Early Painting by Thomas Eakins."

New Series—Vol. 3, Summer 1944, p. 1–7. A. Hyatt Mayor, "Photographs by Eakins and Degas."

New Series—Vol. 5, Summer 1946, p. 15–26. A. Hyatt Mayor, "The Photographic Eye," p. 23, 25.

New Series—Vol. 12, March 1954, p. 176, 185. Robert Beverly Hale, "American Painting, 1754 –1954."

Vol. 26, March 1968, p. 306, 307. Gordon Hendricks, "'The Champion Single Sculls.'"

The Minneapolis Institute of Arts

Vol. 29, Feb. 3, 1940, p. 22–25. "A Portrait by Thomas Eakins."

Newark Museum. *The Museum*

Vol. 13, Winter–Spring 1961. William H. Gerdts, "Additions to the Museum's Collections," p. 22.

New Jersey State Museum, Trenton

Bulletin 14, 1973, p. 9–85. Zoltan Buki, Curator, Fine Arts, and Suzanne Corlette, Curator, Cul-

tural History, eds. "The Trenton Battle Monument Eakins Bronzes."

North Carolina Museum of Art
Vol. 8, Dec. 1968, p. 12–22. Dorothy B. Rennie, "The Portraiture of Thomas Eakins."

Pennsylvania Museum of Art; from 1938 Philadelphia Museum of Art
Vol. 17, Oct. 1920. "Resignation of Dr. Leslie W. Miller."

Vol. 25, March 1930. "Thomas Eakins, 1844–1916." (See under "Exhibitions: One-man.")

Vol. 26, Jan. 1931, p. 21–25. Henri Gabriel Marceau, "The 'Fairman Rogers Four-in-hand.'"

Vol. 39, May 1944. "Thomas Eakins Centennial Exhibition." (See under "Exhibitions: One-man.")

Vol. 53, Spring 1958, p. 47–50. John Canaday, "The Realism of Thomas Eakins."

Vol. 57, Winter 1962, p. 39–62. Theodor Siegl, "The Conservation of the 'Gross Clinic.'"

Vol. 60, Spring 1965, p. 48–64. Gordon Hendricks, "A May Morning in the Park."

Vol. 65, July–Sept. 1970, p. 48–49. Theodor Siegl, "Conservation."

Vol. 74, June 1978, p. 18–23. Theodor Siegl, "*Spinning* and *Knitting:* Two Sculptural Reliefs by Thomas Eakins."

Rhode Island School of Design
Jan. 1972, p. 18, 19. "Selection 1: American Watercolors and Drawings from the Museum's Collection."

City Art Museum of St. Louis
Vol. 22, Oct. 1937, p. 42–45. Meyric R. Rogers, "Recent Additions to the Washington University Collection: Portrait of William Dennis Marks."

Virginia Museum of Fine Arts.
Arts in Virginia
Vol. 9, Fall 1968, p. 34–39. Gordon Hendricks, "The Belle with the Beautiful Bones."

Wadsworth Atheneum
Vol. 4, Spring and Fall 1968, p. 39–48. Gordon Hendricks, "On the Delaware."

Worcester Art Museum
Vol. 20, Jan. 1930, p. 86–94. G.W.E. [George W. Eggers], "Thomas Eakins."

Associates in Fine Arts at Yale University
Vol. 8, Feb. 1938, p. 50, 51. T.S. [Theodore Sizer], "Eakins' 'John Biglen.'"

Yale University Art Gallery
Vol. 28, Dec. 1962, p. 16–21, 48. "Recent Gifts and Purchases."

Notes

References to the text are specified as follows: the first number is that of the page; the numbers following the colon are those of the lines on the page.

The kinds of information and documents furnished by Susan Macdowell Eakins in the early 1930s are designated:

SME 1 Conversations with her
SME 2 Letters from her
SME 3 Eakins' original letters
SME 4 Her copies of his letters
SME 5 Letters from other persons.

ABBREVIATIONS

Names of People

BE Benjamin Eakins
BB Bryson Burroughs
SM Samuel Murray
SME Susan Macdowell Eakins
TE Thomas Eakins

Institutions

AAA Archives of American Art, Smithsonian Institution

Hirshhorn Hirshhorn Museum and Sculpture Garden, Smithsonian Institution
MMA Metropolitan Museum of Art
NAD National Academy of Design
PAFA Pennsylvania Academy of the Fine Arts
SAA Society of American Artists
WC Wallace Collection, Joslyn Art Museum, Omaha

Publications

Hendricks Gordon Hendricks, *The Life and Works of Thomas Eakins*, New York, 1974.
Hendricks, *Photographs* Gordon Hendricks, *The Photographs of Thomas Eakins*, New York, 1972.
Hirshhorn *T.E. Coll.* *The Thomas Eakins Collection of the Hirshhorn Museum and Sculpture Garden*. Introduction and text by Phyllis D. Rosenzweig. Washington, D.C., 1977.
McHenry Margaret McHenry, *Thomas Eakins who painted*. Privately printed, 1946.
PMA *T.E. Coll.* Theodor Siegl, *The Thomas Eakins Collection*. Introduction by Evan H. Turner. Philadelphia Museum of Art, 1978.
Schendler Sylvan Schendler, *Eakins*. Boston, 1967.

11. Middle Age

1:1 ff Section I is based largely on conversations and correspondence with a number of persons in 1930 and 1931, and later: Mrs. Eakins, Mary Adeline Williams, Eakins' former pupils Samuel Murray, Charles Bregler, Thomas J. Eagan, David Wilson Jordan, Frank B. A. Linton, J. Laurie Wallace, James L. Wood, James Wright, and Francis J. Ziegler; and Eakins' friends and sitters Mrs. Stanley

Addicks (née Weda Cook), Adolphe Borie, Clarence Cranmer, Mrs. James M. Dodge, Mr. and Mrs. Nicholas Douty, Mrs. Helen Parker Evans, Mrs. Mary Hallock Greenewalt, Mrs. E. Farnum Lavell (née Eleanor S. F. Pue), Leslie W. Miller, Ernest Lee Parker, Mrs. John B. Whiteman (née Alice Kurtz), Mrs. Lucy Langdon W. Wilson, and others.

1:13–16 Dietrich account book, July 31, 1886.

1:17–20 McHenry, p. 60, 125.

2:1–17 Johnson to TE, March 28, 1887. SME 5.

3:2–23 PAFA: "Susan Macdowell Eakins" exhibition, 1973, p. 10.

3:29–32 McHenry, p. 73, 59.

4:8–9 Letters from Sartain to TE. SME 5. Hendricks, p. 36, said: "Will [Sartain] at least partly out of jealousy, had ceased being as friendly as he had been before." Also p. 142, 174, 283. But in 1930 SME lent me at least fifteen letters from Sartain to TE, continuing into the 1910s, all friendly and intimate.

5:22–25 Harrison S. Morris, *Confessions in Art,* 1930, p. 32–33.

5:32–34 Mrs. Stanley Addicks, May 1931.

5:38 to 6:2 MMA memorial exhibition catalogue, 1917, text by Bryson Burroughs, p. vii. He must have had a copy of this letter from SME. The *National Cyclopedia* article, vol. V, 1894, p. 421, repeats TE's information about his ancestry, which is not known to have been published before.

6:3–16 Letter, Feb. 12, 1897. SME 3.

6:35 to 7:2 PAFA memorial exhibition catalogue, 1917, p. 10.

8:24–26 MMA *Bulletin,* Nov. 1917, p. 222.

8:32–33 Interview with Clarence W. Cranmer, 1930.

8:37 to 9:1 To Beatty, Sept. 20, 1899. AAA.

9:5–6 *The Art World,* Jan. 1918, p. 293. William Sartain, "Thomas Eakins."

9:8 to 10:2 *The Arts,* March 1931, p. 385. Charles Bregler, "Thomas Eakins as a Teacher."

10:23–42 To Bryson Burroughs, MMA, Dec. 12, 1927. MMA.

11:7–16 From Mrs. John B. Whiteman, née Alice Kurtz, May 1930.

11:19–22 To Bryson Burroughs, MMA, June 3, 1923. MMA.

11:25–27 SM, 1931. McHenry, p. 110–111.

11:27–33 SME 1. Thomas J. Eagan, 1930. SM, 1931. McHenry, p. 109–110.

11:33–35 TE's drawing: G 241.

12:11–19 To Cushing, July 14, probably 1894; quoted in Hendricks, p. 228.

12:21–24 McHenry, p. 127. Mrs. Lucy L. W. Wilson, 1930.

12:35–41 Letter to me, April 23, 1930.

13:7–12 Mary Hallock Greenewalt, 1930.

13:22–31 *New York Evening Post,* May 14, 1892. *Harper's Weekly,* May 14, 1892, p. 459. *New York Tribune,* May 19, 1892. *Boston Transcript,* June 7, 1892. *Catalogue of the First National Loan Exhibition of the National Art Association,* Washington, D.C., May 18–27, 1892.

13:31–33 *Art Interchange,* May 1902, p. 124.

14:33–34 SM, 1931.

14:34–35. 15:21–23 Mrs. Addicks, May 1931.

15:2–3, 17–19 *Philadelphia Press,* Feb. 22, 1914.

15:10–12 Ernest Lee Parker, 1930.

15:12–17 McHenry, p. 50–51; story from the sculptor Beatrice Fenton.

15:20–21 PAFA memorial exhibition catalogue, 1917.

16:3 ff Hendricks' statement, p. 176, "Eakins may have visited two ranches," and so on, is incorrect, as proved by TE's letters.

16:5–8 To Albert or George Tripp, Dickinson, Dakota, 1887, n.d. SME 5.

16:10–13 Horace Traubel, *With Walt Whitman in Camden, January 21–April 7, 1889,* vol. 4, 1959, p. 135.

16:22 to 20:2 Information and quotations from six letters to SME from TE in Dickinson, in July, Aug., Sept., and Oct. 1887. SME lent me these letters in 1930, and I copied them in toto. One of them, July 26 and 27, is now owned by Mr. and Mrs. Daniel W. Dietrich II.

19:31–39 Letter from Dickinson, late Sept. 1887. WC.

20:2–5 Letter from Transit House, Union Stock Yards, Chicago, Oct. 14, 1887. WC.

20:10 to 21:7 Letter from Philadelphia, postmarked Dec. 8, 1887. WC.

21:17–24 McHenry, p. 93.

21:25 to 22:23 Morris, *Confessions in Art,* p. 33–34.

22:36–40 Brandywine Museum, "Eakins at Avondale," 1980, p. 10.

23:6–9 To Wallace, Oct. 22, 1888. WC.

27:4–6 Hendricks' statement, p. 178, that TE brought back from Dakota a painting, *Cowboys Circling,* "previously unknown to history and now unlocated," which "belonged to John Hemenway Duncan," is incorrect. The only known paintings done in Dakota are sketches. *Cowboys in the Bad Lands,* which TE gave to Duncan, was painted in 1888, the year after his Dakota visit.

12. Walt Whitman

28:4–10 *Specimen Days*, Philadelphia, 1892; written Aug. 27, 1877.

28:23 to 29:18 *Leaves of Grass*, Philadelphia, David McKay, 1900, p. 98, 105, 98, 101, 40, 62, 63, 198, 43, 45, 99, 209, 441.

29:26–27 Ibid., p. 11, 49.

30:16 to 31:13 Mrs. Stanley Addicks, née Weda Cook, May 1931. Her music to "O Captain!" has not survived. I have been unable to find in Whitman's poetry a passage about "the hand of the mechanic," and so on, but TE's quotations (or Mrs. Addicks' memory of them), though probably inaccurate, deserve recording. How much TE read of Whitman is unknown; he was not a great reader. The only known record of his owning books by Whitman is his letter of Dec. 22, 1898, to Small, Maynard & Co., Boston, who had published an edition of Whitman's works for which TE had lent negatives of some of his photographs of the poet for illustration. The letter, owned by Seymour Adelman, reads: "My dear Maynard, If you have finished with the negatives of Walt Whitman, will you please look them up and return them to me? I am certainly a very poor correspondent, never having thanked you for your beautiful present of the complete works of the poet. They have given me the greatest pleasure and I am indeed very thankful."

31:23–25 The dates of TE's meeting Whitman and of his painting the portrait are problematic. A photograph of the poet generally accepted as by TE (Hendricks, *Photographs*, fig. 151) was dated April 1887 by Whitman himself, on a print in the Yale University Library. Traubel reported Whitman recalling, on Feb. 15, 1889, that after "two or three weeks" of their first meeting TE came to Camden and started to paint the portrait. He was still working on it on Feb. 28, 1888, and it was "about finished" on April 15, 1888.

The portrait itself is signed and dated at upper right: "EAKINS / 1887"; but under the second "8" a "9" is faintly visible. Until the original canvas was lined in 1954 it was inscribed on the back: "WALT WHITMAN PAINTED FROM LIFE / by / THOMAS EAKINS 1897/1887" ("1897" crossed out and "1887" substituted). Traubel in his 1906 volume, p. 131: "Whitman's portrait came back to the Academy of Fine Arts several years after Whitman's death. Evidently then Eakins was asked to sign and date it, which he did, making an error of '1897' and then compounding the error by erasing the '9' and substi-

tuting an '8.' We know from Whitman's records that it should have been 1888." If Traubel was correct, this could not have happened on the PAFA's first exhibition of the portrait, in 1891, when Whitman was still living; nor on the PAFA's second exhibition of the picture, in 1908.

To further complicate matters, someone, after TE's death, retouched the signature and date on the recto of the canvas, making them much darker and bolder. But "9" is still visible under the second "8."

So the dates of the first meeting and of TE's starting the portrait remain uncertain. If Whitman's date on the Yale photograph, and his recollection of TE's starting the portrait two or three weeks after their first meeting, are correct, the portrait was probably begun in the spring of 1887. In that case, TE could not have worked on it continuously, as he did not finish it until April 1888.

31:26 to 33:9 Horace Traubel, *With Walt Whitman in Camden (January 21–April 7, 1889)*. edited by Sculley Bradley, Southern Illinois University Press, 1959, p. 155–156.

33:37–40 Horace L. Traubel, Richard Maurice Bucke, and Thomas B. Harned, editors, *In re Walt Whitman*, Philadelphia, David McKay, 1893, p. 144. "Walt Whitman at date" by Horace L. Traubel.

34:3–5 *In re Walt Whitman*, p. 389. "My summer with Walt Whitman" by Sidney H. Morse.

34:6 to 35:27 Traubel, *With Walt Whitman in Camden (March 28–July 14, 1888)*, Boston, Small, Maynard & Co., 1906, p. 39, 41, 42, 131, 153, 155, 156, 266, 284, 367, 434.

35:28–34 Traubel, *With Walt Whitman in Camden (November 1, 1888–January 20, 1889)*, New York, Mitchell Kennerly, 1914, p. 526, 527.

35:35–42 Traubel, *With Walt Whitman in Camden (January 21–April 7, 1889)*, p. 105, 227.

36:1–4 Traubel, *With Walt Whitman in Camden (April 8–September 14, 1889)*, edited by Sculley Bradley, Southern Illinois University Press, 1959, p. 499.

36:5 to 37:4 TE's photographs of Whitman are discussed fully in Hendricks, *Photographs*, p. 9–10, fig. 151–160. The dating of them by various writers on Whitman is conflicting, but Hendricks believed that they probably extended from April 1887 into 1892.

McHenry, p. 85–86, based on interviews with Murray, stated that the latter "made many of these

photographs," using TE's camera, while TE painted the portrait; and that "Murray frequently went to take the pictures without Eakins." However, Murray's reminiscences were not always accurate, and he took special pride in his contacts with Whitman, of whom he modeled a bust in 1892. In the Small, Maynard edition of Whitman's works, Boston, 1898, opp. p. 379, a cropped illustration of one of TE's portrait photographs (Hendricks, *Photographs*, fig. 157) is credited to TE; and TE's letter of Dec. 22, 1898, to the publisher requested return of the negatives to him. The published photograph closely resembles most of the ten now generally ascribed to TE. If any of the "negatives" sent by TE to the publisher had been by Murray, TE with his solicitude for his colleague's interest would have given him credit.

McHenry, p. 85: "It is astonishing to find that in the account of Whitman by Traubel, . . . there is not one mention of the visits of Murray and Eakins." This may be true as to Murray, but certainly not as to TE.

37:5 to 38:11 "Round Table with Walt Whitman" by Horace L. Traubel, *In re Walt Whitman*, p. 297, 322.

38:12–18 Traubel, *With Walt Whitman in*

Camden (*March 28–July 14, 1888*), p. 39.

38:21–26 Annie Nathan Meyer, "Two Portraits of Walt Whitman," *Putnam's Monthly and The Reader*, Sept. 1908, p. 707–710. SM told me in 1931 that Whitman gave the portrait to a man in settlement of a debt of $150, and paid nothing to TE. This does not agree with Ms. Meyer's account, which she evidently got directly from TE.

38:30–31 Copy of a typed statement dated June 1897, initialed by TE and Murray. Hirshhorn. Letter, SM to a Mr. Vanuxem, Oct. 19, 1898, Hirshhorn: "I made the cast myself assisted by Mr. Eakins on the day following Walt Whitmans death. The idea of making it was the thought that some day there might be a statue and the mask in this case would be invaluable."

The statement in my 1933 book, p. 124, that TE and Schenck made the death mask was based on an article on Schenck by Nelson C. White in *Art in America*, Feb. 1931, p. 85, and a letter to me from Mr. White. However, McHenry, p. 85, said: "Murray also remembered that it was he himself who had made a plaster cast of the hand and a death mask of Walt Whitman. Schenck used to go to see Whitman but had no part in making a death mask said Murray."

13. The Agnew Clinic

39:2 ff Regarding the title of *The Agnew Clinic:* Record Book 1 listed it as "Clinic Picture—Dr. D. Hayes Agnew"—obviously not a title. The first known published title was *Portrait of Dr. Agnew* in the World's Fair, Chicago, 1893; the second, *The Clinic of Professor Agnew*, Louisiana Purchase Exposition, St. Louis, 1904; the third, *The Agnew Clinic*, Lancaster Historical Society, 1914. TE in a letter to Professor John Pickard, University of Missouri, June 1907, called it *Clinic of Professor Agnew*. In the MMA and PAFA memorial exhibitions, 1917, the title was *The Agnew Clinic*, which has been used since then.

Information about its commissioning and the identity of the physicians and students is given in *Official Guide of the University of Pennsylvania*, 1906, p. 64, and *The Old Penn Weekly Review*, Oct. 30, 1915, and April 1931, p. 171.

39:15–22 SME letter to Professor Edgar F.

Smith, University of Pennsylvania, July 13, 1919, lent to me by SME: "The Agnew Clinic was obtained by a class of students of a certain year, who desired a portrait of their beloved teacher, sought Mr. Eakins and agreed to pay seven hundred and fifty dollars for the single figure. Mr. Eakins delighted with the opportunity to paint a man whom he both admired and respected, determined to give the boys a great composition—'The Agnew Clinic.' Mr. Eakins never regretted that the students could only pay him the sum originally agreed upon for a single figure portrait of Dr. Agnew." Also *Philadelphia Record Magazine*, March 29, 1914.

41:3–4 SME 1. She also told this to George E. Nitzsche of the University of Pennsylvania, who published it in the *Official Guide*.

41:33–35 Interview with Ziegler, 1930.

43:5 to 45:13 SME 1. Interviews with SM, 1931. McHenry, p. 106, 143–144, based on informa-

tion from SM. *Philadelphia Inquirer*, Feb. 26, 1914. *Philadelphia Record Magazine*, March 29, 1914.

45:5–6 Interview with Bregler, 1930.

45:14–21, 29–38 J. Howe Adams, M.D.: *History of the Life of D. Hayes Agnew, M.D., LL. D.*, 1892, p. 332–335, 341.

45:24–25 Frame. McHenry, p. 146.

47:17 TE letter to George Corliss, PAFA actuary, Jan. 9, 1891. PAFA.

47:20 to 48:38 Hart's letter to Grayson, Grayson's to TE, Coates's to TE, and TE's draft of a letter to Coates with the quotation from Rabelais were all lent to me by SME and copied by me. The PAFA has the original of the last letter, without the Rabelais quotation.

49:1–5 Clipping from an unidentified Philadelphia newspaper, Feb. 11, 1891, lent to me by SME.

49:7–15 Written statement, undated, by SME about the *Gross* and *Agnew* clinics, lent to me by SME.

50:34 to 51:9 SME 3.

14. The Portrait-Painter

59:24–29 Letter from Leslie W. Miller, May 14, 1930.

59:38–39 Letter from Mrs. John B. Whiteman, May 1930.

59:38–39 Letter from Mrs. John B. Whiteman née Alice Kurtz, May 17, 1930.

59:40–42 To George D. McCreary of the Union League of Philadelphia, June 13, 1877. SME 3. (See Volume I, p. 141.)

64:3–12 Letter from Leslie W. Miller, April 23, 1930.

64:13–16 Henry David Thoreau, *Walden*, Boston, 1893, p. 36, 38.

64:30–36 The Victorian armchair appears in these paintings: *Kathrin*, 1872; *Elizabeth Crowell and Her Dog*, early 1870s; *Professor Rand*, 1874; *The Zither Player*, 1876; *Mrs. Brinton*, 1878; *Sewing: A Sketch*, probably 1879; *Dr. Leidy*, 1890; *Miss Van Buren*, 1890–1892; *Ruth*, 1903; *Suzanne Santje*, 1903; *Edith Mahon*, 1904; and *The Old-fashioned Dress*, 1908.

64:37–39 The Chippendale side chair appears in these works: *William Rush*, etc., oil, 1877; *Seventy Years Ago*, watercolor, 1877; *Seventy Years Ago: Study*, oil, probably 1877; *Retrospection*, oil, 1880; *Retrospection*, watercolor, probably 1880; *Knitting*, relief, probably 1883.

69:6–7 Interview with Mrs. E. Farnum Lavell, née Eleanor S. F. Pue, 1930.

69:8–12 To Miss Pue, n.d., summer 1907. Virginia Museum of Fine Arts.

69:15–17 Letter from Mrs. Robert C. Reid, née Maud Cook, Sept. 6, 1930.

69:18–20 *The Connoisseur*, Dec. 1944, p. 114.

70:21–22 Letter from Mrs. Greenewalt, May 13, 1931.

72:9–22 Interview with Mrs. Dodge, 1930.

72:37–43. 75:8–9 Letter from Leslie W. Miller, April 23, 1930.

74:2 to 75:7 PMA *T.E. Coll.*, p. 143.

77:6–7 Gilbert Sunderland Parker, PAFA, Eakins Memorial Exhibition, 1917, p. 9.

81:9–13 *American Medical Biography*, 1928.

81:18–36 SME 3.

81:38 TE destroying first DaCosta portrait. SME 1.

83:8–10 PAFA, "Susan Macdowell Eakins," 1973, p. 12.

83:17–23 Letter from Leslie W. Miller, April 23, 1930.

84:1 ff An account of Weda Cook and *The Concert Singer* is "Thomas Eakins' *The Concert Singer*" by Synnove Haughom, *Antiques*, Dec. 1975, p. 1182–1184.

84:36–37 To Professor Henry A. Rowland, Oct. 4, 1897. Addison Gallery of American Art.

86:31–32 Letter, Hennig to TE, Feb. 19, 1897. SME 5.

86:36–37 The pianist is Samuel Myers. McHenry, p. 121: "Helen Parker Evans remembered that Eakins was greatly moved by good music. Samuel Myers and Frank Linton used to give musicales on Saturday afternoons, and when Thomas Eakins came 'he would sit in a corner and sob like a child'"—an unattractive picture of Eakins, contrary to what others have written and said about his enjoyment of music.

90:8–15 Letter, Dec. 22, 1907. SME 5.

90:20–24 G 122, 202, 203, 204, 205, 205A.

91:26–40 Letter, May 1930.

94:6–12 Letter from Major Elizabeth O. Carville, Dec. 8, 1969.

94:26–32 Hendricks, p. 263.

94:32–37 McHenry, p. 128–129.

96:25–26 One of TE's former pupils, later violently anti-Eakins, told me in 1930 or 1931 that TE was "abnormal," "very loose sexually," and indulged in "sexual excesses." He said that once when SM was modeling a bust of a Philadelphia girl, TE came in, went into the next room, and reappeared stark naked, walked in front of the sitter, and said: "I don't know if you ever saw a naked man before; I thought you might like to see one." (When I repeated this story to Mrs. Addicks, she thought that it was in character. SM, naturally, never mentioned it.) This former pupil seemed obsessed with the subject of sexual immorality and said other things about TE that were factually incorrect; for example, that his "abnormality" was caused by his mother having died in childbirth.

Clarence Cranmer, who admired TE but was inclined to tell tall tales about him, said that he was "natural," he would as soon take off his pants in front of a woman, and did so. Francis Ziegler thought TE was an exhibitionist, but he did not enlarge on it.

The above stories are recorded for what they may be worth, as part of the Eakins legend.

97:36–42 Letter, July 1939, Hirshhorn. Hirshhorn *T.E. Coll.*, p. 129.

15. Sculpture

99:4–5 SM's birth date has often been given as 1870. But the record of his death in the Philadelphia City Hall Archives says "d. 11/3/41, b. June 12, 1869," and his gravestone in Cathedral Cemetery, Philadelphia, reads "1869–1941." The catalogue of his first known exhibition, the PAFA 62nd annual exhibition, 1892, said: "Born in Philadelphia. 1869" —information which must have come from him. After his death Mrs. Murray, furnishing biographical information to the *National Cyclopedia of American Biography*, gave the year as 1869, which was used in the *Cyclopedia*, vol. 37, 1951, p. 186. The 1870 date appeared first in *Who's Who in America* in the early 1900s. In my 1931 interviews with him I found that he had no clear memory for dates.

99:7–10 McHenry, p. 71–72. Hirshhorn *T.E. Coll.*, p. 13, quotes a statement by Mrs. Murray's nephew-in-law John B. Thomson which had been approved by Mrs. Murray for Miss McHenry.

The Boulton record of Art Students' League of Philadelphia students (Vol. I, p. 295) does not list SM under "Feb. 1886," but does list him in all seasons from 1886–87 through 1890–91, the last season recorded. He is listed in the day classes in all seasons in which day and night classes are given separately; never in the night classes. His address is always 41 Bell Street, Philadelphia. On April 15, 1891, he was elected vice-president of the League; as such he was a member of the Board of Control. (He himself, when I talked with him in 1931, was uncertain when he had joined the League.)

99:11–16 SM in 1931 could not remember the date when he began assisting TE in the Chestnut Street studio. However, he told me that he helped TE with *The Agnew Clinic;* this would be in the spring of 1889, no later than May 1.

99:27–30 Circular owned by the Hirshhorn Museum. Hirshhorn *T.E. Coll.*, p. 125.

101:1–4 McHenry, p. 92.

103:20–22 Hendricks, *Photographs*, fig. 234, 277.

103:30–33 Letter, July 14, 1895. Hendricks, p. 228.

103:36–38 McHenry, p. 134.

105:5–10 Letter, Nov. 3, 1892. Hirshhorn.

105:12 ff A full account of the Witherspoon Building sculptures is "Samuel Murray, Thomas Eakins, and the Witherspoon Prophets" by Maria Chamberlin-Hellman, *Arts Magazine*, May 1979, p. 134–139. I am indebted to Mrs. Chamberlin-Hellman for the information in this account.

105:29–35 Letter to *Philadelphia Inquirer*, Dec. 19, 1921. Hirshhorn.

105:37–39 Letter, Huston to SM, Sept. 9, 1896. Hirshhorn.

105:40–41 Mrs. James M. Dodge told me in

1930, and Margaret McHenry in the 1940s (McHenry, p. 128), that the statues were made in a studio on Wissahickon Avenue.

106:22–25 To Rowland, Oct. 4, 1897. Addison Gallery of American Art.

106:41–42 To Morris, Feb. 16, 1897. PAFA.

107:21–25 To Beatty, Sept. 20, 1899. AAA.

107:26–41 To Mrs. Johnston, June 21, 1907. Minneapolis Institute of Arts.

109:2–3 McHenry, p. 128.

109:30 Hendricks, p. 221.

110:16 ff I am grateful to Maria Chamberlin-Hellman for permission to read her unpublished article "The Monumental Architectural Sculpture of Thomas Eakins," 1972. The section on the sculpture on the Brooklyn Memorial Arch is the most complete coverage of this subject. The notes that follow specify the information about sources in the Brooklyn city records for which I am indebted to Mrs. Chamberlin-Hellman's article.

112:1 to 116:4 Cleveland Moffett, "Grant and Lincoln in Bronze," *McClure's Magazine*, Oct. 1895, p. 419–432.

116:13–14 Brooklyn Park Commissioners, *35th Annual Report of the Department of Parks of the City of Brooklyn and the 1st of the County of Kings: For the Year 1895*, 1895, p. 12.

117:4–5 *Brooklyn Daily Eagle*, Dec. 22, 1895, p. 6; Dec. 23, 1895, p. 4, 6.

117:5 to 118:2 "Public Sculpture in Brooklyn," *Art Amateur*, Feb. 1896, p. 60.

118:4–12 Brooklyn Park Commissioners, *36th Annual Report of the Department of Parks of the City of Brooklyn, and the 2nd of the County of Kings: For the Year 1896*, 1897, p. 35.

118:14 to 119:5 Chamberlin-Hellman, "Architectural Sculpture," p. 39.

119:6 ff A complete account of the Trenton Battle Monument in every aspect—historical, artistic, and financial—is "The Trenton Battle Monument Eakins Bronzes" by Zoltan Buki and Suzanne Corlette, in the New Jersey State Museum, Trenton, *Bulletin 14*, 1973. The authors base their account on the Trenton Battle Monument Association *Minute Book*, 1884–1918 (unpublished); on the *Programme*, *Dedication of the Trenton Battle Monument*, *Oct. 19th, 1893*; and on *The Trenton Battle Monument*, Trenton, 1895. I am grateful to Mr. Buki for his kindness in researching and furnishing additional information on the monument and its history.

119:38 to 120:8 *Bulletin*, p. 70, note 7. *The Minute Book* continued: "It is expected that Mr. Eakins, in collaboration with Mr. O'Donovan will

execute these three relieves." But there is no evidence, documentary or stylistic, that O'Donovan worked with TE on the reliefs; on the contrary, TE exhibited them three times in 1894 and 1895 as by himself.

120:8–10 *Bulletin*, p. 39; p. 46, note 16.

120:16–32 A description of the *Crossing* relief, the identity of the figures, the type of boats used, the action of Colonel Hand, and other details, was given in the Dedication *Programme*, p. 49; quoted in the *Bulletin*, p. 72, note 10.

Hendricks, p. 224, caption for fig. 236: "In bow of left-hand boat, left to right: Colonel William Washington, Alexander Hamilton, and Lieutenant James Monroe." The same information is given on p. 332, CL-161. However, the Dedication *Programme*, p. 49, identified the figures as "Captain William Washington and the Lieutenant of his company, James Monroe," and "Colonel Edward Hand, . . . evidently alarmed at some noise on the New Jersey shore." Mr. Buki in a letter to me, Jan. 9, 1978, on the basis of Monroe's physical description and Colonel Hand's action, identified the figures, left to right, as Monroe, William Washington, and Hand. Captain Washington was not promoted to colonel until 1778.

121:3–11 Dedication *Programme*, p. 49. (*Bulletin*, p. 66; p. 73, note 13.) Hendricks, p. 224, caption for fig. 237, and p. 332, CL-162: "At right, mounted, is Alexander Hamilton." But the *Programme* said: "The mounted figure of this brave soldier [Hamilton] . . . is conspicuous in the foreground."

121:28–33 *Bulletin*, p. 41; p. 46–47, note 19. *New York Times*, Oct. 20, 1893.

121:34–38 *Minute Book*, June 23, 1894. (*Bulletin*, p. 41; p. 47, note 25.) Hendricks, p. 224–225: "When the Battle Monument dedication was held on October 19, 1893, . . . Eakins' three reliefs were present only in staff. . . . One of the three reliefs, *The Surrender of the Hessians*, was not liked, and the sculptor Karl H. Niehaus was asked to do another to replace Eakins' version." But the *Surrender* relief on the monument at the dedication, as illustrated in the Dedication *Programme*, was by Niehaus. In reply to my inquiry about Hendricks' statement, Mr. Buki wrote on Jan. 9, 1978: "A recent search of the *Minute Book*, *The Programme*, 1893, and *The Trenton Battle Monument*, 1895, again reveals only that the bronze panels were installed in staff for the dedication of the monument. There is no indication whatsoever that Eakins' third panel was not liked, therefore prompting the committee to

award the contract for the 'Surrender of the Hessians' to Karl Niehaus."

121:38–40 *Bulletin*, fig. 16, p. 71.

121:42 to 124:6 In the PAFA 64th annual exhibition, Dec. 17, 1894–Feb. 23, 1895, the relief was listed simply as "Bas-relief of Trenton Battle Field Monument." A letter to the PAFA from Maurice J. Power of the National Fine Arts Foundery, New York, Dec. 11, 1894, stated that the relief, in bronze, was being shipped to the PAFA. A letter from TE to Harrison Morris of the PAFA, Feb. 25, 1895, gave "the address for the bronze panel" as Power of the Foundery. *The Art Amateur*, March 1895, p. 106, reviewing an exhibition of the Architectural League in the Fine Arts Society's building, New York, and speaking of "the remarkable display of sculpture," mentioned "among works of importance" "Mr. Thomas Eakins's relief of artillerymen for the Battle Monument at Trenton." So it is probable that this relief, obviously *The Opening of the Fight*, was the bronze recently shown at the PAFA.

The Association *Minute Book*, Dec. 26, 1895, said: "The bronze tablets, upon which workmen had been employed during the winter in the National Art Foundry in New York, were brought to Trenton in the spring and put into position on the monument. The artist made some changes in the tablet 'the opening of the fight' and it is now considered the most beautiful of them all" (*Bulletin*, p. 75, note 17).

The relief in the PAFA 65th annual exhibition, Dec. 25, 1895–Feb. 22, 1896, was listed simply as "Panel for Trenton Monument." On Dec. 4, 1895, Power had telegraphed TE: "Trenton relief good condition except lower margin will forward it tomorrow." On Dec. 6 TE wrote Morris: "I received evening before last the enclosed telegram and will repair the lower margin if desirable." The Pennsylvania Railroad Co. shipping receipt to Power, New York, Dec. 6, 1895, covers "Plaster of Paris model. Owner risk of breakage," to be shipped to Thomas Eakins, Philadelphia. (The above documents are in the PAFA archives.) Since the bronzes of both reliefs were already installed on the monument, TE evidently exhibited the plaster of the *Crossing* in the PAFA. He photographed both plasters, and SME had the photographs in 1930. Neither plaster has been preserved.

124:9 to 125:2 *Bulletin*, p. 72, note 7; p. 47,

note 26; p. 53, 54. Power's letter to the PAFA, Dec. 11, 1894, said that the bronze relief "should be insured in my name for twenty five hundred dollars."

125:13 to 126:4 Letters to me from SM, May and June 1931.

126:6–8 Corcoran Gallery of Art: "The Sculpture of Thomas Eakins," May 3–June 10, 1969, organized by Moussa M. Domit, Assistant Director, who wrote the catalogue.

126:8–19 *Bulletin*, p. 42–43.

126:35–39 TE to Dr. Edward J. Nolan, Academy of Natural Sciences of Philadelphia, Aug. 14, 1911, in the Academy archives.

128:31–34 Letter to me, April 23, 1930.

128:36–37 SME lent me this draft. I copied only a short excerpt.

128:40 to 129:3 SME 1.

129:9–11 *Proceedings of the Academy of Natural Sciences of Philadelphia, 1894*, Philadelphia, 1894, vol. 46, p. 172–180, illustrated with drawings by TE in linecut. A reprint, paged 1–9, was made for TE; 100 copies.

Before the paper was published, TE at the suggestion of Dr. Edward J. Nolan, editor of the *Proceedings*, consulted Dr. Allen, then rewrote some parts. "I am glad to have had Dr. Allen's help in the matter," he wrote Nolan. "He pointed out a number of loose phrases which he fixed. . . . In two of three cases he added explanatory notes signed by himself which pleases me greatly. In other cases he approved of expressions which at first he had disliked. . . . Nevertheless with all the corrections, I recognize that he has treated me with leniency in not making me conform too strictly to the conventionalities having announced myself a painter: just as I would recognize in drawings made by him to express his own ideas in his own way an excellence that would surely diminish with too much artistic interference" (letter, June 12, 1894, Academy of Natural Sciences).

Hendricks, p. 226: "In 1894 Eakins read a paper at the Philadelphia Academy of Natural Sciences. . . . He had spent much of the summer working on the paper. . . . In this he was helped by Dr. Harrison Allen." But TE gave the paper on May 1, 1894; and afterward, in June, rewrote parts in consultation with Dr. Allen (TE letters, June 8, 12, 14, 1894, to Dr. Nolan, and June 29, 1894, to William J. Fox. Academy archives).

16. The Later 1890s

131:25–27. 132:10–21 SME 1. Interviews with SM, 1931. McHenry, p. 112–114, including information from SM.

131:28 to 132:8 Hendricks, p. 228.

132:28–30 A photograph by the Brooklyn Museum showed the portrait with the frame, which was later discarded and has disappeared. TE to Harrison Morris, PAFA, Dec. 6, 1895, in PAFA archives: "My picture of Frank Cushing went to the Academy today without its frame for which I beg your indulgence. The frame itself is at the house and if you cannot send for it Monday I shall send it myself."

132:30–34 In 1930 the stretcher bore a label of the PAFA 65th annual exhibition, 1895–96, but the painting was not in the exhibition. Bregler wrote me April 30, 1942: "This fine painting was rejected when sent to the Penn Academy. I wrote to the Academy years ago for the names of the jury."

132:37 to 135:7 TE to W. J. McGee, April 17, 1900. Bureau of American Ethnology, Smithsonian Institution.

135:9–10 *Official Guide to the University of Pennsylvania*, 1906, p. 100.

135:10–12 Letters from Culin at the Brooklyn Museum to TE, April 23, 29, 1905. SME 5.

135:18–23 Letters from Mrs. Culin to me, June 4, July 1, 1930. In 1930 SME lent me a bank slip with a sketchy drawing by TE of the main features of the portrait, inscribed "Culin" in TE's hand.

135:32 ff Accounts of Ella, and her illness and suicide, are given in McHenry, p. 95, 100 (without mentioning suicide); Schendler, p. xi, 133, 155, 288, 291; Hendricks, *Photographs*, p. 4; Hendricks, 1974, p. 194–196, 235, 236. Schendler's account is based in part on a conversation with Ella's cousin Donald Stephens, son of Caroline Eakins Stephens. Hendricks in *Photographs* and his 1974 book gave acknowledgments for information about the Crowell family to Ella's siblings Caroline, Frances, James, and William Crowell, and to Inga and Donald Stephens.

In May 1931 Weda Cook Addicks told me that she was a friend of Ella, who was studying nursing; that Ella came to see her and said that by mistake she had given a patient an overdose of a drug which almost killed him, so she was going to kill herself; but first she was going to kill Mrs. Addicks; she had a revolver, Mrs. Addicks said. Mrs. Addicks said to me that she spent one of the worst hours of her life dissuading her. She said that Ella left and took the same overdose herself, which almost killed her. Mrs. Addicks said that later Ella tried to kill Eakins, and finally killed herself. All recollections years after the event must be taken with a grain of salt, but a story by someone so close to Eakins deserves at least to be recorded, in justice to him.

The story of the overdose of a drug is also given in Hendricks, p. 235. Ella's threat to shoot Eakins was told to me not only by Mrs. Addicks but by Ella's sister Frances Crowell at Avondale in 1931. Her brother Thomas Eakins Crowell told me about 1960 that Ella was deranged and was shut up in the Avondale house.

137:20–23. 140:3–6 Statement, unsigned, in the MMA memorial exhibition catalogue, 1917. In the PAFA memorial exhibition catalogue, 1917, it was repeated, in quotes, and signed "Thomas Eakins." SME wrote Bryson Burroughs of the MMA, Sept. 27, 1917: "Enclosed is a description of the Rowland portrait, written shortly after the portrait was finished, hoping the College—Johns Hopkins—would be interested to have the portrait there for a while. They were not interested." MMA archives.

137:27 ff TE's letters to Rowland quoted in this section are owned by the Addison Gallery of American Art. I am grateful to the Gallery for permission to publish them.

140:11 to 141:2 The date in the signature is almost illegible; the "7" looks like a "1." The MMA memorial exhibition catalogue gave the date as 1891, which I used in my 1933 book. The Eakins-Rowland correspondence, not then available, establishes the date as 1897, as does reexamination of the signature.

143:7–10. 144:11–13 Rowland to TE, Sept. 15, 1897. SME 5.

144:17–20 To Stokes, Jan. 3, 1904. Hirshhorn. Schendler, p. 289, said that TE lent the portrait to the PAFA, which kept it in the basement. But the "Academy" in TE's letter refers to the NAD's 79th annual exhibition, 1904, which included the portraits of Rowland and Rear Admiral Sigsbee.

144:23–26 Remsen to Wilson, Oct. 12, 1908. SME 5.

nary with financial assistance by the Wyeth Endowment for American Art.

198:2–5 The following portraits have Latin inscriptions: *The Artist and His Father Hunting Reed-birds,* c. 1874; *The Chess Players,* 1876; *The Crucifixion,* 1880; *Arcadia,* 1883; *The Agnew Clinic,* 1889 (on the frame and on the verso of the canvas); *Dr. Charles Lester Leonard,* 1897; *Salutat,* 1898; *Salutat: Study,* 1898; *George Morris,* 1901; *Dr. Patrick J. Garvey,* 1902; *His Eminence Sebas-* *tiano Cardinal Martinelli,* 1902; *Colonel Alfred Reynolds,* 1902; *The Translator,* 1902; *Bishop Dennis J. Dougherty,* 1903; *Mrs. Mary Hallock Greenewalt,* 1903; *Archbishop Diomede Falconio,* 1905; *Professor William Smith Forbes,* 1905 (on the recto and the verso); *Mrs. Lucy Langdon W. Wilson,* 1908.

198:11–15 To Dr. Heuser, June 28, 1908. Archives of the Catholic Historical Society, Philadelphia.

18. Growing Recognition

199:4–23 Carnegie Institute, "Retrospective Exhibition of Paintings from Previous Internationals," 1958–1959. I am indebted to Leon Anthony Arkus, Director, for additional information about TE's relations with Carnegie.

199:29 to 200:6 McHenry, p. 109: "Thomas Eakins had many friends who were artists. Bontet De Monville [Boutet de Monvel], Sargent, Simon, Degas—all of them used to visit the Eakins house for dinner. The Carnegie Institute (Eakins had often served on its jury) brought over these artists from Europe." These statements were based on interviews with SM, who also told me that Eakins used to bring the Carnegie jury home with him (from Pittsburgh to Philadelphia!) and give them an Italian dinner.

De Monvel, Sargent, and Degas were never on a Carnegie jury; Lucien Simon not until 1922. Degas visited the United States only once: New Orleans, 1872–73.

McHenry, p. 117, also based on SM: "As a young man Eakins had seen Sarah Bernhard [sic] and Rachel he said. . . . Murray remembered that when Madam Bernhard used to come to Philadelphia she and Eakins were great friends." Rachel died in 1858. As to Bernhardt and TE being great friends, this seems highly unlikely.

Another SM story (McHenry, p. 111–112): "Dr. Gross, too, came often to the studio for he had known Murray's father." Gross died in 1884, two years before SM met Eakins.

The Art Amateur, Nov. 1901, p. 151, apropos of the Carnegie jury, quoted Edmond Aman-Jean as saying of his fellow jurors: "Some of them are for me old friends found again, with whom I have had great delight talking over the old days when we were students together at the Ecole des Beaux-Arts. . . . Among them . . . Thomas Eakins, Robert W. Vonnah, and Frank W. Benson, three students and comrades in Paris whom I am very happy to meet again." Aman-Jean, born in 1860, would have been six to nine years old when Eakins was in Paris.

201:20–21 PAFA memorial exhibition catalogue, 1917, p. 8.

201:22–24 Lloyd Goodrich, *John Sloan,* 1952, p. 30.

201:39–42 Letter, n.d. PAFA.

202:15–23 Letter to E. C. Babcock, Babcock Galleries, New York, Dec. 4, 1939. Babcock Galleries.

202:33–34 The complete list of TE's awards is as follows: Massachusetts Charitable Mechanics' Association, Boston, 1878, silver medal for two watercolors, *Study of Negroes* and *Young Lady Looking at a Flower;* World's Columbian Exposition, Chicago, 1893, bronze medal for ten paintings including the *Gross* and *Agnew* clinics; Exposition Universelle, Paris, 1900, honorable mention; Pan-American Exposition, Buffalo, 1901, gold medal for *Professor Barker of the University of Pennsylvania;* Universal Exposition, St. Louis, 1904 (Louisiana Purchase Exposition), gold medal for *The Clinic of Professor Gross;* Pennsylvania Academy of the Fine Arts, 1904, the Temple gold medal for *Portrait of Archbishop Elder, of Cincinnati;* National Academy of Design, 1905, Thomas R. Proctor Prize, $200, for the best portrait in the exhibition, for *Portrait of Professor Leslie W. Miller;* Carnegie Institute, 1907, medal of the second class, carrying with it a prize of $1,000, for *Portrait of Professor Leslie Miller;*

American Art Society of Philadelphia, 1907, gold medal for *Portrait of Rear Admiral Melville.*

Hendricks, p. 178, said that TE's portrait of Professor George F. Barker won the Thomas B. Clarke prize "for the best American figure composition painted in the United States" at the annual exhibition of the NAD, 1888. The Clarke prize that year was won by H. Siddons Mowbray. The only prize TE ever received from the NAD was the Proctor prize in 1905 (Hendricks, p. 250, said "1904").

202:38–43 Geoffrey T. Hellman, "Some Splendid and Admirable People," *The New Yorker,* Feb. 23, 1976, p. 61–62.

203:8–14 *Art Interchange,* May 1902, p. 110.

203:20–21 *International Studio,* Dec. 1901, p. xlii.

203:22–26 *The Critic,* Jan. 1904, p. 34.

203:32 to 204:2 Hartmann, *A History of American Art,* 1902, vol. 1, p. 189, 200–204.

204:7–24 Caffin, *The Story of American Painting,* 1907, p. 230–233.

204:33–43 Isham, *The History of American Painting,* 1905, p. 525–526.

208:10–18 Letter, Dec. 12, 1903. SME 5.

208:33–40 Letter, Sept. 25, 1903. SME 5.

212:17–21 Letter, June 25, 1941. Minneapolis Institute of Arts.

212:26–30 Statement by Mrs. Johnston, Nov. 30, 1935, attached to the portrait.

212:31–41 To Mrs. Johnston, June 21, 1907. Minneapolis Institute of Arts.

220:27 McBride papers. AAA.

220:28–29 Morris, *Confessions in Art,* 1930, p. 95.

222:4–5 Interview with SM, July 23, 1931. Also SME inferred this in talking with me, 1930.

222:15–17 Mrs. Addicks told me, May 8, 1931, that TE had told her this story, and that he was pleased that Sargent wanted to meet him. Since it was published in my 1933 book it has been repeated, sometimes with embellishments; e.g., Peyton Boswell, Jr., *Modern American Painting,* 1939, p. 142.

222:22–24 McHenry, p. 106.

222:31–38 Agnes Repplier, *J. William White, M.D.: A Biography,* 1919, p. 113.

223:2–6 Letter, May 2, 1904. SME 5.

223:9–14 Letter, Feb. 9, 1906. SME 5.

223:16–25 Letter, Feb. 23, 1906. SME 5.

223:33–35 McHenry, p. 131.

224:5–7 Interview with Mrs. Douty, June 10, 1930.

224:16–20 McHenry, p. 124.

19. Later Portraits

227:6–10 Stokes to TE, Dec. 14, 1903. SME 5.

227:12–16 TE to Stokes, Dec. 15, 1903, Jan. 3, 1904. Hirshhorn. Hirshhorn *T.E. Coll.,* p. 198, 199.

227:31–33 SME to me, Dec. 1, 1933. Fairfield Porter in *Thomas Eakins,* 1959, p. 20, stated incorrectly that TE applied these methods and others equally rigid to posing "the model" for *The Concert Singer.*

228:9 to 229:8 TE to Stokes, March 11, 1904. Hirshhorn. Hirshhorn *T.E. Coll.,* p. 200, 201.

229:23–26 Ogden to TE, March 28, 1904. SME 5.

229:29 to 231:3 TE to Ogden, April 7, 1904. SME 3.

231:4–17 Ogden to TE, April 8, May 13, 1904. SME 5.

231:18–24 TE to Ogden, May 22, 1904. SME 3.

232:11 Information on price from SME.

232:37 to 234:1 Letter, Sept. 19, 1905. SME 5.

234:8–11 Letter, Richard T. Cadbury to Edward Robinson, MMA, Oct. 17, 1917. MMA archives.

234:12–13 Letter to me from George D. Wood, June 18, 1930.

234:18–20 Letter to me from Katharine Buckley, June 21, 1930.

234:35–36 Beatty to TE, May 14, 1910. SME 5.

234:38 to 236:9 Otto C. Wolf to TE, May 21, 1910. SME 5.

236:13–17 Schmidt to TE, Oct. 13, 1911. SME 5.

238:22–24 Curtis Wager-Smith, "A Maker of Portraits in Silhouette: Kate Parker," *The Book News Monthly,* 1915, p. 201–204. The illustrations include her silhouette of TE, now in the PMA.

238:25–28. 242:13–15 Written by Mrs. Kate Parker on the back of her silhouette of TE.

238:28–29. 242:1–5 McHenry, p. 130.

240:1–9 Hendricks, p. 262 and fig. 293.

242:6–11, 15–16 Mrs. Helen Parker Evans to Sylvan Schendler, Sept. 26, 1969. Courtesy of Sylvan Schendler.

20. Old Age

243:1 ff Regarding the chronological order of the three later Rush paintings: The first discussed, *William Rush Carving*, etc. (G 445), is signed and dated 1908; it was finished by March 30 of that year (TE's letter to John W. Beatty, Carnegie Institute, March 30, 1908). Its concept and main elements are the same as those of the Rush paintings of 1876 and 1877.

The other two unfinished, undated paintings, *William Rush and His Model* (G 451) and *William Rush's Model* (G 453), although on the same general theme and of the same size, are entirely different in concept and composition: the sculptor not carving, but helping the model down from the stand; and the model seen full-face, not with her back turned. It seems unlikely that TE would have started two paintings so different from the *Rush Carving* works of the 1870s and the 1908 one, abandoned them, and then painted G 445; it seems more probable that he painted G 445 first.

As to the relative dates of the two unfinished canvases, G 451 and 453, the former shows only the model, stepping down from the stand, seen full-face; the sculptor; and the carved scroll in the foreground; and the only existing study for it, G 452, is of the model alone, with an indication of the sculptor's hand. It is possible that TE planned to include other elements, such as the carved figure of the Nymph.

G 453 and the two studies for it, G 454 and 439, show that he planned a more complex composition: the model stepping down; a woman waiting for her with a cloak; the sculptor; and the carved figure of the Nymph. The model is not full-face, but turned somewhat toward the female attendant, giving more value to the lines of her body. Her figure, somewhat left of center in G 451, is somewhat right of center, allowing room for the attendant. The foreground scroll, which in G 451 hides the sculptor's legs, is not present.

From the foregoing it seems evident that in G 451

TE did not plan to include the third figure of the female attendant. The more complex composition of G 453 (as planned), the more effective lines of the model's figure, and the absence of the foreground scroll suggest—although there is no definite factual evidence—that G 451 probably preceded G 453.

243:4–6 Aside from his student works, TE's female nudes consisted of the two *William Rush* paintings of 1876 and 1877 (G 109, 111), and two studies for them (G 110, 113); a small study for *Courtship*, about 1877 (G 122); a study of a woman's back for Alice Barber's illustration in *Scribner's*, 1879 (G 202); the oil *Arcadia* and a small study for it, probably 1883 (G 196, 197); an undated watercolor and an oil study for it (G 205, 204); two undated oil studies, not connected with any known compositions (G 203, 205A); and the three 1908 *William Rush* paintings and five studies for them (G 445–447, 451–454, 439).

Hendricks, p. 344, C.-L. 276, calls G 205 "*Mrs. Thomas Eakins, Nude, from Back*, c. 1884?" But neither the figure nor face resembles Mrs. Eakins'; and when I was examining the watercolor and the oil study for it (G 204), both then in her possession, she did not indicate that they were of her.

Hendricks dated G 203 and 205A, both in the Hirshhorn Museum, as "c. 1908" (p. 324, C.-L. 102 and 103), perhaps because of a supposed relation to the 1908 *Rush* paintings. But there is no such unmistakable relation as in the studies cited above. The fact is that there is no evidence for the dates of the four undated nudes, G 203–205A.

Hendricks, p. 113, illustrated G 202, owned by Mr. and Mrs. Daniel W. Dietrich II, as a study for the 1876 version of *William Rush*. But it is identical in forms, pose, light, and shadows to the figure of the model in Alice Barber's illustration, "The Women's Life Class," *Scribner's Monthly Illustrated Magazine*, Sept. 1879, p. 743. Evidently TE helped his pupil Miss Barber by painting this study of a key figure in her illustration.

The catalogue of the exhibition at the Brandywine River Museum, "Eakins at Avondale, and Thomas Eakins: A Personal Collection," March 1980, p. 49, gives the various dates attributed to G 202, but does not connect it with Alice Barber's illustration.

245:36 to 247:3 Letter, May 29, 1931, from Anne K. Stolzenbach, Department of Fine Arts, Carnegie Institute, to E. C. Babcock, Babcock Galleries, New York. A label on the stretcher of the painting in 1931, with the title "William Rush Carving the Allegorical Figure of the Schuylkill," also bore two numbers which correspond with Carnegie's registration and case numbers.

In the Babcock Galleries' exhibition of paintings from SME's collection, Dec. 1930, the catalogue stated that the painting "never left Eakins' studio until we obtained it for this exhibition"—which evidently meant that it had not been previously exhibited.

In the 5th biennial exhibition of the Corcoran Gallery of Art, Dec. 15, 1914–Jan. 24, 1915, TE showed "William Rush, Carving." This was probably the 1877 version, in view of the Babcock Galleries' statement. In the Brooklyn Museum exhibition "Contemporary American Painting," April 4–May 3, 1915, TE showed William Rush carving Allegorical Figure of Schuylkill River. Henry McBride in the New York Sun, Nov. 4, 1917, spoke of having seen this painting in the Brooklyn show, and called it "a regular little gem," which would be appropriate for the 1877 version but not for the 1908 one.

245:36–39 To Beatty, March 30, 1908. Mr. and Mrs. Daniel W. Dietrich II.

247:8–10 In The Painter and the Photograph, 1964 and 1972, p. 163, Van Deren Coke illustrated a series of motion photographs from Eadweard Muybridge's Animal Locomotion, showing a nude woman walking down steps, facing us; one of the photos shows her in a position close to that of the woman in William Rush and His Model. Coke wrote, p. 162, 165: "Eakins used a Muybridge photograph as a reference for the model's movement" and "chose to follow rather closely Muybridge's photograph, which was lighted from above." But although the positions of the women's bodies and legs are similar in the photograph and the painting, their arms are in different positions, as Muybridge's model is carrying a cloth over her head, while TE's model's right arm is in a completely different position. The light in the Muybridge photo comes from above and to the right; in TE's painting, from the side and the left, so that the shadows on the bodies are entirely different. Any persons walking down steps naturally appear in similar successive positions. It is hard to see why TE would have used the Muybridge photograph when he had a living model to study. In my opinion, the similarities, such as they are, are coincidental. TE used his own photography to a limited extent in his painting; but aside from his use of the Muybridge motion photographs for A May Morning in the Park—a fact well documented—he did not use photographs by other photographers, except for a few portraits of deceased persons.

247:22–31 In the catalogue of the Eakins exhibition at the National Gallery of Art, 1961, I said (p. 20): "That he came to consciously identify himself with Rush is shown by the fact that in one of the late versions [G 451] he substituted for Rush's figure his own." I repeated this in the catalogue of the Whitney Museum's Eakins exhibition, 1970, p. 19. This was too categorical a statement; the resemblance, though unquestionable, did not justify calling the substitution a definite "fact."

247:32 "Minor exception." G 205A.

249:2–5 See Volume I, p. 28.

257:13–28 To George Barker, Feb. 24, 1906. WC.

257:32–34 From Mrs. John B. Whiteman, May 17, 1930.

257:34–36 Quoted in full in Schendler, p. 226–227.

257:36–37 A feature-length color film, "Eakins," produced in 1971 by Daniel W. Dietrich II, directed by Christopher Speeth, with musical score by J. K. Randall.

257:39 to 258:5 To Louis Cure, March 9, 1907. SME 3.

258:14–19 McHenry, p. 141.

258:29–34 Interviews with SM, 1931; also McHenry, p. 135.

258:35 ff "Loan Exhibition of Historical and Contemporary Portraits, illustrating the evolution of Portraiture in Lancaster County, Pennsylvania. Under the auspices of the Iris Club and the Lancaster Historical Society." Lancaster, Pa., Nov. 23–Dec. 13, 1912. The catalogue listed The Agnew Clinic as No. 1, with a long appreciative statement at the beginning, and illustrated it as the frontispiece.

McHenry, p. 135, 136, 141–148, gives a detailed account of the exhibition.

259:5–16 Philadelphia Inquirer, Nov. 11, 1917.

259:18–21 New York Sun, Nov. 4, 1917.

259:22–32 Interview with SM, 1931.

259:35–39 Statement by Mrs. Johnston, Nov. 30, 1935, attached to TE's portrait of her. Minneapolis Institute of Arts.

260:5–6 To FE, April 1, 1869. See Volume I, p. 46.

260:10–15 To Mrs. Addicks, Feb. 17, 1914, owned by Mrs. Allen Addicks. Illustrated in *Antiques*, Dec. 1975, p. 1184.

260:30–32 To Hart, Sept. 13, 1912. AAA.

262:32 ff Bryson Burroughs' correspondence about TE, the 1917 memorial exhibition, and the MMA's relations with SME, as well as other correspondence about the exhibition, are in the MMA archives. I am deeply grateful to Patricia Pellegrini, Archivist of the MMA, and to John K. Howat and Natalie Spassky of the American Painting Department, for making available this wealth of material. The quotations in this and the next chapter are from the MMA archives unless otherwise indicated.

262:32 to 265:5 Morris to BB, Jan. 5, 1910.

265:6–10 BB to Morris, Jan. 6, 1910.

265:11–14, 17–19 TE to BB, Jan. 12, April 17, 1910.

265:20–23 Memorandum by BB, May 15, 1910.

265:26–27 TE to BB, June 16, 1910.

267:5–18, 37–38 Interviews with SM, 1931.

267:22–32 *Philadelphia Inquirer*, Feb. 8, 22, 1914.

267:32–33 *Philadelphia Press*, Feb. 22, 1914.

267:38–39 PAFA archives, courtesy of Catherine Stover, archivist.

268:1–9 Henri to Barnes, Feb. 1914. Hirshhorn. Illustrated in Hirshhorn *T.E. Coll.*, p. 222.

268:10–18 Barnes to TE, Feb. 27, 1914. Hirshhorn.

268:30 to 270:11 *Philadelphia Press*, Feb. 22, 1914, p. 8.

270:15–17 *Philadelphia Inquirer*, Feb. 7, 1915.

270:36–38 Hendricks, p. 274–275: "*Starting Out after Rail* was sold to the Metropolitan Museum. . . . The other sporting picture, *Pushing for Rail*, was given to the Metropolitan at the same time, a deal which was probably made when the museum bought *Starting Out after Rail*." The correct facts are as given herewith.

271:1–8 Weir to BB, n.d.; and Feb. 17, 1916.

271:11–15 Weir to SME, Dec. 15, 1917.

271:18–25 TE to BB, April 23, 1916.

271:26–29 Art Club to TE, April 1916. SME 5.

271:32 to 272:3 Interviews with SM, 1931; also McHenry, p. 135.

272:4–5 Letter from SME to me, Oct. 16, 1932.

272:6–10 "Artists Renew Friendship of Paris Here in Philadelphia," *Philadelphia Evening Ledger*, Jan. 19, 1916. Hugh J. Harley, "True Romance Revealed in Unique Bonds of Three Gifted Artists," *Philadelphia Press Magazine*, Feb. 13, 1916. The third artist was SM.

272:11–17 Interview with SM, 1931. In 1932 I sent the unrevised text of my book to SME, asking for corrections of facts. I had included an account, based on interviews with SM, of his taking care of TE in his last illness. SME wrote me, Oct. 16, 1932: "I would correct your account of the period when my husband was an invalid. Murray was not the nurse. A constant visitor, always helpful, anxious to be of service to us, Miss Williams and I the nurses."

272:19–24 Interviews with Thomas J. Eagan and David Wilson Jordan, 1930. Obituary in *Philadelphia Inquirer*, July 2, 1916.

272:24–27 McHenry, p. 133.

272:30–32 From SM, March 15, 1933.

21. Posthumous Fame

273:9–12 Figures from PMA *T.E. Coll.*, p. 45. Hendricks, on the other hand, said, p. 275: "He left an estate of $64,481.17, having reduced, by his unprofitable profession, the estate that had been left him sixteen years before." The source of this figure is not given. TE had inherited from his father about $30,000, not $90,000 as indicated by Hendricks (see note to p. 168). Also, the residue of his estate was not "left to his wife and Addie Williams," as stated by Hendricks, but left in trust, the income to be paid to SME and Miss Williams.

273:23–29 Letter, Nov. 6, 1917. PAFA.

274:5–10 Information from BB, 1930–31.

274:11–13 BB to Robinson, Feb. 24, 1917.

274:17–40 Dates, 1917, of letters between BB, SME, and Parker, in the order in which they are referred to: SME to BB, March 15; BB to SME, March 19, April 17; BB to Parker, April 25; Parker to BB, May 18; BB to Parker, May 21; BB to SME, June 13, July 17; SME to BB, July 19, Sept. 6.

274:36–38 List, Aug. 27, 1917.

275:3–5 John Andrew Myers to Robinson, Sept. 5, 1917.

275:9–11 Mrs. Van Rensselaer to Kent, Sept. 30, 1917.

275:11–17 Cox to Kent, Sept. 6, 1917.

275:18–21 BB to Sargent, Sept. 6, 1917.

275:21–24 Sargent to BB, Sept. 8, 1917.

275:24–26 *Bulletin of the Metropolitan Museum of Art*, Nov. 1917, p. 218; reprinted in *International Studio*, July 1918.

276:2–13 BB to Henri, Oct. 4, 1917.

276:15–18 Henri's full statement is in his *The Art Spirit*, 1923, p. 86–88. Quoted in full in William Innes Homer, *Robert Henri and His Circle*, 1969, p. 177.

276:18–26 Henri to BB, Oct. 29, Nov. 13, 1917.

276:28–33 Cecilia Beaux to BB, Nov. 10, 1917.

276:35 to 277:6 SME to BB, Sept. 27, Oct. 25, Oct. 31, 1917.

277:7–17 *New York Sun*, Nov. 4, 11, 25, 1917. The three reviews are republished in McBride, *The Flow of Art*, selected by Daniel Catton Rich, 1975, p. 130–142.

277:22–25 Information from BB, 1930.

277:30–37 *Philadelphia Inquirer*, Nov. 4, 1917.

277:38 to 278:4 Helen Henderson to Lewis, Nov. 6, 1917. PAFA.

278:26–31 SME to BB, Jan. 4, 1918.

279:3–5 Cranmer to PAFA, Sept. 19, 1919. PAFA.

279:16–20 *The Arts*, April 1930, p. 564, 566.

279:37–41 SME to BB, June 3, 1923.

280:9–17 *The Arts:* "Thomas Eakins," March 1923, p. 185–189; "Thomas Eakins, the Man," Dec. 1923, p. 302–323; "Catalogue of Works by Thomas Eakins," June 1924, p. 328–333.

280:19–25 *The Arts*, March 1923, p. 225.

281:2–6 SME to BB, Oct. 31, 1917.

281:9–12 Henri to Miss Crager-Smith, March 23, 1919; quoted in William Innes Homer, *Robert Henri and His Circle*, 1969, p. 179.

281:14–18 PMA *T.E. Coll.*, p. 7.

281:19–37 BB to SME, July 7, 1927.

282:1–4 Cranmer to PMA, April 7, 12, 1929. PMA *T.E. Coll.*, p. 8.

282:13–22 Fiske Kimball, unpublished memoirs, PMA archives. PMA *T.E. Coll.*, p. 7, 12, 150.

282:25–33 SME to SM, Nov. 30, 1929. Hirshhorn.

283:1–4 *Pennsylvania Museum Bulletin*, March 1930, p. 3–5, 17–33.

283:5–8 "Sixth Loan Exhibition of the Museum of Modern Art," May 1930.

Index of Illustrations

Index